THE EMPIRE STATE

2022

ARCHIVES AND HISTORY AWARD

LONNIE G. BUNCH III

Tuesday, November 1st, 2022
Cultural Education Center, Albany, NY

Lonnie Bunch

*Archives
Partnership
Trust*

a fool's errand

a fool's errand

CREATING THE
NATIONAL MUSEUM OF
AFRICAN AMERICAN HISTORY AND CULTURE
IN THE AGE OF BUSH,
OBAMA, AND TRUMP

LONNIE G. BUNCH III

SMITHSONIAN BOOKS
WASHINGTON, DC

Published by Smithsonian Books
Director: Carolyn Gleason
Creative Director: Jody Billert
Senior Editor: Christina Wiginton
Editorial Assistant: Jaime Schwender

Edited by Evie Righter
Typeset by Scribe Inc.

Library of Congress Cataloging-in-Publication Data

Names: Bunch, Lonnie G., author.
Title: A fool's errand : creating the National Museum of African American History and Culture in the age of Bush, Obama, and Trump / Lonnie G. Bunch III.
Description: Washington, DC : Smithsonian Books, [2019] | Includes bibliographical references and index.
Identifiers: LCCN 2019001828 | ISBN 9781588346681 (hardcover) | ISBN 9781588346773 (ebk.)
Subjects: LCSH: National Museum of African American History and Culture (U.S.) | African Americans—Museums—Washington (D.C.)—Planning. | Museums—Social aspects—United States. | Museums—Washington (D.C.)—Planning.
Classification: LCC E185.53.W3 N383 2019 | DDC 069.09753—dc23 LC record available at https://lccn.loc.gov/2019001828

Manufactured in the United States of America
23 22 21 20 19 2 3 4 5

This book is dedicated to my
colleagues at the National Museum
of African American History and Culture and to
the staff of the Smithsonian Institution,
both of whose commitment to excellence,
to service, to scholarship, and to the
American public is often unnoticed but
greatly appreciated by me.

And to my grandchildren,
Harper Grace and Myles, in the hope that
they will live in an America
worthy of their dreams.

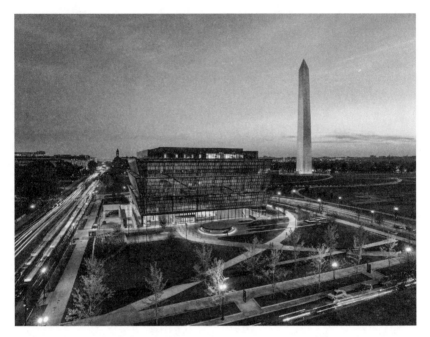

The National Museum of African American History and Culture at twilight on a summer evening, with the Washington Monument in the distance. **PHOTOGRAPH BY ALAN KARCHMER**

CONTENTS

PREFACE IX

CHAPTER 1 WHAT HAPPENS TO A DREAM DEFERRED? 1

CHAPTER 2 YOU END AS YOU BEGIN 17

CHAPTER 3 NOW THAT YOU HAVE IT,
 WHAT YOU GONNA DO WITH IT? 43

CHAPTER 4 DESIGNING A DREAM 67

CHAPTER 5 FINDING THE STUFF OF HISTORY 87

CHAPTER 6 REALIZING A DREAM TAKES MONEY 117

CHAPTER 7 BEFRIENDING PRESIDENTS AND MANAGING
 CONGRESS: A LONG WAY FROM NEW JERSEY 137

CHAPTER 8 EXHIBITING AMERICAN HISTORY
 THROUGH AN AFRICAN AMERICAN LENS:
 MAKING A WAY OUT OF NO WAY 157

CHAPTER 9 ALL IN THE FAMILY: BUILDING A
 COMMUNITY OF CARING COLLEAGUES 177

CHAPTER 10 FILLING THE HOLE: THE CHALLENGE OF
 BUILDING ON THE NATIONAL MALL 195

CHAPTER 11 WELCOMING AMERICA HOME:
 THE OPENING OF THE NATIONAL
 MUSEUM OF AFRICAN AMERICAN
 HISTORY AND CULTURE 213

CHAPTER 12 A FIRST YEAR OF SURPRISE AND WONDER:
 HELPING AMERICA TO REMEMBER 241

 EPILOGUE 257

 ACKNOWLEDGMENTS 263

 INDEX 267

Lately it occurs to me what a long,
strange trip it's been.

—GRATEFUL DEAD, "TRUCKIN'," 1970

I can remember quite vividly how thirteen years ago I tried to talk myself out of accepting the position of Founding Director of the National Museum of African American History and Culture. Why take on a task that had proven impossible to accomplish for nearly a century? Why did I think that I could craft a museum that would explore the sweep of African American history and culture without staff or collections? How does one lead an institution that was a museum in name only, yet was expected to grapple with one of the most divisive and important issues in America—race? And can the candor and complexity needed to engage what has always divided Americans occur within the Smithsonian Institution, a complex known more for celebration and commemoration than for embracing controversy and illuminating all the dark corners of the American past? I wondered if I was simply a fool to even contemplate these challenges.

Then I remembered a novel that I was first introduced to in an undergraduate history class taught by Thomas DiBacco at American University. Written in 1879 by Albion W. Tourgée, it was entitled *A Fool's Errand: A Novel of the South During Reconstruction.* Tourgée was an abolitionist and lawyer who ventured into the South during Reconstruction to help ensure that the former Confederate states would return to the Union in a manner that would guarantee that the formerly enslaved would have the rights and the

protections granted all citizens. Tourgée witnessed how violence and intimidation destroyed the experiment of Reconstruction. Upon his return to the North, he crafted a novel as a way to express his frustrations, his anger, and also his hopes that there would one day be a fairer and freer South. To Tourgée, a "fool's errand" was worth the risk, the fear, and the costs because it was a noble cause that was essential and could help a people, a nation, heal.

As I reread the novel in 2016 I saw the journey to build a museum that could help bridge the chasms that divide us as a "fool's errand," but an errand worthy of the burdens, an errand that would force me, allow me, to use all that I had learned throughout my career. A journey that could help, using history and culture as a tool, a nation come to grips with its tortured racial past and maybe find understanding and hope through the creation of a museum. I was excited enough to say yes to the offer, but unsure of just how much a museum could truly help a country be better.

An answer came nearly a year after the museum opened on September 24, 2016. Whenever I go from my parking space to my office, I ride the service elevator so that I can engage and thank members of the security and maintenance units. That day, a young African American woman pushing a cleaning cart into the elevator asked if she could speak to me. With a mixture of trepidation and pride, she said: "I don't know if anybody has said this, but I want to thank you for all that you did—for us—by building this museum, our museum." When I tried to explain that so many people deserved the credit for the museum, she nodded, but continued speaking about what the museum has come to mean to her, especially when juxtaposed with the Trump White House and the Washington Monument. She went on to say that walking through the museum reminds her of the strength of "her people" and gives her hope for the future. As she exited the elevator, she said that based on what she has learned in the museum "we will be OK."

I have had many people comment about the museum, from presidents to foreign dignitaries, from Baptist ministers to former high school classmates, yet her clear and heartfelt appreciation encapsulated much of what I had hoped the museum could be: a site of memory that could educate and inspire; a museum whose collections, exhibitions, and scholarship would aid the visitors in better understanding the world they inhabit; an institution that would recenter African American history and culture as key to our understanding of who we are as Americans; and, ultimately, a building that was seen as a symbol of possibility, resistance, and resiliency on the National Mall in Washington, DC.

The need for that resistance and resiliency was reinforced by an event in August of 2017. On August 12, 2017, a group of racist white nationalists, neo-Nazis, and members of the Ku Klux Klan descended on Charlottesville, Virginia, supposedly to protest the removal of a statute honoring Confederate General Robert E. Lee. In actuality, their goal was, through marches and mayhem, to return America to a time when racism was a core American value. During the ensuing riot, an antiracist protester, Heather Heyer, was killed.

The day prior to the melee and murder, two white supremacists were visiting Washington, DC. They hailed an Uber driven by an African American woman. As the car approached the building that houses the National Museum of African American History and Culture, the passengers launched into a racist tirade, spewing epithets and hatred. The driver immediately stopped and ordered the two men out of her car with a warning not to "tarnish" a museum that matters.

There is no way that we could have predicted how visible and how important the museum has become. I knew that as part of the Smithsonian Institution, the museum would have a national and international profile, but no one could have anticipated that it would become such a site of pilgrimage and meaning. And I could not have imagined the array of experiences that would change me: I am still stunned that Oprah hugged me and Quincy Jones calls me at home; that people stop me on the street to offer prayers, or say thank you, or to complain about who or what is not in the museum; or that my words and opinions find their way to op-eds or to television; and that despite hundreds of thousands of miles flown, I still have no premier status.

All of which would not have been possible without the creativity and sacrifice of so many. While this book chronicles the creation of the national museum through my lens, my experiences, it is a story of hundreds who labored, who believed, and who sacrificed. Thanks to colleagues in the museum and in the academy, the museum's guiding Council, and the thousands who provided financial, moral, and spiritual support, a century-long dream was realized and, as a result, a museum, a gift, was given to the nation.

Lonnie G. Bunch III
London, England
November 2018

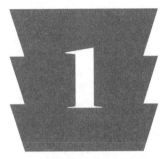

What Happens to a Dream Deferred?

Langston Hughes, 1951

Success is not final, failure is not fatal:
It is the courage to continue that counts.

—WINSTON CHURCHILL

My mantra for that day, September 24, 2016, was whatever you do, don't trip and fall. After eleven years of struggling, believing, convincing others to believe, threading the political needle, and surviving nearly 495 fundraising sojourns, tens of thousands had gathered on the National Mall to bear witness to the opening dedication ceremony of the Smithsonian Institution's National Museum of African American History and Culture. Sitting under the museum's "porch" on a stage with President and Mrs. Obama, former President Bush and First Lady Laura Bush seated just in front of me, Chief Justice John Roberts, the Chancellor of the Smithsonian across the stage from me, the American icon John Lewis next to me, and an array of senior Smithsonian officials everywhere, I finally let myself accept the enormity of what we had accomplished and what the opening of a museum intended to help America confront its tortured racial past could mean to a nation weary of a divisive presidential campaign, and a country still struggling to define its identity in the twenty-first century. To control my nerves, I forced myself

to take in the crowds, the more than 7,000 VIPs (in other words, their support had earned them chairs) and the multitude who watched the ceremony on Jumbotrons from the hillside and from the grounds of the Washington Monument. I realized how much I did not want this moment to end. I did not want to forget a single second because while the success of this endeavor was due to the efforts of hundreds, the vision and the stress of leadership was mine alone.

I was gratified to see an audience more representative of America's diversity than what one commonly experiences in Washington. The crowd, while well represented by those usually associated with this company town— former President Bill Clinton, Speaker of the House Paul Ryan, Nancy Pelosi, Minority leader—also included museum supporters and visitors who just wanted to experience this moment. It felt more like a mini-Obama-like inauguration rather than the celebration of a museum opening. Even the speeches soared to match the significance of the moment. President Bush delivered what I consider to be the best speech of his career, reminding us that slavery was America's original sin and that a great nation embraces its past rather than hides from its moments of pain or evil.

I was so moved by President Obama who could not conceal his emotions as he framed the African American experience as not a separate or shameful past, but a key part of who we are as Americans. And Congressman John Lewis, standing with the moral authority of someone beaten but not broken during the Civil Rights Movement, as he sought to help a nation bind its racial wounds using the museum as part of the healing balm. What lightened my mood and lessened my fear was listening to Patti LaBelle sing the song I requested, Sam Cooke's "A Change Is Gonna Come." Her rendition reminded us that even in the most difficult time, change was possible. Her closing line that the change would be Hillary was embraced by the audience, especially Bill Clinton who leaped from his seat, would ultimately be proven wrong only a few weeks later.

As the "Voice of God" called me to speak, all I could think about was how Congressman Lewis's feet were blocking my path to the podium. After eleven years, all I could do was pray, please Lonnie, don't trip because that is all that anyone would remember. I managed to arrive at the podium, and I was choked with emotion and gripped with fear. And, once again, I was overwhelmed when I saw so many people standing, applauding, and calling out my name. At that moment, my thoughts turned to my father and grandfather, both named Lonnie. My grandfather, who began life as a sharecropper on the Perry Plantation outside of Raleigh, North Carolina, had sparked my love of

Lonnie Bunch Sr., grandfather of Lonnie G. Bunch III, who raised his namesake son to become a scientist and a teacher, and inspired his grandson to become a historian.
PHOTOGRAPH COURTESY OF LONNIE G. BUNCH III

history, and my Dad, a scientist and teacher whose race had limited his career options, had prepared me to be a black man in America. My mind drifted back over the years it had taken me to arrive at this setting. I could never have imagined all the experiences, disappointments, times of great joy, all the visits, and all the people I would encounter. Most importantly, I felt the spirit of my namesakes, the other Lonnie Bunchs, because in many ways the crowd was honoring them too, their struggles and their lives, as much as they were recognizing me. I could not believe that the one hundred-year-long journey—and my own eleven-year sojourn—to create a black presence on the National Mall was over.

So many experiences throughout my career had prepared me and positioned me for this, the grandest challenge of my life, what some have labeled my calling. As a young curator at the National Museum of American History, I had been tasked to lead a curatorial team to craft an exhibition that explored America during the nineteenth century. A major element of the exhibition would explore the impact and the legacy of the enslaved. To humanize the experience of slavery, I wanted to focus on a single plantation as a microcosm of the history of the peculiar institution. I traveled throughout the South in search of the perfect subject. I visited sugar plantations in Louisiana and cotton plantations in Alabama and tobacco farms in North Carolina. Eventually I was taken to the Friendfield estate, a rice plantation outside of Georgetown, South Carolina. There, standing next to a slave cabin extant since the 1840s was Princy Jenkins. In his nineties, Mr. Jenkins had once lived in one of the cabins with his enslaved grandmother.

To tap the knowledge Princy Jenkins had about the life of the enslaved on that plantation was the Holy Grail for a young historian. He told me how the enslaved did a "hard sweep" in the front of the cabin to kill the grass so there would be no vermin near their home. He took me to the rear of the cabin and explained the food that the enslaved grew to supplement the rations they were given. Next we went to one side of the cabin and he spoke about the role children played in monitoring the chimney to alert the adults in case of fires. Then I went to the other side of the cabin, but Mr. Jenkins would not accompany me. I asked him what had happened there and he again refused to come to that side of the cabin. Finally, I implored him to explain, and he just said that he would not come over because there was nothing but rattlesnakes living there. After I stopped running, I asked him why he had not mentioned how dangerous that spot might have been. He replied that people used to remember, now too much is forgotten. He then said words that have shaped my career: if you are a historian then your job better be to

help people remember not just what they want to remember, but what they need to remember. Right after he said those words, he shook my hand and left me standing alone by the cabin as he returned to his work as the caretaker of the plantation. I never saw him again and I am sorry that I did not have the foresight to thank him for sharing his wisdom and his history with a stranger from Washington, DC.

The struggle to help reshape America's memory, to recenter race in the construction of the nation's identity, and in the words of Mr. Jenkins to remember what America needed to remember, not just what it wanted to recall about the role and impact of African Americans, by creating a place on the National Mall was a century-long battle. From 1915, the idea for a memorial in Washington was initiated by African American veterans of the Civil War whose presence and contributions to the Union victory had not been included in many of the commemorations that accompanied the fiftieth anniversary of the war's conclusion. At a time when racial segregation was the law of the land, when hundreds of African Americans were lynched and brutalized annually, when the images of blacks in film, in advertising, and in the media were ripe with stereotypes that denigrated and dehumanized, the idea to create a counternarrative was embraced by many in the African American community. It was hoped that this entity would not only honor the patriotism of the African American soldier but would also have a physical space for programs and presentations that would expand America's knowledge about the black community. Just at this initiative was getting organized the First World War seized the nation's attention and the monument was never constructed.

During the 1920s, a diverse array of African Americans, including Mary McLeod Bethune, W.E.B Du Bois, Mary Church Terrell, and Kelly Miller, supported the notion of a black presence on the National Mall. A campaign made visible, in part, by the African America press led to the hiring of Harlem architect Eric R. Williams, who created the preliminary design for what was called the National Negro Monument. In 1929, the US Congress would pass Public Law 107, signed by President Calvin Coolidge, that would support the creation of such a building, but it would need massive nonfederal fundraising support, something that the onset of the Great Depression made impossible.

The notion of recognizing the contributions of black Americans gained currency as the nation struggled to change during the post-World War II Civil Rights movement. To many, among them Congressman James Scheuer, a Democrat from New York, the Civil Rights struggle should also broaden

WHAT HAPPENS TO A DREAM DEFERRED?

American education to include the presence and contributions of blacks. In 1966, Congress created a commission to study the feasibility of a National Negro History Museum. Though there were concerns raised by the fledgling African American museums and art galleries in numerous urban centers that a national presence may hurt their efforts, many leading African American figures testified in support of this museum—baseball legend Jackie Robinson, Betty Shabazz, widow of Malcolm X, the author James Baldwin, to name only a few. Just as the commission moved forward, Dr. Martin Luther King Jr. was assassinated in 1968, and the nation's gaze turned away from the creation of a cultural institution.

The idea for a national presence lay fallow until the mid-1980s when an African American businessman who created the most successful tour mobile company in the nation's capital, Tom Mack, contacted Congressman Mickey Leland to campaign for a national museum on the Mall. Soon joined by Civil Rights hero, John Lewis, Leland began to push for legislation that would create a stand-alone black museum. Time and time again, the bills failed to work their way through the legislative process. In the early 1990s, a bill passed the House of Representatives, but was squashed in 1993 when Senator Jesse Helms prevented it from receiving a vote in the Senate. After Leland's death in 1989, Congressman Lewis, working with a group of Congressional colleagues, introduced legislation that seemed destined to failure every year.

The Smithsonian was always ambivalent about the creation of a national museum that explored the black experience. As early as 1989, the leadership of the Smithsonian in the presence of Secretary Robert McCormick Adams opposed a separate museum and instead proposed that "just a wing" of the National Museum of American History be dedicated to this history. This remark generated a great deal of negative criticism and led the Smithsonian to bring one of the leading African American museum professionals in the nation, Claudine Brown, to assess the Smithsonian's efforts at interpreting and preserving black culture by conducting a study of the issues involved with creating a museum. Brown brilliantly evaluated the need for this work and explored the challenges to this task, including the limited number of professional people of color at the Institution. After a careful and detailed analysis, Brown encouraged the Smithsonian to create a national museum. Though new leadership arrived at the Smithsonian in 1994 with the appointment of I. Michael Heyman as the tenth Secretary, the Institution still questioned the need for "ethnic" museums on the Mall, but as a concession to the growing interest in a museum in Congress, Brown received the institutional support to create the Center for African American History and

Culture, not as a stand-alone museum but as a unit housed within the aging Arts and Industries Building. This would allow Ms. Brown and her colleagues to enhance and enrich the African American presence on the Mall in ways that the National Museum of American History did not have the staff or the space to accomplish.

In 2001, legislation introduced by John Lewis and Representative J. C. Watts Jr. to create a twenty-three-member Presidential Commission to evaluate issues of location, cost, and collections was enacted and signed by President George W. Bush. Led by Dimensions International CEO Robert Wright and Claudine Brown, the commission released its report strongly advocating for a national museum on April 3, 2003. Six months later in November 2003, legislation crafted by John Lewis, J. C. Watts, Senator Sam Brownback, and Senator Max Cleland, the "National Museum of African American History and Culture Act" (Public Law 108–184) was enacted. Nearly ninety years after the idea was first broached, legislatively, the museum existed. As my father used to say, "patience is a virtue." But ninety years was a long time to be virtuous.

During the years leading to the passage of the museum legislation, I was blissfully distant. In January 2001, after thirteen years as a curator and later as the Associate Director for Curatorial Affairs at the National Museum of American History, I left Washington to become the President of the Chicago Historical Society (CHS, now the Chicago History Museum), one of the nation's oldest museums that was venerated but not visited. Leaving the Smithsonian was extremely hard and I had to come to grips with the fact that I would probably never return to the place where my career had begun and flourished. So as I settled into my first job as a museum director I never thought about the National Museum of African American History and Culture—much.

Once the legislation was passed and the Smithsonian was in search of institutional leadership, I was startled by the number of board members of the CHS and university and museum colleagues and friends at the Smithsonian who assumed that the job of founding director was mine or, at least, that I would want to be considered for the position. And during my time at the National Museum of African American History and Culture (NMAAHC), I came to realize this job was my calling, but in late 2004 when I was first approached about the possibility I was less than interested. In fact, I turned down the chance to compete several times. There were many factors for my reluctance. The sheer enormity of the task was such a daunting challenge. The charge of conceptualizing and building a national museum,

one potentially on the National Mall, was frightening enough, but even more unsettling was the reality that this was a museum of no: no staff, no site, no architect, no building, no collections, and no money. And it carried the weight and the burden of history. It was both the pressure of fulfilling dreams that had been deferred for nearly a century and the realization that this museum would became the national arbiter and legitimizer of African American culture and history in ways that would overshadow all the years of amazing scholarship emanating from the nation's universities and colleges. I was not John Hope Franklin, Benjamin Quarles, Letitia Brown, Marion Thompson Wright, Sterling Stuckey, or any of the other pioneering scholars whose work and creativity forced the academic canons to make way for African American history and culture. I did not know if I could create a museum that was worthy of their efforts and talents.

I was also not sure that I was willing to make the personal and professional sacrifices needed to make real the hopes of so many generations. And I was uncertain whether I wanted to spend a decade or more of what could be considered the prime of my career to take on a project that even the most ardent supporters doubted would be realized in their lifetimes. When Hill Hammock, chair of the board of trustees at the CHS, learned that my name was being bandied about, he suggested that it would be better to be the second director of the museum because the burden of being the founding leader would be too great.

There was no denying that the pressure, the visibility, and the risks would be huge. I wrestled with the impact of taking this job would have on my family and my health. If I did return to Washington, it meant that I would have to commute for at least a year. When I left Washington to head the Chicago Historical Society, my oldest daughter was entering her last year in high school and my family had to stay in the area so she could graduate with her class. The family remained and I commuted each week. I hated the commute. The 6 a.m. Monday morning flights. The rush to attend early morning meetings. And the loneliness of coming home to an empty apartment with the only activity of the evening being the choice of which microwavable dinner to blast. I did not fancy having to repeat that experience since my youngest daughter would complete her senior year in high school while I commuted to the Smithsonian. And though I have been labeled a "public historian," the reality is that I am quite private. I wondered if I wanted or could handle the media scrutiny that would accompany being the face of a museum that did not yet exist. Though at that point I had no idea just how much attention I would attract.

The most important factor in my hesitation was the symbolism of an African American as president of a major cultural institution in a city like Chicago. Throughout my career I have always been critical of a museum profession that was awash in whiteness. The lack of diversity, especially in leadership positions, means that museums have not made the commitment to their communities or to their colleagues to be institutions that grapple with our differences. To see culture, history, and the arts as more than sources of beauty, exoticism, and nostalgia, but to use them as tools that help the audiences navigate the challenges of contemporary America. In an article I wrote twenty years ago, "Flies in the Buttermilk: Museums, Diversity, and the Will to Change," I challenged the museum profession to train, promote, and hire people of color as leaders of institutions. In Chicago I had the chance to demonstrate how diverse leadership can make an organization better. Our nearly five years of success included increased visitations and visibility, and exhibitions and programs that mattered. And our institution was being seen as a museum valued by an array of communities. I hoped that I had opened doors at other institutions to appreciate and nurture people of color. In essence, my fervent hope was that my work in Chicago would provide greater access to positions of influence and ensure that future generations of diverse scholars and museum professionals would not have to refight the battles I had fought. I worried that taking the helm of what some people felt was another "black museum" would be taking a step back, that I would be retreating from the struggle that had shaped my whole career.

Ultimately, the possibilities and the challenges of creating a national museum proved too alluring to resist. Being president of the Chicago Historical Society nurtured my soul. Yet being part of the birth of the National Museum of African American History and Culture nurtured the souls of my ancestors. Until I returned to the Smithsonian in 2005, I had never written about or mentioned ancestors. But the museum should be about more than an individual's dream. This endeavor was more important than anything I could ever do. To me success was doing work that would make my ancestors smile. And the opportunity to make them smile was part of what convinced me to pursue this position. I was, however, also moved by the potential to put in place ideas, values, and stories that mattered to me, that were often overlooked. The museum would not be about me, but it would be a laboratory to test and to implement my hopes for what a museum could be in the twenty-first century. I wanted a museum that was a tool to help people find a useful and useable history that would enable them to become better citizens; a museum that would explore and wrestle with issues

WHAT HAPPENS TO A DREAM DEFERRED?

of today and tomorrow as well as yesterday. I craved to be part of an institution that was of value both in the traditional ways of curating exhibitions, enriching education opportunities, and preserving collections and in nontraditional ways, such as being a safe space where issues of social justice, fairness, and racial reconciliation are central to the soul of the museum.

To accomplish these goals, a museum must be a welcoming place that is ripe with stories well told. Stories that would allow a museum to humanize and make accessible the past in a manner that was interactive and engaging, that recognized that visitors bring their own histories with them, and that they need to feel that their memories are as valid and as encouraged as the exhibitions a museum would feature. My ideas of interactivity and engagement stemmed not just from an interest in technology, but from the storytelling that I overheard as a boy growing up at our family barbecues in Belleville, New Jersey. Whenever family and friends of my parents gathered, I noticed that the older men eventually settled deep in the backyard so that their laughter-driven stories remained private. I could not wait until I was old enough to join in and learn the secrets of their laughter. I just knew that I would benefit from their wisdom, which for a teenage boy was focused on dating and girls. When I was finally old enough to join the men, I was initially so disappointed. Instead of the secrets of courtship, they were discussing the history of baseball. All that wait for baseball. But as I listened, I became fascinated. First someone would say that Don Newcombe was the best player they had ever seen. But then an uncle would say that no, no one was better than Jackie Robinson. Then a cousin would add "Cool Poppa" Bell into the mix. Soon everyone was sharing an opinion. But the wonder of the conversation was that everyone was engaged and each person's contribution enriched the discussion and took the gathering in directions unanticipated. I never forgot the sheer joy and wisdom of those occasions. What I wanted was a museum that could replicate the excitement, ownership, and shared learning that came from those conversations, a museum that was not intimidating but as comfortable as the backyard barbecues of my childhood.

What finally convinced me to contend was my hope, my definition of what this museum could be. During the creation of the National Museum of the American Indian (NMAI), I had worked closely with Roger Kennedy, the director of the National Museum of American History, who was quite supportive of the developing NMAI. It was Roger Kennedy who first stirred my imagination about the possibility of becoming a museum director at the Smithsonian. He warned me that to be successful in that role one had to be independent of the Castle—the nineteenth-century building that

housed the leadership of the Smithsonian—and be able to raise one's own resources and develop one's own relationships with members of Congress. Advice I heeded later in my career.

Through Roger Kennedy I became an ally and supporter of the innovative work of Rick West, the visionary behind the creation of NMAI. He believed that it was crucial to create a museum that demonstrated that native people still existed, that they were not extinct. He felt it was essential that the stories told in the museum service the native community as the primary audience. Based on the problematic history between native communities, curators, and museums, this was a logical and reasonable course of action. But I realized that the patterns established by NMAI would not suit the NMAAHC. Many potential directors of NMAAHC were speaking out about the need for this to be the best black museum in the country. I believed the museum could be much more than that. It should demonstrate that based on generations of scholarship, the African American story is bigger and more important to simply be in the hands of one community. In essence, a new museum should help all who enter or encounter it realize that they are shaped and informed by the African American experience regardless of who they are. When I did not see others with such an expansive framework, I felt I had to weigh in. To my mind, this should be a museum for the next century, not the last one.

After many conversations with my family about the impact this choice would have on our time together and the possibility that the stress of this work could shorten my life, I decided that I would seek the job as the Founding Director of the National Museum of African American History and Culture. Making this decision took almost as long as the interview process. From the fall of 2004 until February of 2005, I drafted written responses to an array of questions, including what was my vision for the museum, what was my management experience, how familiar was I with the political arena, what success had I in fundraising, and where did I hope the museum would be in ten years? I found these questions quite useful as they helped me to draft a preliminary sense of the vision and the strategy that would be my guiding document once I secured the position and began my tenure back at the Smithsonian.

The interview process proved to be much more challenging. I remember flying to Washington and being ushered into the conference room of Sheila Burke, the deputy secretary (the number two person) of the Smithsonian Institution. While I had known Sheila prior to my leaving NMAH for Chicago, she greeted me with reserve, not like a former colleague. I thought this might not bode well. I sat at the head of a very long table that

seemed too big for the room. It might have seemed so large because there were at least twelve people squeezed around the table poised to ask questions in a rapid-fire manner. The search committee included representatives of the Presidential Commission, scholars such as Deborah Mack, formerly of the Field Museum in Chicago, and Charles Ogletree Jr. of the Harvard Law School whose prize pupil, Barack Obama, would soon be running for the US Senate; prominent individuals with influence within the African American community such as Lerone Bennett Jr. of *Ebony* magazine; and senior officials from the Smithsonian such as James Early. The questions came from all sides of the table, but most focused on my time in Chicago as a museum director and my interest in and ability to fundraise. Obviously, there were questions about my vision for the museum. I expected more probing about my own scholarship and my sense of how one builds a national collection. I must admit, as a former college professor, I enjoyed the banter and the challenge of being nimble. I felt good about the interview, but in hindsight I worried that I may have stumbled over questions about working with Congress and about my own relations with the moneyed elite.

I was more troubled when I realized that the other finalist was Claudine Brown, someone whose work and vision I so admired. I was less anxious about the competition and more concerned about what the job might mean to her. After all, she had devoted years to this endeavor, first as an analyst of what was possible at the Smithsonian, then as the leader of the Center for African American History and Culture, and finally as the co-chair of the Presidential Commission who had toiled for years to analyze the potentiality of a stand-alone museum on the Mall. I was more upset at the prospect that I might lose a friend and a valued colleague than I was of losing a job. There were very few African Americans at the highest levels of the museum profession. People such as Amina Dickerson, John Fleming, Juanita Moore, Spencer Crew, Howard Dodson, and Claudine were my peers, my support group, and my friends. I hoped that this process would not cause a rift. Earlier in my career I had actually withdrawn from a job search because I did not want to compete with a friend. This time would be different. Later, when I was asked to return to speak with Secretary Lawrence Small, I thought that I might be offered the job. Even before I celebrated with my family, I wanted to reach out and talk with Claudine, but I did not know what to say. It would be several years before we could share the experience and rebuild our friendship. I am most grateful that we spent time together once she returned to the Smithsonian as the Assistant Secretary of Education and Access before her all too early death in 2016.

I had hoped that my interviews were strong enough to induce Secretary Small to hire me, but I was still surprised when he offered me the position. Candidly, I was stunned. During the last year of my tenure at NMAH, which was his first year at the Smithsonian, we had a problematic relationship. In my mind, he was brought to the Smithsonian, from corporate America, to increase its fundraising profile and to bring a sense of order to what he once called "undisciplined and out of control curators," of which I was proud to be one. My first interaction with the Secretary occurred when he wanted to address the curatorial staff at NMAH, which was my unit. After expressing his excitement at some of the wonderful collections of the Smithsonian, he then made clear the limits of academic freedom at the Institution. He suggested that a curator's interests must always be subordinated to the institutional priorities. In essence, he proclaimed a new day at the Smithsonian. Later that day I shared with him that his talk did not go over well and that I believed there could be a balance between individual scholarly pursuits and the needs of the Institution. We agreed to disagree, though it was clear who had the power.

During his walk-through of the museum, he commented on the presence of an exhibition that chronicled the history of the First Ladies, but noted that we had nothing as substantive on the presidency. He later ordered that the museum create an exhibition that explored the story of the presidents and that we needed to open it by the next presidential inauguration, which was in less than a year. Being told what to do by the central administration and to curate an exhibition in less than a year created a great deal of what we called in my New Jersey neighborhood, agita. Yet, I realized he was right. We did need such an exhibition and if we were as good as the public thought we should be able to do something within that time frame. So, in concert with NMAH Director Spencer Crew and Curator of Political History Harry Rubenstein, I took the lead in curating a major exhibition, The American Presidency: A Glorious Burden. It was my task to be the intermediary with the Secretary. We had many moments of disagreement and what diplomats called "frank and candid discussions." We debated everything from some of the interpretive frameworks to the color of the carpets. Ultimately, we worked together and the exhibition opened in November 2000, just prior to the inauguration of President George W. Bush.

I thought that our previous interactions might disqualify me in his mind, so I was pleased but quizzical when Secretary Small asked me to return to the Smithsonian as the director of a paper museum. Before I gave him my answer, I wanted him to know that I was the same person with whom he had

previously had a strained relationship. And that being a museum director in Chicago had only sharpened some of my political and curatorial edges. He responded by recalling a debate we had had over the racial content of one of the many videos within the American Presidency exhibition. On the occasion he was worried that I would be unreasonable and demand that the contested racial content be untouched. He said that he was pleasantly surprised when I agreed to edit the piece so that we could both be satisfied with the content. While I did not remember the episode, I understood that he knew that I would stand my ground, especially over issues of race, but that I was also reasonable, whatever that meant.

Once we reached an agreement about my employment, I made small talk by asking about his family, which prompted me to begin to mention my children, at which point he abruptly cut me off, saying that he did not want to know too much about me in case he had to fire me. Talk about deflating one's confidence. I had not yet even started and he was contemplating my replacement. Some welcome home.

I returned to Chicago and began the process of transitioning back to Washington. I was offered the position in March 2005, but I could not begin to lead this fledgling effort until July. The Chicago Historical Society was in the process of creating an exhibition that commemorated the fiftieth anniversary of the murder of Emmett Till by exploring the history of racial violence in America. This work was so important to me: it helped the museum embrace challenging histories and it allowed me to honor Mamie Till Mobley, the mother of the slain child whose actions forced America to look at itself and helped to reignite the Civil Rights Movement. I did not realize it at the time but Mrs. Mobley's actions and friendship would play a key role in many of the decisions I would make as director of NMAAHC. Since I could not leave in the middle of such an endeavor, the Smithsonian agreed not to release the news of my hire until later in the spring.

In light of how much my life was changing, my wife, Maria, and I decided to take a brief holiday with friends to a beach resort in Mexico. Before I could even walk on the beach, I received an anxious call from the Office of Public Affairs at the Smithsonian: someone had leaked my appointment, and both the *Washington Post* and the *New York Times*, and several other media outlets, were set to run articles. And the Smithsonian wanted me to be interviewed. This was the first of many missteps. I had not shared the news of my departure with my staff and now they would learn about my abandoning them from the press with me out of the country. This would be a true embarrassment because many of the museum's donors and my supporters would not learn of

my departure in the way I had hoped. The resolution: I spent hours trapped in an expensive hotel room, only being able to glance at the ocean, while talking to a plethora of journalists about plans I had not developed and dreams I was not close to realizing.

After arriving back at Chicago's O'Hare Airport, we made our way to our home in Oak Park. Though Ernest Hemingway apocryphally said that Oak Park was a place of wide lawns and narrow minds, we loved living in that community. As we pulled into the driveway, I noticed piles of packages on the front steps. Looking at the material, I realized that nearly a dozen architectural firms had sent information to me about their interest in designing the National Museum of African American History and Culture. Between the attention from the press and now from the design community, I gradually began to understand that this new journey would be unlike anything I had ever experienced. What I found more frightening was the fact that there were few models in history that I could draw upon where people had embarked on such a "fool's errand" as I now had.

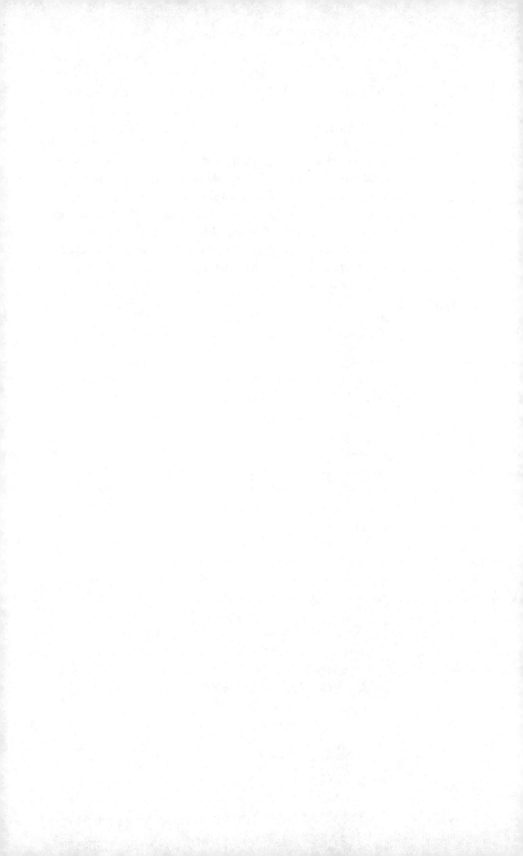

You End as You Begin

All I am askin'
Is for a little respect.

—ARETHA FRANKLIN, "RESPECT," 1967

After being rootless my first week back at the Smithsonian in July of 2005, I was excited to learn that I had been given offices in L'Enfant Plaza, a hotel and office complex a quarter of a mile removed from the National Mall, but tantalizingly close enough to serve as a constant reminder of what could be accomplished with creativity, unrelenting effort, and a bit of luck. So, one morning the entire staff, all two of us—Tasha Coleman and myself—walked up the hill, anxious to see the space we would call home and the offices that would be the seat of our planning, praying, and plotting for the next several years. Winding our way through the hotel lobby, we took the elevator to the seventh floor and soon found ourselves grinning as we stood in front of the doors to Suite 7102.

Our happiness was short lived as the doors were locked. We then went to the hotel desk and explained that I was the director of the newest Smithsonian museum and I needed the key to our offices. After several blank stares we were told we never heard of you and we cannot provide you access to the suite. Undeterred, we then sought out the security office and explained our situation. Unfortunately, it immediately became apparent that being a

museum director did little to impress the security force. They refused to help and, in fact, looked at us as if were we pulling a scam, as if there was some hidden treasure just waiting for us in empty office space. Maybe I should have worn a tie. Anyway, after knocking on a few more doors and being unable to interest anyone in helping us with our plight, we walked back to Suite 7102 and just stared at the locked doors, like two forlorn waifs. What did we next see but a member of the maintenance staff who was just happening to pass by with his cart loaded with tools. Drawing on skills I still had from growing up in North Jersey, I talked him into loaning us a crowbar. We used it to break in, and though the door frame was permanently damaged, at least we were in.

Standing in the empty offices I thought, now what? Do I focus on finding the staff or creating an engine for development? Do I concentrate on building the collections or developing the intellectual agenda and exhibition frameworks? Is now the moment to think about the architects and the look and the construction of the edifice? Was this the period to find common ground with the museum's Board of Trustees (the Council), or create the collaborative networks within the Smithsonian? Or was this simply the time to panic?

———·•·———

I realized that it was fitting that we would break into our offices because even after nearly a century-long wait no one was really ready for this museum: not the Smithsonian, not Congress, not the philanthropic community, not other cultural institutions, not the general public—and especially not me.

My own unreadiness had been on display at my first Council meeting in June 2005. Since nineteen members of the Council had been chosen prior to my appointment, the leadership of the Smithsonian had asked that I come to Washington earlier than scheduled to attend the meeting and to provide an overview of my plans to the members. The venue was the National Museum of African Art, a building that I had always found difficult to navigate. As I walked down the stairs, searching for the conference room, I was unsure of what to expect. How committed was this group to the long road ahead? And how would they react to me? After all, they had had no input in my hiring, yet we would have to work together for an undefined period.

———·•·———

When I walked into the room, the members of the Council were already seated and chatting informally. I was ushered to a seat between Robert Johnson, the entrepreneur who created Black Entertainment Television (BET), and the iconic Oprah Winfrey. Sitting across from me were some of the most influential corporate leaders in America: Dick Parsons, the Council co-chair and CEO of Time Warner; Ken Chenault, the CEO of American Express; Ann Fudge, who led Young & Rubicam; and Sam Palmisano, the head of IBM. I was terrified. How could I fit in with such a powerful and elite gathering? I felt a long way from New Jersey. The only person I knew was Linda Johnson Rice, a friend from Chicago who was the Co-chair and the CEO of Johnson Publishing. The meeting seemed to last forever. I remember trying not to rush my answers to their questions. I shared my sense of what the museum could be, but also asked their opinions. I was just grateful when the evening ended with no major missteps on my part. It was essential that I build a rapport with the Council, but I was unsure how to connect with them. In my mind, I was clearly intimidated.

The next morning, I met with Secretary Small, the CEO of the Smithsonian Institution, and he mentioned that I had seemed quite nervous at the meeting. What an understatement. He then gave me the most important advice I could have received. He said that I should recognize just how powerful the Council is both individually and collectively, but that I should not underestimate my own status. He went on to say that I "am just as respected and as famous in my field as they are in theirs." And that they wanted to be with me as I created the museum. This was so helpful, and true: I actually did know more about founding and sustaining a museum than they did. And while those words never completely eliminated my fears and nervousness when attending the more than forty Council meetings during the run-up to the opening of the museum eleven years in the distance, they gave me the confidence I needed to provide the leadership that the Council expected and deserved. That conversation brought to mind a quotation from Lyndon Johnson that I had come upon as I worked on the American Presidency exhibition during my tenure at the National Museum of American History. Johnson said that "no matter how big you are, you are not big enough for the presidency. But no matter how small you are, the presidency makes you bigger." I could only hope that LBJ was correct and that I would grow into the role of founding director. And I just hoped I could do it quickly.

As unprepared for the initial challenges of leadership as I might have been, in many ways, the Smithsonian was even less equipped—or, to put it

another way, at least not ready to treat this endeavor as a museum equal to, in both stature and importance, the other SI units. While senior leaders such as Larry Small, Sheila Burke, and Richard Kurin, the head of the Center for Folklife and Cultural Heritage, championed and supported this project, other parts of the Smithsonian were blasé, or often hostile. To provide some sense of institutional coordination, I participated in meetings of the NMAAHC Oversight Committee. Led by Deputy Secretary Burke, the meetings included what seemed to be a cast of thousands, representing the fullness of the Smithsonian bureaucracy. To me, the gathering should have been named the "slow it down, we did not really want to do this" committee. While important decisions were sometimes made, often it felt as if the group's function was to criticize, grouse, and stonewall while wringing their hands at the task before them. I did try to bring important issues to the gathering that could help counter some of the institutional reticence. A small action that spoke volumes involved the Smithsonian Institution credentials. On every SI employee's identification badge, the acronym of that person's respective museum was displayed prominently: two examples, the National Air and Space Museum staff had NASM on their badges, while NMNH represented the National Museum of Natural History. NMAAHC was not visible on my badge or on those of the first group of staff I hired. When I asked why that was, I was told by the SI Security Office that the museum did not exist and therefore its name would not grace the badges. Yes, but I was keenly aware that we needed to make visible this invisible museum, and an acronym did that. It mattered. After I strongly complained about this to Sheila Burke through the Oversight Committee, the museum was given enough credibility to have its acronym appear on ID badges—a modest but crucial victory in the struggle to be recognized. Something as simple as having our initials visible suggested that we were more than an idea, more than a concept: we were a museum.

———••———

Other fights and slights soon followed. Shortly after my return to Washington, I had attended a meeting comprised of other museum directors at the Smithsonian. One of my colleagues expressed concern that NMAAHC was taking congressional support and philanthropic dollars that would be better spent in other parts of the Smithsonian. And then she claimed: "This new entity was hurting the Smithsonian." I wanted to bang on the table and ask why NMAAHC was seen as such a threat. Rather than yell my outrage, I

simply reminded my fellow directors that NMAAHC was part of the Smithsonian, so any support, any attention, it garnered would add luster to the entire Institution. At the same gathering, another colleague was agitated that the new museum would "obviously seize any Smithsonian collections that are connected to African American culture. And that we must all fight to counter that action." Ironically, it never occurred to me that the new museum would take collections from within the Smithsonian. But I was offended that, without consulting the museum staff, it had been determined that the new museum would be a predator that must be contained.

A more serious incident involved the central Smithsonian Office of Advancement. As I was leaving the Chicago Historical Society, I was pleased by an action taken by its Board of Trustees. Though concerned that I had decided to return to Washington, some Board of Trustee members thought it would be an important gesture to contribute money in support of my new endeavor as a way to thank me for my service. After seeking the advice of the Office of Advancement at the Smithsonian, I was given directions as to how the gifts could be made. Ultimately, nearly $70,000 was sent to the Smithsonian to be earmarked for NMAAHC. Several months later, I was contacted by Hill Hammock, the former CHS board chair, who was concerned that no one who contributed to the new museum had heard from the Smithsonian. I was surprised. When I contacted the Office of Advancement, they could not find any record of the gifts. It would take several weeks before they found the "lockbox" that held all the money given to the museum. At no point were any of the donors acknowledged, much to their, and my, dismay. When this was finally resolved and the Chicagoans received the appropriate acknowledgments I was told no one had paid attention because they did not expect the new museum to raise any money so soon.

Even the Information Technology unit of the Smithsonian was unprepared for the requirements of the new museum. Making the museum visible was one of the initial goals of my tenure. One way to do that was to birth the museum online, something considered quite different and innovative in 2005. Thanks to the leadership of its CEO Sam Palmisano, IBM was willing to contribute mightily—staff, hardware, and financial resources—to help the museum garner supporters and interest via a virtual presence. To support this online activity, IBM was willing to donate several servers as well as an operating system known as Ruby on Rails. Initially, the Smithsonian declined both the servers and the operating system because the Institution had never been offered servers before and the operating system was not compatible with current SI platforms. While this recommendation was done without

malice, it suggested to me that SI was unwilling or unable to embrace innovation. Ultimately, we demanded that SI take advantage of this offer.

This near-miss, however, rang a cautionary note. Going forward, NMAAHC would have to find ways to navigate the tension between the traditions of the Smithsonian and the needs and opportunities of a twenty-first-century museum. I could not imagine the response from other donors and innovators if this gift had been rejected. I knew that the museum would have to become conversant with new technologies to be the successful institution that modern-day audiences needed and expected.

While it had taken Congress nearly a century to pass legislation enabling the museum, not everyone in Congress was supportive. And even those who voted for the bill were not sure that the effort would meet with success. Yet, without the continued backing of the legislative branch, there would be no museum. So many of my initial days at work back in Washington were spent going up to Capitol Hill to meet with the members. I think the Office of Government Affairs was surprised at how quickly I was embraced by many in Congress, especially the Illinois delegation. A bi-partisan group that included Senator Dick Durbin (D) and Representatives John Porter (R), Bobby Rush (D), Danny Davis (D), and Jan Schakowsky (D), and later a friend named Barack Obama would acquaint me with many of the representatives I would at some future time need to engage.

A meeting was scheduled so I could be introduced to a powerful member of the Committee on Appropriations, who will remain unnamed, because his support would eventually be needed. Smithsonian colleagues suggested it would be a difficult encounter due to his antipathy towards the Smithsonian and this new endeavor. The night prior to the meeting both of us were at the same reception at the Library of Congress. After introducing myself, we discussed how he and my mother were from the same region of North Carolina. It was such a pleasant conversation that I anticipated a comparable discussion the next day.

As I entered his office on the following morning, I noticed that he had an array of staffers standing against the wall, all unsmiling. As I began to greet him, he interrupted, then talked for twenty minutes about how he did not like the idea of the museum and that he would never support it. He began to repeat the phrase, "I will give you $25,000 to make it a website and then the museum can go away." He kept repeating the phrase

"make it a website," and I was stunned. All of the pleasantries of the prior evening had vanished, replaced by a sense of aggressive negativity. I was unsure of what I should do. When he finally paused, to counter the notion of a web presence, I spoke about the power of the authentic. I mentioned how moved I was during my time at the National Museum of American History by the manner in which the public engaged objects such as the Star-Spangled Banner and the Greensboro Lunch Counter that I had collected during my curatorial career there. Suddenly, he stopped talking and turned red. He grabbed his neck and started to cry. Was he having a heart attack? My mind flashed to the news headline: "Member of Congress killed by Smithsonian museum director."

———

As his staff hustled me out of the room, I wondered if my tenure as director of NMAAHC was over before it even started. After twenty minutes, he came out of his office, much to my relief, and spoke about how my words touched him. He had forgotten that during the Greensboro lunch counter sit-in, he was a college student who had raised money to help post bail for any of the black students who were arrested. He thanked me for restoring his memory and said that he liked me. He was still not going to support the museum, but he was grateful that I had stopped by. That encounter prepared me for the ambivalence I would face from Congress. And it also reminded me to use stories about the past to excite and engage the members of Congress, something I would do for the next decade. This would not be my last interaction with a skeptical or hostile Congress.

Despite the fact that so many people and institutions were unready for both the efforts needed to create this museum and its potential presence on the National Mall, we had a vision of what the museum could become and a strategic sense of how to fulfill the dreams first posited so many generations earlier. I must give credit to an unlikely source who helped me see a way forward: Richard M. Daley, who was mayor during my time in Chicago. It is hard for me to admit that I have an appreciation and even a fondness for a Daley. After all, his father Richard J. Daley's tenure as mayor of Chicago was ripe with racism, hostility, and hatred for certain communities within the city as well as police violence and brutality. Mayor Daley, the younger, was generally supportive of my work in Chicago. He attended a number of exhibition openings at the Chicago Historical Society and he appointed me as a member of the committee tasked with convincing Boeing to move its headquarters from

Seattle to Chicago. In fact, I have more pictures taken with him than any other political figure I encountered during my career.

Once it was clear that I was leaving the city to return to Washington, not everybody was happy to see me go. There was criticism from many donors that I had gotten people excited only to leave after five years. And when I was asked to come to City Hall to meet with the mayor just prior to my departure, I was unsure of the topic of the gathering. As you enter the mayor's suite, there is a general waiting room. From there a visitor is escorted into one of two rectangular holding rooms where the mayor would enter, hold a brief meeting, then move to the other space while another visitor replaced the earlier one. Usually Mayor Daley was very direct, with meetings only lasting a few minutes before he moved to the next appointment. But when I sat with him we chatted an unusually long time—about family, about the city, and about the importance of culture to the tourist economy. Finally, I asked him what he needed from me in order to clarify the reason for the appointment. He said that he had heard the criticisms leveled at me, and wanted me to know that he understood and applauded my return to the Smithsonian. He did ask why I would leave Chicago to return to a "one-horse company town like Washington." He then said something that was transformative. He wondered why I would leave an established museum to "run a project." Daley raised all the right issues. It was difficult to leave Chicago. It is a city where the corporate, political, and cultural entities work collaboratively to improve the lives of all Chicagoans. It was exciting and instructional to serve on committees tasked to access the future of the city, to be part of a community that recognized the important role culture plays both economically and spiritually.

After the meeting, I keep thinking about what Mayor Daley had said about running a project. His final hand-off had forced me to grapple with the limitations of supervising a project. In many ways, projects are like movie scripts in Hollywood. Everybody has one and yet very few are realized as films. Since this project idea had been floating around for decades, why should anyone believe that this time would be different. I realized that my job ultimately was to make an array of people, potential funders, Congress, average citizens, and Smithsonian colleagues, believe, truly believe, that a museum would arise on the Mall, believe that millions of dollars could be raised, believe in the redemptive power of history, and in my leadership and vision. A tall order.

Wrestling with this conundrum led me to frame this endeavor not as a project but as a museum that already existed, it just did not have a building.

In those initial years, this became our slogan and our guiding principle: we exist now. It was an idea that was simple to articulate, but challenging to achieve, and it put a double burden on the early staffers. Not only must they immerse themselves in the planning for a building and its content, but now they also had to begin to service audiences by curating exhibitions, creating websites, and providing educational opportunities. In essence, we had to prove that the wait for the museum was over—though the wait for the building might be a decade away. What helped us to ease the wait was a vision for a twenty-first-century museum—a vision that we hoped would help America find some reconciliation and healing over issues of race. At the very least, through our efforts the nation could find a truer, more candid sense of its history, its identity, and itself.

One can tell a great deal about a country by what it remembers. By what graces the wall of its museums. And what monuments have privileged placement in parks or central traffic intersections. And what holidays and patriotic songs are the bane and balm to generations of school children. Yet one learns even more about a nation by what it forgets. What moments of evil, disappointment, and defeat are downplayed or eliminated from the national narratives. Often in the United States the issues of race and the centrality of African American culture are given short shrift in textbooks, popular chronicles, and national memories. These issues became goals the museum hoped its vision could help address and assuage.

I needed to develop a vision that would be engaging and easy to articulate, that appealed to a variety of future constituencies and reflected my hopes for what museums could become in the twenty-first century. I had spent many years lecturing at museums, universities, community organizations, and scholarly conferences both within the United States and in many countries in Europe, Asia, and Africa. These experiences had allowed me to see the best and the worst of the exhibitions, organizational structures, and community partnerships in a range of cultural organizations. I reread reviews of recently created institutions—the Australian National Museum, the National Museum of the American Indian, the Musée du quai Branly in Paris; studied the decades of notes from my journals that reminded me of the details about the array of exhibitions I had seen throughout my career; and spoke with friends and colleagues from universities and museums to gain their insights. And now was the moment to use those experiences, those connections, to shape what I hoped would be an institution that was a beacon that illuminated new directions and possibilities for museums. When I

arrived in Washington in July 2005, I had a polished vision statement already prepared.

The vision of the National Museum of African American History and Culture that evolved from the months of research and writing I did before beginning my new job had four pillars or components. The first pillar posited that the museum will be a place of meaning and memory. It will, in the words of Princy Jenkins, help all remember not just what they want to remember but what they need to remember. It would provide, as the eminent historian John Hope Franklin who served as the Chair of the Scholarly Advisory Committee (SAC) at NMAAHC until his death in 2009, emphasized to me many times, "the unvarnished truth." Thus, one should be able to explore familiar stories and names like Frederick Douglass, Sojourner Truth, or Maya Angelou in new ways, with different insights.

The museum must also illuminate stories and narratives that humanize history and make visible those traditionally omitted from America's historical memory. It must be a place that helps us remember the enslaved woman from an Alabama cotton plantation who arose each morning, fed, and loved her children before a day bent over in the cotton fields, and then refused to let that labor strip her of her humanity or her hope. Or tell the history of the family that left Mississippi in 1913 for the South Side of Chicago in search of economic opportunities and freedom from the violence and unrelenting bigotry in the South, only to find that some of the same limitations based on race followed them north. And discover the accounts of students who dropped out of Brandeis University to join the Civil Rights Movement in 1964. Or remember women like my own grandmother, Leanna Brodie Bunch, who took in the laundry of other families and scrubbed floors not her own so that her children and grandchildren would not have to work on bended knee.

—————

By remembering, then, the museum would also seek to help America confront its tortured racial past. Here visitors should pause and possibly cry as they pondered the pain of slavery, segregation, the unmet expectations of the northern migration, and the grinding legacies of poverty and racial violence. Yet they should also find the joy and the resiliency that is at the heart of the African American community. A visitor should be able to tap their toes to Louis Armstrong, Billie Holiday, Aretha Franklin, or someone from the hip hop world—a domain that I had no idea of who we would feature—that my

future colleagues would know. There must be an exploration of the cultural richness that emanated from literature, film, theatre, storytelling, fashion, and food ways. If the museum was to be successful, it would need to explore the struggle for racial justice and the manner in which the African American community consistently adapted to changing circumstances and "made a way out of no way."

The power and the centrality of memory—and the role a national museum can play—was made dramatically clear thanks to my interactions with Mamie Till Mobley, the mother of the martyred Emmett Till. During my tenure at the Chicago Historical Society, I became very close to Studs Terkel. Not only was Studs a great oral historian who championed the stories of those considered on the margins of society, he also knew everyone. Studs was a Chicago treasure who always wanted to illuminate the lives of those he called "average but essential." We would meet weekly to discuss his work and invariably he was late. He would rush into my office apologizing because there was a demonstration or a strike that he had to attend before coming to the Historical Society. I asked Studs who I should meet in order to become more familiar with the city. He immediately answered "Mamie Mobley, Emmett's mother." He arranged for Mrs. Mobley to join me for lunch in my office.

On the day of the lunch, I anticipated a ninety-minute meeting, but once this small but powerfully intense woman shared her story, I knew the day was hers. She spent nearly six hours chronicling the story of her son from the time she kissed him farewell at the train station before he embarked for Mississippi until his funeral at Roberts Chapel and his burial at Burr Oak Cemetery in Alsip, Illinois. Never shedding a tear, she shared some of the most painful moments of her life: receiving the news that Emmett was stolen from the home of her uncle, Moses Wright, in response to a perceived affront to a white woman that has since been disproved; to the discovery of his body; to the devastation of seeing his butchered remains; to her decision to allow the casket to remain open so "the world could see what they did to my son." While she kept her emotions in check, I cried more than any other time in my life.

I was so moved by her candor and amazed at her strength that when the *Chicago Tribune* asked me to write an article about someone the city of Chicago should never forget, I wrote about Mamie Till Mobley. Her commitment to ensure that Emmett's death would be a clarion call that reignited the post-WWII Civil Rights struggle and the manner in which she reinvented herself as an educator who shaped the lives of generations of children on the

South Side of Chicago were just part of her legacy. As our acquaintanceship grew, I spent time talking to her about her son. One Friday, just prior to her death in 2003, Mrs. Till Mobley spoke about how she had carried the burden of Emmett's death and the meaning of his loss for almost fifty years. She was tired and wondered who would pick up that burden. I felt as if it was a charge to me, to ensure that people like Emmitt Till should always be remembered by the American public. As I conceptualized the National Museum of African American History and Culture, I knew it had to fulfill Mamie Mobley's charge: to be a place that carried the burden of history and the weight of memory, regardless of how painful or difficult it was. At the core of the museum, therefore, would be a commitment to remember.

Yet, being a site of memory, though important, was not enough for a museum of the twenty-first-century. This institution had an even greater challenge: it must use African American history and culture as a lens to better understand what it means to be an American. While the museum must revel in and reveal the richness and complexity of African American history and culture for that community, it must also embrace the challenge that all Americans regardless of race must come to understand how they are profoundly shaped and made better by that history. In essence, NMAAHC would not be a museum by black people for black people, not an ancillary narrative, but the quintessential American story. If one wants to understand core American values of optimism, resiliency, and spirituality, where better than to look than African American history. If one needs to comprehend the promise of American life and the limits of that promise where better to turn than to this museum. This needed to be a museum that placed race and the African American experience as essential elements in the remaking of notions about American memory and identity. In a way, it needed to borrow from the campaign of presidential candidate Obama, which celebrated one's blackness but embraced and owned one's American-ness. Ultimately, this museum had to tell both a people's journey and a nation's story. This notion, while shaped by the best current scholarship, also reflected my personal history. Growing up black in an overwhelmingly white environment forced me to develop a cultural schizophrenia where I saw the benefit of seeing a situation through a dual perspective, of being able to straddle and understand multiple points of view. I felt using that duality—seeing American history through both a black and white lens—would enable the museum to convey a more complex and, ultimately, truer vision of the nation's past.

A third pillar of the museum's vision was the need to place African American history and culture within a global context. Americans often revel

in their commitment to isolationism, the illusion that America can refrain from engagement with the trends and challenges that inform the rest of the planet. In actuality, America has always been buffeted and shaped by international considerations. The museum, through its exhibitions and programs, hoped to help Americans come to grips with their global presence. The African American experience was nothing if not shaped by international concerns of trade, diaspora, empire, labor, and markets. In a modest example, my career as a historian of black America was made richer, more complicated, and more nuanced after working in or leading projects in Japan, China, South Africa, the United Kingdom, and Australia. One never sees America in the same light after viewing it from afar and grappling with the commonalities and the challenges to American exceptionalism that come from an international perspective.

Equally important was the desire to reveal the impact of African American culture globally. The influence of African American culture worldwide was brought home to me when I had the chance to spend time with village elders in a Sami community in northern Scandinavia. I was there to fulfill an interest that began when I learned about this culture in a fourth-grade geography book. During the conversation, through a translator, I was asked, "Was I an American?" "Yes." "And did I know Al Green, the singer?" I was astonished. Who knew that the influence of R&B and gospel star Al Green would have an impact in places so distant?

———————

I should not have been surprised. One only has to recall how at the end of the successful Solidarity Worker's Movement in Poland, their leader Lech Wałęsa led the singing of the Civil Rights anthem, "We Shall Overcome." Or how Nelson Mandela referred to the way African American freedom fighters like Frederick Douglass and Martin Luther King Jr. inspired him to stay the course during the antiapartheid movement in South Africa. Another prime example is the global popularity of rap and hip hop, which grew from the beats and words of black and Latino performers in American cities to become a musical and stylistic phenomenon that has shaped the world. The museum, then, would work to help Americans gain greater comfort in, and understanding of, their international involvement through African American history and culture.

The final pillar in this vision of NMAAHC was a recognition of the role that so many cultural institutions, especially African American museums,

have played in preserving African American history by emphasizing collaboration as a core value. Few contemporary cultural entities have the resources needed to match their dreams, which makes collaboration a wise and needed policy. Yet collaboration has not been a priority within the Smithsonian Institution. The abolitionist Frederick Douglass once said, referring to an upcoming presidential election, "the Republican Party is the ship and all else is the sea." In many ways, the Smithsonian often sees itself as the mother of all museum systems that rarely needs to find partners. While that is changing, the creation of NMAAHC was only possible thanks to the work and creativity of so many institutions, including some sister Smithsonian museums.

The pioneering work of the Charles H. Wright Museum in Detroit, Margaret Burroughs's efforts at the DuSable Museum in Chicago, John Kinard's labors to transform the Smithsonian through the Anacostia Museum, Rowena Stewart's work in Rhode Island and Kansas City, and Harry Robinson's creativity in Dallas, Texas, are the institutional and personal shoulders on which NMAAHC stands. So it is important that while the museum in Washington would become a beacon that draws millions in its doors, it was essential that NMAAHC use that attraction to also push people back to local museums. For example, if one is moved by the display of jazz in the museum, even more can be learned from the Jazz Museum in Kansas City. Or, if one is interested in delving more deeply into enslavement, an exploration of the River Road Plantations in Louisiana is an excellent site. And that sense of collaboration and partnership would extend to other Smithsonian units such as the National Museum of American History or the National Air and Space Museum. The commitment to collaboration stemmed from both an acknowledgment of the history of the African American museum profession and the realization that by implementing this vision, an individual museum's impact could be magnified through the efforts of other cultural partners.

The vision for NMAAHC, created in 2005, proved to be foundational, shaping all aspects of the museum's development from the look of the building to the diversity of the staff to the intellectual content of the exhibitions. Yet for me, ensuring that this would be viewed as a museum for all, a cultural site that illuminated the impact of African American culture on the identity of all Americans, would be an important contribution in a racially troubled America.

While the objective of creating this vision was to give NMAAHC a framework for moving forward, the greater goal of the museum was not just

to erect a signature building that was ripe with memorable objects and exhibitions, but to be a site of transformation that would make America better (a phrase we used well before candidate Trump spoke of greater) by helping to bridge the chasms like race that have divided America since its inception. We had crafted a vision that we hoped would help a country heal. A vision that would allow America to hear the voices of people who had long been undervalued, or ignored. A site for debate and of difficult conversations, but a setting that embodied the meaning of Langston Hughes's words "not without laughter." With this vision we hoped a country would see its whole self reflected in the experiences of black America. Guided by the optimistic notion that America is a work in progress, the museum sought to create new generations of activists who would be inspired by and who would build upon the history that one would experience in the museum, to help America to live up to its higher ideals, and to aspire, in the words of Abraham Lincoln's First Inaugural Address to the "better angels of our nature."

In addition to defining just what the "better angels of our nature" meant in a national museum, my first year in Washington was dominated by the need to wrestle with the issue of schedule, the politics of the African American museum field, and, most importantly, the selection of a location for the museum. I soon discovered that there was not a firm timeline for the opening of the building. Many of the senior leaders in the Smithsonian office responsible for design and construction projects told me in initial meetings that this was a federal endeavor without any federal capital support, so I should plan for twenty or more years before completion. They pointedly explained that the completion of NMAI took seventeen years *after* a director was hired. And they almost gleefully let me know that the Holocaust Museum was a twenty-year-long venture. There was no way that I would allow this endeavor to take twenty years. Being black in America prepared me to struggle against long odds. I recalled Martin Luther King's admonition that justice delayed is justice denied. I believed that the longer this museum took to open the less likely it would garner the support and excitement it needed. I vowed not to let this endeavor fail again. Luckily, since this was my third museum job at the Smithsonian, I had an array of colleagues to turn to for assistance. I immediately sought out Derek Ross, chief of construction at the Institution, who was a genius at all things involving the construction of a building. I asked him if it was possible to complete the project within a decade. With a wry, conspiratorial smile, he said, "of course." Several weeks later he handed me a chart that showed all that needed to be

accomplished and how it could be done in ten years. His document was to be my construction bible going forward, and it allowed me to sound knowledgeable in meetings, thanks to Derek Ross.

———·—

I knew that just saying that construction could be completed in a decade was not enough to convince the Institution to agree on a schedule. After talking with the newly arrived Deputy Director Kinshasha Holman Conwill, we realized that 2015 would be the anniversary of several key moments in African American history. That year—2015—would be the sesquicentennial (one-hundred-and-fiftieth anniversary) of the end of the Civil War and the anniversary of the passage of the Thirteenth Amendment that abolished slavery in America. That year would also be the fiftieth anniversary of the enactment of the Voting Rights Act of 1965, an act after the amendment ensured that the descendants of the enslaved would have their voting privileges protected. With this trifecta of significant moments, we spoke to the White House, members of Congress, and finally the Smithsonian leadership, where Larry Small and Sheila Burke confirmed that 2015 would be the date of our opening. This helped to make the endeavor real, we now had charts and timelines that gave both a sense of urgency and a concrete reality to making NMAAHC a reality. This was an amazing moment that convinced me that I had the political and strategic chops that were needed to work the system and to respond to unforeseen and unanticipated challenges. As I skipped back to my office celebrating an important milestone, it dawned on me how much there was still to do. I could not allow myself to revel in early victories, I needed to remain focused and prepared to face all the moments of doubt and struggle that lay ahead.

I knew that the African American museum field watched the passage of the legislation creating the museum and my return from Chicago with hope, concern, trepidation, and uncertainty. Fortuitously, the annual meeting of the Association of African American Museums (AAAM) in 2005 would take place in Washington, and at the L'Enfant Plaza complex that housed my offices with the infamously twisted doorframe. So much of the relationship between this new endeavor and the field would be shaped by my hour-long presentation. I was worried not only because the audience would be made up of many of my skeptical peers but also because this would be the first time that many within the Smithsonian would see me present in an important formal gathering. I was aware that the room was quite filled

as I sat trying to envision the response to my talk. I began by acknowledging how important the organization was to me and that when no one knew my name, AAAM had embraced me, and how I was pleased to be back with the family. I spoke about the pioneers who had opened doors for me, pointing out several elders in the room. Finally, I argued that creating the museum was not just my job, but that it would take the efforts of so many in attendance because all museums that cared about African American history and culture would benefit from a successful national museum. I ended by saying that the audience was comprised of people who had dared to dream and believed when there was nothing concrete to experience. Yet they persevered. I asked them to help me make believers of a country. I was gratified by the applause and by the positive comments. They believed in me and they trusted my vision of a museum. Now it was up to me to keep the faith.

Once the enabling legislation was passed, there was nothing as important as determining the location that would become the permanent home of the National Museum of African American History and Culture. It had to be a place that would be powerfully symbolic and have the needed acreage to build a signature structure. I recognized how much this issue was weighing on my mind when I awoke every day for a week hearing the lyrics from a 1934 Cole Porter song, "Oh give me land, lots of land under starry skies above, don't fence me in."

Since the dedication of the museum in 2016 (more about this later), its placement on the National Mall seems a foregone conclusion, but in 2005 there was no guarantee that the Mall would welcome the National Museum of African American History and Culture. Traditionally, site selection was not the purview of the Smithsonian. In the past, whenever Congress instructed the Institution to create a new museum, it also determined the location. There was great angst in Congress about this legislation and one of the ways to ensure passage was to compromise on the choice of the site. Rather than mandating a Mall location due to concerns about giving the last museum site on the Mall to this initiative, the act required the exploration of four locations. And then the governing body of the Smithsonian, the Board of Regents (comprised of members of Congress, "citizen" regents, the Chief Justice, and the Vice President) would make the final determination. Some have suggested Congress was unwilling to commit to a

Mall location for an African American museum and absolved themselves of any responsibility by handing the decision to the Institution.

———·—

Four sites were already under consideration by the time I assumed my duties in July 2005. Two were on the National Mall: the Arts and Industries Building, and the Monument site. The remaining two were "reasonably" close: the Banneker Overlook, and the Liberty Loan location. It was my task to work with a series of consultants and with the museum Council to make a recommendation by the end of 2005 to the Smithsonian Regents.

It was immediately clear to me that the issues were ultimately just how important was a new structure and how key to the success of this museum was a site on the National Mall. The symbolic value of the National Mall cannot be overstated. Working at various Smithsonian museums for several decades, I had experienced just how meaningful and important the Mall is to America's identity. While many called the Mall America's front lawn, I saw it as the place where the world comes to confront and engage the history, symbols, and culture that define what it means to be an American. It was a public space that in 2005 had few real representations of America's diversity, especially as the monument to Dr. Martin Luther King Jr. was still six years from being realized. By changing the tint and tone of the sites along the Mall, I knew that a new museum that wrestled with questions of race and identity would enrich and enlarge the expression of monumental American-ness.

During the twentieth century, the National Mall was the site of marches, protests, and symbolic gestures that ranged from the Ku Klux Klan rallies in the 1920s to the anti-war demonstrations of the 1960s and 1970s to the placement of the AIDS Memorial Quilt in 1987 and 1996. For African Americans the Mall is sacred ground. What became the National Mall was originally part of a plantation dependent on the labor of the enslaved. By 1926, African Americans used that land as rallying spaces to demand racial justice. In 1939, Easter morning, Marian Anderson gave a free concert at the Lincoln Memorial. The March on Washington (1963) and the Poor People's Campaign (1968), dreams of the martyred Dr. King, had both made effective and visible use of the Mall.

More importantly, a placement on the National Mall gave a sense of legitimacy and recognition that the story the site represented was important

to America and central to understanding who we are as a nation. I thought it was essential and an important opportunity that the placement of NMAAHC contrast with the traditions and the monumentality of the Mall that was awash in whiteness. The Mall could use a bit of color. While I believed strongly that the museum deserved a spot on the Mall, I had to be publicly neutral and work with two consulting firms, Plexus Scientific and Page Southerland Page, to evaluate the four sites based on a criteria that included location, compatibility with current regional planning, existing site conditions, environmental factors, budget, and the support or lack thereof from the regulatory agencies responsible for the National Mall.

After all these years, I still cannot find the Liberty Loan site, so I knew then that few tourists would be visiting that spot. This 2.5-acre location came with a "temporary building" erected during World War I that was situated farthest from the Mall though it did have views of the Tidal Basin near the Jefferson Memorial. To make this site option feasible not only would a building need to be demolished and a home found for the current occupants, but the rerouting of a major access ramp to Route 395, the main artery heading south from the nation's capital, would also be required. Luckily, few argued that this would be a suitable space for the new museum.

More problematic was the Banneker Overlook, an 8-acre plot of land facing the Southwest Waterfront that sat at the end of the brutally uninspiring L'Enfant Plaza promenade. Nearly one half mile from the other Smithsonian museums, it was also isolated and separated from the Mall by a large edifice that housed the Department of Energy. On the plus side, this was an open space that could easily house a significantly sized structure with room for expansion and innovative landscaping. And this site had strong support from the then Mayor of Washington, DC, Anthony Williams, who hoped that this museum would be part of his vision for a revised Southwest Waterfront area. He also believed that the museum could sit on an intermodal transportation center that would ease commuter problems in the District. As much as I wanted the District to evolve and thrive, this museum could not be placed so far away from any significant visitor traffic in order to be a symbol of the new Southwest Waterfront concept.

Others, such as Judy Feldman and her organization, the National Coalition to Save the Mall, believed that there should be a moratorium on any new buildings on the National Mall. In fact, they had a fanciful notion that

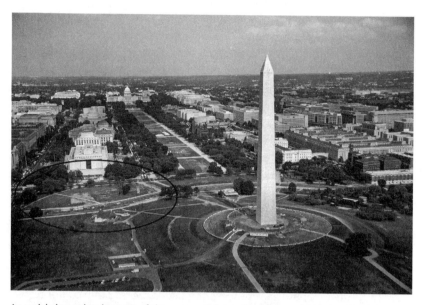

An aerial view, taken in 2006, of the museum's future location on the National Mall, just 800 feet northeast of the Washington Monument. **PHOTOGRAPH COURTESY OF THE NATIONAL MUSEUM OF AFRICAN AMERICAN HISTORY AND CULTURE**

by placing NMAAHC at the end of 10th Street on the Overlook site, this, in turn, would lead to the expansion of the Mall. And that the museum would be in Feldman's words "not the last museum on the twentieth-century Mall, but the first museum on the twenty-first-century Mall." I was glad that others had dreams for the museum, they just were not the dreams we needed or elected to follow. And there was more: this space had been named in honor of Benjamin Banneker whose genius and creativity contributed to the design of Washington, DC, and many people felt the museum would give visibility and prominence to both the site and Banneker's story. I was sympathetic to that concern. And I appreciated what a potent symbol this museum would become. I must admit, I was disappointed in how many wanted to use this decision for their own purposes, thinking little about what a museum of the Mall could mean to the nation.

The third choice was a structure I loved, the Arts and Industries Building, situated on 3.5 prime acres in the heart of the National Mall. This was the first building constructed by the Smithsonian to be a museum. A photograph of the building with African American visitors plainly visible had been used by Claudine Brown and her colleagues in a campaign in the 1990s to

generate interest that the National Museum of African American History and Culture was coming. When my wife worked in the Central Education Office of the Smithsonian, her offices were housed in A&I. And when our youngest daughter attended the Smithsonian Early Enrichment Center as a toddler, her classroom was also there. It was a grand building, historic, and it was deteriorating rapidly. Some even suggested that the building had outlived its usefulness and should be swept away for a newer structure. But many preservationists and historians like myself fought to preserve an important part of Washington's shrinking architectural legacy. Once it was clear that the Adolf Cluss–designed building would not be demolished, to me, this was not a viable option; its condition presented too many challenges. Just stabilizing it would have cost hundreds of millions of dollars. But even stabilized, the historic nature of its construction limited the changes needed to upgrade and modernize any museum spaces. And there was another lingering issue: respect. There were many in the African American community who were concerned that if the museum were housed in a "second-hand or hand-me-down" structure that would suggest that African Americans were still relegated to the status of second-class citizens. As much as the site appealed to me as a historian and long-time Smithsonian employee, I concluded that it was not suitable for the newest national museum.

Which left the Monument site—and it was the best suited to house the National Museum of African American History and Culture in my opinion. This 5-acre location, on Constitution Avenue, was uncluttered with structures, within 800 feet of the Washington Monument, in the shadow of the White House, with opportunities for distinctive and historic landscaping. This was the Promised Land. It would give the museum visibility and interesting juxtapositions with the monuments that would ensure the museum would become part of iconic Washington. But while I was pleased, many others responded quite negatively to this prime location. A member of the regulatory agency, the Commission of Fine Arts, stopped me at a White House event to warn me that the museum "would not be well served by the choice." Someone from the National Coalition to Save the Mall bemoaned the fact that building on that spot would "kill grass." I wanted to, but did not, send them a picture that showed the grass was already dead.

There is little doubt that many of those who did not support this location raised legitimate issues: how would any building relate visually to the Washington Monument? We would be building in a flood zone and how would the traffic at such a major intersection affect visitation? Others wondered if

the views of the monumental core would be altered or obstructed by a new structure. These were issues that we would have to address in any preconstruction planning, regardless of the site.

———·——

But not all the criticism was free from the taint of racism. There were actual websites that stressed that African America need not be on the Mall. Some critics even suggested that the museum may not be worthy of the "last spot on the Mall." My challenge was to remember that race would always be the undercurrent of many discussions and decisions, and I could not allow myself to be held captive by the narrow and hateful thinking of others.

From July 2005 until January 2006, thinking about, strategizing, and analyzing the odds of site selection were my constant companions. To build support and to put pressure on the Smithsonian, it was essential for the Council to agree with my choice. I began by organizing a bus tour where I took the entire Council to view each site first hand. After visiting the Monument site, Council member Bob Johnson proclaimed, "Why see anything more? The museum needs to be on this spot." We did our due diligence nonetheless and walked each location, but the Council was unanimous in its demand that a new building arise from the National Mall. The Council then passed a resolution to the Board of Regents supporting my desire to build on the corner of Constitution Avenue and 14th Street—or as I soon described the location as being on "Constitution between the Fourteenth and Fifteenth Amendments" (these were the Constitutional amendments that granted citizenship and the right to vote to millions of the formerly enslaved).

———·——

The next step was to give the Regents a sense of the spaces. I used the trip to diplomatically convey how symbolically important it would be for the museum to have a place on the Mall and how many in the African American community were looking for the Regents to, in the words of filmmaker Spike Lee, "do the right thing." While there was broad support within the Regents, it was far from unanimous.

The greatest boost for placement on the Mall came from a source that few people expected, President George W. Bush. The legislation was a bill

that he signed into law, and he was quite proud of that fact. At a celebration of Black History Month in February 2005, he proclaimed "We have a chance to build a fantastic museum . . . on the Mall." I cannot overstate how much the President's words meant to this enterprise. Whenever I was on Capitol Hill, I used his words to garner attention and backing from any Republican I encountered. Pointing towards the commitment from the President allowed the staff to take the high ground; we were no longer tentative or defensive, the President was on our side.

Regardless of the public support from the Council and the President, there was little guarantee that the Regents would not listen to those who felt the Mall was already overcrowded and that the museum should be placed in another part of the city. In fact, both major regulatory agencies, the Commission of Fine Arts and the National Capitol Planning Commission, had expressed reservations about the presence of the museum on the Mall. I was apprehensive and I thought how do we handle the growing media attention this decision was beginning to receive? I was very fortunate that the head of the Smithsonian Institution's Office of Public Affairs at this time was Evelyn Lieberman. While I did not know Evelyn prior to my return in 2005, she became my most trusted advisor, a consistent advocate, and a candid, almost too candid, friend. She had come from the world of politics, first working for soon-to-be Vice President Joseph Biden and then Hillary Clinton. If this was New York, she would be called my Rabbi, in Chicago the term was my "Chinaman," but regardless of the label, it is not an overstatement to suggest that the museum would not have reached the heights it ultimately did without Evelyn's political, profane, and profound touch.

Evelyn suggested that the museum contact two seasoned Clinton operatives to guide us through the final stages of site selection. Maggie Williams and Patrick Griffin had helped the Clinton Administration weather the many public relations storms that almost destroyed that presidency. Maggie and Pat began to meet regularly with Kinshasha Holman Conwill and me to assess our concerns and to help us prepare for the media scrum that would accompany the decision. My major worry was what should my reaction be if the decision was not to place the museum on the Mall, or to relegate it to an aging and deteriorating structure? From the beginning, I had thought that though a different decision would be disappointing I would make the best of any site. I soon realized that was not true; I did not want to invest years of my career to building an institution that would be

hindered and maybe fatally flawed based on the wrong location. I remember one meeting where the four of us were wrestling with my stance. Maggie Williams silenced the discussion when she said, "If they choose a site you do not think is suitable, you must walk away." I was not sure I was ready to leave after only five months, but the clarity of her thinking was inescapable—do you want to represent a decision that would be perceived as a slight, an insult to Black America? I told no one, not even my family, but I decided two days prior to the scheduled announcement that I could not lead an institution situated at either the Liberty Loan site or the Banneker Overlook, and I probably would find the Arts and Industries Building unacceptable as well.

On the morning of January 30, 2006, the Board of Regents was to announce its decision. We met in a crowded small auditorium located in the claustrophobic, underground Ripley Center in the National Mall. I hoped the space did not symbolize that the Smithsonian was to bury this endeavor far off the Mall. Though an amazing array of media outlets wanted a scoop and asked me what had been decided, I had no idea. Just in case, I had prepared two sets of remarks; one full of joy, the other deliberately more ambiguous, as it would serve to ease the way if I needed to leave the project. I was glad that the ceremony was to move crisply. I felt like a child either awaiting Christmas morning or dreading a spanking for bad behavior. Secretary Lawrence Small opened by welcoming the gathering and then Roger Sant, the chair of Smithsonian Regents, made the announcement: the museum location of choice was the Monument site on the National Mall. Sant ended his brief remarks with the simple statement: "We believe we have picked the best possible site for this museum."

I do not recall if there was any applause at the announcement, but I was overjoyed. And I still had a job. When I was called to the podium, all I could say was a line the *New York Times* had used as its quotation of the day on page one, "My first task for tomorrow is to stop smiling."

I did not realize the national impact of the decision until I saw *Saturday Night Live* a few days later. On the "Weekend Update News" segment, they announced that the National Museum of African American History and Culture would soon be built on the National Mall next to the Washington

Monument. As the camera panned the Mall, there appeared a large black tower much larger than the white monument to our first president. While I was not happy that this segment exploited long-held racial stereotypes, it did make one thing clear: our work would never be invisible. And that made me happy.

Now That You Have It,
What You Gonna Do with It?

*In the beginning, there was
neither nothing nor anything.
Darkness hid in darkness–
shrouded in nothingness.*

—ZORA NEALE HURSTON, *MOSES, MAN OF THE MOUNTAINS*, 1939

My joy was fleeting, I confess. Now an all-out effort to create a twenty-first-century museum would begin in earnest. No longer were we dreamers without parameters or a sense of reality. Now we knew that we had to make that five-acre site work *and* sing in a way that engaged all Americans; that we would have to involve regulatory agencies that had problematic relationships with the Smithsonian, which, I feared, would act as protectors and stern guardians of the Mall, not as facilitators to help craft a signature, green museum.

———

What made this next phase so especially challenging was my decision to take a tiered approach. Not only would the staff need to participate in all the preliminary efforts to create a building program, a bible that would shape

the curatorial and architectural decisions over the next several years, but it would also need to generate programs and products that would reinforce the notion that the museum existed already, just without a structure. The visibility that came from both actions was crucial: these initiatives would be the foundation for a fundraising strategy. They would also serve to inform the public that progress was being made and that the museum would surely happen.

While the museum was still years away in the minds of many, we soon learned that a lot of people had opinions about what kind of institution the NMAAHC should be. And they were quite willing to share these with me— while I was dining out at restaurants, walking down the Mall, sitting in a movie theatre, presiding at any of my numerous presentations and lectures, even knocking on my front door. And then there were the collegial suggestions: after delivering the keynote address at the annual luncheon of the Association for the Study of African American Life and History (ASALH) in 2006, a group of scholars and activists pulled me aside to let me know that while my talk was adequate, they wondered how "angry" the museum would be. They wanted me to understand that the museum had to "out holocaust" the United States Holocaust Memorial Museum. In their opinion, NMAAHC had to focus on "what they did to us," in a way that made crystal clear the barbarity of lynching and the horrors of slavery.

Yet, as life would have it, that very same afternoon as I was walking through my neighborhood, an elderly African American woman smiled as I approached her. She said she recognized me and wanted to thank me for working to develop the museum. She hugged me, then whispered, "Whatever you do, don't discuss slavery." To her, the museum had an opportunity, maybe even a mandate, to educate and inspire generations of black youth, not burden them with the legacy of slavery. As she ambled away, she called out, "Don't forget, no slavery."

Many of my scholarly colleagues, and not just those focused on slavery, had strong opinions as to what should be the core interpretive framework for the museum: some felt that discussions of the diaspora or the economic and cultural relationship between Africa and the colonies in the Americas should take precedence; other academics focused on their particular specialization; still others believed the museum must be encyclopedic in order to capture the vast scholarship that had been generated over the past half century. A group of more conservative politicians and educators saw the museum as a symbol of progressive vindication. The nation was once

flawed, but now is not, which could be an excuse to curtail or limit some of the legislative victories of the Civil Rights Movement as unnecessary because so much has changed. What became clear to me given the number and range of these opinions was this: the museum could be used by many with an array of political agendas. It would be difficult if not impossible for me to control how others would use the museum to further their own interpretations. So it was essential that the museum's interpretive agenda be thoughtful, cognizant of the differing opinions, ripe with scholarship, and defensible. While it took years to navigate those shifting visions, what I used as my north star were the words that a man who shined shoes shared with me.

I am not superstitious, but whenever I am due to fly I have my shoes shined at the airport. This is such a ritual that I can identify where the stands are in almost every airport in America. After a long fundraising visit to Austin and San Antonio, Texas, I was heading back to Washington via Dallas. Since storms had delayed my flight, I went in search of a shoeshine, and found one. An elderly African American man began to work on my shoes. After a few minutes, he asked if I "was that museum guy from Washington?" I nodded affirmatively, but no further conversation ensued. After he finished, I handed him eight dollars. He handed it back to me, saying "Keep it for the museum." I was touched, but I pushed the money back in his direction, believing he really needed the payment. Suddenly he said, "Don't be rude. I am not sure what is in a museum, but it may be the only place where my grandchildren will learn what life did to me, and what I did with my own life." His words—and the eight dollars he refused to accept—stayed with me during the eleven years we worked to open the museum. While I heeded a variety of opinions, his candor carried the most weight. The museum had to make people like the shoeshine man proud and visible by telling their stories, which may seem minor but in actuality speak volumes about the experiences and dignity of so many Americans whose lives never appear in newspapers or in history books.

One of the first steps in conceiving a museum that would matter to the man who shined my shoes in Texas was to hire consultants who could work with my colleagues and me to craft a blueprint to capture the functional needs and space considerations of the future building and marry that information with our vision. We were fortunate to hire a team led by architects Max Bond and Phil Freelon. J. Max Bond Jr. was the dean of African American architects, who had designed buildings throughout the world. These included the Birmingham Civil Rights Institute and the National September 11 Memorial & Museum in New York City. Phil Freelon, a generation younger, had created an array of structures on the campuses of several historically black

colleges and universities and in 2004 had designed the Reginald F. Lewis Museum of Maryland African American History and Culture in Baltimore. In addition to their own expertise, Bond and Freelon also created a team— exhibition designers, museum programmers, educators, and experts in audience research. For nearly two years (from 2007–2009), they used a variety of tools to gather the data needed to help us make decisions about the future museum: from structured focus groups to informal street surveys, to scientific sampling techniques to penetration analysis to modeling comparable institutions.

An extremely useful aspect of this work was what I called the public engagement phase. Beginning in 2008, we traveled to numerous sites, comprised of very different audiences, to introduce the museum to these groups and to gather information about their knowledge of and interest in African American history. We met with a plethora of entities including the Organization of American Historians in New York City; the American Alliance (formerly Association) of Museums in Denver; the National Black Arts Festival in Atlanta; the Association for the Study of African American Life and History in Birmingham, and a group of artists and cultural administrators at the Los Angeles County Museum of Art. The team of Bond and Freelon along with staff from NMAAHC began each of these gatherings with a film beautifully narrated by Ruby Dee that introduced the importance of African American history and culture in a way that was elegant, accessible, and engaging. It was important to have someone like Ruby Dee on camera because her very person instantly conveyed to the audience that this endeavor had the support of important individuals. Then it was my turn. I would speak about the vision for the museum and explore the contemporary meaning of history. I asked what would they expect in this museum, what stories must be told, and how should the museum address difficult or painful subject matter?

By the end of this phase we had gathered germane and useful information. But it was on March 2, 2008, a session with the National Association of Counties, that I began to worry. This meeting was a disaster. As soon as I had begun speaking it was clear that most of the sixty people in the room would rather be at the dentist's office. They yawned, tapped their fingers on the desks to tunes in their heads. Few hid their restlessness. I tried every moving story and every humorous fact that I could recall. Nothing worked. So, I cut my talk short and asked them for feedback about what they had heard or thought about the museum. The silence was overwhelming. After a few comments from the group about the need to have good music and explore local stories, it was time to end the pain and shorten this session.

As I was leaving, one of the facilitators allowed "that was not too bad." If that was her definition of success and if future participants were as unresponsive, maybe the museum would remain an unrealized dream. This session made me fear that we would not gather the kind of thoughtful data we needed. It also made me more careful about the selection of organizations we would engage. The reluctance to participate and the notable dearth of response from this gathering actually tempered my enthusiasm and expectations for other meetings. Fortunately, future gatherings did prove to be more helpful, with participants who engaged. We did learn that a diverse array of Americans was excited about this museum, especially if it could be inclusive and relevant; tell a history that was not "watered down;" think globally; and be willing to grapple with current issues. Just what I wanted and needed to hear.

The additional data gathered from the audience research and visitor studies in the spring of 2008 reinforced the excitement and the acknowledged need for the museum. Researchers interviewed visitors to the National Mall as they exited other Smithsonian facilities; questioned people as they entered sporting events in downtown Washington; and waylaid tourists walking along the Inner Harbor in Baltimore. Those who participated in these informal surveys expressed great interest in a possible museum, but acknowledged their limited information and understanding about black history. It was also clear that while African Americans would be a core audience, many non-African Americans would find a museum of this type of interest and of value.

Bond and Freelon also focused on studies that would directly help to shape the museum's future building. A key area of investigation was the physical analysis of the site itself. Much of the work explored the topography, the water tables (a factor that would prove to be challenging during the construction phase), and the historical significance of the five acres. I was surprised when I learned that if the site had any important archaeological or historical materials, the entire project could be at risk until some form of mediation was found. The irony was not lost on me: I had spent several years explaining how this site was part of sacred ground where African American lives unfolded first as a plantation and then as the location of an integrated community in nineteenth-century Washington. Now, if any evidence of that history was unearthed, we would encounter the first real obstacle to construction. There were several days of digging and drilling boreholes to see what was under the surface of our selected site. As this unfolded, I paced the perimeter, as if my presence had any impact. After several days of analysis,

it became clear that the site was part of a historical landscape, but little of historical note had occurred on our land. One hurdle cleared.

This analysis did not untangle the question and impact of our land being something called a hinge site. To some of the regulatory agencies, our site was part of the Washington Monument, which meant that much of the design, landscaping, and visitor patterns must be shaped by a visual allegiance to that nineteenth-century obelisk. Others saw our site as part of the National Mall and that references from the design of the Mall and the interplay with other Smithsonian structures by definition must impact our creative decisions on design and construction. These discussions about the actual site that would soon house the museum became more central once the design architects were hired, something that was still several years away at this point. Regardless of the lack of a final definition on this issue, the programming document made some key assumptions that would later drive the architectural choices. The museum's staff, now grown to nearly a dozen, worked with the consultants to determine the space needs for the museum, the size of the exhibition galleries, what space for collections was needed on the Mall or at an off-site facility, how large should the auditorium be, and what the retail requirements were. Decisions needed to be made or the project schedule would be at risk, so I made guesses, which were occasionally based on data but most often on my instincts and experiences.

Part of what guided my decisions about space had to do with my notions of the special nature of the Mall. Having worked for thirteen years at the National Museum of American History, a building that had large storage capabilities throughout the building, I knew both the value of storage and the ever-expanding needs of the collections. I decided that our new museum would never be as massive as some of our sister museums and that we should focus on the visitor experience. In part, my decision was shaped on the recognition that space on the Mall was too valuable to be a storehouse of collections. We would find storage off the National Mall.

While we knew that we wanted to privilege the public spaces rather than staff or collections' storage areas, Bond and Freelon helped us take educated leaps of faith as to the square footage needed for the exhibitions, for the shop, for offices, and the café. Through exercises like "blocking and stacking (a 3D model to define adjacencies and floor relationships)," we agreed upon the spatial needs and general locations for all the requirements needed by a new museum from elevators and boilers to the gift shop. We now had an envelope and a sense of what could fit inside the museum. This was a key

moment because it was both a signal that concrete progress was being made and it also gave us tools to begin to estimate the budget requirements. The predesign work estimated the museum would need 313,000 square feet to accomplish all our dreams at a cost of $330 million to construct and another $170 million to outfit, design, and install the exhibition program. At first, I was a bit stunned at how much money I would have to raise to complete this endeavor but after reviewing the costs of other museum projects such as the construction of the National Museum of the American Indian, I determined the price was steep but unavoidable. The key was to work over the ensuing years to prevent budget creep in order to control costs—and expectations. Candidly, I had to be comfortable with the ambiguity of this process because I needed to keep the project moving forward rather than allow any delay or sense of uncertainty derail a museum that some did not value.

The final aspect of this phase involved creating an exhibition master plan for the museum that outlined gallery spaces that could be built within the museum. This was arguably one of the most crucial parts of the preplanning, and it was also the area created from whole cloth. It would take several more years before an actual exhibition agenda, which would build upon this earlier work, shaped by the union of audience research, academic scholarship, and the vision of yet-to-be-hired curators. At this point, I assumed the role of lead curator, a position that I maintained during the eleven-year run-up to opening. In addition to addressing the fundraising needs, representing the museum in Congress and with the media, hiring staff, and other duties that were the responsibility of any museum director, I wanted to ensure that the exhibitions and the scholarly interpretation would meet the highest standards based on my knowledge and experience. This was not an easy task, but I felt the need to ensure that the museum present history and culture in a way that was engaging, ripe with storytelling, and shaped by a cinematic narrative. By 2008 and 2009, the museum's collections were minimal and unlikely to support a robust exhibition program of diverse and challenging exhibits. The best that this phase could provide were broad categories, such as committing to an exhibition narrative that took the visitor from the fifteenth century to the present; displays that would explore sports, the military experience, cultural products like fine art, music, film and theatre, and the power of place and regionalism.

I cannot overstate how important the overall master planning was, and how ably the Bond and Freelon team maneuvered, massaged, and prodded the museum to make hard decisions even if they were subject to future

revisions. And future revisions there would be. Yet this work was a crucial step in realizing our dreams. We now had concrete data that would allow me to show Congress, the Council, and the Smithsonian that progress was being made. This phase gave us broad parameters that would soon allow us to consider one of the most important decisions that I would make, the hiring of the architects to design the National Museum of African American History and Culture. This phase left unanswered numerous questions and posed many challenges that we would grapple with for the next five years: could we create a museum that recalled African American history from the margins of America's identity?; could this museum help Americans find reconciliation and healing on the complex and thorny issue of race that, to paraphrase Thomas Jefferson, was like "holding a wolf by the ear"?; and how could we use every space in a museum, including the restaurant and shop, to extend the history and the learning into nontraditional spaces?

This work still left us to wonder what the role of Africa would be in an African American museum, and what purpose does a national museum serve in a transnational age? We knew that no museum can become a community center, but how could this museum be at the center of its many communities? Could a national museum fulfill the dictum of the early twentieth-century pioneering museum director John Cotton Dana who demanded that "museums be of direct and useful service to their communities"? In the summer of 2018 I spoke at the Edinburgh International Culture Summit. During the conference, a colleague said something that reinforced so many of my beliefs. He said, "Ships in port are safe but that is not what ships are made for." He argued that for ships to do their best work they had to take the risk of leaving a safe harbor. I was convinced that the National Museum of African American History and Culture should be a museum that left the safe harbor of nostalgia and celebration to take the risky task of making America better. Ultimately, those inspiring words could not help us determine how to be bold, embrace and make accessible difficult histories, contextualize contemporary racial concerns, and still survive. But I was determined to find a way.

Although this phase was central to our work, I felt that it was equally important that concurrently the museum become more visible and more concrete. The prebuilding work was geared to those who understood what was needed to build a museum, those inside the bubble, and it was key that we create concrete products that demonstrated the creativity of the curatorial and education staffs; that allowed our group to test ideas and modes of presentation that would eventually inform the exhibition and educational

agendas of the museum and build enthusiasm. This excitement was an important tool to generate public support and congressional attention. We could not afford periods of silence, because some supporters would then interpret that invisibility to mean that the museum had disappeared, or, worse, would soon fail like the prior attempts had. All of these actions were interconnected. It was a balancing act that forced me to find ways for a small staff to seem bolder and bigger and demonstrate on various dynamic platforms that the museum existed, just not in a building—yet

To build this wave of support, we embarked on a variety of activities from 2006 until 2015 that made the museum visible. I was very fortunate to have many friends and wonderful colleagues from the years I spent at the Smithsonian prior to returning in 2005. As I shared my vision to make the museum concrete as quickly as possible, many Smithsonian colleagues offered to help. The first and maybe the most influential was Richard Kurin, who was then the head of the Smithsonian Center for Folklife and Cultural Heritage, which oversaw the annual Folklife Festival on the National Mall. For the next decade we used the spotlight of the festival to share programs and to raise issues that were crucial to the interpretation of African American history. We began planning our involvement immediately, which culminated in June 2006, with "Been in the Storm So Long," a program profoundly shaped by the 2005 disaster, Hurricane Katrina. We decided that the best way we could help the city of New Orleans was to illuminate the culture (and the history) that was almost washed away by the storm waters. We hired musicians from New Orleans to perform and their presence helped remind all who attended of the crisis still unfolding in that city. This was an example of how the museum would not just be a place of history, but would use history and culture as a way to illuminate and contextualize important contemporary concerns.

Each year from then on, the Folklife Festival became an opportunity to increase our visibility and to explore topics that one day might have a place in the museum. In 2007, the museum sponsored programs that examined the impact of black culture in Virginia as a way to problematize the celebrations of the founding of Jamestown in 1607. In 2013, in collaboration with curators from the Center for Folklife, we mounted an extensive program, "The Will to Adorn," which addressed the impact of the African diaspora on the style and the culture of African Americans. The festival in 2009 allowed us to explore the power of African American speech through a program called "Giving Voice." During this festival we worked hard to brand the museum

events. Since the festival is held during the heat and humidity of June and July, we gave out fans, a tradition in black churches for generations. The fans, printed with the words sponsored by the National Museum of African American History and Culture, made clear that this program was created by the museum. We also had T-shirts printed emblazoned with Giving Voice. This was when I began the tradition of asking the audience to look to the western part of the Mall and squint. I would then say, "Soon, with your support, you will see a museum rising that reminds us that we are all shaped by African American culture." While each of these festival activities was highly scripted, I soon learned that no one could control where this culture would take the audience—and me.

The centerpiece of the "Giving Voice" program was the appearance of the comedian and activist Dick Gregory. He was a perfect choice because as one of the leading comics in the early 1960s his presence helped to integrate and to challenge the lily-white landscape that was television of that era. He was also someone we wanted to recognize because he had sacrificed much of his career to support the burgeoning Civil Rights Movement. When I met with him, we chatted about how honored we were to have him at the Smithsonian. I then discussed the type of crowds who typically came to the festival. I mentioned that this was a "G"-rated audience, full of families with children, hoping that this would ensure that he might tone down some of the language in a few of his routines.

The plan was for him and me to have a conversation on stage, rather than a stand-up performance. I understood that he had strong political and conspiratorial opinions, but I knew that this was Washington so his comments, though edgy, would not be a surprise. The stage setting included two chairs and a couch, giving him a choice of seat. As soon as we sat down, my hopes for a "G"-rated conversation faded fast. The first words out of his mouth were "I have not seen a sofa like that since I was in a Mexican whorehouse." My immediate reaction was to ask when that was but quickly decided otherwise, deciding to try to steer the conversation back to his career as quickly as possible. The rest of the evening was a struggle, an enjoyable struggle. I tried to ensure there were more laughs than obscenities but I think the cursing won out.

My favorite festival was in 2011, when we focused the entire program on music, namely rhythm and blues, or soul. This was the soundtrack of my youth, and I was going to enjoy it. We began with a group of teenagers from Stax Music Academy, a school in South Memphis, Tennessee, who got things

going by introducing new generations to the music of Otis Redding, Carla Thomas, the Staple Singers, and Isaac Hayes. Thousands flooded the Mall to tap their toes to songs like "I'll Take You There," "Try a Little Tenderness," and the "Theme from Shaft." I was pleased with the crowd's reaction because we needed to excite the diverse audiences that attended the Folklife Festival. A highlight for me was the sight of the emcee, the museum's Deputy Director Kinshasha Holman Conwill, in a large, Angela Davis–style Afro wig. Who said you cannot embark on the journey of a lifetime and still have fun?

The next evening, we celebrated the sounds of Motown with one of the key performers of that genre, Martha Reeves, without the Vandellas. Martha was backed up by many of the musicians who would finally receive public acclaim with the release of the documentary *Standing in the Shadows of Motown* that chronicled the music creativity behind the words of the Motown records.

Did we, including the hundreds in attendance, relive our youth! We were the Temptations, we crooned as if Smokey Robinson was on the Mall. We swayed as if Diana Ross and the Supremes were serenading us. The final evening, we celebrated Don Cornelius and his creation of *Soul Train*—his genius of a television show—that had taught millions how to dance and brought the music of black America into the homes of teenagers, regardless of race. We actually had several of the original *Soul Train* dancers perform. And we ended the evening with "The Sounds of Philly: The Music of Kenny Gamble and Leon Huff." The team of Gamble and Huff were in attendance as we listened to The Soul Survivors remind us how the "expressway to your heart . . . it's much too crowded . . . at five o'clock." And people still approach me to say how much they swooned when Harold Melvin & the Blue Notes sang "If You Don't Know Me by Now," and Billy Paul reminded us of the joyous pain of love when he shared his version of "Me and Mrs. Jones."

In 2012, we may have even topped that unforgettable night by ending the festival with a formal concert by George Clinton and Parliament Funkadelic, one of the most moving evenings and worrisome nights we ever experienced. In 2011, George Clinton would donate the Mothership, an iconic stage prop that represented for many fans the ultimate symbol of Clinton's style of funk. I had been struck by how many media requests we had had to discuss this acquisition. And how many people, including family, who would ask, "Do you really have the Mothership?" The evening of the concert, there were concerns that a free performance by George Clinton would overwhelm the plan for an audience of five thousand. At the last minute, we decided to place monitors far down the Mall to handle any overflow. The concert drew

many celebrities and government officials, from the Attorney General Eric Holder to members of the Congressional Black Caucus to corporate CEOs to celebrity emcee Tom Joyner. In other words, there were security and law enforcement officials everywhere. As I went backstage, a euphemism as it was nothing more than a tent backed up to the temporary performance platform, I was overwhelmed by the amount of marijuana smoke. I said to the performers, "Don't you realize that you are surrounded with police officers? And maybe you should refrain from smoking?" After being informed that they could not perform without a bit of weed, I realized there was nothing I could do but let the performance go on. I introduced the program by saying that you are about to hear something never uttered by a Smithsonian museum director. I shouted "bring on the funk" as my way of calling George Clinton to the stage. The museum at that point was just a few years from opening, and I worried how the headline "Museum Director Busted in Pot Sweep" might go down, or, to put it far more seriously, how it might undermine all the hard-won progress we had made. Throughout the entire performance I divided my attention: sometimes I actually enjoyed the music, but more often I was watching to see if the police had arrested any of the performers. Participating in the festival proved so helpful. It gave the museum concrete programs to keep our progress visible and it enabled NMAAHC to make contact with celebrities and individuals whose collections or whose influence could come into play in the future. Taking part in the festival introduced the museum to the diverse local audiences that attended the event each summer. We were able to introduce the centrality of African American culture through the workshops and intimate conversations. And it allowed my staff to have some fun.

The festival was just one of the many tools we used to build support and momentum. Another endeavor, one of the most innovative, was a collaboration with StoryCorps, the brainchild of David Isay, a friend from my time in Chicago. StoryCorps believed that each person's history is valuable. StoryCorps began by establishing recording booths in places like New York's Grand Central Terminal, where families shared their stories—children interviewed grandparents; friends exchanged life lessons, and so on. These recordings, in turn, are shared with the interviewees and are also archived in facilities like the Library of Congress. Dave and I had discussed how his brilliant work could help in the creation of NMAAHC. We decided that we would create the StoryCorps Griot Program that would encourage African Americans to share their stories. And each story recorded would have a home in the museum and in the Library of Congress. We began by taking

the StoryCorps recording booths to Detroit in May 2007. We would use a variety of means to inform and motivate potential participants. I spoke at churches; we used the internet and traditional media opportunities to spread the word. From Detroit we went to Newark, Cleveland, Los Angeles, and to more than a dozen venues.

Participation was great in the Griot Program, with families and individuals sharing personal, often untold, stories that illuminated issues of race in ways that were new and deeply candid. One interview that still moves me involved a young African American boy who interviewed his grandfather. After a series of unremarkable questions and answers, the boy asked "Granddad, what was the saddest day of your life?" The elder man paused and then responded with a memory that seemed as fresh as the day it happened. It was nearly the end of the Second World War. After seeing combat overseas, he was shipped to a base near Washington, DC. He had not been to the District before, so he decided to explore the city and what he called "the monuments of freedom," the Capitol, the monuments, the museums. Near the day's end, he was tired and decided that he would rest by seeing a movie before heading back to his post. During the 1940s, there were movie theatres all along Pennsylvania Avenue near the Capitol. He recalled how he went to a theatre and as he waited in line, in the reflection off the glass that was caused by the bright setting sun, he saw the Capitol, and he smiled as he thought about America. When he arrived at the window, he reached under the glass to purchase his ticket. The cashier noticed the color of his skin and refused him admission. In a voice racked with pain and emotion nearly fifty years later, he said: "Of all the things I experienced and all the losses I suffered, that rejection, that moment was the saddest day of my life."

I was stunned when I heard this because I had expected him to say the loss of a spouse or a child was the reason for the most difficult day of his life. To hear his pain was a clear reminder that the legacy of discrimination and segregation is an unresolved hurt. I hope that his sharing relieved him of that weight and educated his grandson to the burdens of the past. What his interview also did was to provide new insights into the past. Historians have written volumes about segregation, but few words have captured the personal impact and the contemporary resonance of racism like his interview.

This collaboration increased the museum's reach and visibility exponentially: David's strategic vision convinced National Public Radio to broadcast these interviews every Friday for several years, with the tag line that they were a result of a partnership that included NMAAHC. This encouraged

more families to share their histories with us, enriching our collections and our story telling. As a result of this relationship, the idea of recording stations throughout the museum that encouraged families to share their memories was something we added long after the rebuilding plan was drafted.

National Public Radio played a major role in our visibility efforts beyond the StoryCorps Griot initiative. In 2008, we began a regularly scheduled program on NPR that allowed the public to see behind the museum walls as to how an institution builds its collections. Once a month, Guy Raz broadcast from my conference room in the Smithsonian Capital Gallery Building near the National Air and Space Museum after the staff grew too large for our offices in L'Enfant Plaza. (I must admit, I was sorry to leave the broken door behind.) Michèle Gates Moresi, Supervisory Curator of Collections, would bring out three or four objects recently added to our expanding collection. Guy Raz and I would discuss what the object was, why it was important, and how we had acquired it.

This simple format, along with the enthusiasm and curiosity of Guy Raz, made for compelling and interesting listening. That was my opinion, but it must have been true because we did these programs for nearly three years. On one show, we examined a WWII-era flight jacket worn by a Tuskegee Airman, the all black fighter squadron whose success during the Second World War led to the integration of the American military in 1948. Raz, like most of the listeners, had limited knowledge about these pioneering aviators, so we were able to discuss history and stimulate a conversation about saving America's cultural patrimony, especially involving African American material. On another program, we explored a silver teapot created by Peter Bentzon, a free person of color in Philadelphia in the eighteenth century. We talked about how I had initially been uninterested in collecting "an expensive teapot," but my colleagues had persevered and how I now was pleased that the museum possessed such an impressive piece of rare decorative arts. This is a wonderful reminder of why you hire good people who see things you do not.

The program I remember the most was one where we brought out a fedora owned and worn by Michael Jackson. Raz could not contain his excitement—"Michael Jackson owned this?"—became a phrase he repeated frequently during that broadcast. Working with Raz allowed the museum to demystify the process of collecting. In many ways, museums like the mystery. They are like the last great craft guild where information is shared only with those

who know the special handshakes or the secret knocks. I want NMAAHC to share the sense of discovery with our potential audiences. This initiative also encouraged people to look into their own possessions to see if they had anything they thought might be significant in the hope that they would contact the museum. Most importantly, using NPR extended the museum's reach and introduced us to an audience that could be supportive of the museum's fundraising needs.

Seeking the broadest possible audience was part of the reason the museum was birthed online. It is hard to imagine, but when we began there was nothing, nothing to show, and nothing to build upon. So when Council member Sam Palmisano offered to use the experience and expertise of IBM to build a web presence we seized the opportunity. Kinshasha Holman Conwill and I began to work with two senior IBM colleagues—Stan Litow, who was a vice president steeped in education, and John Tolva, who had the technological proficiency. They emphasized that we should not build a typical website, but a more flexible presence that could adapt to changing technologies and evolving user needs. The site was built to expand so that we could add more content as it was developed.

After those first meetings, I would go home and write historical episodes, biographic sidebars, and timelines that would be part of our web offerings. We struggled to find ways to differentiate our presence, especially since the initial offerings would be sparse. And then the IBM staff pointed us towards what became the Memory Book. This device would allow user-driven content to supplement what we created. It encouraged those interested to share their family stories with word or picture, or their memories of important historical moments. The Memory Book became the centerpiece of the site. User friendly, it was also a way for the museum to learn information that might enrich and deepen our own exhibitions and presentations. In addition, the Memory Book would allow us to capture data about the users and their expectations, and how the NMAAHC could be most useful to them. This was key because I needed the staff to understand, in complex and nuanced ways, our audiences. And I wanted to use the best of the new technologies to help guide our future choices.

Not all the avenues we used to enlighten the public were driven by technology or the media. I felt it was crucial that the museum, which often meant me, would be represented at conferences, participate in scholarly discourse, lecture at universities, and engage with museum professionals globally. Immediately after returning to Washington, I hit the road. In the first four years alone, I took nearly one hundred trips in order to make

the museum visible and credible: from Boston to Shanghai to St. Louis to Liverpool, and all points in between. Often these sojourns were to universities like Stanford, Harvard, Hampton, Michigan, and the Cooperstown Graduate Program to engage students and to hear from academics as to their vision for the museum. In January 2007, I was asked by the historian James Oliver Horton to accompany two other scholars, James Campbell then at Brown University and David Blight of Yale University, to explore the intersection between academic history and public memory. This was a critical discussion that would help me develop the interpretive agenda for NMAAHC, and a trip to Hawaii in January made it all the more appealing.

During a break in the conference, I decided to drive my two colleagues on a sight-seeing tour to the northern end of Oahu as both were unfamiliar with the island. After an hour we stopped in a small town to wander about. Somehow, we ended up in a Famous Amos cookie shop. Much to our surprise, the real Famous Amos was in the store, on the premises. He greeted us warmly. We spoke about the origin of his business. And then he began describing different cookies, telling us to take samples. Soon we had a large bag filled with cookies. As we started out, he allowed "That will be thirty dollars." So there we were—three accomplished scholars scrambling to find the cash among us . . . for "samples," lots of them.

I continued to speak at additional conferences, avoiding all cookie shops. My travels brought me to a symposium on "the other" at the Jewish Museum in Berlin; a gathering of conservation and preservation experts at the Salzburg Seminar in Austria; an assembly of collectors of African American art in St. Louis, and a meeting of African, European, and America historians grappling with the global dimensions of slavery at Cape Coast in Ghana. The Ghanaian trip had a profound effect on me and helped me conclude that any of the exhibitions that would one day grace the museum would have to be scholarly yet charged with emotion. Visits to the slave castles in Cape Coast and Elmina were moving, painful, and unforgettable. The first thing I noticed was how rough the seas were. It was as if the Atlantic Ocean was angry or not at peace because of the burden of having transported millions of enslaved Africans to labor and to die in strange lands. And then it was impossible to miss the large and foreboding buildings called castles or forts, which were actually dungeons to house the captives as they awaited to board the ships. As I entered the structure at Cape Coast, the bright reflections off the gleaming white stone of the castle hurt my eyes as I descended into the bowels of the dungeons. I could only imagine the pain

and confusion as I stumbled along the uneven stone, and I was unshackled. The deeper I went, the more slippery the stones, as if the tears of those once imprisoned had never dried. While other visitors focused on the "door of no return," seemingly the last foot fall on which the African stood before the voyage to the new world, I was transfixed by the darkness and the dankness. I could not imagine how anyone could survive that ordeal. Yet thousands did. I wanted to cry out for those who died and sing praise songs in honor of the ancestors who survived. That visit convinced me that no one would leave NMAAHC without feeling both the pain and the power of the enslaved.

While there were probably more efficient and effective ways to carry the message that the museum existed and that great progress was being made than lecturing around the world, I found the opportunity to engage personally with colleagues and peers to be a crucial component in our ultimate success. And while I hope these gatherings gave a face to the project and promoted a sense of excitement and anticipation, I personally gained so much more than I gave. I learned how to hone the message and tell the stories that made listeners care. I experienced so many sites and cultural institutions that would enhance my understandings of what is possible in a museum and challenge me and the staff to push the boundaries and enlarge our dreams. These trips reinforced my commitment to making the invisible and the forgotten central to our understanding of who we are. And those visits always reminded me of what I had learned from Princy Jenkins: help the public remember not just what it wants but what it needs to remember despite how painful the memory.

Probably the most traditional method of museum promotion is the changing exhibition, and in the case of NMAAHC, the most important and useful tool to demonstrate that NMAAHC was a viable entity with a promising future. I had not forgotten Mayor Daley's cautionary concern that few care about a project. While museums are more than the sum of their exhibitions, these presentations that are at the heart of any museum are a mosaic of word, idea, artifact, and image that educate and enrich. To me, crafting exhibitions prior to the building served several crucial functions. Each exhibition was part of a foundation upon which we would later build the museum. These foundational presentations enabled the museum to test ideas and interpretive frameworks, as well as gauge visitor expectations and audience appetites for challenging subjects. Crafting early exhibitions were key tools in the recruitment of a strong staff. It is a challenge to say to

scholars or educators that you will have to work a decade before you see the fruits of your labor. Few ambitious museum professionals would risk their most productive years working on such a project. These exhibitions allowed scholars to curate and to publish, educators to develop learning materials and workshops that gave them a better understanding of the museum's future audiences, designers to give vent to their creativity and allowed all segments of the museum staff, from administrators to security personnel, to sharpen their skills. Most importantly, these exhibitions signaled to the media, to potential donors, to Congress, and to the African American community that the museum was not too far distant. That now is the time to believe and to invest.

From April 2007 until May 2015, the National Museum of African American History and Culture curated or mounted ten temporary exhibitions of which four traveled to museums and venues around the nation and five were accompanied by major publications:

- Let Your Motto Be Resistance: African American Portraits, April 2007–November 2007
- The Scurlock Studio and Black Washington, January 2009–February 2010
- The Kinsey Collection: Shared Treasures of Bernard and Shirley Kinsey, October 2010–May 2011
- Ain't Nothing Like the Real Thing: How the Apollo Theater Shaped American Entertainment, April 2011–March 2012
- Slavery at Jefferson's Monticello: The Paradox of Liberty, January 2012–October 2012
- Changing America: The Emancipation Proclamation and the March on Washington, December 2012–September 2014
- Marian Anderson: Artist and Symbol, April 2014–November 2014
- Rising Up: Hale Woodruff's Murals at Talladega College, November 2014–March 2015
- Through the African American Lens: Selections from the Permanent Collection, May 2015–December 2018
- For All the World to See: Visual Culture and the Struggle for Civil Rights, April 2012–March 2017

The variety and diversity of content and presentation were also part of our strategy to give the public a sense of the depth and scope of the museum's

curatorial vision. We hoped to create excitement based on the comprehensive nature of the history and culture that the museum would eventually explore.

The museum was able to mount such an aggressive exhibition schedule thanks only to the support of colleagues who were willing to take a chance on a start-up and the small but gifted staff that had joined this endeavor. An example of that good will was the creation of our very first exhibition, Let Your Motto Be Resistance: African American Portraits. How does one create an exhibition without the collection? In our case, I met with Marc Pachter, at that time the Director of the National Portrait Gallery. Marc was another of my longtime Smithsonian colleagues who provided crucial support in the early stages of museum building. Marc and I had worked together a decade earlier when I lead the Smithsonian team charged with the creation of the American Festival, an exhibition of music and historical artifacts from the holdings of the Institution that opened outside of Tokyo, Japan, in 1994. During our time together, Marc and I wondered if we two curators might ever become directors at the Smithsonian. Circumstances allowed us both to attain positions of leadership. I spoke with Marc and asked if we could mine his holdings and craft an exhibition based on African American portrait images. The years of friendship paid off as he not only agreed to provide access to his collections but also to host the finished exhibition.

As this was the museum's inaugural exhibition, I knew it would be highly scrutinized and that it had to be innovative and just plain good. I immediately turned to another friend of many years, Deborah Willis, a MacArthur "Genius" Award recipient in 2000 and the preeminent scholar of African American photography. Despite all of her prior commitments and her recent transition to a faculty position at New York University, Deborah immediately agreed to curate this important show. Along with Kinshasha Holman Conwill, we decided that this exhibition must provide new insights into a long-held collection. Deborah wanted to use portraiture to show how African Americans used both the lens and the pose as tools in the struggle for equality. Thus, thanks to Deborah's gifted vision, images of Sojourner Truth, W.E.B. Du Bois, Lorraine Hansberry, and Wynton Marsalis were seen as more than simple pictures, but as choices to counter prevailing stereotypes and to project a sense of agency. The interpretive framework was clear, but what title could capture the sweep and boldness of Deborah's analysis? During our conversation I remembered some of the

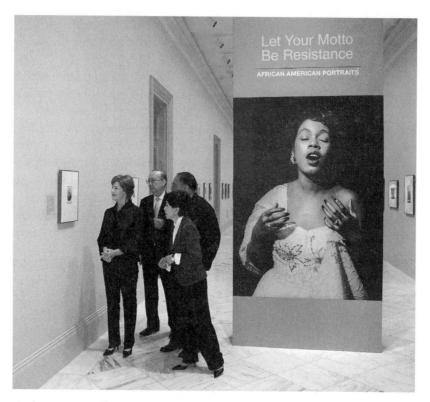

The first temporary NMAAHC exhibition, Let Your Motto Be Resistance, at the National Museum of American History, in 2007, with then First Lady Laura Bush, National Portrait Gallery Director Marc Pachter, Representative Doris Matsui, and Lonnie G. Bunch III.
PHOTOGRAPH BY KEN RAHAIM/SMITHSONIAN INSTITUTION

areas I researched as a historian of nineteenth-century America. I thought of a speech given in 1843 by a free black minister, Henry Highland Garnet. He wanted to inspire African Americans, both enslaved and free, to aggressively demand freedom and fairness. In his speech he urged blacks to "let your motto be resistance!" Kinshasha and Deborah loved the phrase, and a title had been found thanks to my love of the antebellum free black community.

The remaining question was where the show should be exhibited. We had the commitment from the National Portrait Gallery, but Deborah and Kinshasha felt that we needed the visibility and attention that would come from opening our first exhibition in New York City. Their connections in the city led to discussions with the director of the International Center of

Photography (ICP), Willis "Buzz" Hartshorn. He knew the importance of Deb Willis's work and quickly agreed to mount the exhibition during the spring and summer of 2007 and to help publicize the catalogue that accompanied the show. ICP was located in the heart of mid-town Manhattan on 43rd Street and Avenue of the Americas. Traveling to the opening, it was heartening to see banners all along the avenue celebrating the exhibition with an image of Jessye Norman photographed by Irving Penn. The fact that both Penn and Norman had allowed the museum to use the image on both the cover of the exhibition catalog and on the banners is a testament to both what the museum would come to mean and to Kinshasha's ability to negotiate.

In October 2007, the exhibition was then highlighted at the National Portrait Gallery. What made that homecoming so special was the manner in which Marc Pachter and his colleagues embraced the exhibition and made sure that a museum without walls was recognized and appreciated. During the opening it was gratifying for me to provide a tour of the exhibit to First Lady Laura Bush and to Smithsonian Regent Congresswoman Doris Matsui, whose support of the museum and of me, proved crucial in the years to come. During our time together prior to the reception, Mrs. Bush spoke admiringly of the images, and also of our interpretation that the works chosen represented more than portraiture.

Let Your Motto Be Resistance was a big success, with both the exhibition and the publication garnering strong and positive reviews in the press. Even though we benefited greatly from the placement of the exhibition in two distinctive and visible sites, I needed to find a way to more clearly brand our efforts. So it made sense to look once again within the Smithsonian for answers. My former home, the National Museum of American History where I had served as the associate director for curatorial affairs, had expertise and collections, and was in need of resources to support an aggressive plan of change and revitalization. So, I first approached many of my former colleagues to solicit ideas and assess their interest in collaboration. I then spoke to the director, Brent Glass, about making a deal.

Dr. Glass arrived at the Smithsonian after I had left for Chicago. I had never met him. Unfortunately, our initial interactions were not as friendly as I had hoped. I arrived a few minutes late for our introductory meeting because that day was the first time I had entered NMAH since I departed five years earlier. It was wonderful to be greeted with enthusiasm and warmth by former colleagues. When I finally arrived at his office, he welcomed me, but also wanted me to know that although many of the museum staff had once

worked for me, they were now his employees. Though that first meeting was uncomfortable and unproductive, I soon went back to Glass with a proposal that could help both museums.

NMAAHC needed a permanent gallery space, or a site it could use until the museum building was completed. This would be a space where we would curate exhibitions that would be identified, marketed, and seen as the product of the new museum. A sign over a gallery with the museum's name, no matter how long or unwieldy the congressionally mandated appellation seemed, was a marker of permanence and would signal a location where our supporters could always find important and interesting work. Such a space would then allow design and exhibition staff to know just how the gallery could shape future presentations. To paraphrase the British author Virginia Woolf, we needed "a room of one's own."

As I surveyed the Smithsonian, the best hope for finding the needed space was at the National Museum of American History. I realized that NMAH was short of resources to implement their master planning, so I offered to pay for the renovation and outfitting of a gallery on the second floor. In essence, I bought a home for NMAAHC. A few days later we were to meet to finalize the agreement and sign whatever paperwork was required. Just prior to that, a senior colleague at NMAH, James Gardner, who I hired to be my deputy while I was at NMAH, called to warn me that there was one final hurdle: the NMAH director wanted control over the content that we would place in the gallery. With that information, I entered into the director's conference room ready for a fight. Glass tentatively raised the issue by saying that since it was his building, he was responsible for the content within it. He then said that it probably will not be an issue, but he wanted to ensure that our exhibitions would be of the caliber expected by the Smithsonian. I almost went "New Jersey" on him, but I was able, barely, to control my anger. I made clear that I, and I alone, was responsible for the content that went into any space owned by NMAAHC. I then suggested that if he could find any moments during my career when we did not meet the highest ethical standards or produced historical products that were not ripe with scholarship, then he could demand the right to oversee our work. He immediately backed down, and we signed the agreement. Ultimately, our relationship grew because he would eventually see that the exhibitions that we crafted brought new audiences into his building and that everyone benefitted from our presence. But that was not the feeling at the beginning.

We celebrated the fourth year of my returning to Washington by opening the first exhibition to be mounted in our new gallery within NMAH.

During my tenure at NMAH I was impressed with the acquisition of a collection of photography that documented black Washington. The Scurlock family, father Addison and sons Robert and George, created an unprecedented archive that captured much of the social history of African Americans in the nation's capital. While this archive was well known among scholars, I thought it deserved the attention of a major exhibition and publication. I was also excited about this exhibition because it allowed the museum to illuminate aspects of Washington, DC, that were unknown to most tourists.

This desire of mine to chronicle the District goes back to my inability to include much Washington history in the galleries and publications of NMAH. I was always a bit offended that millions would visit the Smithsonian and not know anything about the city beyond the Mall. Not only would this work allow the museum to illuminate the District, it would also give me the opportunity to co-curate the exhibition with one of my current colleagues, Paul Gardullo, and a former staffer, Michelle Delaney. Working with Paul, who had recently joined the museum's curatorial staff, allowed us to spend time sharing my philosophy of exhibitions (that they must humanize history and yet be immersed in the best scholarship) and discussing the array of curatorial decisions that undergird any exhibition project. These occasions were edifying because they helped me understand Paul's strengths in a way that would assist me in planning how his talents should be utilized in the curation of the permanent exhibitions, a process not yet underway but always on my mind.

As the night of the opening approached, I wanted to be sure that all aspects of the gala, from the food to the speeches to the entertainment, met the highest standards. Once again, the future museum would be judged by events like the opening. Fortunately, Adrienne Brooks, the museum's director of development, orchestrated the night and ensured that the more than seven hundred guests would have a memorable experience. One of those in attendance was Congresswoman Eleanor Holmes Norton, a sometimes critic of the Smithsonian who represented the District of Columbia with zeal and a love of the city. As she approached the podium, I was unsure of her assessment of the evening. She surveyed the audience, then said that she was amazed that we "were able to draw eight hundred people for a museum without a building." And she added how "good you will be when you have your own structure." This was exactly what I needed her to say. The strategy of being real without a building was working. It was essential that we remain true to our initial plans.

The museum learned something from every exhibition we mounted or program we produced. Each incrementally moved us closer to the Promised Land, our site on the Mall. From the 2012 exhibition, Slavery at Jefferson's Monticello, we were able to test how the media, how the public, and how the Smithsonian would react if we explored the relationship between the nation's Founding Fathers and slavery. Then, in 2012, with the Changing America exhibit, we sharpened our interpretations of slavery and employed design as a way to humanize the enslaved with human-scaled imagery. Mounting For All the World To See in 2012 helped us better understand the strengths and challenges of collaboration and the need to enhance the visual literacy of our visitors. Every effort was strategic and had to move the museum closer to fruition.

After several years of preparation, testing, and introducing the nascent museum to the public, we were ready to begin a process that would lead to the biggest decision we would face since the selection of the site: the choice of an architectural team to design our structure. The preplanning documents had provided us with a broad skeleton of building needs and possibilities, while the changing exhibition program had yielded much-needed content and goals. We thought we were ready.

Designing a Dream

Two roads diverged in a wood, and I—
I took the one less traveled by,
And that has made all the difference.

—ROBERT FROST, "THE ROAD NOT TAKEN," 1916

I had no idea just how intense and unrelenting discussions about the look of the building would become. The building, or rather its design, became almost a national obsession. There was not a presentation, reception, or scholarly conference where someone did not ask about or offer their opinion as to the appearance of the building. I was tired of hearing "what will it symbolize?" "How will the design fit with the other structures on the Mall?" "Who is the architect?" "Will the building look black?" My concern was not because the questions were not interesting and important, but that I had no real idea how to answer the questions. During my job interview, I had spoken convincingly about my earlier experiences with construction: being part of the core team that built the California African American Museum in Los Angeles in 1984 and overseeing the transformation of the Chicago Historical Society. In actuality, I did more observing and pointing than doing. And there are few projects as challenging and as visible as building on the National Mall.

While designing and constructing a building in Exposition Park in Los Angeles in the 1980s was on a much smaller scale and budget, it was relatively

high profile, reason being that it had to be completed in time for the 1984 Olympics as many of the events would be held at the Coliseum located within the park. The Los Angeles Organizing Olympic Committee had made clear that if the building was not completed a month prior to the games, it would haul in trees and cover the construction site, something that would be an embarrassing failure.

As a young curator working for the state of California, I never let my ignorance stop me from trying to contribute to the design and construction process. I attended meetings with the architects and spoke about the curatorial needs of the structure, but the process of predesign on that undertaking was nowhere near as formal as the one we followed for NMAAHC. (And I was making it up as I went along on that, too.) As the Olympics approached, the construction schedule slipped, and I had to begin to install an exhibition that I curated on the history of African American participation in the Olympics before the completion of the structure. Three weeks before the deadline we were told that the metal and glass doors to the building were held up in Mexico because significant levels of radiation had been detected. As it turned out, my most important contribution to the design and construction of the California African American Museum was my willingness to sleep in the galleries each night for a week to protect the collections until the doors arrived. I did not realize how empty Exposition Park was after nightfall. The first few nights, I could not sleep out of fear of the darkened park and worry about the success of my first major exhibition. By the end of the week, I was so exhausted that I would have slept through any attempt to break into the museum.

Though I was prepared to camp out on the Mall if need be, I hoped my contributions would be more useful this time. Yet I felt that I was still "making it up." I had no idea as to the shape and look of the building. I realized that if the construction had occurred when originally conceived in the early twentieth century, the structure would be strongly influenced by Southern motifs since the African American community was overwhelmingly Southern and rural. Or, if the building had been completed after WWII, the look would be more reflective of the urban experience. I had little sense of what a structure that housed an African American museum should resemble. But many others had what they perceived as the right solution and look for the museum. Some believed the building had to look "African," though no one was sure what that actually meant. Someone sent a few plans that called for the building to be completely submerged and out of sight as a nod to the fabled Underground Railroad, a system that enabled many enslaved

to gain their freedom. I think that this plan had more to do with the desire for the museum not to block views of the Washington Monument than it did to honor those who ran and walked towards freedom.

The most original unsolicited idea was sent to our offices in 2008. As I sat at my desk, my executive assistant Debora Scriber-Miller (more on her role as the linchpin of the museum in later chapters) struggled to bring in a large package of architectural drawings. There were more than 100 pages that detailed what this person felt was the perfect structure. As we reviewed the material, I realized that this "architect" had developed a design of the building in the shape of a Black Power fist. At first, I laughed, but then realized that the number of drawings suggested that this was a serious effort (or an insane gesture). Either way, the person who mailed the material had spent hours designing his or her answer to the public's questions. I must admit, I have confidence in my abilities, but I knew I could not possibly sell the idea of a Black Power fist right next to the Washington Monument.

Issues of race were embedded in the selection of the architect and in any future design. I knew that there were few significant buildings in the nation's capital that were designed by African American architects—and not one of the structures and buildings on the Mall in 2006 was shaped by black designers. As someone who had often been the only African American in a room of museum professionals, I understood in a deeply personal way just how significant the choice of a black architect would be to the architectural profession and to the nation. As if I needed reminding, the National Organization of Minority Architects seized every opportunity to school me on what one architect called "my duty." It seemed that whenever I spoke at a public venue someone representing minority architects would question me, confront me, and call on me to state that my choice of an architect would be black. While I understood the argument and was supportive in breaking the mold of who had the chance to design something on America's front yard, this building was a government project and must adhere to the federal guidelines. So, my response was that we would follow the laws, and that I was hopeful that a rich array of minority firms would have a strong chance to be our architect of record. What that did was simply defer the issue until the selection process unfolded. Yet it did not stop me from wondering: did the architect for this museum have to be black, and what were the political and cultural ramifications for the museum and for me if a non-African American was chosen?

There were many questions that would take months or years to answer. I did not know how the building would look, but I had a strong sense of what

it needed to represent and how I wanted people to feel as they engaged or entered the structure. Like numerous aspects of this endeavor, many of my notions about architecture were shaped by my time in Chicago. Living in Oak Park, Illinois, meant that I experienced the creativity of Frank Lloyd Wright every day. Visiting the many structures he designed, I thought about pacing and the visual juxtapositions that were evident in all of Wright's work. And working in Chicago allowed me to experience a range of architectural styles and expressions, from Louis Sullivan to Mies van der Rohe to Louis Skidmore. Part of Chicago's greatness and its identity is due to the creation of so many signature buildings. Whatever the final shape of the NMAAHC building, I wanted it to be a memorable structure that would contribute to and challenge the architectural landscape of Washington, DC. I hoped to contribute to making the architecture of the city less monumental—and more unforgettable.

It was crucial that the museum express a strong sense of the richness of African American history and culture. While it had to revel in its blackness, the structure also needed to embrace its American-ness. I wanted a building that would reference the spirituality, resilience, uplift, and hope that have been key elements within the African American community that have shaped America's identity in ways most Americans do not understand. I wanted the building to also make effective use of the National Mall. Usually when people enter a building on the Mall, they are inside a structure that could be anywhere. The concept of the building I had in mind needed to create views of the National Mall that help visitors understand that the Mall is sacred and full of footprints that reveal the long-standing but often invisible African American presence. While I did not want to be too heavy handed or obvious, I needed the building to have a darker hue that would symbolically remind all who visit the Mall that there has always been a dark presence in America. A presence that was often overlooked or undervalued. This building would be a visual antidote to that historical amnesia.

Another element was the need for the building to be sustainable, to be the first green museum on the National Mall. I wanted to attain LEED, Leadership in Energy and Environmental Design, gold status at a minimum. This was important to me because museums globally look to the Smithsonian and I felt we could influence the plethora of new museums being built as to the importance of embracing sustainability. My commitment to the environment goes back to my days as an undergraduate student at Howard University. I decided to take a group of my classmates down to the Mall to attend the second Earth Day celebration. I remember that we sat on ground not too

far from where the museum would be built listening to the Beach Boys perform. A group of white students were immediately in front of us. During the concert one young woman looked at us quizzically and asked, "Why are you black guys here? This is not a Civil Rights demonstration." I never forgot that ignorant remark, especially since the African American community suffered the effects of environmental racism, and sustainability had always been a key element in the lifestyles of rural African Americans. And besides, protecting the environment is a Civil Rights issue to me.

I knew that we were asking a great deal of a building, of an architect. As it was with all aspects of the museum, we wanted to attain a higher standard of excellence. We needed the building to be memorable and visually engaging, but we also needed it to work as a museum—as a site for collections, education, and engagement. This was not to be a monument to architectural creativity. It must pay homage to a community and to a nation by recognizing that what goes inside is ultimately more important than the external façade.

By the fall of 2008, we were ready to begin the process of hiring a team of architects who would partner with the museum over the next six or seven years. This was a long-term commitment, a marriage, and we wanted to enter into this arrangement with passion, optimism, and a belief in happily ever after. But we could not afford a mistake that could cost the museum time or money, both of which were in short supply. Some of my worry at this time stemmed from the experiences of NMAI and its challenges with their chosen designer. Several years into the design process, NMAI decided that the relationship with the original architect was damaged and was not producing the creativity the museum wanted. NMAI then went through a long legal process before uncoupling from the initial architect and finding someone who could complete the design work. This rupture caused nearly a year's delay and increased the cost of the project. There was much worthy of emulation from the building of NMAI. The process of finding the architect was not something I needed to follow.

What I felt we needed was an international design competition that would allow the most gifted architects to compete to build the museum. With the support of the museum's Council, I met with the then Secretary of the Smithsonian, Wayne Clough, and the heads of the Institution's units responsible for architectural design and construction to argue for such an expansive competition. I was surprised at how quickly this notion was criticized. After all, I was reminded, the Smithsonian rarely held such a competition and yet it had produced several important buildings like the National Museum of African Art and the Udvar-Hazy building in Virginia that houses collections

from the National Air and Space Museum. Many in the room argued that a competition was costly and difficult to manage. I felt this was management by custom and tradition at a time when I was trying to find innovation and engagement.

I felt strongly that an expansive design competition was best for the project. I thought that African American history and the black community deserved our best efforts, which should include the most gifted and appropriate architects. The museum's vision included a better understanding of our global connectivity, so why not open the process beyond the borders of the United States? I was also influenced by many of the naysayers who believed that we "would not be well suited" by the site. There was no denying that the site had significant challenges: concerns about water and the maneuvering of museum deliveries through the congestion along Constitution Avenue; how we would define the site's relationship to the Washington Monument and to the National Museum of American History and the array of regulatory agencies and consulting parties that could shape the final design. To address those considerations, I wanted to see a competition to give us the best possibility for success. And I realized, I needed the help.

Eventually, the Smithsonian authorized a design competition, in part, due to the key support of Sheryl Kolasinski, the chief architect at the Smithsonian. Sheryl became one of the museum's closest and most able allies until she left the Institution in search of grander challenges and greater responsibility. The leadership of the Smithsonian was, however, quite concerned about the cost. Once again, I turned to my relationships in Chicago for aid. The Driehaus Foundation in Chicago had always supported the arts and culture and had a special affinity for architectural innovation, so I approached them about support for the construction of the future edifice. Though they were not able to assist with the construction budget, they contributed resources that, along with a small grant from the Ford Foundation, covered all the costs of the design competition. With these resources, we were able to hire Don Stastny of StastnyBrun Architects to serve as the design competition advisor. Stastny's charge was to handle all aspects of the competition by guiding the Smithsonian through this unfamiliar process; to facilitate the communication in order to garner the interests of architects; to help determine who would be appropriate jurors; and to facilitate those gatherings.

It became clear to me that both the request for qualifications and the request for proposals needed language that was inclusive and direct. Following a government formula, architects were first asked to submit their

qualifications (RFQs): did they have the technical capabilities needed, had they ever worked on projects of this scale; and what was their prior experience with regulatory agencies. This initial request brought in over seventy proposals that were scrutinized by a technical committee comprised of architects, budget analysts, and engineers. Twenty-two firms were then sent the request for proposals (RFPs), which allowed them to provide greater detail as to their interest in the project, their approaches, and their personnel. This group was reviewed and the names of six finalists were submitted to me and the architectural jury. What made this process palatable was the acquiescence to my demand that both the RFQs and the RFPs required the firms to demonstrate an appreciation and understanding of African American history. This was a crucial addition that the Smithsonian Office of Contracting opposed. Yet it allowed each firm to find ways to demonstrate that appreciation. Some firms were comprised of minority architects who had worked in that arena, others included scholars or cultural professionals to provide the needed expertise.

Chairing the design competition jury was incredibly difficult. First, there was the challenge to find the right jurors, which had to include Smithsonian expertise, external specialists, and members of the Museum Council whose buy-in I needed if they were to help raise the dollars needed to fund the architects and the construction. Second, there was the hurdle of actually guiding the jury to the decision I wanted or being flexible enough to let the jury help guide me. Finally, as the chair, I had to articulate and defend whatever decision we arrived at through our collective deliberations.

It would be essential to work with Don Stastny to create a jury that would be collaborative yet candid. The jury needed to be of the highest quality so that whatever the final decision it be legitimate in the minds of the public and especially architects. After consulting with the Council Co-chairs Dick Parsons and Linda Johnson Rice, we agreed that in addition to the two of them, we would add two more Council members, Jim Johnson, the former CEO of Fannie Mae, and Franklin Raines, formerly the head of the US Office of Management and Budget. I wanted to broaden the jury so that some members would be new to the museum and would, therefore, not be held captive by earlier decisions or discussions. I also felt the need to have several scholars, so I invited Maurice Cox who was then the Director of Design for the National Endowment for the Arts and Adèle Naudé Santos, then Dean of the School of Architecture and Planning at the Massachusetts Institute of Technology. More than likely, any design would receive a great deal of media attention, and I wanted a seasoned journalist to help us in this area. I was

pleased when Robert Campbell, architecture critic of the *Boston Globe*, agreed to lend his expertise.

To help the Smithsonian feel that it was an integral part of this process, we included Sheryl Kolasinski, the Institution's chief architect, and Michael Bellamy, director of the Office of Engineering, Design, and Construction. The group, though large, still felt incomplete to me. Eventually we would need the approval of the governing body of the Smithsonian, the Board of Regents. To fill that spot, I added Robert Kogod, who was the head of the Regents' Facilities Committee and a leader of the Washington business community as the President of Charles E. Smith Management LLC. I hoped that this was a group whose credibility and judgment could not be questioned. This was the assembly that I needed to shepherd.

In January of 2009, we brought the six finalists to the Smithsonian for an all-day orientation that would be the beginning of the design competition. The program began with Stastny discussing the dates and details: each team would have two months to formulate design concepts and to produce a model of how each team's concepts would appear on the National Mall. I then spoke for an hour about the vision for the museum, my hopes for the building, and the long wait for the fulfillment of this dream. I reminded the finalists that this was more than a museum. It was a site to make a country better and I needed their best efforts to make that happen.

My expectations were high, but I was genuinely impressed with the six finalists. The teams included "star architects," architects of color, innovative younger designers and architects with an international pedigree. All the architectural teams were highly accomplished. They included Devrouax & Purnell and Pei Cobb Freed & Partners; Diller Scofidio + Renfro in association with KlingStubbins; the Freelon Group, Adjaye Associates and Davis Brody Bond; Foster + Partners/URS joint venture; Moody Nolan Inc. in association with Antoine Predock; and, Moshe Safdie and Associates Inc. in association with Sulton Campbell Britt & Associates. Collectively, these creatives have won many national and international awards: three are recipients of the American Institute of Architects highest honor—the Gold Medal—and two teams the Pritzker Prize, a recognition of outstanding architectural creativity.

The group was so strong that I wondered how we would choose among them. I believed that this assembly could produce magic on the Mall and I was anxious to see what they would create. The models and their materials were due to the jury by early March. Then we would interview each team about its

model, its process, and the manner in which they worked with clients. As the designs arrived and the day approached for the interviews, I felt the stress of the impending decision. What if we chose the wrong architectural team? How would I ensure that the building would be impressive enough to jump-start the development activities? And did I know enough to hold my own with such noteworthy professionals?

Each of the design presentations took on the personality of the lead architect and was shaped by the jury's reaction to the model. I had hoped that we would see different solutions to the challenge of building on the Mall. And we were about to see wildly divergent schemes that challenged the jury to accept the boldness and sometimes idiosyncratic nature of the concepts. I was anxious to meet with the team Foster + Partners/URS joint venture. Sir Norman Foster is a legend, whose work has reshaped so much of the cultural landscape. I thought about how his design of the Kogod Courtyard in the Smithsonian's Reynolds Center for American Art and Portraiture not only enlivened a quiet museum complex but also changed the rhythm and the feel of the downtown area surrounding the museum. His presentation to the jury demonstrated an understanding of the impact and importance of African American culture and an appreciation of the challenges presented by the regulatory agencies to building on the Mall. His design model was respectful of the Mall, maybe too much so. The building had some strong attributes but not as impressive as I had hoped.

The discussions of the work of Diller Scofidio + Renfro in association with KlingStubbins applauded their innovative and engaging style. We were struck by their presentation about how a structure could reshape the feeling of the Mall, which reflected the work Diller Scofidio + Renfro did in designing the Institute of Contemporary Art in Boston in 2006. There, the jutting structure's creative positioning turned the public's attention to the waterfront and seemed to use the site effectively. That said, their model for NMAAHC seemed too monumental and a mass that would have difficulty escaping the restrictions that I knew the regulatory agencies would suggest. I was very fond of the presentation and the design of the team Devrouax & Purnell and Pei Cobb Freed & Partners. Their talk, delivered by the son of I. M. Pei, was moving and gave us confidence in the team. The model was rather traditional and would fit in quite comfortably with the other structures on the Mall. For those of the jury who valued tradition, this structure was highly rated. The Moody Nolan Inc. in association with Antoine Predock design was the most nontraditional of all the submissions. The team's suggestion that this

building should be organic and at one with the landscape was appealing, but the model was not. It was so unusual and so different that it would clash with the other buildings and monuments on the National Mall. When Moshe Safdie and Associates Inc. in association with Sulton Campbell Britt & Associates made its presentation, I was enamored with the building model. It was ripe with sunlight, its scale had presence but was not monumental, and its protruding bowlike structure harkened back to the slave trade, the inhumane business that created the modern world. Also impressive was the design and the talk given by the Freelon Group, Adjaye Associates and Davis Brody Bond. The coloration and the scale of that design captivated many of the jurors. What made the conversation memorable was David Adjaye's quiet but powerful presentation about the global importance of black culture and the role this building could play in making those stories more accessible. While every design and conversation was useful in helping me think about the way to maximize the five-acre site, there was no clear consensus.

I decided that all the models, which became the property of the museum, should be seen by the interested public. This decision was met with resistance by many within the Castle, the place that housed the Smithsonian leadership. There was a concern that a lack of public interest, which meant few people would make the effort to view the models, might be interpreted negatively: that the project appealed to a limited audience. This possibility could undermine the burgeoning fundraising and the growing awareness in Congress.

It was not enough for me to show the models, I wanted to draw even greater attention to the designs. I decided to have cards available that allowed the visitors to vote for their favorite model. Even I understood this was a risky endeavor. As one senior Smithsonian official complained, "What is he going to do when the public chooses one design and the jury another?" In essence, if the ultimate choice was rejected in this unscientific poll, would that call into question the jury's voice?

I was willing to accept the risk. I needed to show transparency so that the ultimate decision would not be undermined or viewed as a deal done by a few. I emphasized this point during my comments at the press conference announcing the exhibition of the models: "We are at this moment because of a carefully crafted process over a three-year period . . . We recognize the responsibility that comes with building on the National Mall." To garner the most visibility, we displayed the models from March 27 to April 3, 2009, in Schermer Hall, which is located near the public entrance to the

Castle building, guaranteeing that the designs would be accessible to a large audience. It was also important to use the exhibition of the models as another example of the progress that was being made towards the construction of the building. And revealing the models enabled me to take potential donors to the space. One of the most important moments was when I walked then Senator Sam Brownback of Kansas through the gallery. He had been one of the sponsors of the legislation and an early advocate for Senate appropriations. When he saw the progress represented by the models, his positive reaction signaled that we could count on his continued support in a partisan legislative body.

We set the date to make the choice of the architect public on April 14, 2009. This meant I had two weeks to wrangle the jury, control the often contentious debate, and help the jury find common ground and come to a unanimous decision. All in two weeks. My sleepless nights began.

As the jury deliberated, I tried to focus and limit the discussions to three areas: how would the proposed design fit within the current architectural landscape of the Mall; would the building symbolically convey notions of African American history and culture; and did the team seem cohesive and would they be effective and collaborative partners? To me, though all these issues were crucial, I found myself wrestling with the question of how innovative we could be. Were we being held captive by traditions of granite and monumentality? I thought some of the designs were too nontraditional or, dare I say, too innovative to survive the scrutiny from the public and the oversight agencies. I wanted a structure that would challenge and enrich the architectural offerings in the nation's capital but would be seen as elegant and worthy of the culture that would be represented by the exhibitions that would populate the future galleries. For me, the decision came down to three finalists. I felt the choice was between the distinctive styles posited by both the Moshe Safdie and Associates and the Freelon Adjaye Bond team, or the elegant but more traditional design by Devrouax & Purnell. As the discussions evolved, the group felt that the more modernist interpretation of the past that was echoed in the designs of both Moshe Safdie and the Freelon Group held the most promise.

The night prior to the final deliberations, I was wracked with uncertainty. I knew we had two impressive designs but how do I decide my preference. I remember asking each team how we handle disagreement as this would be a multiyear relationship. I felt that the Safdie response hinted at a less than collaborative process with the architect's creativity leading the

endeavor. I believed that the museum staff had a strong and clear vision, a vision that needed to be given substantial weight during the process of design. Yet—I was quite attracted to Safdie's model.

Near the end of the day, it became clear that the overwhelming sentiment in the room favored the model and approach by Freelon Adjaye Bond. I concurred. I found the building's style and coloration helped to place that dark presence that I desired on the Mall. And I was taken by the quiet elegance of David Adjaye and the solid reputation and productivity of the entire team. The addition of the landscape architecture firm of Gustafson Guthrie Nichol gave me great confidence that the exterior grounds would be beautiful and yet extend the interpretive canvas beyond the structure. I was convinced that Freelon Adjaye Bond could create the signature green building of our dreams. But my enthusiasm was tempered by several concerns. David Adjaye was not yet Sir David, an honor he would receive in 2017. He was brilliant, but in many ways untested by a major commission such as this. I worried that this project needed the maturity of someone, like Max Bond. Though Bond's spirit informed the design, his death in the midst of this process weakened the team. A few weeks before his death in February 2009, Max visited my offices. He wanted me to know that he was the glue that I could always rely upon. My confidence soared when he said in more colorful language that if anyone "screws up," he would make it right. I was also worried that the "Corona," the distinctive bronze filigree that enveloped the building, might make it look too African and not enough American. I did not want anyone to think this was the National Museum of Africa. This was an issue that I would work with the architects on to make sure that the building, the Corona, and the grounds engulfed all who entered into African American history and culture.

I was determined that the jury be unanimous in its choice, especially if we chose the Freelon Adjaye Bond partnership. As a result of the work of Bond and Freelon on the prebuilding planning, I heard whispers that some thought that Freelon Adjaye Bond had the inside track. In reality, they only became contenders when they added the vision and dynamism of David Adjaye. Yet, to squash any hint of favoritism, I needed a clear and strong endorsement of the decision. Finally, after several more hours of debate, the jurors agreed unanimously to select the Freelon team as the architects to design the National Museum of African American History and Culture. We announced the decision on April 14, 2009.

The overwhelming response was positive with the *New York Times* and *Washington Post* applauding the preliminary design, with the caveat that I needed to find the money and have the political savvy to protect and implement the architects' vision. That would prove to be challenging. In the years

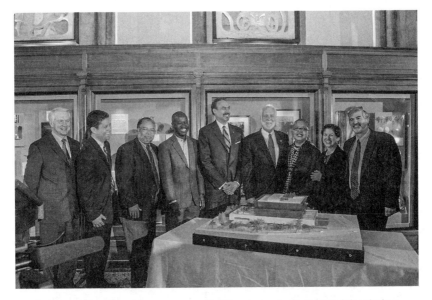

Lonnie G. Bunch III at the public announcement of the winning design team and the winning model for the museum in the foreground, April 2009. This group includes (from left) architect Hal Davis, architect Peter Cook, Founding Director Lonnie G. Bunch III, design architect David Adjaye, architect of record Philip Freelon, Secretary of the Smithsonian G. Wayne Clough, Deputy Director Kinshasha Holman Conwill, Deputy Director for Operations Sheryl Kolasinski, and Acting Provost Richard Kurin. **PHOTOGRAPH BY MICHAEL BARNES/SMITHSONIAN INSTITUTION**

to come, the reality of schedule as well as pressures on the budget and building on what was once the edge of the Potomac River would force difficult yet essential decisions. And not everybody was pleased. A few months after the announcement, I attended a reception at the White House. Someone who I later learned was a member of a team we had not chosen confronted me with the words, "So how is that ugly design by that non-African American?" But on April 14, those worries were, in the words of a 1950s doo-wop classic by the Heartbeats, "a thousand miles away."

The process of government contracting dictated otherwise, but I began to work with the Freelon Adjaye Bond team immediately after the decision was announced. I quickly learned that creating a model was not necessarily a blueprint for the finished product. I so loved the building they had presented that I felt we could accelerate the design process. I was so wrong. I was surprised that there had been little thought given to the realities of engineering, systems, loads, and materials. The model represented dreams that were not close to being realized.

I thoroughly enjoyed the initial collaboration with Freelon Adjaye Bond, though there were times when I felt like a middle-school principal adjudicating playground fights about schedule, budget, power, and control. No one will ever deny the egos of star architects, and this project was replete with them. During the predesign phase, I had traveled a great deal with Phil Freelon and Max Bond to view museums and buildings in New York City, the site for the 9/11 Memorial & Museum, for one, and in Ottawa to assess the design and visitor engagement at the Museum of Civilization (now called the Canadian Museum of History) and the National War Museum in Canada. These trips allowed me to develop a shared understanding of the vocabulary of architecture and a sense of what aspects of the designs in the museums we visited appealed to the Smithsonian team.

I needed to forge that common bond with David. I traveled first to London in 2011 so that he could walk me through several of his buildings to better understand his style and core values; from there to Germany, where we spent a day scrutinizing the Jewish Museum Berlin by Daniel Libeskind. This was useful because the building had been designed with gashes and sharp edges on the exterior façade. And it spoke powerfully about the impact of the Holocaust on the Jewish communities. I found the building less successful as a museum space. The exhibitions were forced to conform to a vision that limited curatorial choice and creativity. This visit allowed me to remind David that he was designing a museum space not simply a building to showcase his talents. Later that year David joined me in Havana, Cuba, where we looked at colonial structures for hints on how certain elements of the past can be incorporated into modern structures. Our time together in Cuba cemented a bond that allowed us to weather the many challenges and decisions yet to come.

Usually David and Phil, with their growing teams, would meet with me and a core group of my colleagues that included Kinshasha Holman Conwill, Jackie Serwer, then the senior curator of NMAAHC, and Lynn Chase, a wonderful project manager who had worked alongside me for thirteen years at the National Museum of American History, twice a month with numerous phone calls in between. On those occasions I was always taken by the burst of creative ideas that flowed from David. I soon came to understand, however, that not all of the ideas that were presented as design opportunities or solutions were fully developed and would later prove insufficient or untenable. It reminded me of my work in Japan in the mid-1990s. I was often frustrated when my Japanese counterparts would ask to revisit an issue that I

thought we had resolved earlier. It took me a few meetings to realize that when the Japanese negotiators said yes, they really meant: maybe. Working with the architects, I had to accept the notion that some of the best ideas were only tentative until engineers or construction specialists reviewed them. Yet I needed to analyze each suggestion in case it came to fruition.

There were many examples where David's brilliance contributed mightily to the success of the building design. Our collaboration in shaping the three-tiered Corona was an example of the partnership at its best. The Corona, the most distinctive external feature of the building, was inspired by David's knowledge of Yoruba culture, a tribal community predominately in Nigeria. The crown-like shape was influenced by a tiered post used to support a protective covering for royalty, specifically a wooden architectural column carved by Olowe of Ise in the early twentieth century. Its beautiful form, angled upward to mimic arms raised in prayer, and bronze color made the building memorable. In the initial iteration, the Corona was solid bronze. Since the medal was reflective, it needed some patterning to pierce the solidness of the façade. David and Phil wanted to use a computer to plan for random interventions into the skin of the Corona. I remained concerned that the Corona was simply a symbol that read African. So, as part of our discussions, I suggested that we need not have random interruptions, but that we should find a way to use the designs on the metalwork and on the sculptured ornamental screens from Charleston and New Orleans, decorative features that graced the mansions of the elite, that were made by African American craftspeople, both enslaved and free, in the era prior to the Civil War. Everyone on the design team embraced this idea and the collaboration led to a signature feature that nodded to Africa, but also remembered and honored the fact that so much of America was built by African Americans whose labor was never recognized.

David's creative flexibility led to another major decision that dramatically reshaped the building. In the initial designs, the Corona was elevated by sitting on a plinth that would house many of the museum offices and support staff. When this idea was presented to the National Capital Planning Commission and the US Commission of Fine Arts, the two entities with regulatory control over the Mall, both commented on the size of the building and the visibility of the base. Rather than simply respond defensively, David moved the plinth, reshaped the building, so that the plinth was below ground—a decision that was both practical and inspired. This dramatically changed the look of the structure by reducing the appearance to three visible

floors. Rather than a building sitting on a block of concrete, it now floated on the landscape, almost jewel-like. His design creativity allowed the museum to meet the space needs in a way that enriched the building.

As a historian, I was always taken by how important water is in African American culture. Many blacks depended on working on the water for their livelihood. And water was a tool used to aid African Americans in their flight from slavery; water washed away or hid footprints and prevented dogs from finding a scent to follow their path. Africans on both sides of the Atlantic worshipped and were influenced by ancestral water spirits and a number of spirituals, such as "Wade in the Water," refer to the transformative power of water. And crossing the water during the trans-Atlantic slave trade fundamentally altered the lives of millions. As we discussed the impact of water, I mentioned that I wanted a space where water lightened the souls of the visitors after they explored moments of pain or terror. David and Phil took our notions about water and made it a central feature of the museum. David designed water features that symbolically had all who entered the building cross water, much like the enslaved who endured the Middle Passage. He also created a memorial space that would have water falling dramatically from above into a room with only a few quotations that would grace the walls to provide a respite for those weary of walking or winded by the emotional experience of remembering. Words, such as a line by singer Sam Cooke that "A Change Is Gonna Come" or Martin Luther King Jr.'s admonition that "We are determined to work and fight until justice runs down like water and righteousness like a mighty stream" helped to stimulate reflections that also inspire one to continue to struggle for fairness and equality.

He also married notions of water, the environment, and Southern culture when he designed a large structure that took its role and meaning from the Southern tradition of sitting on the porch. In David's hand, the porch was not only a site of relaxation and conversation but, when combined with the water feature, it also created a microenvironment that manufactured a coolness always hard to find during a humid summer day in Washington, DC. There is no doubt that during the design phase of this project we were witnessing the maturation of a gifted architect.

Yet not everything that was promised was delivered as practical realities occasionally trumped creativity. When the idea of the porch was proposed, it was to be a space where visitors would find shade and discover wonderful views of the National Mall. I was determined to provide as many vistas as possible: this design really appealed to me. The proposed canopy would be a signature feature of the building at an impressive 198 feet in length. I was

told it could easily happen, so I had drawings developed that showed future visitors to the museum utilizing the upper porch, with the possibility of food service there. I even rented a cherry picker so that I could see what the views would be from there—wonderful, in a word—which added to my excitement. Only to be disappointed later when the architects could not design a way to make access to the upper porch accessible for all. In actuality, the upper porch would have caused problems that I was not smart enough to anticipate. There were very few outdoor plazas in Washington that were used effectively due to the city's oppressive summer heat and humidity. And the security personnel at the Smithsonian feared that food would become projectiles in the hands of the myriad of unsupervised groups of school children who descend on the District annually.

Another idea that gained my excitement but later my disappointment was the ceiling designed for the main event and gathering space that later became Heritage Hall. This massive space was the entryway for all who visited the museum. David designed a complex ceiling comprised of over 300,000 pieces of wood, hanging from a yet-to-be designed superstructure. The number of wood pieces referred to the nearly 350,000 Africans who survived the Middle Passage to be enslaved in the United States. I loved the notion, but no one could determine how to make this design work. How would the wood be held in place? And what would over 300,000 pieces of wood dangling overhead actually look like? There were issues of fire retardant, control of ambient sound, and cleaning concerns that were never adequately addressed. David was never happy when an idea was rejected, and I often fought for and helped him achieve his vision, but for this idea I never saw a fully developed scheme that I could support. There was always tension between the architect's vision and the director's responsibility to find beauty and savings at the same moment. I believed in David, but I also had to trust my instincts.

I think my biggest disappointment was the struggle around the materiality and color of the Corona. From the inception, I wanted a dark color. The architects said that bronze was the best material and that with bronze there would be no discoloration as there is with copper. I enthusiastically accepted their assurances and we all, architects and the Smithsonian, began to speak about the wonders of the bronze Corona, the way the sun would reflect off the surface and the manner in which the Corona would appear differently colored based on the angle of the sun. After nearly a year of celebrating bronze, I was told that the architects just realized that bronze would be too heavy for the site or for the structure. I was angry but placated when told that an aluminum-based Corona could be painted, dyed, or somehow

colorized into the much-adored and much-promised bronze patina. While some of this effort took place during the construction phase, which I discuss later in the book, this decision to eliminate the bronze Corona for a bronze-like Corona caused years of anguish, struggles with the regulatory agencies, clashes between designers and construction experts, and months of me trying to determine subtle differences apparent to others as I reviewed Corona panel samples. I think I ultimately examined more panel samples than there are carny games on the Jersey Shore. And I was much better at the carny games.

Looking back, I am disappointed that I did not probe more, did not fight harder, for the actual bronze. I should have asked whether additional money could make the difference. I was assured that there was nothing one could do to make the bronze work. Someone smarter, more skilled in construction, might have found a solution, but I could not. While I think the finished Corona is beautiful and is as reflective as I had hoped, I still feel that one of my biggest regrets during this entire project was not finding a way to protect the bronze Corona. While I cared about the tone and the materiality of the bronze, I was more upset that I had championed a specific material and now I had to retract my commitment. And that by stepping back from this pronouncement we opened many months of unneeded and unpleasant debate with the regulatory agencies and within the Smithsonian. For this project to be successful, it was crucial that I not make public missteps and that my decisions were not open to second guessing. Retreating from a bronze Corona allowed my leadership to be called into question.

What I never regretted was working with the landscape architects Kathryn Gustafson and Rodrigo Abela. I met with Kathryn during one of my early trips to London in 2010 so I could see her award-winning design of The Diana, Princess of Wales Memorial Fountain. Located in Hyde Park, this quiet and beautiful site was overwhelming in its simplicity. I wanted that understated creativity to be brought to the grounds of the NMAAHC. What Kathryn and Rodrigo designed was a landscape that spoke of resiliency and hope that was an extension of the themes and values of the museum. Their plan was subtle but powerful. Black granite walls would serve as a security barrier. Breaks in those dark walls would symbolize moments when African Americans broke through or made gains in the struggle for freedom and fairness. Their initial drawings called for the planting of 350,000 blue crocuses, which represented the 350,000 enslaved African Americans whose labor and culture shaped a nation. And the sea of blue spoke of the waters crossed and the beauty of a people. Kathryn and Rodrigo succeeded in integrating

their vision so that it was not competing with but complementing the dreams of the museum. Ultimately, their creativity helped to bring a sense of perspective, human scale, to a landscape overwhelmed by a monumental core.

From the process that led to the hiring of the architects to the shaping of a common design vision to the positive benefits that came from the regulatory agencies to the struggles to find the appropriate tension between creativity and reality, the design phase produced wonderful ideas and a plan for a beautiful building. Yet so much was unknown. The challenge of implementing the systems needed to create a sustainable building, the burden of so many wonderful but untested ideas, and the need to be both innovative and traditional meant that so many final decisions were left to the team that would actually construct the edifice. The design phrase solved what it could, but it would be years before the full needs and challenges of this design would be known. This project forced me to become more comfortable with ambiguity—to contain my obsession for immediate solutions and to accept the fact that I could not solve these issues alone.

Finding the Stuff of History

I have climbed the highest mountains
I have run through the fields
But I still haven't found
What I'm looking for.

—U2, "I Still Haven't Found What I'm Looking For," 1987

After all these years, I can easily recall how much my left arm hurt from when Charles Blockson repeatedly punched me in the fall of 2009. I had received a call from Dr. Blockson where he claimed to have important artifacts that illuminated the life of Harriet Tubman. The call was a surprise; I knew of Dr. Blockson, but I had not spoken to him in many years. I was intrigued, but as a historian of nineteenth-century America I doubted that any significant material from Tubman had survived. I knew that there were a few Tubman objects in a small museum in her former home in Auburn, New York, but that was the extent of what existed. It was, however, Dr. Charles Blockson on the phone—the most significant black bibliophile and collector of African American history of his generation and someone whom I had admired for his decades-long efforts to preserve black culture. And the possibility of actually finding collections that would help the public better understand Tubman's abolitionism, her role in helping hundreds to escape slavery, her

contributions during the Civil War, and her postwar life meant that despite my skepticism, I needed to travel to Philadelphia to see Blockson. If the trip proved unsuccessful, at least I could find a Philly cheesesteak sandwich for my troubles.

I was accompanied by my Deputy Director Kinshasha Holman Conwill and the museum's very gifted and dedicated Senior Curator Jackie Serwer. We met Dr. Blockson in a library at Temple University that housed most of the books he had dedicated his life to save. Blockson is a big man, a former football player at Pennsylvania State University, which made the box that he carried seem so tiny, too small to hold a legacy as important as that of Harriet Tubman. I sensed that our trip may have been for naught. And then he opened the box and took out pictures of Harriet Tubman's funeral in 1913 that few had ever seen. As I expressed both surprise and pleasure, Blockson showed his enthusiasm by exclaiming "get out of here," as if he could not believe my positive reaction, and that is when the punches started. Other objects appeared: a homemade knife and fork that Tubman carried with her on her forays into the South to rescue the enslaved; pictures and souvenirs from the christening of a ship in Tubman's name during WWII; a few items from her home. And each time an object was revealed and I showed any emotion, Blockson punched me again. Twenty-five artifacts were unveiled that day and twenty-five times my left arm felt the strength of this former lineman.

As each artifact appeared, our small group became an "amen corner," responding to my assessments like the "call and response" sermons that were the staple of African American churches. And then Blockson extracted the final two objects. The first was a shawl that had been given to Harriet Tubman by Queen Victoria as a sign of respect for Tubman's courage. This shawl may have been the garment seen enveloping Tubman three days prior to her death: a sacred relic. Last, Blockson handed me a hymnal that Tubman had carried for decades that had all the spirituals that she supposedly sang as a way to alert the enslaved that she was near and that the time to seize their freedom was at hand. By this time, I was crying profusely as were all my colleagues. I was not sure whether it was from the pain of the blows or from the emotions I felt seeing parts of Tubman's life reflected in this collection right before our eyes.

Blockson was so excited that he demanded that we follow him to his home where he had an extensive collection of African art and on to lunch. He drove the same way he collected, fast, with unpredictable turns and a commitment to let nothing stop him. Unfortunately, I did stop for the red

lights he ignored. Frantically I tried to keep up, risking the lives of my col-
leagues, because we knew that he had shared something special with us and
now I wanted to understand what he planned to do with those objects. After
viewing his impressive art collection, most of which was outside our col-
lecting interests, we finally made it safely but scared to a restaurant. I took
every opportunity to suggest just how important this collection would be to
the fledgling museum. As I reiterated my excitement about specific pieces
of the collection, he continued his assault on my arm. The pain was soon
replaced with worry: did he want to sell the collection? Would the price
be too prohibitive for the Smithsonian? During the lunch, I gingerly raised
the issue of cost. He stopped me and said, "This belongs in a place where the
public can enjoy the collections. It is yours." I was floored. These artifacts,
which had been entrusted to him by a great grandniece of Tubman, objects
worth millions, were to become part of the holdings of NMAAHC, a museum
that was real only in my imagination. In March 2010, Congressman Robert
Brady of Philadelphia, the ranking Democrat on the Committee on House
Administration, one of the Congressional committees with oversight of the
Smithsonian, arranged for the signing of a deed of gift and the formal trans-
fer of the Blockson collections to NMAAHC to take place in Congressional
office space on Capitol Hill on March 11, 2010.

The actual ceremony was quite remarkable and an example of how the
work and the spirit of NMAAHC was shaped by African American culture.
After Congressman Brady reflected on the importance of Dr. Blockson's life
and career, the bibliophile took over the gathering. The audience was aston-
ished when Blockson mentioned that he chose to sign the formal transfer
of the collection on March 11, which was one day removed from the ninety-
seventh anniversary of Harriet Tubman's death. He then revealed that his
own enslaved ancestors were rescued from slavery by Tubman, making a
dramatic link to this mythical figure. Once again, we were all crying. Block-
son then asked the audience to hold hands and to sing a spiritual that Tub-
man's friends hummed to her, comforting her before her death. Then Fleur
Paysour, the museum's director of communication, who was also a mezzo-
soprano, led the audience in the singing of that spiritual that comforted Tub-
man, "Swing Low, Sweet Chariot." And as a reporter for the *Washington Post*
wrote: "For a few minutes, the hearing room had a sanctified spirit." I do
not know of any other Smithsonian donations ceremony described in that
manner.

Charles Blockson's donation was transformative for the museum. And
it reflected the generosity of the public that would allow the museum to

Charles Blockson, third from left, with his donation to NMAAHC of prized Harriet Tubman possessions, including her hymnal, with Lonnie G. Bunch III, Representative Robert Brady, and Senior Curator for Culture Elaine Nichols. **PHOTOGRAPH BY MICHAEL BARNES/ SMITHSONIAN INSTITUTION**

build its collection in the succeeding years. Blockson could have sold the collection or restricted its use to his library at Temple University. Instead he ensured that Tubman's life would be available to the millions who would eventually visit the museum. Blockson's act also convinced me that we could find collections that were associated with important figures in unlikely places. His donation helped me to believe and to convince potential support-ers that the collections of this museum would be special and worthy of the rich history of black America. The pain in my arm had been worth it.

When I became the director of the museum, I had many concerns, many issues that caused me to worry. Nothing, not raising money, hiring staff, managing the bureaucracy of the Institution, or dealing with the museum's Council caused me greater concern than the challenge of building a national collection. If there was one axiom that shaped the museum careers of curators of color, it was the belief in the paucity of objects that illustrate African American history and culture. Very few museums had significant arti-facts and objects that explored race, therefore, making the crafting of tradi-tional exhibitions very difficult and usually unlikely. As curators struggled

to explore stories that had been left out of the museum canon, they had to creatively address this collection gap.

One of the most important efforts to overcome the lack of collections was the brilliant work of Spencer Crew. In 1987, Crew curated the exhibition, Field to Factory: Afro-American Migration, 1915–1940, that demonstrated how this lack of material can be overcome. Working with a designer, James Sims, who had a grasp of theatrical design, allowed Crew to make effective use of scenic set designs and evocative manikins to weave a narrative that was not held captive by the lack of collections. While Crew's work served to free many museums from the sole reliance on objects, it also cemented the notion that this paucity was an unavoidable and insurmountable hurdle.

When the President's Commission on the National Museum of African American History and Culture issued its report in 2003, it accepted the notions that significant collections did not exist and that the museum should focus its collecting on contemporary cultural productivity and settle for borrowing what limited material existed from other institutions. Throughout much of my career, I was steeped in the view that little Africa American cultural patrimony existed. As I conceptualized the museum, I remembered moments that called that assumption into question. In the 1980s, I was searching for objects that would be the foundation of an exhibition that I was then curating, Black Angelenos: The Afro-American in Los Angeles 1850–1950, and to that end was advised to visit one of the doyennes of black Los Angeles. I entered her house, which was darkened to keep out the heat and dust that accompanied the Santa Ana winds that struck Southern Californian in the fall. After several cups of weak tea, I pressed her as to what material she had that could be of help. She said she had nothing of value. After many hours of conversation, to either placate me or get rid of me, she instructed me to look in the garage but, she said, "There is nothing in there." After rummaging through boxes with dust older than I was, I found a treasure trove of objects that became the core of my exhibition, including uniforms and identification cards from when this woman worked in the war industries plants during World War II and material that documented a boycott of businesses that did not hire African Americans from the 1920s. Recalling that experience helped me to recognize that there were collections not in museums that could be accessed and obtained. I came to believe that all of the twentieth century, most of the nineteenth century, and a bit of the eighteenth century still existed in the basements, trunks, and attics in people's homes. What we needed was a strategy to help us access these collections.

This raised a central question: did a twenty-first-century museum need to build a traditional collection? After all, the new technologies allowed

millions to view collections without ever leaving their homes. Was the challenge of acquiring and the cost of maintaining collections necessary? Should NMAAHC be driven by technology rather than artifacts? While I believed NMAAHC had to master and use technology in ways I would have never imagined earlier in my career, I thought the acquisition of collections was even more important, especially for a museum that was part of the Smithsonian galaxy. When visitors come to the Smithsonian, they appreciate the technology, but they come to see the Wright Flyer, the Ruby Slippers, the giant dinosaurs, or James Whistler's painting of the Peacock Room. Rarely does one come to the Smithsonian to see a film, unless it is *To Fly!*, which is the wonderfully clever orientation film crafted by the National Air and Space Museum to celebrate its opening in 1976. To be credible, I felt that NMAAHC needed to have collections that rivaled the traditional holdings of the Institution. As my curatorial staff soon discovered, this was a decade-long endeavor that would challenge our commitment and creativity.

What became the core activity that drove our collecting efforts was a multiyear, regional initiative entitled Save Our African American Treasures. This was an idea shaped by many influences. I struggled to sleep one evening in late 2007 and found myself viewing something on television I had never seen, *Antiques Roadshow*. As I watched people share their artifacts and stories, I remembered my tea-drinking visit in Los Angeles, and those two ideas led me to create this foundational program. The museum staff was still quite small in 2007, so any new idea or effort had to fulfill many needs. Most importantly, "Treasures" had to assist the museum in building its collections in a unique way. We framed this as a preservation initiative that helped families preserve their history through objects of meaning. Our hope was that this material would be saved, either by NMAAHC, a local museum, or by the families themselves. What I needed this program to do as well was to increase our visibility by giving the museum a new way to excite the media and increase the coverage we received. We knew these events where senior citizens or young adults interacted with curators and interesting collections made wonderful media moments that allowed the museum to reach many more people than could attend a program. With this coverage, we believed that the excitement generated by a Smithsonian visit would increase the number of people who might become donors of artifacts in the future. "Treasures" also enabled us to strengthen our relationships in Congress. Wherever we took the "Treasures" program, we alerted the senior member of Congress that we would be in their state or their district. The opportunity for a member of Congress to have a picture placed on the front page of the local newspaper standing

with a constituent, often African American, holding a piece of history was too seductive to ignore. These programs became a way NMAAHC demonstrated its value to Congress and garnered future support for the resources needed to craft a building and to develop a strong staff.

Solidifying the museum's collaborative relationships with regional museums was another important contribution made by this program. There was always a fear within the museum community that NMAAHC as a representative of the Smithsonian Institution would swoop into a region, and the loud sucking sound one soon heard was the museum vacuuming up collections and financial resources to the detriment of the local cultural institutions. Always cognizant of these concerns, I used the "Treasures" program to demonstrate how our presence enriched all the museums that we encountered. At each event, we positioned the local museums as equal partners in all the press announcements. And we provided each smaller museum with a presence at the event where they could display materials or advertise upcoming programs that would introduce new audiences to the wonders of the local institutions. Ultimately, I believed that NMAAHC had to give gifts to America to prove our worth. The "Treasures" program provided Americans the opportunity to preserve their cultural heritage and to learn how their stories connected with the larger currents of American history. We hoped that these programs generated goodwill by focusing on what we helped preserve as well as what we added to the museum's collections.

From January 2008 until November 2014, the museum partnered with local museums and educational entities to host thirteen Save Our African American Treasures programs in communities as diverse as the Mississippi Delta, Dallas, Detroit, Brooklyn, Jacksonville, Topeka, Saint Helena Island, and Washington, DC. As I thought about how and where to launch the initiative, I turned once again to my time in Chicago. I needed a venue that a diverse audience would feel comfortable attending and one that was centrally located or easily accessible. So I contacted an old friend, Mary Dempsey, at that time the Library Commissioner for the City of Chicago, for permission to hold our inaugural gathering in the Harold Washington Library Center, named for the first African American mayor in Chicago. Thereafter, every one of the remaining twelve programs followed the format we used in Chicago. There would be a series of workshops focused on preservation: how does one preserve textiles or photographs, for example. We also had an introductory class on collecting and preserving family histories. We consistently conducted interviews with residents to gather more intimate details about the region that hosted the event.

The centerpiece of the program was what I called "bring out your stuff," an activity geared to preserving collections for future generations. Unlike *Antiques Roadshow*, our program did not discuss monetary worth but focused on an object's historical or cultural value. An individual would bring an object, a photograph, a union button, a tool, or a document and he or she would be seated with a curator and a specialist in conservation or preservation. After discussing what the object illuminated about history or community, a conservator would assess the condition of the artifact. The conservator would then create an archival box to preserve the object or a cradle to limit stress on the binding of a family bible, for example. All of this object-specific preservation work was free—the museum's way to thank the public for supporting the eventual birth of NMAAHC.

On that January day in Chicago, the staff worried that the weather, a tad chilly (five degrees below zero with a significant wind chill factor), would affect attendance. I knew that Chicagoans would not let weather stop them from coming, but I was worried as well. This was the kickoff of a program that was untried by the Smithsonian. It had been costly to bring so many historians, curators, collection specialists, and conservators to Chicago. And now the weather was not cooperating. I could not afford to have this program fail. I had worried needlessly. By the time we opened the doors at 10 a.m., there were already 100 people braving the cold to share their histories with the museum. The day was a wonderful success, with the public gaining new knowledge about the history and the preservation needs of the objects they had brought. And the staff of the Smithsonian was energized to see the concrete impact of their work and their expertise.

Two objects stand out from that Chicago event. One was a pin with the image of Madam C. J. Walker, an entrepreneur whose work in black women's hair care products revolutionized an industry and made her one of America's few black women millionaires; pins like this one had been given to women who comprised her sales force. The other object was a white hat worn by a supervising Pullman porter, black men who catered to the needs of white travelers who journeyed across the nation in sleeper cars. This porter hat spoke volumes about the work ethic of the porters and status within the African American community that countered the stereotypical images of black porters that were common in the early twentieth century. Both the pin and the hat quickly became part of the museum's collections.

While each "Treasures" program had memorable moments—from members of our staff trying to flee Atlanta before a paralyzing snowstorm

trapped them in the city; to families in Topeka, Kansas, sharing the threats and the price paid as a result of the struggle to integrate America's schools; to the grace and visibility that the former First Lady Laura Bush brought to the program in Dallas, Texas, in June 2011—my memory brings me back to a series of "Treasures" programs held in Charleston and on Saint Helena Island, South Carolina, in May 2009. We began the event with a wonderful address by Congressman James Clyburn, whose love of history and whose knowledge about black Charleston set a tone of enthusiastic discovery. Hundreds of people attended bringing wonderful objects for review. Congressman Clyburn and I were held in rapt attention by a man who used the head of a plow that he brought to the program as a means to educate his grandson, and all who could hear him, about the rhythm of preparing the ground for seed, planting, and harvesting cotton as well as the struggle for sharecroppers to do more than eke out a living. This is why the work of museums like ours is so important. It is not only about the opportunity to remember but also to educate and inspire future generations like his grandson. Of course, it was helpful that the local paper, the *Charleston Post and Courier* carried a picture of the grandfather with the congressman. It never hurt to have friends in Congress.

It was unusual for this program to do back-to-back site visits, but the next day we traveled to the Sea Island of Saint Helena in the heart of Gullah country. Until recently, the isolation of the Sea Islands ensured the protection of its unique Gullah language and culture. That day we were pleased by the number of oral histories that unpacked the rituals and customs of those whose enslaved ancestors shaped the cultivation of rice. One woman in her seventies brought a quilt and spoke powerfully about how each square represented someone from her family who was now deceased. Creating the quilt was her way to honor her ancestors. We cried when she gently held the quilt and made clear that as long as the quilt existed her forebears would never be forgotten. It was such an honor to create an archival box for her to house that real treasure.

I cannot quantify the impact of the "Treasures" program on the public, but I am sure that the goodwill generated by our efforts led to support and excitement about the museum. Each program brought a few important objects into the museum's collection. Its greater impact was the media attention it generated, which ensured that each major acquisition received local, if not national, attention. This visibility then stimulated other contacts that led to donations that enlarged the collections and made the museum real in

the eyes of many. By the end of a decade, the museum went from not having a single artifact to having more than 35,000. Thanks to the work of a thoughtful and tireless curatorial and collections staff, 70 percent of the museum holdings came from the basements, garages, and attics, from the homes of a diverse array of Americans who trusted the Smithsonian brand and soon came to trust the National Museum of African American History and Culture.

While the museum succeeded in acquiring the "stuff of history," there were also a few disappointments. For two years, I had been speaking with representatives of Motown to gather collections that would allow the museum to explore the musical and marketing brilliance that emanated from a small house on West Grand Boulevard in Detroit. Music, as the record label's slogan once proclaimed, that was the "sound of young America." After several trips to Detroit, I flew to Los Angeles to meet with the founder and the force behind the success of Motown, Berry Gordy. I was to meet Mr. Gordy at his estate in Bel Air.

As I slowly made my way up the steep but beautiful hillside above West Los Angeles, all I could think about was how important the music of Motown was to a black child growing up in an Italian neighborhood in New Jersey. Ironically, the music from Detroit was one of the few things that transcended race and allowed many in my small town to find common ground, if for only as long as the record played. Years later, I attended a conference in Detroit and somehow four historians were able to enter the Motown Museum after hours. Having the space to ourselves, four relatively senior academics—Clement Price, Giles Wright, Spencer Crew, and myself—became teenagers all over again as we stepped into the room where so much of the music was recorded: for an hour, rather than discussing the impact of Frederick Douglass or the role of African American migration in the shaping of urban America, we became off-key versions of the Temptations, the Four Tops, Marvin Gaye, the Miracles, and even Martha Reeves and the Vandellas.

With a sense of awe, respect, and excitement, I knocked on Berry Gordy's door. I was greeted by the sounds of Motown. Everywhere in his home there were videotapes of Motown artists performing throughout the country and the world. As I tried to decide on which performance I should focus on, a small man wearing expensive pajamas joined me. For the next five hours, Berry Gordy regaled me with stories of the music, the performers, and the business. He spoke about instilling discipline in the performers and his own lack of understanding about the innovation of Marvin Gaye's important 1971 album, *What's Going On*, which brought issues of war and

environmentalism to the black record-buying public. We then discussed the state of the Motown Museum and its collections. Every time I tried to bring up a donation to NMAAHC Gordy deftly returned to the subject of music. Suddenly the music went silent. It was time for me to leave. Driving back to the airport, I realized I would have great memories of my day with Berry Gordy—but no collections for the museum.

Another near miss was due to our own confusion and miscommunication. There is a wonderfully generous collector named Tom Liljenquist whose collections focused on nineteenth-century photography and slavery-related documents. Liljenquist's holdings of Civil War–era material is highly prized. He approached the museum's curatorial staff with the offer to donate nearly one hundred military-related images. This included a rarely seen one of a black Civil War soldier sitting for a portrait with his family. His wife's dress reflects middle-class aspirations and their two daughters are wearing matching dresses and bonnets. The soldier has his arm around one of his daughters, embracing her. I have never seen any other image that could match the beauty and poignancy of that photograph. That portrait was offered to us as part of a collection with numerous other images of white soldiers. A curatorial decision was made to reject the acquisition because most of the images were not of African American soldiers. When I found out about the decision, it was too late. The collection was donated to the Library of Congress, where that haunting photograph is prominently displayed as one of the jewels of the Library. I am still angry over that missed opportunity.

Fortunately, missteps such as that with the Liljenquist collection have been rare. And the generosity of the American people to share their families with the museum has led to some very significant acquisitions: for one, the gift from the family of Joseph Trammell. Born enslaved in northern Virginia, Trammell gained his freedom at least by 1852. He was given a document, his freedom papers, to prove that he was now a free man of color. Trammell realized that his liberty and that of his family were dependent upon that document. Fearful that the paper would be lost or destroyed by perspiration as he labored, Trammell made what he called a handmade tin wallet to protect the paper, to protect his freedom. According to the family, most evenings Trammell would free the paper from the wallet and discuss the importance of freedom. The family kept the paper and the wallet for nearly five generations and then deeded it to the museum.

Or the kindness of the opera mezzo-soprano Denyce Graves. Ms. Graves befriended the pioneering performer Marian Anderson. Ms. Anderson integrated many of the operatic stages in America, but one of her finest and most

important moments was on Easter Sunday, 1939. Ms. Anderson had been denied the opportunity to perform because of her race at Constitution Hall, then under the control of the Daughters of the American Revolution. When this affront was brought to the First Lady at the time, Eleanor Roosevelt, she resigned her membership in the DAR and facilitated the opportunity for Ms. Anderson to perform from the Lincoln Memorial on Easter morning. The dress she wore that morning was eventually given to Ms. Graves, who recognized the importance of having the public remember the courage and the creativity of Ms. Anderson by donating the dress to NMAAHC. This dress helped the museum expand the story of that morning. All of the photographs and motion-picture footage of that performance are in black and white. When I watch that footage, I wonder how Marian Anderson contained her nervousness, until I see the actual dress. It makes a bold statement—in bright orange and blue. This is the costume of a diva, not someone intimidated by the moment. Obtaining that object and making it accessible to millions of visitors broadened the interpretation and the impact of that performance.

I was so moved by the actions of Gina McVey. After learning of our search for collections through the media, she traveled to my office from the West Coast to share some items from her grandfather, Lawrence McVey. Like so many people who I encountered during this more than decade-long journey, Ms. McVey knew that her family had a story but needed the validation that came with an acknowledgment by NMAAHC. More importantly, so many wanted to contribute to the birth of the museum in ways beyond providing financial support. Sharing their artifacts not only helped the museum build its collections but also helped families value the bits of their own history tucked in closets or hidden in attics. When Gina McVey entered my office, she literally emptied a bag of articles that she had been told by family was from her grandfather's military career, but she knew little more than that. As I explored the photographs and documents, I saw that her grandfather was a member of the 369th Infantry Regiment known as the "Harlem Hellfighters." This was an all black unit, with the exception of white officers, that fought valiantly during the First World War. Initially scorned by the American military establishment, they were placed under French command. Despite the bigotry they faced, they performed so well that they were awarded the highest unit citation in the French army, the Croix de Guerre. There, in the pile on my desk was his medal. She immediately offered to donate the objects to the museum.

One of the most generous and essential donations was made by Joyce Bailey in honor of her mother, Lois K. Alexander, who had dedicated her life

to the study and preservation of black fashion. Ms. Alexander founded the Black Fashion Museum, initially in Harlem, and later relocated to Washington, DC. While much of the collection focused on talented African American designers like Ann Lowe and Peter Davy, the diversity of the additional material is what makes this collection, and its gift to NMAAHC, so extraordinary. This acquisition includes a dress sewn by Rosa Parks that she was carrying when she was arrested in Montgomery, Alabama, in 1954; costumes designed by Geoffrey Holder from the Tony Award–winning musical, *The Wiz*; dresses worn and created by enslaved women; and costumes from television shows like *Julia*, which featured Diahann Carroll as one of the first black women in a nonstereotypical role. The richness of this collection would eventually help the museum develop exhibitions that explored slavery, film, television, theatre, style, and cultural identity. This collection meant so much because it was foundational for the museum. With nearly one thousand objects, it was the first major acquisition for NMAAHC when Joyce Bailey donated it in 2007. For several years after that, I would encounter Ms. Bailey and she would always thank me, often with tears, because the museum kept her mother's legacy alive. It was I who should always thank her.

I have always been grateful as well to Juan Garza, a self-described "Afro-Ecuadorian," who contributed the very first object in the museum's collection. During my first year as director, I was commuting back to Chicago on weekends, which meant during the week I was lonely, so I spent too many hours in the office. One night I received a call at 8 p.m. from a recent acquaintance who worked in Latin America. He asked me if I might be interested in meeting Juan, a folklorist whose work studying the impact of the African diaspora on Ecuador was original and controversial. Like several countries in South America, Ecuador struggled to reveal the hidden history of racism within its nation. Juan's work illuminated moments that many would rather forget.

By the time Juan arrived, it was nearly 11 p.m. and I hoped for just a brief meeting. But he was fascinating as he told the story of his community and explained the challenges of being an academic of color in Latin America. He shared how many of the formerly enslaved fled to swampy areas for freedom far away from the gaze and grasp of white slave owners. He then unwrapped a large package revealing a wooden object unfamiliar to me. As a result of location, many Afro-Ecuadorians traveled the waterways by canoe. It was the role of elderly women to make the canoe seats. The seat in front of me had been carved by his grandmother. My interest increased when I noticed the carving on the seat. It was the symbol of the West

African trickster, Anansi the Spider. This object immediately broadened the museum's global scope: here was a piece shaped by blacks in Ecuador that retained its ties with Africa. How wonderfully appropriate for a museum that sought to frame much of its work and many of its future exhibitions using an international perspective that would help all who encounter the museum understand that this country has always been shaped by forces and factors outside its borders.

This began a fruitful relationship with Juan who would email encouragement to me several times a year. Unfortunately, Juan died before he could see the boat seat in a museum installation. Yet his story, as told through the canoe seat, is central to the interpretation of the influences on African America culture. As difficult and unpleasant as I found commuting to be, nights such as the encounter with Juan Garza almost made up for the loneliness of the life of a commuter.

One of the most difficult challenges of collection building was obtaining high-quality African American art. Working with Kinshasha Holman Conwill and Jackie Serwer, both experts in black artistic expression, we determined to take seriously the museum's name and explore the role and impact of culture. I wanted the museum to provide a sweep of African American art that would introduce the visitors to the wonders of artists such as Henry O. Tanner, Richard Hunt, Augusta Savage, and Romare Bearden within the walls of a history museum. In essence, we hoped that our art holdings would be enriched by the framing and contextualization that is the work of a museum of history. The costs of building such a collection seemed so great that I came close to abandoning our interest in developing such an important visual arts collection. We did not have the kind of resources to purchase all the art we needed and much of the work is already in the hands of collectors and museums. Kinshasha, Jackie, and later Tuliza Fleming, the curator of African American art at NMAAHC, developed a strategy of courting donors. Unlike many who acquired non-African American art, those whose holdings are ripe with black art are often recent collectors who are unlikely to give their entire collections to NMAAHC. So, the strategy was to ask potential donors not for their entire collection but just for a few pieces that would be the foundation of the museum's art collection.

While this process did prove useful, it did not sway as many collectors as we had hoped. That is, until Robert Johnson responded to our pleas. As mentioned earlier, Johnson was the co-founder of Black Entertainment Television (BET) and an active member of the museum's Advisory Council.

Johnson was also the owner of one of the most significant holdings of black art: the Barnett-Aden Collection. These artworks represented some of the most important African American artists working during the last two centuries. Johnson deeded five very significant pieces to the museum: the iconic *Head of a Negro Woman* (1946) by Elizabeth Catlett; an important painting by Henry O. Tanner, *Flight into Egypt* (1916); an unappreciated work *Self-Portrait* (1941) by Frederick C. Flemister; a pivotal Romare Bearden, *A Walk in Paradise Gardens* (1955); and *The Argument* (1940) by the almost impossible to collect Archibald Motley. Johnson's generosity influenced many other owners of black art to add to our growing collections. The additions from Johnson's collection not only enriched the museum, but they also gave NMAAHC credibility by marking us an important institution with a worthy art collection.

To be a credible institution meant having collections that were worthy of the rich history and culture that we sought to interpret. I began to develop a list of objects or subject matter that we needed to collect if we were to be an institution that educates and matters. It was important that the museum collect items that illuminate the role of African Americans in the military and in sport, but these were secondary to the need to find material that illuminated the experience of slavery and the slave trade. It was also essential that the museum house objects that depict iconic moments or individuals in popular culture and music.

To me, slavery had to be a priority. As we performed our initial audience research, we discovered a telling dichotomy. To some, understanding slavery was the most important contribution this museum could make. Yet, to an equal number, the last aspect of history they wanted to engage was slavery. I felt that with such a passionate divide, we had an opportunity—and an obligation—to help the public grapple with slavery.

I was struck by the brilliant new scholarship, like that of Sowande' M. Mustakeem and Stephanie E. Smallwood, on the slave trade and on the vessels and individuals involved in this barbaric yet fundamentally transformative enterprise that shaped the modern world. I realized that most of our audiences would have a very limited understanding of how essential the slave trade was in the making of modern Europe, Africa, and the New World. I decided that the museum needed to collect pieces of a slave vessel. I never liked the notion of re-creating slave ships. It always felt fake and reduced the involvement of the enslaved into a Disneyesque experience. I just wanted a few relic-like pieces treated like religious icons that could make the trade

concrete yet allow the visitor to feel the spirits and imagine the lives of those affected by the wholesale forced movement of millions of Africans.

So how hard could it be to find remnants of a ship? There had been hundreds involved in the slave trade. Hard, in a word. It would take us years and thousands of miles of travel to answer that question and to find artifacts that would recall the process and the pain of the trade. I called museums, maritime sites, ministries of culture, and numerous scholars. No one had an easy solution. So—we created one. Under the leadership of Paul Gardullo, one of the curators at NMAAHC, we developed a partnership with a small endeavor housed at George Washington University in Washington, the Slave Wrecks Project, which was the brain child of Professor Steve Lubkemann. Together we began the search for slave wrecks. Part of what made this search so difficult was that while the field of maritime archaeology has grown since the 1960s, the focus of study rarely included slave wrecks, which did not hold out the hope of sunken treasure like those carried by Spanish galleons or the cache of vessels like the *Titanic*.

We were initially focused on the wreck of the *Enrique*, a vessel that had left Bristol, Rhode Island, in the eighteenth century bound for the Cape Coast Slave Castle in Ghana. The *Enrique* departed Ghana with 144 Africans, many bound for an American-owned plantation in Cuba. As the ship neared the Cuban coast, it was confronted by British warships. Attempting to flee, the *Enrique* foundered and sank with considerable loss of life in Matanzas Bay, which is east of Havana in the black belt of Cuba. Discovering and saving remnants of this vessel would be a major contribution not only to the museum but also to the field of maritime archaeology. There had never been a wreck of a slave ship discovered that was on a voyage actually carrying a cargo of the enslaved. I felt that a discovery of this sort would enrich our understanding of the slave trade. After all, scholars have mined so many sources, but the evidence under the seas was still elusive. The appeal of the *Enrique* was that it was American owned and headed to an American plantation. Salvaging this relic would provide a dramatic lens to introduce Americans to a history of their own that is little known.

For more than two years, beginning in 2012, we negotiated with the myriad of agencies, offices, and associations in Havana and Matanzas. We met with the minister of culture and the head of underwater archaeology. I dined with the city historian of Havana and met with museum directors throughout the country. I visited a gifted painter, Manuel Mendive, whose artistic creativity captured the spirit of slavery and the slave trade better than any work of history published. And I traveled to plantation settings and

Santería (an Afro-Cuban religion that combines elements of the beliefs of the Yoruba people and Catholicism) sites to understand better the continuing influence of Africa on the Cuban people. I was enamored with Cuba: its fading colonial buildings, the music coming from every corner and cantina, and the uncertainty of a post-Castro world. I was not enamored with the bureaucracy. While we would continue to work in Cuba, I knew that we needed to broaden our search if I was to find what I needed in time for the opening of the museum.

The deadline of opening brought renewed pressure on our search for a slave ship. Fortunately, we learned of research that was being done by Jaco Boshoff and a team of maritime archaeologists working at the Iziko South African Museum in Cape Town. Ironically, I had deep ties to South Africa. I had begun working with South Africans prior to the end of apartheid in 1990. In fact, Dr. Boshoff reminded me that he heard me lecture in 1991 about the need for South African museums to prepare for the dramatic changes that would be needed to support the new South Africa. This country was more to me than a place to lecture. The struggle against apartheid and South Africa's commitment to finding reconciliation and healing changed my work. The revolution in South Africa reinforced my belief that history is an effective tool to change a country by embracing the truth of a painful past. South Africa educated me to a new world of possibilities. So I was anxious to renew old acquaintances, especially if this work allowed me to tell the story of the slave trade. With the additional support, both financial and scholarly, that NMAAHC could bring to the project, we embarked on the discovery and retrieval of a Portuguese slaver, the *São José Paquete Africa*.

The *São José* left Lisbon in 1794 initially for the section of West Africa called the "slave coast" by Europeans. Running afoul of British warships that sought to limit the access of other nations to the lucrative trade, the *São José* headed to Mozambique, where it landed to take on board 512 Africans, mainly from the Makhuwa tribe to be sold into slavery in Brazil. As the vessel rounded the Cape of Storms, now Cape of Good Hope, in December 1794, the weather worsened, causing the *São José* to run aground and sink among the rocks three hundred feet from the shore in Camps Bay. Nearly half of the enslaved perished and those that survived were quickly sold in Cape Town a few days later. After months of research followed by weeks of diving, the wreck of the *São José* had been discovered scattered along a wide swath of sand bars. Those lost were now remembered: and a ship that sank with an enslaved cargo was unearthed for the first time.

Once I was certain that we had, in fact, found the *São José*, I shared the news in 2015 with Nicole Young, a senior producer, and Scott Pelley of the CBS News magazine *60 Minutes*. It was hard for me to believe, but I then learned that *60 Minutes* had taken a great interest in the museum and in me. I received a call in 2013 from Ms. Young saying that they were working on a piece on the role of the enslaved in the building of the US Capitol and could they interview me about this history. I agreed but was quite shaken. Me on *60 Minutes*? The interview went well. Afterwards I shared the story of the development of the museum and it piqued their interest. A year later, *60 Minutes* did a major profile on the museum, creating increased visibility and excitement that helped the museum's credibility and fundraising efforts. So, when they called again, I was pleased that they wanted to follow our work on the *São José*. As a result of the notoriety from appearing on such a landmark program, a DC journalist made the remark that "Lonnie Bunch must be the only person in Washington who does not fear a call from *60 Minutes*."

I alerted *60 Minutes* that I planned to go to Mozambique to meet with and pay my respects to the Makhuwan descendants of those who were lost on the *São José*. The crew from CBS felt that this was such an important story that they would accompany me to East Africa. I had never before traveled to that region and I was eager to see the country. After landing, the team— Curator Paul Gardullo, Project Manager Carlos Bustamante, Senior Public Affairs staffer Fleur Paysour, and myself—checked into our accommodations on Mozambique Island. Clearly the wealth of the slave trade had built this paradise of wonderful eighteenth- and nineteenth-century buildings surpassed only by the beauty of the beaches. We stayed at a guesthouse that was functional but had seen better days. My room was "malaria proof," with large mosquito nets draped over the bed. Unfortunately, the door was only half size, so the swarms of mosquitos had a direct way in and clear path to me.

One of the more poignant moments occurred when I was asked to speak at the Slavery Memorial Garden on the island. Like so many nations, Mozambique is struggling to find the appropriate way to remember the impact of the slave trade. This small garden, located near a site where vessels involved in the trade were berthed, had a circular path that led to the water. After greetings from the US Ambassador Douglas Griffiths, I spoke about the emotions I felt being immersed in a community shaped by the slave trade. Though I had no personal or family ties with this island, being there forced me to wrestle with my own enslaved ancestors as I tried to understand the pain of my forebears and how incongruous it was for

me to lead this endeavor. We then took roses and tossed them into the water in remembrance of all those stolen from Africa. The event concluded with women from a local tribe performing a series of beautiful dances. I felt the warm embrace of an Africa that was little known to me. This euphoria was interrupted when a local scholar explained that the dances were initially designed and performed to curry favor or to cement alliances with the Portuguese slavers to ensure that those Africans taken to the New World were not stolen from their tribe. Both the complexity and ambiguity of slavery were never more apparent to me than at this moment.

The next day, we drove off the island to the mainland where I would meet the Makhuwa people. On arriving, the first thing I noticed was a large ramp that angled steeply down to the water, called the ramp of no return. As I walked down the ramp, I tried to imagine what the enslaved experienced. It was hard for me to keep my balance, and my legs were free of shackles. Looking down the ramp, you saw the beauty of Mozambique Island with its turquoise waters, paradise, except the enslaved were leaving behind everyone and everything they knew. As I escaped the ramp, one of the tribal chieftains introduced a young woman in the early thirties. She thanked me for coming because one of her ancestors was on board the *São José* and was one of those who perished. I began to cry when she explained that they think of him daily and that he is a permanent presence in her life.

Then the chief said that he had a "gift" for me. Though I was unsettled by his attire—all the chiefs dressed like generals in the Portuguese army—he handed me a white bowl-like vessel that was encrusted with cowrie shells. As I opened his gift, I was confused. The container was filled with soil. Addressing the gathering, he said that his ancestors have asked for my help. The ancestors wanted me to take the soil back to Cape Town and sprinkle it over the site of the wreck of the *São José* so that his "people can sleep in their homeland for the first time since 1794." I was overwhelmed by the responsibility. I knew I would fulfill his request.

The word ancestors had taken on important meaning to me after I accepted the position as director of NMAAHC. Before 2005, I never mentioned ancestors. I never viewed my ancestors as an integral part of my life. Once I returned to Washington to lead this museum endeavor, respecting and acknowledging my ancestors become a key part of my day. I realized that NMAAHC would become such a part of who I am that the ancestors I mentioned were not disconnected but a part of my family, my history. The first time, I mentioned ancestors was when a reporter asked me in 2005 how I define success. Rather than pointing towards a completed building or

This shell-covered basket, given to Lonnie G. Bunch III by the chief of the Makhuwa people, held soil that was sprinkled into the waters off South Africa over the sunken slave ship, *São José*, to commemorate those lost on board in 1794. **COLLECTION OF THE SMITHSONIAN NATIONAL MUSEUM OF AFRICAN AMERICAN HISTORY AND CULTURE**

educationally rich exhibitions, I simply stated that success was making the ancestors smile. I have no idea why I uttered those words. However, when the chief asked me to honor his ancestors by sprinkling the soil over the wreck, I understood in a deeply spiritual way.

The return to Mozambique Island was either by boat or by Land Rover. As I watched sailboats struggle to reach the island due to the direction and strength of the wind, I knew that the boats would have a difficult time navigating the currents, so I went by land. The rest of the SI team took the boats. Hours after I arrived back, the team still had not returned. Finally, nearly six hours later, they appeared. They were limping and disheveled. It seemed that the wind had prevented the boats from docking on the pier. At some

point, it was determined that they needed to jump in the water and wade to shore, but when they jumped they landed in a field of sea urchins whose sharp spikes injured several of my colleagues. I spent the rest of the evening searching for the only doctor on the island and attending to everyone's wounds. After this, we were glad to return to Cape Town.

Coming back to Cape Town also gave us a chance to share the success of the collaboration with the Iziko Museum that led to the verification, exploration, and ultimate retrieval of artifacts and to fulfill the request of the chief of the Makhuwa tribe. The site of the wreckage of the *São José* was near what was now an elite reserve in Cape Town called Camps Bay. We were fortunate that one of my personal heroes, Judge Albie Sachs, lived in the enclave and hosted the ceremony to honor those lost in that 1794 tragedy. Judge Sachs, a contemporary and colleague of Nelson Mandela in the fight against apartheid who led the drafting of the new South African Constitution, also had ties to Mozambique where, while in exile, he was severely wounded in an assassination attempt by the apartheid regime.

The weather on the morning of the ceremony was horrendous. Torrential rains and gale-force winds meant that Judge Sachs's home was inundated with wet and cold scholars, diplomats, camera crews from *60 Minutes*, and museum officials. We wondered if the weather was similar to what the *São José* had experienced. You could see how the strength of the wind could force a vessel onto the rocky coast. We had planned to have a boat take three divers to the wreckage, but the seas were too rough. After a round of speeches, I decided that the three divers, two women and one man representing, America, Mozambique, and South Africa, should swim out to the site, if possible. Once the divers neared the ship, they took turns scattering the soil over the water. And as soon as it had disappeared into the sea, the rain stopped and the sun shone brightly. This is no exaggeration, it was as if the ancestors smiled and the weather dramatically changed. I immediately thought, never mess with the ancestors.

⸻

We returned to Judge Sachs's home, where a poet who was descended from South Africans once held in bondage, Diana Ferrus, read a poem in Afrikaans and English that captured the mood of the day and enriched all of our spirits. Most of those enslaved in South Africa were given a last name based on their birth month. For example, Judge Sachs's wife

was named Vanessa September. Diana's poem was entitled "My Name Is February":

My Name Is February

Auctioned, sold, the highest bidder, disposed of my real name,
 paid no compensation for that,
My name stolen, sunk underwater it still lies with the family and
 the wreck of the *São José*.

Witnessing Diana alternatively read in English and Afrikaans the poem in its entirety was life changing and life affirming. There was no better way to honor and remember the millions lost and the millions whose lives were transformed in a strange new world.

Finding relics from the *São José* was the goal of my journey, but I discovered so much more about Mozambique, about slavery in South Africa, about maritime archaeology, and about myself. I knew that relics from the ship such as wood from the hold that we would eventually display was not an inanimate object, but a touchstone to give meaning and humanity to the subject of slavery. It would serve as a totem that would prod Americans to replace the silences that we find so comforting with conversations, though difficult, that could lead to reconciliation and healing. I was humbled when shortly after my return home I was sent an editorial that had appeared in the *Boston Globe* that recognized the value of this work. "Bunch . . . hunted for years for a wreck to creative an 'evocative space' to remember the nameless people who died in the Middle Passage. In finding one, Bunch might move America closer to its own passage of acknowledgment, apology, and amends."

As the work of building the collections garnered more media attention, the pace of acquiring significant material quickened, in part due to a generosity and an interest in sharing stories that were little told. For example, thanks to the work of two of my colleagues, curators Nancy Bercaw and Mary Elliott, the museum obtained another object ripe with meaning and symbolic value, a slave cabin from the Point of Pines Plantation on Edisto Island, South Carolina. Collecting this structure enabled Nancy and Mary to engage the current residents in a manner that encouraged conversation across racial lines about slavery and its continuing impact on the island. Or, this one: after seeing the response to the performance of many of their songs at a summer Folklife Festival, the record producers responsible for the "soulful sounds of Philly" in the 1960s and 1970s, Kenny Gamble and Leon

Huff, donated instruments and a carpet-covered door used to soundproof their studio to the museum. Or, the donation by Bank of America, facilitated by CEO Brian Moynihan, an active member of the NMAAHC Council, of photographs taken by Jeanne Moutoussamy-Ashe that capture the vanishing Gullah culture on Daufuskie Island, South Carolina. The acquisition of collections tapped into diverse sources that affirmed that the museum was becoming more visible and more appealing whether to individuals, communities, or corporate entities.

Another essential artifact was obtained when a media story mentioned my interest in exploring the history of the Pullman porters who serviced white travelers during the golden era of train travel in the first half of the twentieth century. During my tenure as Associate Director for Curatorial Affairs at the National Museum of American History, I was acquainted with Pete Claussen who was a member of the museum's board of directors. Pete and I became friends when we discovered we both grew up in Essex County, New Jersey. Claussen heard of my interest and phoned me from his home in Knoxville, Tennessee. The founder and CEO of Gulf & Ohio Railways, Claussen did not know of any Pullman cars available, but he owned a segregated railcar from Southern Railway, and was I interested? I immediately flew to Knoxville and then Pete and I traveled to Chattanooga to view the car. It stood abandoned and rusting in a side yard, and I was not at all sure this was the object the museum needed. Then Pete and I entered the car. I saw how the section for whites was roomier, with storage and large bathrooms, while the "colored" side was smaller and much more modest. I now wanted that car because it would tell the story of segregation in a way that pictures and label copy could not. Of course, the issue of moving it, restoring the interior and exterior, and installing it in the museum would challenge the staff for the next few years, but I knew we needed this car. Thankfully, Claussen actually owned the car, and he donated it to the museum. Not only did he transfer ownership to us, but he also supported both the restoration and interpretation of his extraordinary gift.

While every acquisition enriched our holdings and expanded our ability to craft a museum full of stories and collections that engaged and mattered, there were several that either surprised me or brought me great personal meaning. In 2009, at the invitation of George McDaniel, a dear friend and a gifted public historian, I had agreed to provide remarks at the dedication of the slave cemetery at the Drayton Hall plantation outside of Charleston, South Carolina. At the conclusion of the ceremony, I was approached by

an archaeologist who wondered if I might be interested in material pertaining to Nat Turner, the enslaved preacher who led an insurrection in Southampton County, Virginia, in 1831. Candidly, I thought to myself that there could not possibly be anything of value relating to Turner or the insurrection that was left to be discovered. I politely declined and went back to Washington.

He was so persistent, though, that I ended up asking the Associate Director for Curatorial Affairs at NMAAHC Rex Ellis to accompany me to the town formerly known as Jerusalem. I must admit, I was surprised and touched as we toured several sites and structures associated with Turner. We visited the location of one of the farm houses that Turner attacked. The house was crumbling and covered with vines but still standing in a field where the current owner of the land recognized the historical value of the home and carefully avoided the structure as he plowed his fields. We learned that during the insurrection the owner of the house had hidden inside the chimney, so I thought the best we could do was to gather bricks from the site of one of Turner's battles. But there was no way that a kid from North Jersey was going into what I knew was a snake-infested building. While I was comfortable dealing with two-legged snakes, I was not going into that house. Luckily, Rex Ellis, a son of the rural South, braved the undergrowth and collected two bricks for the museum—the only objects I thought we would ever obtain that were associated with Nat Turner.

We then drove to the county courthouse and were apprised that when Turner was captured he had in his possession a sword, which we saw in the courthouse archives, and a Bible that may have been lost to history. Before we left Southampton County, we stopped along Negro Head Road. Some saw this name as a recognition of the black presence in the county, but we realized that this was the road where the heads of those executed for participating in the insurrection were placed as a warning against future attempts to escape bondage. We said a prayer and then returned to Washington.

In the following weeks, both Rex Ellis and I discussed our trip with the media, which led to a call from a member of the Francis family. This family of slaveowners had owned a plantation in the path of Turner's rebellion,

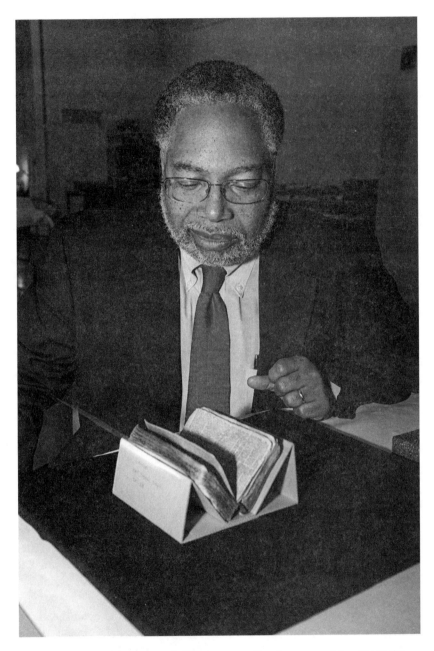

Lonnie G. Bunch III with Nat Turner's Bible, an astounding discovery and donation to the museum, made by Wendy Porter in 2011. **PHOTOGRAPH BY MICHAEL BARNES/SMITHSONIAN INSTITUTION**

and a number of them were killed during the insurrection. Learning of our interest in Turner, Maurice Person, a descendent of the Francis clan, and his stepdaughter, Wendy Porter, decided to donate Nat Turner's Bible to the museum. The sword stayed in the possession of the county, but the Bible was given to the Francis family since many of their members were killed during the revolt.

———•———

Once we investigated the Bible to determine its authenticity, both by testing for the age of the paper and examining archival and photographic records, I was elated to have something as important as Turner's Bible. Even though I have collected many artifacts during my career, I was excited and in awe of Turner's Bible. To hold this object in my hands, though they were encased in white gloves, connected me to a history long ago. It was through reading Revelations in this Bible that Turner decided that he had to strike for his freedom. I could not have imagined that the museum would ever have secured such a crucial artifact. It was a constant surprise to discover what historical material still survived and to experience the degree of trust so many had in the museum to preserve America's cultural history.

In August 2009, the museum received an object that meant so much to me, that became one of the most sacred artifacts in the museum's collections: the casket in which Emmett Till was buried. The murder of Emmett Till shocked a nation and revitalized the burgeoning Civil Rights Movement. Yet that happened only because of the courage of Emmett's mother, Mamie Till Mobley, who insisted that Emmett's casket remain open so the world could see what was done to her son. Her actions prevented Emmett's death from being unacknowledged or forgotten like so many other murders and violence acts that were seemingly part of everyday life in the Jim Crow South. When the Justice Department reopened the investigation into the case in 2005, Emmett was disinterred and then reburied in another casket. The original casket was to be placed in storage in the Burr Oak Cemetery in Alsip, Illinois, where Emmett's remains were first interred. As part of an unfolding scandal at the cemetery, the original casket was discovered unceremoniously stored in a shed where raccoons nested and where the casket deteriorated. When I learned of the family's anguish at this situation, I called Emmett's cousin, Simeon Wright, to express my concern.

As a result of our conversation, the family wondered if the museum would accept and care for this precious object. I must admit that I was quite torn by this offer. Should the museum collect a casket? Was this too ghoulish? I never wanted to exoticize the African American past and would this be an artifact where morbid curiosity would outweigh any educational or historical value? I called together the senior staff to discuss my concerns. After a robust and candid conversation where strong feelings against accepting the donation were expressed, I decided that we would honor Emmett Till and especially his mother and my friend, Mamie Till Mobley, by accepting the casket. At that stage, I was not sure if or how we would display it, but I wanted to make sure this history would be preserved. Once I decided to move forward with the donation, we needed to determine how we would stabilize, refurbish, and store the casket? And what kind of ceremony should acknowledge this important acquisition?

Whatever we would do with the casket, I did not want to have the object disrespected in any way. I had a special storage unit built with very limited access to prevent gawkers from taking selfies that would appear on the internet. I decided that we should have a ceremony in Chicago that would mark this moment and allow the museum to honor Mamie Till Mobley. Fifty-four years after the murder and the funeral of Emmett Till, we had a ceremony at the site of the service, Roberts Temple Church of God in Christ on State Street on the South Side of Chicago. With a chorus comprised of many of the people who had sung at the original memorial as members of the children's choir, we had a ceremony both sad and joyous. Sad as we remembered the pain and the death, but joyous as we celebrated Mamie Till Mobley's courage and the changed Civil Rights landscape galvanized, in part, by Emmett's death. After hearing from Simeon Wright, a cousin of Emmett's who was in the room when Emmett was kidnapped, and Linda Johnson Rice, the daughter of John Johnson, who courageously published photographs of Emmett's broken body in *Jet* magazine when most of the media would not, I spoke. I simply thanked the family for having faith that the Smithsonian would be respectful in the way we would preserve the casket and interpret Emmett's life and death. Equally important for me was to use this donation to honor Mamie Till Mobley. She always reminded me that someone else had to carry the burden of ensuring Emmett was remembered. By accepting the casket into the collections of the museum, Emmett Till and Mamie Till Mobley would always be associated with Chicago and Mississippi, but now that they were part of the Smithsonian, they belonged to the nation.

There are literally thousands of stories about the objects in our collections. I could write about how the fact that both George Clinton and I were born in Newark helped to ease the way for him to donate the iconic Mothership, which would become one of the most visited items in the museum. I could share how the curatorial creativity of Kevin Strait allowed him to weather the mercurial Chuck Berry and bring back to Washington the guitar upon which he wrote many of his early hits like "Maybellene" and the candy apple red Cadillac so famously seen in the movie *Hail! Hail! Rock 'n' Roll*. I could marvel at the story of how a white US Air Force captain's love of vintage airplanes led to the discovery and eventual donation of a PT-13 Stearman aircraft that was used in the training of the Tuskegee Airmen during WWII. I could reveal how aggressive work by the Office of Curatorial Affairs led to collecting the entire presidential campaign office in Falls Church, Virginia, of candidate Barack Obama in 2008. Or how museum specialist Timothy Burnside's love and knowledge of hip hop led to the donation of the MPC beat machine used by producer J Dilla.

Most important of all, the work of the curators and collections staff turned the lack of collections from a weakness into the museum's strength. Not only would the acquisition of more than 35,000 objects in the museum's holdings enable the institution to be as collection-rich as its sister institutions in the Smithsonian, but it also guaranteed that NMAAHC could convey a complex, deep, and diverse history that would let us illuminate all the dark corners of the American past. In addition, the museum's success raised important questions and lessons for museums and historic sites. This process taught us to test and challenge the prevailing wisdom about the paucity of African American artifacts. What we discovered was a paucity of effort and creativity rather than a scarcity of collections. I hope that our efforts will spur other institutions to embrace community-driven collecting and commit the resources to look inside the basements and garages for material that was once deemed less important to the interpretive agenda of museums. Not every cultural organization will discover items from Harriet Tubman, Nat Turner, or Marian Anderson, but every museum that makes the effort will find objects that document the lives, the work, the resiliency, and the dreams of their community.

Personally, collecting the African American past made me realize the importance of building on the networks and contacts that I had carefully cultivated during my three-decade-long career. I was continually reminded how my time in Chicago or Cape Town opened doors that enriched our holdings.

And how colleagues and friends from universities, at the National Air and Space Museum, the California African American Museum, the Chicago Historical Society, and the National Museum of American History provided information, counsel, and help that was instrumental in our evolving into a museum with no collections to nearly 35,000 objects in less than a decade.

Realizing a Dream Takes Money

That is more money than God can count.

—Montrose Bunch (My Mom)

One week after I became the director of NMAAHC, I was asked to join a lunch meeting with the insurance company Aflac. Thanks to the work of the Secretary of the Smithsonian Institution Lawrence Small and the efforts of Robert Wright, the co-chair of the Presidential Commission on the Development of the National Museum of African American History and Culture who was also on the company's board of directors, Aflac was ready to make a major gift to the museum. My job was to demonstrate that the museum now had the leadership it needed to begin this push to create the nineteenth museum of the Smithsonian. In essence, all I had to do was not screw up. The meeting, which included Dan Amos, Aflac's CEO, went quite well. I shared my vision for the museum and explained how my prior experience had prepared me for this role. As dessert was served, Amos casually mentioned that his company would contribute $1 million to the campaign to build the museum. This was wonderful news. Aflac became the first Founding Donor, the first major corporation to support the museum. And then to the surprise of all at the luncheon, Amos presented me with the check for the entire amount.

I had never held such a large check before. As everyone was leaving the meeting, I stood grinning. Maybe raising money will not be that difficult, I thought. Richard Kurin, the head of the Smithsonian Center for Folklife and Cultural Heritage, reentered the room. Sensing my jubilation, Richard said, "Congratulations, now all you need is five hundred more such checks." There went my euphoria. At that moment, I understood just how challenging it would be to raise hundreds of millions of dollars. In fact, that night I played the Powerball lottery for the first, but not the last, time. I hoped to hit the number so that I could donate any winnings to the museum. I never did win. We had to raise the money one strategy session, one presentation, one meeting, and one handshake at a time.

After several preliminary internal discussions, we set the budget for the museum at $500 million, which would cover the cost of construction and the design and installation of the exhibitions. Legislatively, the federal government "pledged" to provide 50 percent of these costs and the other half would come from private donations from corporations, foundations, and individual philanthropists. There was no mechanism committing the government to a specific schedule of financial allocations, no one-to-one match of federal dollars to private donations, or any language to help me understand how this public-private partnership would work. In reality, my job was not just to raise $250 million from the private sector, but also to convince Congress to provide for the cost of construction. Separate from this budget was the need to wrangle the federal government to support the growth of the staff needed to complete this endeavor. Despite the lack of clarity, I decided that I needed to focus on the nongovernmental fundraising in hopes of obtaining a few early development successes. When I mentioned the fundraising requirement of my new job to my mother, she exclaimed, "That is more money than God can count." I just hoped that I could be successful so that one day we could count that high. From the earliest stages of the fundraising efforts, I knew that I could not raise this money alone. In fact, any credit for our success must be given to my development colleagues and the Council, especially Kenneth Chenault, Dick Parsons, and Linda Johnson Rice.

Not long after, I held a meeting in my L'Enfant Plaza office with the broken doorframe with Kinshasha Holman Conwill and Virginia Clark, the head of the fundraising arm of the Smithsonian, to determine strategies and to assess the characteristics of a successful capital campaign. It was clear that we would need a committed and active board to open doors and to help close the asks; a strong and appealing vision that was buttressed by

innovative strategies tailored for specific sectors and individuals; a seasoned staff whose expertise would bolster my weaknesses and complement my strengths; a campaign of visibility that would create an environment conducive to philanthropy; a leader of the campaign with passion, confidence, and nimbleness; and early victories to create a sense that it was possible to reach such a high goal. I added one other quality that I learned from my time in Chicago: stamina. The stress of hundreds of presentations, the strain of travel, and the need to be the face of a campaign meant that I had to be physically and mentally ready for the toll this would take on my body and my soul.

With the help of consultants, we sharpened our overarching vision so that it would be an effective development tool. I believed that if NMAAHC was seen as a black museum for African Americans only, it would find support, just not at the level we needed. So we crafted a vision that emphasized how the museum examined the American experience through the lens of a particular community. Framing the museum as a source of a quintessentially American story increased the number of potential supporters. We also positioned the museum as a unique experience. How often does one get to contribute to the creation of a national museum that is part of the Smithsonian, and particularly one that seeks to make a country better by bridging the chasms that divide the nation? Positioning this endeavor as unique allowed us to appeal to corporations and foundations who shied away from supporting bricks and mortar. Over time we would develop different strategies to appeal to corporations (such as those with diverse senior leadership or who supported patriotic or nationally significant projects or who had a strong African American consumer base or, candidly, corporations whose image would be improved by embracing this museum), and foundations (especially those interested in innovation, in an enlightened citizenry, in scholarship or social justice) and special segments, such as creating a competitive environment where African American fraternities and sororities competed to demonstrate their support for this initiative. I also felt it was essential that we develop plans that focused on the major donors, but did not neglect the individuals with limited means who wanted to contribute to this unique enterprise. Broadening the number of people who felt ownership and a kinship to this project I knew would pay financial and political dividends in the future.

Without a doubt, the generator for the greatest support for the museum came from the NMAAHC Council. While the original Council members were recruited by Secretary Small, we were able to add individuals who strengthened our access into areas like Silicon Valley and Hollywood. Since this

was a fundraising board with little fiduciary responsibility, the initial members were overwhelmingly CEOs of major businesses. Their support began immediately after my arrival when the Co-chairs of the Council Dick Parsons and Linda Johnson Rice encouraged all Council members of means to contribute $1 million each to create a fund that provided the museum with the resources to hire consultants needed to supplement the small staff. With that initial contribution from the Council, we began to build a fundraising operation capable of raising the massive amount of support needed to create the museum.

When Kenneth Chenault of American Express assumed the role as the chair of the Capital Campaign Committee, the activity of the Council grew appreciably. The Council played many roles: most importantly, during our meetings they would identify corporations and individuals that were likely supporters and then they would work with me and the staff to begin the process of courting the donors. The Council also hosted small dinners or receptions where I could meet and engage the local business community, such as the one we had in Seattle where Patty Stonesifer gathered a group of corporate and foundation leaders from the Northwest; or Earl Stafford, another Council member, who invited African American businessmen into his home so I could share the story of the museum and garner their support. In later years, Linda Johnson Rice would bring Chicagoans together for the architect David Adjaye and me to make joint presentations. All of these gatherings led to additional support for the museum. Thanks to the direct intervention of Council members like Tony Welters, Sam Palmisano, and Ken Chenault, entities such as Time Warner, American Express, IBM, United Technologies, the National Basketball Association, the National Football League, Xerox, United Health Group, and dozens of others became Founding Donors giving at least $1 million each to the capital campaign.

Not every Council recommendation became a Founding Donor. In fact, the worst fund-raising experience I had occurred from a Council member lead. We had a large media firm in the Northeast in our sights as a prime target for the campaign. Minda Logan, a senior development officer responsible for corporate giving, arranged for the two of us to visit the president of this company's charitable foundation. As was the norm, Minda prepared me for the meeting. A nimbleness was required as meetings often went off in unplanned directions: in addition to suggesting what a unique opportunity it was to support the birth of a new national museum, we decided to focus on the importance the African American consumer meant to their business success. If that did not resonate, we might emphasize how many of the

company's business competitors were already supporters of this endeavor. I was very pleased when the president of the company's foundation, an African American, did not need a sales pitch. She spoke with great enthusiasm about the museum and how she hoped her organization would become financially involved. She then paused and said that a decision to support the museum was an issue that needed the approval of the senior corporate leadership. We ended the meeting by commenting on the beautiful views from her offices and agreeing that she would push this request forward.

A few months passed and despite our efforts to reestablish contact, we heard nothing. We decided that we had to move on to other prospects. Almost six months later, our Council member contacted the firm's CEO to see if we could restart the process. Much to my surprise, it was reported that the CEO expressed interest and a meeting would be forthcoming. A date was set, and we made plans to return to the corporate headquarters to meet with senior leadership, the people who could green light the donation. We were told that it would have to be a very early meeting, so we took a train leaving Washington at 5 a.m. to ensure our on-time arrival. When we checked in at the reception area we were told to have a seat and that someone would bring us to the meeting. Several hours passed. We waited, and waited some more as the scheduled time for the meeting ticked by. Then a woman appeared and called out a name. It was not mine.

After several minutes of listening, we realized that she was seeking us, though she did not use our names but said the name of the person we were to meet. Finally, despite the unusual greeting, we headed in to the meeting. As we meandered through a web of offices, our current contact did not respond to any of my comments about our excitement that this meeting was finally scheduled. She offered no water and no conversation. We were led into a conference room where we waited another twenty minutes. Finally, a senior vice president joins us. He said that he should let me talk, but instead he brusquely explained that neither he nor his company was interested in supporting the museum. He added that he only took the meeting as a courtesy to my Council member. After a few more minutes, he led us back to the reception area. I was stunned. If there was no interest, he should have declined the meeting. And I was angry: we had made an earnest effort, rushed to this meeting, for this brief but effective brush-off. What made it even worse was when we passed the woman who had initially greeted us, she covered her mouth to hide the fact that she was laughing at us.

As we walked back to the train station, neither Minda nor I could believe what had happened. Hearing no was just a normal part of any fundraising

campaign, but this was different. It was rude, thoughtless, and unprofessional. On the train ride back to Washington, Minda and I were in a state of disbelief. Neither of us had even heard of someone being treated so dismissively. What bothered me the most was a nagging question: would a white museum director been treated with such disrespect, such condescension? During my life, during my entire career, I have been attuned to the slights, assumptions, and hurdles based on racial attitudes and beliefs. I cannot count the number of meetings I attended where I integrated the gathering and had to find ways to handle and address the racial subtext in the room. I had to learn how to control my anger and to find ways, sometimes with subtlety occasionally with righteous indignation, to overcome the notions of white privilege that shaped many of these sessions. I am thick skinned enough to handle most of these notions except when it comes to respect. I vowed never to let anyone use race to disrespect me or my staff. And here was a moment of disrespect that I could not respond to or counter. I must admit, if this had happened prior to any other development victories, I would have been devastated and unsure of my ability to lead this campaign.

Fortunately, the activities of the Council met with much more success than failure. The ability to sustain this campaign and to ultimately meet our goals was due, in large measure, to the leadership of the Capital Campaign Chair Ken Chenault. His prowess at marshaling needed resources such as supporting the hiring of consultants to shape our online development activities and his willingness to use his personal and corporate relationships paved the way for successful solicitations from professional athletes like Kobe Bryant to the Bloomberg Philanthropies to the Executive Leadership Council, a group of black corporate executives that was committed to expanding opportunities for minority advancement. More than just a money man, Chenault consistently provided guidance and support to me during the eleven-year journey to complete the museum. I do not believe we would have been so successful without the leadership of Ken Chenault.

Another key actor in the success of the museum's fundraising was Oprah Winfrey. From the very beginning, Oprah Winfrey showed a supportive kindness to me. At the first Council meeting, where my nerves were more apparent than my leadership skills, she sought me out to say how much she had enjoyed an article that I had written about my time heading up a Smithsonian exhibition team in Japan. The fact that she both took the time to read the piece but also to offer words of encouragement spoke volumes about the character of Oprah Winfrey. Even before she became a financial contributor, she would spend hours with me at Harpo Studios, now Harpo Productions, in

Chicago. Though I had met Oprah during my tenure as president of the Chicago Historical Society, I did not really know her. When I visited her studios for the first time, I was unsure what to expect. I sat in her waiting area, surrounded by beautiful African American art. I was so distracted I did not even realize someone was yelling, "Lonnie Bunch, where are you?" She greeted me like I was family.

From that moment we had many wonderful and helpful discussions about the need to understand one's audience and the importance of storytelling on television and in a museum. Over time, she became the largest financial supporter of the museum. One of my favorite Oprah moments occurred when she called in from California during a Council meeting in 2015. As we neared an important fundraising milestone, there was a discussion as to how we would close the gap. Oprah, who had already committed more than $12 million, said she liked round numbers, so she increased her gift by another $8 million. What an amazing moment. After a period of surprise, the Council applauded as if they were celebrating the winning touchdown at a football game. Never had I been so moved by a voice coming out of a phone. This unsolicited gesture speaks volumes about the wonderfully supportive person that is Oprah Winfrey. While Oprah's commitment to African American culture and the museum were the determining factors, I also felt that she came to believe in me, that with her support I could fulfill the dreams of many generations. I cannot overstate how important her backing and friendship came to mean to me.

There are other names, less well known and maybe only familiar to me, that were instrumental to the museum's development activities: Adrienne Brooks, Princess Gamble, Minda Logan, Eva Headley, Margaret Turner, Shiba Haley, Kevin Thomas, Kinshasha Holman Conwill, Thameenah Muhammad, March Wood, and so many others who were part of the fundraising cadre of the museum. If the Council opened many doors, it was the staff that developed the tactics, prepared and scheduled the director, created the glossy materials, drafted the proposals, ensured a smoothly running back of the house operation, and liaised with and, if necessary, controlled the central development arm of the Smithsonian. They, more than me, are responsible for the millions of dollars that the museum raised from nonfederal sources.

One of the important strategies we developed involved foundation giving. When the staff was small, we decided to focus our initial attention on foundations because we believed those funders would be excited by the vision and the possibilities of the museum. We did not have much concrete to show but we went to the places that respected ideas and scholarship.

Kinshasha Holman Conwill and Adrienne Brooks shaped the presentations that I would make to the foundations. One person, Darren Walker, then at the Rockefeller Foundation and before becoming the president of the Ford Foundation, spent many evenings with us in New York not only helping to hone the message, the pitch, but also contacting his colleagues in other foundations and suggesting that they should meet with the museum. This resulted in significant seven-figure gifts from the Rockefeller, Ford, and Kellogg foundations. In addition, Council member Patty Stonesifer used her long history with the Bill & Melinda Gates Foundation to obtain a foundational gift of $10 million to support the construction of the museum. We needed the guidance of individuals like Darren Walker and Patty Stonesifer because we had to convince foundations to take the unusual posture of supporting the construction and not just programmatic initiatives.

My development colleagues realized that we needed to leverage that initial foundation largesse. They convinced the foundation presidents to sign a letter that would be sent to other like institutions. The letter would simply state that each of the signatories had supported the museum and they encouraged their colleagues to learn more about this endeavor. This letter enabled the development staff to begin dialogues with a number of foundations that had rarely supported the Smithsonian Institution. This strategy opened many new doors. As a result of receiving this letter, senior program officers at the Lilly Endowment Inc. agreed to meet with me. Adrienne Brooks and I flew to Indianapolis not knowing what to expect. After making clear that the meeting was a courtesy to the foundation directors who signed the letter, I was able to speak about the museum as a place of history and spirituality. Knowing that the Lilly Endowment had previously supported programs that explored America's religious traditions, I focused my talk on the interpretation of African American culture that would be at the heart of the museum and how notions of religion and spirituality would be embedded in all parts of the museum. This caught their attention. Within a few weeks after the initial meeting, the Lilly Endowment became a substantial Founding Donor.

The burgeoning visibility and positive press about the museum allowed the staff to find support in unusual quarters. The late Margaret Turner, a senior development officer who was both frighteningly focused and able to cultivate wavering donors, decided that the museum should approach a church for support. Now I tend to follow the instincts of my staff, but I had never known an African American church to support a museum. After all, the church is the primary recipient of African American philanthropy, not a dispenser of financial support in the cultural arena. Margaret was relentless. She decided

to focus her attention on the Alfred Street Baptist Church, one of the oldest religious organizations in Alexandria, Virginia. Founded by African Americans once held in bondage, Alfred Street Baptist Church had an appreciation for history that Margaret hoped to exploit. She also knew that the church's pastor Reverend Doctor Howard-John Wesley was an innovative leader who appreciated the educational value and cultural significance of NMAAHC. Margaret realized that several of our major individual donors attended the church as did she. For nearly a year, Margaret prodded, answered questions, and asked for support. I paid little attention because I knew it was unlikely that the church would open its coffers. I should never have underestimated Margaret. In November 2015, I attended a church service at Alfred Street Baptist Church where they announced a gift of $1 million to the museum. I was called to the pulpit to receive a check, and I was frankly overwhelmed. To hear Reverend Wesley and other members of the congregation talk about the importance of the museum and their willingness to break tradition to support NMAAHC touched me and reinforced my commitment to creating a museum that mattered and gave meaning to the abiding faith and resiliency of the African American community.

The development staff was also instrumental in helping me to design and implement a membership program. When I first raised this idea, the highly paid development consultants and the leadership of the Smithsonian Office of Advancement were all vehemently opposed to wasting time and money on a membership program. Did not I understand, they said in a condescending manner, that the museum was a decade away from being realized and that when it is completed it will be free? Why would anyone buy a membership from a nonexistent entity? What benefits could you provide? They did not understand my vision. When I was a young curator in Los Angeles, I interviewed a family about the history of race in the city. The matriarch of the family pointed towards a wonderful nineteenth-century photograph in an antique oval frame. You can have the image for the museum, she said, but you cannot have what is stuck in the frame. When I removed the photograph from the wall, I noticed that wedged in the frame was her father's membership card from the NAACP dated 1913. I never forgot how important that card was to that family—it represented, in a concrete manner, their enduring commitment to the struggle for racial equality.

Despite the lack of support from the central development office, I decided that a membership program would be an essential tool in my struggle to go from an idea to a building. To me, becoming what we later called a "charter member" to the museum was more about ownership and a sense of

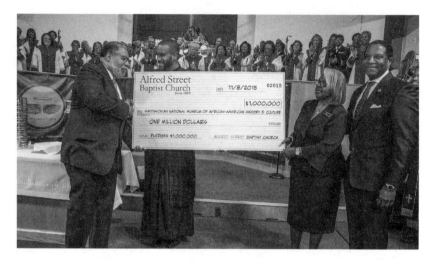

Reverend Doctor Howard-John Wesley, pastor of the Alfred Street Baptist Church in Alexandria, Virginia, presenting Lonnie G. Bunch III with a $1 million check to support the museum, 2015. **PHOTOGRAPH BY MICHAEL BARNES/SMITHSONIAN INSTITUTION**

contributing to the greater good than it was about raising money. I needed to give the public something tangible that allowed supporters to show their commitment to this endeavor. For as little as twenty-five dollars, anyone could become a charter member and know that they, by virtue of that contribution, had joined the cause of building a national museum. I believed that giving people this sense of ownership would increase the knowledge about and the visibility of this museum. Equally important were the political aspects of a membership campaign. NMAAHC had limited influence in the United States Congress. As the membership numbers grew, I had my head of government relations, Cheryl Johnson, track the numbers of NMAAHC members in each congressional district. This was information I would use whenever I was visiting members of Congress.

Ultimately, the numbers of individuals who joined as members grew to over 200,000, which made it the largest membership program in the Smithsonian. Not bad for a museum with no building and no premiums. By the time the museum opened in 2016, the profit from the membership campaign averaged $5 million. This source of unencumbered money provided me with a flexibility to support new ideas or fill budgetary voids. What the initial resistance to this idea demonstrated was that this project had special needs, unique opportunities, and an African American perspective that made

it different from other SI museums. It also had a worldview that was not often understood or appreciated by other units of the Smithsonian. Yet the idea of membership had resonated with the public. I cannot count the number of times someone approached me at the grocery store, the movies, or at a restaurant and displayed, with great fanfare and pride, their membership card. I was at an airport a year prior to the museum's opening when one voice, then another shared their enthusiasm about being members. And even when I was on jury duty, a bailiff pulled me aside to show me his membership card. I was personally overwhelmed by the response to our charter membership program. Its success revealed a national hunger to better understand this nation's essential but tortured racial past. But it also underscored the long history of African Americans supporting, with their resources and their spirits, institutions that contribute to the struggle for racial equality. I was so moved because this support demonstrated that NMAAHC would be more than a museum about the past, but an important actor as America continues to grapple with the need to fulfill the promise of liberty embedded in the Declaration of Independence and the Constitution.

Yet no staff, not even one as gifted as my colleagues in development, always had the impeccable timing or the perfect pitch. I would often rely on my Chicago connections for support and guidance. Based on my prior history and friendship with the principals, it was logical for another of the senior development officers, Princess Gamble, to schedule a visit to a major Chicago investment firm, Ariel Investments, led by two friends, John Rogers, Jr., and Mellody Hobson. Princess and I arrived at the office in Chicago by midmorning and were asked to wait because they were in some unexpected meetings. During what seemed an unusually long time, we noticed a plethora of activities, hasty assembled gatherings, and numerous telephone exchanges. Finally Mellody Hobson joined us. As always, she was very pleasant, but she seemed distracted. Finally, she explained that now was not the time to discuss any financial commitment because that morning, September 15, 2008, the global financial crisis that would cause a worldwide recession had shaken the financial markets. I thought the only worst time would have been to ask Wall Street for support during the Stock Market Crash that occurred on October 29, 1929. Several years after our visit, when the economy had stabilized, Mellody and her spouse George Lucas did become Founding Donors of the museum. Fundraising teaches one patience.

When I was the associate director at the National Museum of American History, I led a Smithsonian team working in Tokyo in 1991 until 1994. Since this was my first endeavor as the leader of a large team engaged in a

high-profile endeavor, crafting a major exhibition on American culture for a Japanese audience, I wanted to project a sense of calm leadership, a feeling that despite the difficulties everything was under control. The phrase, *mondai nai*, which translated means "no problem," was my mantra. There is no denying that though I publicly practiced a *mondai nai* persona during the eleven-year journey to opening, the grind of fundraising took its toll. How could it not when I took nearly 450 trips seeking support, made more than a thousand fundraising presentations, heard no or this is outside our scope at least 300 times, was interviewed by print journalists and television or radio reporters with monotonous regularity, and saw my hair and beard turn from black to a shade I call "Smithsonian Gray"? The final product made every one of these moments worth the effort, but that does not mean it was not without stress, significant stress.

When I started this work, I loved the travel, and by the time we dedicated the museum, I hated planes, trains, and hotels. But they were essential to the success of the campaign. I can remember almost every journey: flying to Atlanta to court Coca-Cola or to San Francisco to pitch Kaiser Permanente or to Minneapolis to gauge the interest of 3M, General Mills, and Medtronic or to Peoria to speak with Caterpillar or to Hartford to meet with United Technologies and a plethora of insurance companies or to Detroit to engage Ford and General Motors or back to Chicago to reconnect with Exelon. All while flying in the least expensive, most uncomfortable government-approved seats, usually in the back of the plane. I came to know my limits: I could fly to Minneapolis and back on a same-day flight, but not to Denver. That was too far.

Taking the train became a luxury. I even grew capable of getting to the train station in time to board the 5 a.m. Amtrak Acela to New York or Philadelphia with a bagel in hand. Here I learned from Kinshasha Holman Conwill how to ease the burden of train travel—use the Red Caps. I had always stood in the long line waiting to board, but Kinshasha introduced me to an array of Red Caps in Washington and New York who would gather you up and make sure you did not have to fight for a seat on the always crowded Acela back to DC. These Red Caps were the most recent iterations of a long tradition where black men turned a job that seemed menial into something more. For generations, whether known porters or Red Caps, they offered a service to white passengers but also provided a sense of comfort and respect that was not often given to black travelers. Something as simple as avoiding the crush of commuters made a day when you had caught the earliest train to New

York City and made the last Acela of the evening home much more tolerable. These men became friends: the Saint, Joe Willie, Peterson, and others I knew only by their faces. They knew my name and remembered when they had last seen me. Besides the kindness of the Red Caps, there was the saving grace of travel on the Acela: the quiet car. There were times I did not want to review the forthcoming meeting or revisit how I should frame the impending discussions. Finding a few moments of solitude and sleep on the quiet car was just the respite I needed to face another presentation in front of funders who were not always so enthralled to see me.

Sometimes the greatest discomfort came from being a passenger in a car driven by someone on the development staff. On a trip to San Francisco and Oakland to meet potential donors, we were crossing the Oakland Bay Bridge when Anna Barber, the development specialist who handled our California fundraising, wanted to show me the section of the bridge that was named after the former Mayor and NMAAHC Council member Willie Brown. She pulled into the fast lane to be closer to the girder where a plaque honoring Mayor Brown was mounted. Instead of pointing at the marker as we drove past, she decides to stop right there in the fast lane on the bridge. I am in the back seat, fully convinced that cars trying to leave Oakland will soon crash into the rear of the rental car and put an end my fundraising sojourns. In the strongest possible voice I encouraged her to move. Which she did, barely avoiding a major accident. She then asked, somewhat disappointed, why didn't I want to take a closer look at the marker. As we headed back into San Francisco I vowed never to be a passenger again.

While travel was tiring and stressful, the sheer number of activities during a trip—the weight of preparing for each presentation and effort to convey passion and purpose—was occasionally overwhelming. When I review my agendas of fundraising activities packed into each trip, I wonder how I survived. For example, on a visit to California from October 16 to 19, 2012, I began the 16th with meetings with the board of trustees of the Museum of the African Diaspora, then an interview with the publisher of the Post News Group. I ended the day at dinner with colleagues from the University of California at Berkeley. On the 17th I began the morning meeting with Willie Brown to finalize my schedule while in the Bay Area. I spent the afternoon at the Presidio with George Lucas. That evening I had dinner with Bernard Tyson, the CEO of Kaiser Permanente. On the 18th I met with Emmett Carson, the CEO of the Silicon Valley Community Foundation, and had dinner that night with Ernest Bates, the CEO of American Shared Hospital Services. Finally,

on the 19th I attended a large gathering at the home of Ann Getty to intro-
duce the museum to a variety of San Francisco's cultural and political elite.
Though the venues and individuals changed, most of my fundraising trips
had the same rhythm and followed similar patterns.

When I think of the impact that this effort had on me, I realize that the
most difficult aspect was not just the stamina and the nimbleness needed,
but the need to maintain my confidence. The success rate for many cultural
campaigns is about one out of three proposals receive a positive response.
Because of the message, the strength of the Council, and the Smithsonian
brand, we had a 50 percent success rate. That meant, however, that nearly
one half of our asks were rejected. In some ways, a museum director involved
with a campaign has to be like a shooting guard in basketball. While you
expect each shot to go into the basket, even if you miss you have to have the
confidence and maybe a bit of arrogance to keep shooting. What buoyed my
confidence were my development colleagues and the deputy director. Even
when I failed, they supported me and placed the blame elsewhere. After each
presentation, I asked for a debriefing that focused on how I could do a bet-
ter job, even if the meeting had gone well. I felt that during the eleven years
it took to open the museum, I needed to improve each year; to sharpen the
presentations and to be comfortable with the uncertainty that accompanied
each meeting with corporate CEOs, foundation executives, or individual phi-
lanthropists. I needed each effort to be better than the last. That was my
choice and my burden.

To further our efforts, we had to create an environment of excite-
ment and prominence that would assist the museum in the transition from
an endeavor little known to one that has the passion and interest of hun-
dreds of thousands. Without a campaign of visibility, a crusade to ensure
that the museum was part of the cultural lexicon of America, the struggle
to introduce the project and to solicit funds would be like the exertions of
Sisyphus, difficult, painful, and ultimately unsuccessful. It was essential to
strategically flood the airways, the newspapers, and social media with news
about the museum. The greater the visibility, the more likely donors would be
intrigued, thus making more solicitations possible.

This path made sense because it took advantage of my ability to commu-
nicate effectively with a broad range of media platforms. When I became the
president of the Chicago Historical Society, I inherited a wonderful museum
that was revered but rarely visited. I decided to increase our visibility by mak-
ing myself—and the Society's personnel—available to the media to provide

historical context or cultural insights to breaking news stories. I also suggested story ideas that would illuminate the work of the museum. As a recent transplant to Chicago, I had shared with a reporter from the *Chicago Tribune* that each night after work I traveled to a different neighborhood in order to familiarize myself with the city. The newspaper embraced this story and wrote a long feature article about my nocturnal sojourns. This immediately increased my presence and brought new attention to the Historical Society. Throughout my tenure there, I appeared on numerous television programs and documentaries, all geared to creating excitement about an institution where excitement was a rare commodity. I thought that we could use a similar strategy to create a sense of anticipation about NMAAHC, or at least some name recognition.

Evelyn Lieberman, the gifted head of the central Smithsonian Office of Communications and Public Affairs, from 2002 to 2015, supported this strategy. She did, however, have some hesitancy. After reviewing some of my earlier media clips and after assessing my performance during media training, she worried that I "did not fear the media enough." I concurred. An interview was not a source of real fear for me. Fear was walking home from Belleville Junior High School trying to avoid the fights and racial epithets that were all too common in the 1960s. Evelyn wondered if my success in Chicago would make me too comfortable with the press and, therefore, more likely to say something that would lead to controversy. I explained that there was no way to create a museum that explored African American history without wading into controversy. We discussed how working with the media was an exchange, a bargain where both parties received something tangible from the process, if it were to be a successful media interaction. Lieberman was the one person in the Castle whom I trusted completely. Her death in the year prior to the museum opening hit me almost as hard as my father's passing. She was that important to me.

With Evelyn's counsel and the efforts of my lead media professional Fleur Paysour, the museum placed me in the position to provide context for journalists and be interviewed strategically by the *New York Times*, the *Washington Post*, *Ebony* magazine, and local and national television programs, all geared to bringing the museum to life. It was essential that we take advantage of every opportunity, or what I soon learned were called "news pegs," to share stories about objects that the museum collected, as well as educational and public programs that expanded the public's understanding of African American culture and to make my new pulpit at the Smithsonian serve as a

vehicle to use history to help America grapple with questions of race. Each interview, each television appearance, introduced new people to the museum and what it would one day mean for the American people.

My first newspaper interview that summer of 2005 was with the *Free-Lance Star* of Fredericksburg, Virginia, and it provided an "Off-Broadway-like" debut that allowed me to try out my responses to questions that I knew I would receive from other journals with a national focus. Though the reporter began by asking the obligatory questions about my career, she quickly focused on issues that I continue to address to this very day: why a separate "black museum"? and "why does slavery still matter"? I explained that this was not simply a black museum for the African American community. Rather it was a museum that helped all Americans regardless of race understand how much the African American experience is embedded in America's identity, yesterday, today, and tomorrow. I also explained that slavery was the cornerstone of American economic growth, political discourse, culture, and foreign policy. As a country, we cannot fully understand ourselves without embracing the nation's interdependency with slavery. The article had a limited readership, but it helped me to prepare for the press gauntlet I would face for the next eleven years.

As much as I had contact with the media in Chicago, it paled in comparison to the personal visibility that accompanied being the Founding Director of the National Museum of African America History and Culture. I could never have imagined the challenge of being the face of the museum. I spent countless hours fielding journalistic inquiries and assessing what television appearances I should accept and what level of visibility should the deputy director assume. In the beginning I would do fifteen or twenty interviews a month. By the time the museum opened, I would engage some aspect of the media nearly every day. I calculated that there were at least six hundred times in eleven years that my face appeared on television or my words were quoted in a newspaper. At first I asked for clips or copies of the programs, but I soon realized the flood of media interactions made collecting them unfeasible. I still struggle with this notoriety because I want the credit for any success to be shared with my colleagues at the museum. Someone approached me recently and said how famous I was. I answered: "Oprah Winfrey is famous, I am just visible."

But visibility has its costs. As someone who is basically shy, having people stop me on the street or stare at me in a restaurant makes me uncomfortable. I soon realized that this attention was also a burden on my family. This explains why I rarely mention my children, or where they live. My time

in the spotlight should not infringe on their privacy. At times, this visibility has led to threats and a few confrontations. A local magazine decided to include a picture and the location of my home in an article about influential Washingtonians. Shortly after the article was published, I parked my car in the front of my house after driving home from the Mall. As soon as I exited the car, a woman jumped out of her vehicle and charged me. Startled, I used my door as a shield. It turned out she was an overly enthusiastic job seeker, but the encounter had been unsettling. What if it had been someone wishing me harm?

Without a doubt, out of all the media appearances over the past decade, my interviews with *60 Minutes* brought the greatest attention. I have been fortunate to be on that program three times. As Nicole Young, one of the show's producers, pointed out, I have been one of the very few people to appear on that program more than twice: once to discuss the role of the enslaved in building the US Capitol; another time to explore the museum's work on the slave ship the *São José Paquete Africa*; and a third time to focus on the history and creation of NMAAHC. The segment that explored the efforts to create a national museum was an important marker in our campaign for visibility. This episode introduced millions of people to the museum, its mission, its current status, and, most importantly, to many of the staff who carry the weight of this effort. I rarely watch myself on television. I am much too critical of my performance and my posture, but I had to see that piece on *60 Minutes*. That segment increased interest in the museum, which led to a spike in the membership growth and made it much easier for the development staff to have their calls returned or their visits scheduled with a sense of urgency.

The most direct result of the impact of the *60 Minutes* airing was on a fundraising trip I made on a Monday morning in May 2015 to New York City. I wanted to meet with the leadership of the Atlantic Philanthropies, a foundation that supported social justice. It was also an organization that was gifting itself out of existence. I worried that they might not consider a museum as a tool for social justice. Additionally, I hoped we were not too late, because a review of their recent giving revealed that a significant portion of the foundation's resources were already committed. Just like the hundreds of time before, I sat in the waiting room, honing my argument and trying to anticipate what the atmosphere in the conference would be. Will they be welcoming and engaging, or will they politely listen, giving little indication of whether the appeal is working. When Princess Gamble and I were ushered into the conference room, the president and senior program officers could

not have been more enthusiastic. They had seen the *60 Minutes* program that explored the museum. It had aired one day earlier on a Sunday night, and they wanted to express their pleasure at meeting with "the people who were on *60 Minutes*." The airing of that segment gave the museum the legitimacy and the cachet that had facilitated such a positive reaction. Ultimately, the Atlantic Philanthropies became one of the single largest donors to the museum, support that might not have happened without the visibility that accompanied our *60 Minutes* spot.

The media coverage of the museum has been overwhelmingly positive, but as Evelyn Lieberman once reminded me, the media can also bring pain and controversy in unexpected ways. It was important to manage any negative press. In early 2016, I was in the middle of an interview with the *New York Times* about the impending opening of the museum in September of that year. Near the end of the interview, completely out of context, the reporter asked if the museum planned to include Bill Cosby in the museum. Mr. Cosby had been accused of rape and sexual assault but had not been convicted at that point. I mentioned that there would be a limited Cosby presence within the exhibitions. The next day, an article in the *New York Times* appeared quoting many of Cosby's accusers, demanding that the museum eliminate all references in our exhibitions to Cosby and his impact on television, comedy, or movies. If we did not accede to their demands, the article suggested that the museum could be seen as supporting a sexual predator.

Immediately, media from around the nation wanted to know how a museum, not yet opened, would grapple with such an important and thorny issue. As the museum was in the final stages of completing the capital campaign, it was essential that we respond decisively and quickly. After consulting with the museum's senior staff, I decided that I would write a statement that would be posted on our website and shared via social media. The statement would be the museum's response. No one from the museum would comment further. The statement I wrote emphasized how strongly we felt that sexual harassment was wrong and needed to be dealt with severely. I continued that as a historian of a community whose history had often been deemed unimportant or been undervalued, I would never erase history. I stated that Mr. Cosby's contributions in entertainment were worthy of inclusion in the museum. I also wrote that any label describing Mr. Cosby would reference the allegations and include language that makes clear that NMAAHC does not "honor and celebrate Bill Cosby." I concluded by saying that whatever interpretation we present now or in the future no one will leave the museum without "recognizing that his legacy has been severely damaged by the recent

accusations." In closing, I wrote that we have made our statement and there is nothing more to say. Within a few days, the storm passed and our development efforts were unaffected.

Creating the appropriate media environment, leveraging the strengths of the Council, and utilizing a gifted development organization enabled the museum to announce several months prior to opening that we had surpassed our fundraising goals. More than $400 million was raised to support the construction, programming within the museum, and the opening festivities, which included nearly $50 million more than what we had initially needed for the construction. I was quite pleased and in awe of the work of my colleagues in development that the museum had had a high success rate, where more than half of our requests were supported. And that nearly 40 percent came from the corporate community where usually in such a campaign 17 percent of your gifts come from corporations. This was due to the leadership and commitment of the museum's Council. Another surprising statistic is that there were nearly 150 gifts at the Founding Donor level of at least $1 million. And of the individual donors at the million-dollar level, 75 percent were African Americans. Counting the membership support, this campaign brought in 63,000 new donors to the Smithsonian. It is my hope that much of the innovation in marketing, utilization of new technologies, and community-centered fundraising strategies will permeate the entire Smithsonian, so that our fundraising efforts for a nineteenth-century institution would reflect the best of twenty-first-century creativity.

I did not celebrate or make a joyful noise when we concluded the capital campaign. Rather I was just relieved: the grinding travel would abate, somewhat. I was pleased that I could come into meetings without the attendees worrying that I came to pick their pockets. And I was happy that my mother could stop fretting about the amount of money her son needed to raise. I was exhausted but satisfied.

Befriending Presidents and Managing Congress
A Long Way from New Jersey

During the presidential campaign of 1960, my father decided that he and I should join the large crowds who wanted to see the Democratic candidate John F. Kennedy when his plane landed at Newark Airport initiating his campaign swing through New Jersey. I remember driving there, struggling to find parking place, and then walking way too far for my seven-year-old legs. I was riding on my father's shoulders as we worked our way through the crowd until we got about forty yards away from the aircraft. I could barely see Kennedy as he walked down the stairs placed up against the plane. He waved, I think, then disappeared. As my father and I trudged back to his car, I knew this trip had to have some special meaning, but I had been dragged away from a neighborhood football game for a momentary glimpse of a man running for the White House, and did not understand why. My father smiled and told me to enjoy the moment because it might be the closest I would ever get to the president of the United States. I nodded, convinced of his wisdom.

It was inconceivable to me that my father would be wrong, that a black kid from a small North Jersey community would have the opportunity to befriend presidents, develop relationships with both Democratic and Republican members of Congress, and have conversations with the chief justice of the Supreme Court. Yet, to create the National Museum of African American

History and Culture, it was essential that I have such access, and take advantage of these contacts. Thirteen years later and I still cannot believe that this endeavor enabled me to get closer than forty yards to those whose influence literally shapes the world.

Working under three presidential administrations and through twenty-six sessions of Congress and wrestling with the often-Byzantine intricacies of the federal bureaucracy has been puzzling and perplexing at times, but working that system is what the job required. I enjoy finding ways to work efficiently within a federal structure, but I am also comfortable finding ways to beat the system as well. This is, of course, all while navigating the politics of race. At the national level, each administration and almost every session of Congress engaged or responded to issues of race. I would argue that one of the most consistent challenges throughout the history of the American presidency is how often racial concerns captured the attention of the president. From the troubling history of the treatment and the wars against Native Americans to the pervasive shadow that was slavery to the calls to address racial violence whether it was the lynching epidemic of the late nineteenth and early twentieth centuries or the murder of Trayvon Martin to the calls for equality from a rainbow coalition of people of color, presidents from George Washington to Donald Trump have often found themselves mired in the politics of race. It was not surprising that reactions to the museum and the varying degrees of support and attention by Presidents George W. Bush, Barack Obama, and Donald Trump were often part of a political calculus that would help the presidents mediate the omnipresent racial divisions within the United States. Placing the National Museum of African American History and Culture on the National Mall, a site ripe with our notions of nationhood, ensured that this new institution would be both a symbol of hope to some and an example of the contestation over the definitions and meanings of American identity.

The involvement of George Bush with the museum initiative predated my return to Washington in 2005. His signature on the bill in 2003 was not only the formal beginning of the process to create the museum but also signaled his commitment to the idea of a museum. My indirect involvement with his administration began approximately the same time. As president of the Chicago Historical Society, I was a member of a group of the leading cultural institutions in Chicago named the Museums In the Park, aptly titled as the entities were located on public park lands. The need to find additional resources to support programmatic initiatives led to a meeting where the museum directors would make the case for increased support directly to

George Ryan, the Republican governor of Illinois at the time. While a few of the other directors would make preliminary presentations, I was to present the final keynote and convince the governor of the importance of these museums. I wondered why the newest member of the group was asked to assume the most important role. I realized that it was less about my talents and more about who had the least to lose. As a historian, I immediately recalled how Martin Luther King Jr. became the leader of the Montgomery Bus Boycott in 1955. King was chosen, in part, because he was the newest and youngest minister in the community and if the boycott failed, the established ministers would be free of blame. I was the rookie and with that came the role of the potential fall guy.

While the other directors talked about how additional support would enable new buildings or content or specific wings to be built, I spoke about the need to stimulate children's imagination to guarantee that future generations were comfortable with creativity and innovation. Governor Ryan must have appreciated my talk because a week later he invited my wife and me to visit him at the Governor's Mansion in Springfield. More importantly, he suggested, without my knowledge, that the Bush White House consider me for a presidential appointment. A few days later, I received a call from a White House aide who peppered me with questions about my professional qualifications. He then asked when the last time was that I voted for a Republican. I said, "When Lincoln ran in 1864." I expected a laugh, but was greeted by dead silence on the other end of the phone—a silence that convinced me that an appointment would not be forthcoming. Three months later, I was appointed to the Commission for the Preservation of the White House.

To attend my first meeting of the committee, I went through the security check at the guard booth located at the northwest corner of the White House. On this spring day, I basked in the warmth of the sun and realized I had only visited the president's house one time, during a rather boring eighth grade field trip. This time I was excited as I waited for someone to escort me into the building. After a few minutes of looking unsure, the Secret Service officers laughed as they informed me that as a presidential appointee I could just walk up the driveway and enter the White House. I tentatively, then giddily strolled to the front door of the Executive Mansion. Heading up the driveway past where the television cameras and reporters were located, I heard someone say, "Is he anybody?" The answer from another journalist was "No." Already humbled by the comments, I entered, and found the meeting room, where I was seated across the table from the Chair of the Committee, First Lady Laura Bush. I sat through my first meeting, knowing little

about the kind of rugs that would have been in the East Room in 1950 or the appropriate nineteenth-century furnishings for the Lincoln Bedroom. After the gathering, I spoke to Mrs. Bush and apologized for my lack of knowledge about furniture. She graciously put me at ease by asking about the book that I was carrying. Almost immediately we shared our love of books. After numerous conversations about the White House and the history of the American presidency, we became friends over the next several months. Through Mrs. Bush I was invited to attend many White House events that led to my becoming acquainted with President Bush.

Shortly after I became the director of NMAAHC, my wife Maria and I were invited to a formal dinner at the White House. I had never been to such an event, so I was unsure what to expect. After being greeted warmly by the president and first lady while participating in the Washington ritual of having a picture taken with the First Couple, Maria and I were escorted to the dining room where spouses sit at separate tables. I was seated at Table 16, with no one I knew. So, I stared at the portrait of Abraham Lincoln that hung near the table, wondering what I was doing in the White House. Gazing at Lincoln reinforced how much my time in Chicago had created opportunities that would serve me in my new endeavor in DC. My communing with Lincoln was interrupted by the presence of George Bush. I was sitting at the President's Table. Me? He then began the conversation by telling the group how important the museum would be and asked me to share my vision. After I nervously rambled on about the museum, President Bush leaned over and whispered that he was very supportive and to feel free to ask for his help.

The support of the president was key to obtaining the financial resources for the museum that the Congress had promised but had yet to commit. There are so many interests lobbying for a portion of the federal budget. To have the best chance of receiving resources, the museum's requests for aid needed to be in the president's budget that was put forth by the Office of Management and Budget. That budget then goes through the Congressional appropriation process. Without the imprimatur of the White House, the museum's requests would never be fulfilled. A strong and public relationship with the Oval Office was an essential element of the museum's ability to begin to grow the annual and capital budgets.

President Bush, whose early affirmation of the need for the museum to have a home on the National Mall was significant, and the first lady were genuinely interested and soon became invested in the success of the museum. President Bush had placed African Americans like Colin Powell and

Condoleezza Rice in sensitive senior positions that had been unobtainable in earlier administrations. And he genuinely hoped that his actions might address the problem of the lack of diversity within the Republican Party. I also believe, whether directly or indirectly, that the destruction that accompanied Hurricane Katrina, the high percentage of African Americans who perished as a result of the storm and the inadequate response by his administration, informed his attitudes towards the museum. While the president never explicitly connected the development of the museum to his fractured relationship with the black community, I learned from others in the White House that supporting the museum, along with the administration's commitment to battling the AIDS crisis in Africa, was a point of pride for the president and first lady.

In addition to the president's active engagement with the Office of Management and Budget, Laura Bush's generosity and public acknowledgment also had an important impact on the museum. To offset the cost of the festivities that accompanied the second Inauguration of President Bush in January 2005, private funds were raised from the president's admirers. Traditionally, any excess money raised by the Inaugural Committee was given to charities or causes important to the first lady. Mrs. Bush decided that half of the unspent cash was to be donated to the museum. This was an important boost to the nascent development activities of the museum. I was so moved by her actions that as Mrs. Bush prepared to leave the White House in 2009, I asked her to join the Council of the museum. She explained that she had only planned to focus on the creation of the George W. Bush Library that was to be constructed in Dallas. She was, however, so excited about the museum that she agreed to serve on the museum's board, which I took not only as a sign of the importance of the museum but also as an expression of our friendship.

Like millions of Americans, I watched the election night returns on November 4, 2008, anxious to see if America would surprise me and elect an African American as its president. I was elated when a colleague and a friend from Chicago, Barack Obama, became the 44th President of the United States. The next evening, I attended a dinner party on Capitol Hill with several political pundits, one of whom cornered me to share his enthusiasm about the election results. During the conversation he expressed a bit of disappointment that NMAAHC was no longer needed. He believed that the election of Obama signaled the dawn of a post-racial America, an America where race no longer mattered, and where there was not a need for museums that would help people understand the stories of America's racial past. I argued

that America would never be postracial, the country's notions about the African American experience would change and evolve, but race and racism would always be essential and divisive factors in shaping the national polity.

The Obama presidency was not a new day, a respite perhaps, but not a new millennium of racial transformation. In fact, President Obama had to strategically thread the needle of racial politics. Proudly African American, he needed to counter the notion that he was the president of a single community. His relationship with the museum reflected that conundrum. During most of his first term in office, Obama privately ensured that the Office of Management and Budget would continue the budgetary growth of the museum and that through my conversations with his chief domestic advisor, Valerie Jarrett, the president would respond to any critical issues I needed him to address. His public endorsement, though visible, was not as vocal as that of the Bush administration. I understood that he did not want to be seen as "the black president." Much like Obama, NMAAHC had to walk the racial tightrope. The museum needed to maintain and expand the support of African Americans, but not be seen as an institution serving just one constituency. Yet President Obama's commitment to the museum was firm. Many times he prodded me to ensure that the construction would be completed during his presidency. He wanted, as he said many times, "to see this museum open while I am still in office."

This was a time of growth, stability, and visibility for the museum. Though I never exaggerated the strength of my friendship with the president, many within the Smithsonian and in Congress assumed I had a daily and direct pipeline to Obama. That assumption was quite useful as it helped me to quell criticisms about the pace of fundraising or the speed of the construction. At one point, when the construction of the building slowed due to problems with ground water, I walked into a tense meeting and simply stated that "I was talking to the president the other day and he is determined to be in office to open the museum. And we will not disappoint him, correct?" The pressure of the presidential gaze gave me the clout I needed to move the project forward.

Near the end of his first term, the president became more publicly associated with the museum. The most important of these public pronouncements was the occasion of the groundbreaking ceremony on February 22, 2012. By 2012, I had been working with a gifted staff on this museum for almost seven years. And while we had accomplished a great deal, with the exception of our exhibitions and public programs, much of the accomplishment remained invisible to most Americans. Groundbreaking would change the trajectory

and the visibility of the museum, if we could be assured that President and Mrs. Obama would attend and the president would be the keynote speaker. Rapidity of decision making is rarely a trait of any White House, and it took months before the administration verified the president's participation and confirmed that the date was now on the presidential calendar.

That date worried some senior Smithsonian officials. What if it snowed? Would it not be better to have the ceremony in the spring? And how many Smithsonian senior staff will have speaking roles? I made clear that the president's schedule took precedence over anything else. I was very fortunate that NMAAHC Deputy Director Kinshasha Holman Conwill, assisted by the person who began this endeavor with me, Tasha Coleman, created and managed the ceremony that required a six-month planning process. The museum also benefitted from guidance from Nicole Krakora and the Special Events and Protocol staff of the Smithsonian Institution. Not only did Kinshasha and Tasha grapple with the myriad of logistical challenges—handling permissions to use the Mall, finding tents capable of withstanding a winter storm, balancing seating decisions with donor preferences, compiling an army of people ready to shovel snow if necessary, working effectively with the Secret Service—they also wrestled creativity with the need to shape the optics and messaging of groundbreaking. Ultimately, the groundbreaking ceremony was a very visible example of the progress that had been made that was not always seen by the general public. I wanted the ceremony to take place on the site where the museum would eventually be located and to signal the final phase of this endeavor, the completion of the dreams of many generations as embodied in bricks and mortar. We also needed the day to thank our numerous donors and also to excite those who had yet to give. I sought to send the message that we were close to completion and if anyone wanted to be a part of this unique museum, now was the time to open their checkbooks. The museum staff planning this event knew that I wanted a multicultural and multigenerational program that balanced celebratory and uplifting moments with words of inspiration and acknowledgment of the importance of African American culture. This day was crucial in still another aspect: it gave the museum Council a major milestone that would not have happened without their leadership and sacrifice. And the components of this gathering needed to rejuvenate many in preparation for the final sprint to opening day.

Two days prior to the ceremony, we were curtly informed that the president would speak but that he would not participate in the actual groundbreaking ceremony. I was dumbfounded. We were told by junior

members of the administration that the president "does not turn dirt." During all the months of planning and communication with the White House, it was always clear that the president would be at the center of the actual groundbreaking moment. I worried how it would look if the president simply sat on the stage as others turned the dirt. I am sorry that I accepted that decision. I should have called Valerie Jarrett or other colleagues in the White House to try to reverse it. This is an example of where I needed to be more forceful and demanding. I knew that a photograph of the president holding a shovel standing next to me would be both a public relations bonanza and a boon to our fundraising efforts. Ultimately, I was just pleased to have the president's presence to reinforce how important this moment was in the creation of NMAAHC.

On the morning of the ceremony, I arrived at the site by 6 a.m. to begin media interviews. First I was to talk with two CNN journalists I greatly admired, Suzanne Malveaux and Soledad O'Brien. I was doing fine until CNN decided that they needed a better vista, one that included the Washington Monument at just the right angle. To get the shot, they perched me, rather precariously, on a step ladder that was wobbly due to the slope of the museum site. I could not believe I had agreed, but there I was, trying not to look like I was about to topple over while participating in a set of important interviews that would alert the country that the completion of the museum was near. I survived the balancing act and few could tell that I was afraid to move while talking for fear of falling. The ceremony was almost flawless. A diverse array of performers, such as Denyce Graves, Phylicia Rashad who was the emcee, the United States Navy Band, Jason Moran, and Thomas Hampson delighted the audience and provided a wonderful musical counterbalance to the array of speakers that included senior Smithsonian colleagues, Mrs. Laura Bush, then Governor of Kansas Sam Brownback, Reverend Calvin O. Butts III, and Congressman John Lewis.

But the day belonged to President Obama. His presence trumpeted the importance of the new museum and sent a clear signal that great progress had been made. He began his remarks by stressing the meaning of NMAAHC to him. "This museum should inspire us . . . ," he said. "It should stand as proof that the most important things in life rarely come quickly or easily. It should remind us that although we have yet to reach the mountaintop, we cannot stop climbing." I was surprised when he mentioned a breakfast we had had at the University Club in Chicago in 2005 as I tried to decide whether I should leave an established museum to take the risks associated with a start-up institution. This memory was not something his speechwriters

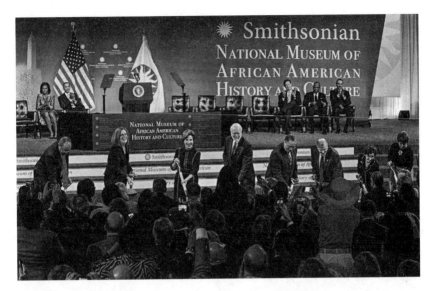

NMAAHC Council members and former First Lady Laura Bush at the museum's groundbreaking ceremony, February 2012. President Barack Obama and First Lady Michelle Obama are seated in the background. **PHOTOGRAPH BY DONALD E. HURLBERT/JAMES DILORETO/SMITHSONIAN INSTITUTION**

would have known. This was something personal between two friends. I was proud that he remembered. He concluded his remarks by mentioning Sasha and Malia. "I want my daughters to see the shackles that bound slaves on their voyage across the ocean and the shards of glass that flew from the 16th Street Baptist Church, and understand that injustice and evil exist in the world. But I also want them to hear Louis Armstrong's horn and learn about the Negro League and read the poems of Phillis Wheatley. And I want them to appreciate this museum not just as a record of tragedy, but as a celebration of life." His comments captured the spirit of the museum, the power of a people, and proved an emotional experience for all in attendance.

Another of the day's highlights came from the youngest participants on the program. One of my former students, Tracey Mina, was the founder of the Stuyvesant Heights Montessori School in Brooklyn. Her students wanted to help the museum, so they raised $600 in coins, which they wanted to present to me. I thought that despite W. C. Fields's adage never to be upstaged by dogs or children, this presentation would be a memorable and emotional moment and I was comfortable being overshadowed by the children. As the youngsters entered the stage, it was clear that the lead boy was quite nervous,

On February 22, 2012, at the groundbreaking ceremony of the museum, President Obama
shares with the audience the importance and impact of the occasion, and all it inspires.
PHOTOGRAPH BY DONALD E. HURLBERT/JAMES DILORETO/SMITHSONIAN INSTITUTION

and he was being helped along, guided, by a little girl. Once she handed me the container of money, she caught sight of the First Lady, promptly brushed past me to walk towards her, waving as she exclaimed, "Hello, Mrs. Obama." She then ran into the outstretched arms of Mrs. Obama for a hug that appeared in every newspaper and provided both the little girl and the audience an unforgettable memory.

Just four days after the triumphant groundbreaking ceremony that made us all feel so good about the possibilities of America, the murder of Trayvon Martin in Sanford, Florida, pointedly and painfully destroyed any notion that the nation was moving into a post-racial era. Throughout Obama's presidency racial hatred and racist epithets were hurled literally and figuratively at the commander-in-chief. For security reasons the number of threats received by the president was never revealed, but it is clear that his administration, his race, put his life at risk. Not nearly as high profile as the president, the museum, even in its developmental stage, provoked anger and racist threats as well from those who felt a changing America was leaving them behind. There were a series of websites that attacked the museum. One had the domain name "Chimpout." This site bemoaned any support for the museum and wished it would never be completed. At one point, the site attacked me, calling me a string of racist epithets. I must admit, I was tempted to contact the site and explain that the sentence critical of me would be stronger if they knew how to use commas.

Despite the hatred hurled at both the museum and the president, President Obama's imprimatur was essential to the museum's success. His counsel helped me to navigate and master the politics of the federal appropriation process. And the smiles and words of encouragement that both the president and first lady expressed whenever we were together at the White House or in attendance at the same function were welcomed and needed. It never hurts to have the President of the United States on your side. The words President Obama spoke at the reception at the White House the night before the dedication ceremony marking the opening of NMAAHC made all the years of struggle and sacrifice worthwhile. That evening the president said to the hundreds in the audience that "NMAAHC could not have been done without the persistence, the wisdom, the dedication, the savvy, the ability to make people feel guilty, the begging, the deal making and the general street smarts of Lonnie and his entire team." Though I smiled, I wanted to cry. But the most memorable moment with President Obama occurred when I walked through the museum with the President, the First Lady, their daughters, and Mrs. Marian Robinson, the first Mother-in-Law. I was pleased as President

Obama and the First Lady pointed out moments of history that they wanted their daughters to remember from discussions about slavery to the music of the Supremes. Equally exciting to me was the genuine engagement of Malia and Sasha. They asked questions of me and shared their reactions with their parents. As we entered the gallery that explored the racial turmoil and cultural flowering of 1968, music of that era blared over the speakers in the otherwise empty gallery. As the music of Motown filled the space, the president began to dance. Immediately his daughters had that expression that accompanies the moment a parent embarrasses them publicly. This was not an administration on tour, it was a family.

I had much less contact with Donald Trump as his election occurred fewer than eight weeks after the opening of NMAAHC. His administration's combative relationship with many in the African American community—from his feuding with Congressman John Lewis immediately after the inauguration to the attacks on professional athletes, the overwhelming number of those singled out for critical tweets were African American, to his refusal to criticize the white supremacists whose rioting in Charlottesville, Virginia, led to the death of Heather Heyer—have deepened the racial divide. Many visitors have told me that since the election in 2016, the museum has gained even greater significance. To some, visiting the museum allows them to find the solace, inspiration, and hope that the current poisonous political partisanship and racial antipathy will one day be overcome.

My first interaction with the Trump administration took place just prior to the inauguration. We were contacted in order to facilitate a visit to NMAAHC. The incoming president wanted to tour the museum on the holiday celebrating Martin Luther King Jr. I had no problem with the request until they added a caveat: the museum would need to be closed to the public. The notion that we would shut out visitors on the first King holiday since the opening of the museum was not something I could accept. So the tour was cancelled. We were then alerted that the now president would visit the museum in February, along with Dr. Ben Carson, the Senator from South Carolina Tim Scott, and Alveda King, a niece of Dr. King. I had hopes that President Trump's visit to NMAAHC in February 2017 would contribute to a broader understanding of race relations in America. I am ever the optimist.

Before President Trump arrived, I was confronted by several of his senior staff who expressed concern that the president was in a foul mood and that he did not want to see anything "difficult." Waiting along with Secretary of the Smithsonian David Skorton, I wondered what kind of tour I should provide. I decided that I would begin the visit in an area that explores

the slave trade and the institution of slavery. It was not my job to make the rough edges of history smooth, even for the president. When he arrived, he greeted the Smithsonian contingent warmly and expressed how much his wife Melania had enjoyed the tour I provided her and Mrs. Sara Netanyahu, the wife of the Israeli prime minister, two weeks earlier. As we descended via elevator into the History Galleries, I tried to find ways to engage President Trump by explaining that the slave trade was the first global business and how its impact reshaped the world in ways that still resonate today. As we continued through the gallery, we approached a section that examined how nations like Portugal, England, and the Netherlands profited immensely from transporting and selling millions of Africans. The president paused in front of the exhibit that discussed the role of the Dutch in the slave trade. As he pondered the label I felt that maybe he was paying attention to the work of the museum. He quickly proved me wrong. As he turned from the display, he said to me, "You know, they love me in the Netherlands." All I could say was let's continue walking.

There is little I remember about the rest of the hour we spent together. I was so disappointed in his response to one of the greatest crimes against humanity in history. Here was a chance to broaden the views and the understanding of the incoming president and I had been less successful than I had expected. As we toured the Civil Rights era, President Trump stopped for a photo op with the White House Press corps, with the president and Alveda King pausing and posing near our exhibition on MLK Jr. There the president proclaimed the greatness of King in his usual cursory manner. During the remainder of the tour, Trump showed real enthusiasm at two points. When we stopped at an exhibition that chronicled the medical career of Ben Carson, his newly appointed Secretary of Housing and Urban Development, President Trump rightly celebrated the medical brilliance and early career of the gifted surgeon. The other exhibition that engaged the president was the examination of Muhammad Ali's career in an area entitled "We shook up the world." The president and I shared our stories about Ali and what he meant to America. I learned that the president had participated in bankrolling many of Ali's fights. That was news to me.

The president's visit ended with a press conference in the museum's main public space, Heritage Hall. Speaking to the White House Press corps, I was pleased that the president congratulated the Smithsonian Institution on this "worthy" effort. And he acknowledged my role. He also used this platform to respond to criticism that he had not addressed the anti-Semitism that seemed on the rise in America. Some journalists later wondered why he

used NMAAHC as the background to explore anti-Semitism but that did not bother me. We built the museum to be a vehicle to challenge America to live up to our country's ideals, so discussing issues of intolerance and religious bigotry within this museum was more than appropriate. I spent much of that day awaiting the president's preferred form of communication, a tweet. When he finally tweeted about his visit, he called the museum and me "amazing." I will take what victories I can get.

A key factor in the museum's success was the ability of the Smithsonian to work through the very different presidential administrations, to build the relationships that made the development of NMAAHC a visible priority regardless of who was in the White House. Having similar successes in the building at the other end of Pennsylvania Avenue, the US Capitol, required different strategies that too relied upon my ability to make friends. The Smithsonian Institution was usually a safe place where supporting the most significant museum complex in the world was not problematic for members of Congress for the nearly thirty years I worked at the Institution. There were, however, key moments where Congress, engaged in what generally were described as the "culture wars," attacked the Smithsonian for being too liberal, an example of political correctness run amok or even anti-American.

My career had seen Congress threaten and occasionally hurt the Smithsonian over exhibitions like that of the National Air and Space Museum's commemoration of the end of the Second World War that featured the airplane that released the atomic bomb on Hiroshima, the Enola Gay. As a result of criticism from veterans and especially members of Congress, the Institution was forced to make significant changes, summed up by a *New York Times* headline, "Smithsonian Substantially Alters Enola Gay Exhibit After Criticism." I knew that NMAAHC would enjoy even greater scrutiny at a time when I needed congressional appropriations to grow. I realized that managing Congress was an oxymoron. There was no way that I could control or even influence the 535 voting members in both houses of Congress. But I remembered how important visible and vocal support could be so I developed a strategy based on the fact that all I needed were thirty angels in the House and Senate who would speak favorably about the museum or use their influence in the cloakrooms and hallways to quiet any criticism that I was sure would arise. While the Illinois delegation was key to this strategy, I needed to ensure that our support flowed from both Democrats and Republicans from both urban and rural districts. Fortunately, Cheryl Johnson, my head of government relations, had worked in Congress for nearly two decades and she

had the skills and the contacts I lacked. It was her creativity that inspired the tactics that allowed me to successfully implement these plans.

As with almost every aspect of the museum's development, visibility was essential. With Cheryl's guidance, we spoke to a member of Congress every week, often when I made the rounds on the Hill. We began with all the House and Senate appropriators who controlled our access to federal dollars and then regularly visited members that Cheryl felt were important to court. The regular trips to the Hill were necessary because the museum needed an unusual combination of support for both the construction costs and the expansion of the museum staff. We worked with key legislators, and they helped us determine what aspect of our needs to privilege every fiscal year. To gain the favor of legislators, we knew we had to be seen as valuable to the member or to their constituencies. This meant I made myself available for speaking engagements both in Washington and in their home districts.

I found it very useful to offer to make presentations involving American history or African American culture in the Capitol and Senate and House office buildings. Since it was impossible for me to travel to every congressional district, we decided that speaking at major events on the Hill was a worthwhile alternative. Plus, I had been on enough planes that I appreciated any opportunity that did not require me to take my shoes off at Washington's National Airport. When the legislature had the Congressional Medal crafted to honor Martin Luther and Coretta Scott King in 2014, the Speaker of the House at that time, John Boehner, asked me to be the only historian to speak at the event. It was stressful following speeches by the Speaker, Minority Leader Nancy Pelosi, and John Lewis, but the visibility and the sense that Congress recognized that the museum and I could be quite useful. That usefulness became political capital that we used sparingly and effectively over the coming years.

I made several other presentations on the Hill, but the one that mattered the most to me was being asked to speak at the Congressional ceremony commemorating the assassination of Dr. King, fifty years later. Once again, Nancy Pelosi along with Speaker Paul Ryan asked for my participation. When I learned that in addition to members of Congress I would be joined by Dr. King's son, Martin Luther King III, the occasion took on special meaning. I recalled the day that my family was traveling back to New Jersey after spending time with relatives in North Carolina. Unaware of the assassination, we drove into Washington, and I remember my mother wondering why there was so much smoke on the horizon. By the time we reached the home of an uncle near Georgia Avenue in the Northwest quadrant, the city felt

like a combat zone. That night I recall hiding in bed, hearing voices outside screaming "They killed the dreamer. What happens to the dream?" To be able to share those memories and to discuss the importance of Martin Luther King's commitment to economic justice for all Americans was a political message I thought was necessary to share with a divided Congress. I became emotional as Dr. King's son spoke not only of his father's legacy but also of the importance of the museum to ensure that future generations never forget the vision and the sacrifice of his father.

Cheryl believed that my presence and my passion for history should be felt outside the nation's capital. She helped to determine what districts I should visit. For example, she suggested that it was important to create excitement among African Americans in Mississippi to bring the project to the attention of that state's delegation. In 2014 I spoke at a Black History Month program in Tupelo, Mississippi, sponsored by Senator Roger Wicker, where I was introduced to leaders within the black community and was taken to all the Elvis Presley sites in his hometown. The following year I returned to Mississippi to bolster our congressional support by visiting the new Museum of Mississippi History and the Civil Rights Museum in Jackson. I was hosted by Representative Gregg Harper, and this visit not only sparked interest and excitement throughout the state but also allowed me to strengthen my relationship with the congressman whose influence helped greatly in the appropriation process. I went on numerous sojourns including participating in Congressman John Lewis's annual civil rights pilgrimage to Alabama that enabled me to spend time with a diverse array of legislators from Steny Hoyer (Maryland) to Eric Cantor (Virginia), both leaders within their respective parties, to Virginia Senator Tim Kaine, whose mastery of the blues harmonica was one of the highlights of the journey to the Mississippi Delta.

My visits were not the only way we demonstrated the museum's value in local communities. Part of the calculus in deciding where our Save Our African American Treasures program would hold an event was the political support and influence that would result from a visit. When we wanted to bring the "Treasures" program to Texas, we decided that Houston would be a good location because of the history of the African American community in the city but also because it would help us court the local Congresswoman Representative Sheila Jackson Lee. Or locating the program in Newark, New Jersey, would help gain the attention of Senators Cory Booker and Robert Menendez. Beginning the "Treasures" program in Chicago was a way to express my appreciation to Senator Richard Durbin and the supportive

congressional delegation. Everything we did during the eleven years prior to the opening was much like a political campaign: gathering support, being seen, crafting a value proposition, and implementing the strategy in a manner that was consistent yet flexible.

While the museum had many supporters, the one consistent champion who was willing to spend his political capital for an endeavor outside of his congressional district was James Clyburn who represented Columbia and Charleston, South Carolina. Our initial meeting where I was introduced to Clyburn was underwhelming and did not foreshadow our future partnership. Early in 2006, Kinshasha Holman Conwill and I were invited to attend the weekly luncheon of the Congressional Black Caucus (CBC) by the then chair Mel Watt. While the CBC had voted to authorize the creation of the museum, there were doubts that it would ever come to fruition. So I traveled to the Hill to cement their commitment. I was told I had fifteen minutes to speak but what I did not know was that this time was over lunch and it would be difficult to keep the group focused. Clearly eating and socializing was the priority. I was convinced few heard my pleas for their assistance and even fewer seemed to care. As result of such a disappointing convening, I scheduled a separate meeting with Clyburn because he was an influential member of the CBC and in the upper echelons of the Democratic leadership in the House of Representatives. The congressman was formerly a history teacher. I came to realize that Clyburn was one of the few members of Congress who could teach history to a historian. He became an ally and then a friend. Whatever the museum needed the congressman would always come to our aid, be it calling the Office of Management and Budget to nudge our request, or using his influence to ensure that the museum's request for an increased appropriation was protected as it moved through the House budgeting process, or publicly associating his name with the museum from its earliest incarnation. I do not think we could have completed the museum in eleven years without the commitment and political savvy of James Clyburn.

Courting the members alone would not have guaranteed success. Part of Cheryl Johnson's skill was recognizing that it was the staffers who served on the committees or who were the liaisons with the members that were key factors in moving the process forward. As in so many organizations, it is the staff that makes crucial decisions and can determine the success or failure of an initiative before it reaches the desk of a legislator. Cheryl facilitated relationships with staffers such as Michael Collins, the chief of staff for John Lewis, or Yelberton Watkins who served the same function for Jim

Clyburn. Cheryl's long association with the House committees introduced me to Virginia ("Ginny") James, the member of the staff who worked nearly a decade to cobble together the funding the museum needed. Ginny, another person shaped by New Jersey, was a senior staff on the Senate Appropriations Committee. Numerous times, we would meet with Ginny and plot out how we could safeguard or increase our budget requests. Staffers like Ginny used their knowledge of the systems and the politics of Congress to protect the museum when so many amendments or the special projects of the members could have derailed our progress. The museum owes a great deal to House and Senate staffers like Ginny James.

As diligently as we worked with Congress, we could not control or foresee criticism or issues that could hamper the museum's progress. As the museum's profile increased, so did the scrutiny. I was surprised to learn that one of the Smithsonian's most consistent supporters, Congressman James Moran from northern Virginia, expressed reservations to the Secretary of the Smithsonian about the museum's existence just prior to groundbreaking in 2012. I was concerned, so I immediately made my way to his office. Clearly uncomfortable, the congressman applauded my efforts, but stated quite strongly that he did not believe there should be a black museum for black people on the National Mall. He talked about his belief that segregation was wrong, but then revealed that he was interested in supporting an idea for a museum of the American people that was being floated as a response to the creation of NMAAHC. After he paused, I think he was taken aback when I said I agreed with him: there is not a need for a black museum for black people. Rather, I argued, NMAAHC is a museum that is quintessentially American and will be one that uses the African American experience as a way to reveal how much we are connected by this experience. I found out a few days later that he found my explanation more than satisfactory. He mentioned to a senior Smithsonian leader that he hopes they don't hire directors like Lonnie Bunch because if "they are as persuasive as Lonnie, we will have dozens of new museums on the Mall."

Shortly after NMAAHC opened in the fall of 2016, I found the museum and my scholarly objectivity called into question by certain members of Congress who threatened to formally censure me because of what they believed was a political decision to omit Associate Justice Clarence Thomas from the museum's exhibitions because he espoused a conservative philosophy that was an anathema to my supposedly liberal agenda. In the House this effort was led by a conservative member, Earl "Buddy" Carter who represented

the Georgia district where Justice Thomas was raised and in the Senate by Tim Scott of South Carolina and John Cornyn from Texas. I anticipated criticism from many quarters but not over the presence of Clarence Thomas in the museum. The resolution that was introduced in the House or Representatives in December 2016 begin by "Recognizing the historical importance of Associate Justice Clarence Thomas." After a long series of "Whereas," the motion honed in on their argument. "Whereas the Museum omits the contribution made by Justice Thomas to the United States." It concluded with the demand that "the life and work of Justice Thomas . . . should have a prominent place in National Museum of African American History and Culture." I was frustrated and worried that something like this action could color and tamper the enthusiasm and relief I felt once the museum opened. I saw, once again, how the Smithsonian could easily become a pawn in larger political debates.

Ironically, Justice Thomas was always present in the museum as part of an exhibit that mentioned both his career and that of Thurgood Marshall. Much of the criticism came because some felt he was not prominently displayed and others chafed at the visibility the museum attached to Anita Hill, whose sexual harassment claims against Clarence Thomas almost derailed his appointment to the Supreme Court, as a symbol of how the media in the last twenty years explored black life. I made clear to the senior leadership of the Smithsonian that this was not a NMAAHC issue but one that involves the entire Smithsonian. If Congress can override scholarship and curatorial integrity and determine who or what should be in a museum, it is only a small step to regulating content and deciding what should be removed from the walls and galleries. I was pleased that Secretary David Skorton agreed with my position and made clear that they were decisions that needed to remain the purview of the Smithsonian. This resolution was never brought to a vote because the Speaker of the House, Paul Ryan, realized that Congress had much more to worry about than a picture or a label in a museum.

I have always believed that the job of any museum director, but especially one at the Smithsonian Institution, required skills that one rarely learns in graduate school. It is not enough to be smart or to be a content expert. One needs to hone not only one's political skills but also to embrace the diplomacy and street smarts that are now required for effective leadership. And I was lucky. I had gifted and knowledgeable colleagues like Kinshasha Holman Conwill and Cheryl Johnson who contributed mightily to the museum's ability to navigate the shifting political currents of three

presidential administrations and twenty-six sessions of Congress. My success was based on developing personal relationships with key elected officials and being strategic about how and when to utilize that personal capital. And having the ability to share a vision about an America made better by a museum, by a culture, and by a community.

Exhibiting American History Through an African American Lens

Making a Way Out of No Way

*Thus saith the LORD, which maketh a way
in the sea, and a path in the mighty waters.*

—Isaiah 43:16

I have a curatorial ritual that I have followed since I was a young curator at the California African American Museum in the 1980s. Whenever I create an exhibition I spend time walking through the gallery just prior to its opening to the public. This is my time to say goodbye, to reflect on the work and the collaborations that made the show possible. Once the public enters an exhibition it is no longer mine. The impact, the interpretive resonance, and the clever (or so I hoped) visual juxtapositions are now for the public to discover.

So, on September 16, 2016, the last day before a series of preopening receptions that would shatter the silence of creation, I walked through all 81,700 square feet of the inaugural exhibitions of the National Museum of African American History and Culture, saying my farewells and marveling at what we had created. I reveled in the 496 cases needed to house the collections, the 160 media presentations, the 3,500 photographs and images

that peopled the galleries, the 3,000 artifacts winnowed down from 10,000 objects that were considered for exhibition, the 15 cast figures whose likenesses were eerily accurate, and the special typeface created for the museum by Joshua Darden, an African American typeface designer. I cried again as I was confronted by the exhibit that displayed the more than 600 names of the enslaved whose lives were forever changed by the separation of families and friends during the domestic slave trade that reached its apex during the forty years prior to the start of the Civil War in 1861. And my sadness turned to anger as I read the names, once again, of the ships that transported so many Africans to a strange new world. But more than anything else, I simply said goodbye.

The creativity and effort needed to get to that day had been herculean. It had taken an army of designers, researchers, curators, educators, project managers, and me. It was unusual for a director to take such an active role in helping to shape every presentation. I decided to put my fingerprints on every product, every publication, and every exhibition because I remembered something an exhibition designer had said to me during my tenure in Chicago. There was a desire to transform the Chicago Historical Society so it could be rebranded as a museum rather than a historical society. I hired a designer whose work had profoundly shaped my first major exhibition in Los Angeles, The Black Olympians, someone whose judgment I trusted. It had been a curatorial-driven effort and I set the tone but stayed out of the scholarly and content decisions. Several months into the design process the contractor came into my office and chastised me. He wanted to know why I was not helping my staff. "You are considered one of the strongest curators around but you are not sharing your knowledge and experience with your staff."

His words stayed with me as we began to develop this museum's exhibition agenda. I had years of curatorial experience and a keen sense of what makes engaging and essential exhibitions, which I vowed to share with my colleagues at NMAAHC. More importantly, I had a clear vision of what the exhibitions should explore, how they should educate and involve the visitors, and in what ways these presentations could bring a contemporary resonance to historical events.

I have often been asked if there was another museum that was a model for our efforts. There was no single museum that I could point to as one to emulate. There were, however, bits of exhibitions that informed my thinking. I had never forgotten the evocative and powerful way Spencer Crew's work in his exhibit Field to Factory captured the small details of African American

migration, such as the child on the train with a basket of food that reminded the visitors that travel for African Americans in the segregated South was fundamentally different from the same experience for white Americans. Or the manner in which the Holocaust Memorial Museum boldly embraced the challenge of exhibiting painful moments, such as a case full of shorn hair or the railcar that transported people to the death camps. I always think about the strangely titled museum in Beijing, the Chinese People's Anti-Japanese War Resistance Museum, which had a contemplative space that encompassed hundreds of bells, as if each bell tolled for someone lost during the invasion of China. I learned much from Te Papa, the Museum of New Zealand, a cultural institution that used a few artifacts in a theatrical setting that spoke not of history, but of how people remembered that past and the ways those memories shaped national identity. And my own work in Los Angeles on the Olympics used cultural complexity and social history as ways to understand how the Olympics transcended sport. I also recalled how the exhibition curated by Gretchen Sullivan Sorin, Bridges and Boundaries: African Americans and American Jews that was mounted at the New York Historical Society, embraced the challenge of interpreting the recent past such as the violence confrontations between blacks and Jews in Crown Heights, New York City.

I needed the exhibitions at NMAAHC to build upon the earlier creative work of other museums but not be held captive by prior curatorial efforts. My vision for the museum's presentations was shaped both by philosophical concerns and the realities of being part of the wonderfully complex and imaginative Smithsonian Institution. After reviewing the mountain of material contained in the audience surveys taken as part of the prebuilding planning, it was clear that the public had a limited understanding of the arc of African American history. I felt that a portion of the exhibitions needed to provide a curated historical narrative. We found it necessary to provide frameworks that would help the visitor navigate the complexity of this history and also create opportunities for the audience to find familiar stories and events that made the museum more accessible, something that was reinforced by some of the criticism directed at the National Museum of the American Indian. Visitors at NMAI had been confused by the lack of a visible narrative that served to deconstruct and make the history of Native Americans more comprehensible. I understood the scholarly reticence to craft an overarching framework narrative because that reduces the complexity of the past and privileges some experiences over others. In a museum, however, the audience searches for the clarity that comes from a narrative that offers guidance and understanding.

The exhibitions within NMAAHC presented a framework that sought to recenter African American history and issues of race in the public's understanding of America's past. Usually Americans have traditionally viewed questions of race as ancillary episodes, interesting but often exotic eddies outside the mainstream of the American experience. Thus, it was important for the museum to demonstrate through its interpretive frameworks that issues of race shaped all aspects of American life: from political discourse to foreign affairs to western expansion to cultural production. And using both the scholarship that undergirded the exhibitions and the imprimatur of the Smithsonian, the museum could stimulate national conversations about the historical and contemporary challenges of race. Americans are sometimes obsessed with racial concerns, but the conversations tend to remain within their own communities. We hoped that NMAAHC could generate discussions across racial and generational lines that were meaningful, complex, and candid.

The exhibitions that the museum hoped to create would use extensive storytelling to humanize history, to people the past in order to make the recounting of history more accessible and more relatable. By personalizing history, we wanted the visitor not to explore slavery, for example, as an abstract entity but to experience it as a way to learn to care about the lives of those enslaved, those who had hopes, shared laughter, and raised families. For the presentations to be successful they had to give voice to the anonymous, make visible those often unseen, but also provide new insights into familiar names and events. Thanks to advice from people like Oprah Winfrey, we knew that the stories must be accurate, authentic, and surprising. That is why the museum exhibitions would make extensive use of quotations and oral histories that would let the voices of the past, the words of those who lived the experiences, drown out or least tamp down the traditional curatorial voice. It was also essential that the stories the museum featured reflect the tension between moments of pain and episodes of resiliency. This must not be a museum of tragedy, but a site where a nation's history is told with all its contradictions and complexity.

I also wanted the exhibitions to have a cinematic feel. As someone who revels in the history of film, I needed the visitor to find presentations that were rich with drama, cinematic juxtapositions, with storylines that elicited emotional responses and interconnectivity so that the whole museum experience was a shared journey of discovery, memory, and learning.

I hoped that the exhibitions would also be cognizant of the tension between tradition and innovation. While I believed that the exhibits needed

to be shaped by rich and interesting collections, I also understood that developing a museum in the twenty-first century meant that technology would cast a larger shadow than it had earlier in my career. Even though the collections would be a key element, we needed to embrace technology as a means to enrich the artifact presentations, provide opportunities to delve more deeply into the history we presented, and to provide ways for younger audiences to access the past through contemporary portals. The stories we explored should be comprehensive, with breadth and depth worthy of both a national museum and the history of black America: exhibits that placed issues of gender and spirituality at the heart of our exhibitions. I also challenged the staff to remember that the African American community, that America, deserved our best efforts. To use a phrase from my college days, there would be "no half-stepping allowed." Every aspect of the exhibitions had to reflect a commitment to excellence.

I believed that my vision would enable the museum to make concrete a past often undervalued. But even more important was the need for the exhibitions to help all who would visit understand that this museum explored the American past through an African American lens in a way that made this a story for all Americans. Ultimately, the exhibition must fulfill Princy Jenkins's admonition by helping America remember not just what it wants to recall but what it needs to remember to embrace a truer, richer understanding of its heritage and its identity.

This was an ambitious and challenging proposition, especially for the small, initial core team of Tasha Coleman, John Franklin, Kinshasha Holman Conwill, and the recently hired curators Jackie Serwer and Michèle Gates Moresi in 2006. This group would meet daily in a conference room lined with large sheets of yellow paper where we wrote down every idea, every hope, and every challenge we had to overcome. The biggest hurdle was the need to plan and later design exhibitions without a significant artifact base to draw upon. The best we could do was to draft broad exhibition topics that the museum needed to address—slavery, the military, labor. We could not finalize the specific interpretations and directions until we obtained collections that carried the stories we felt were important. In essence, crafting the exhibitions, much like every aspect of this endeavor, felt like we were going on a cruise at the same time as we were building the ship. Everything was in flux and all our best ideas remained tentative. From the very beginning we all had to be comfortable with an ambiguity that complicated our efforts.

We also had to find ways to distill the five decades of scholarship that emanated from the work of generations of academics whose research had

made the field of African American history one of the most vibrant and extensive areas of study in universities. How did we guarantee that our exhibitions reflected the most current scholarship? And how did we navigate the ever-changing interpretive debates? What kind of exhibitions were needed if we were to help Americans grapple with their own culpability in creating a society based on slavery, or a nation that accepted segregation as the law of the land? We quickly realized that starting with nothing but a dream was liberating and unbelievably frightening. The ultimate success of our exhibition efforts was dependent upon the nimbleness of the growing curatorial and educational staff, the organizational and planning capabilities of the museum's Office of Project Management (OPM), and the collaborations that were forged with our university colleagues.

Academics are usually described as the smartest kids in the class who never learned to play well with others. This was not the case during the creation of NMAAHC. I was gratified by the generosity of the scholarly community. While I always assumed I could depend upon the many friends I made in universities, the positive responses and the willingness to help a project that all saw as important was overwhelming. Almost no one refused our calls for help. Political and scholarly debates were an element of this work, but those disputes were usually set aside for the good of the museum. Very early in this process I wrestled with how the museum should interpret slavery. I believed that exploring the "Peculiar Institution" (a nineteenth-century name for slavery) was essential for an America still struggling to embrace the history and the contemporary resonance of slavery. During a discussion with Alan Kraut, one of my former history professors at American University, we focused on my commitment to presenting a major exhibition on slavery that explored the lives of the enslaved and the influence slavery had on antebellum America. Kraut solved my dilemma when he said simply: "The framework should be slavery and freedom." His suggestion made clear the duality of the African American experience that the museum needed to explore; it was both a fight for freedom, fairness, and equality; and it was the challenge not to define Black America as simply a source of struggle.

The most consistent and important academic vehicle that shaped NMAAHC was the Scholarly Advisory Committee (SAC) that was created in 2005. On paper, it was formed to provide intellectual guidance and be a conduit to the best scholarship coming out of universities. Chaired by John Hope Franklin, the revered dean of African American historians, SAC was the Smithsonian's way to shield the nascent museum from criticism that scholarship was not at the heart of the endeavor from its inception. It is true

that SAC was the intellectual engine, along with the curators, of NMAAHC. Yet SAC was so much more. It was a cauldron of scholarship and camaraderie that made our ideas better and brought forth new insights and interpretive possibilities.

Just being with John Hope Franklin was a learning experience for everyone in the room. I felt blessed, a word I do not use lightly, to sit next to John Hope during those meetings. I had always regretted not being one of his graduate students, but now I was given the chance to learn, to be schooled by one of the most gifted and well-known historians of the twentieth century. As a child, whenever the family dined together, my father would discuss issues that he thought we should understand. I don't remember how old I was when he spoke about a history course he had taken at Shaw College in the 1940s and how impressed he was with the writing of someone named John Hope Franklin. I am sure that he was the only historian my scientist father ever mentioned to me. I felt as if my father was with me as John Hope whispered ideas and historiographical concerns that only I heard. John Hope guided and prodded the group—and the museum—to find ways to tell the unvarnished truth and to use African American history as a mirror that challenged America to be better, to live up to its ideals. John Hope's presence and authority inspired us all to do work worthy of the career and spirit of this groundbreaking historian. He committed the final years of his life to the museum and I would do everything possible to ensure that his efforts were rewarded by a museum that honored his life and legacy.

In addition to John Hope, SAC was a gathering of leading historians like Bernice Johnson Reagon, Taylor Branch, Clement Price; foremost art historians, such as Richard Powell, Deborah Willis, and Alvia Wardlaw; innovative anthropologists and archaeologists, including Johnnetta Betsch Cole and Michael Blakey; and educators of the likes of Drew Days, Alfred Moss, and Leslie Fenwick. I guess the best way to describe the intellectual energy, the vibrant and candid discussions, and the spirit of fellowship and collaboration that was evident at every one of those gatherings is to say that attending a SAC meeting was like a wonderful Christmas gift that made you smile and made you better. These were exceptional scholars who became close friends and who gave of their time—attending three or four meetings annually—and shared their life's work. For all of that, their compensation was our gratitude and the knowledge that NMAAHC would not exist without their generosity. The ideas that flowed from those sessions were reflected in many of the curatorial decisions that would shape the inaugural exhibitions. We discussed every aspect of history and culture, including the difficult task of filtering out

stories, individuals, and events that, though worthy, could not be included in the exhibitions. These discussions were passionate and candid but always respectful and productive.

At each meeting, a curator or myself would present exhibition ideas and later complete scripts for discussion. I can still feel the heat from Bernice Johnson Reagon whenever she felt that issues of gender were not as central as they needed to be. I smile when I recall the carefully considered and gentle prodding of my dearest friend Clement Price as he reshaped our interpretation of postwar urban America. Michael Blakey and Alvia Wardlaw spent hours pushing us to embrace artistic and archaeological complexity more fully. And Alfred Moss made sure that our notions of religion and spirituality encompassed a diversity of religious beliefs and practices. Our ideas sharpened as Drew Days and Taylor Branch helped us see the subtle nuances at work during the Civil Rights Movement.

As a result of one SAC meeting, the museum discovered a phrase that would provide the glue to bind together every exhibition we would create. Johnnetta Cole and Bernice Johnson Reagon responded to a curatorial presentation that sought to examine the manner in which change occurred in America by referring to a biblical quotation in Isaiah 43:16. "Thus saith the LORD, which maketh a way in the sea, and a path in the mighty waters." Which meant that God will make a way where there seems to be no way. That idea, of making a way out of no way, became not only the title of the proposed exhibition, but also a way to understand the broader African American experience. Almost any story that the museum exhibited ultimately revealed how African Americans made a way out of no way. Despite the odds and the oppression, blacks believed and persevered. Making a way out of no way was more than an act of faith, it was the mantra and the practice of a people.

In time, every curator and educator presented to SAC. SAC nurtured the staff with tough love. Often the precepts of the presentations were challenged and occasionally rejected, but the staff was better for the experience. And the final exhibition products were finely tuned and highly polished after undergoing what I called the "SAC touch."

The Scholarly Advisory Committee was our rock for more than a decade. We counted on their guidance and on their candor and even their criticism. The work of SAC was buttressed and expanded by an array of historians who also contributed to the shaping of the museum. I wanted the curators to experience the differing interpretations of African American history so that their work was placed within those scholarly contexts. We accomplished this by participating in what I called "dog and pony" shows with

colleagues around the country. I wanted to benefit from the diverse scholarly voices within university history departments. I contacted close friends and asked if they would organize a day where the curators and I would come to campus to discuss the museum's vision, our interpretive agenda, and explore the exhibit ideas that we were developing. All I asked for were a few bagels and a lot of critical conversation.

Among the many campuses we visited, I was so appreciative of Edna Medford who organized our sessions at Howard University; Eric Foner at Columbia; Jim Campbell at Stanford; and David Blight who agreed to host our very first meeting at Yale University. Our gathering in New Haven included historians, literary scholars, folklorists, and political scientists. The staff presented the tentative exhibition ideas to the group and then David Blight and I facilitated the discussion. So much was revealed during that day: how we needed to broaden our definition of culture; how central the use of literature would be to give voice to the history, and how important it was for the nation that the museum craft a complex yet accessible exploration of slavery. At Howard University, we wrestled with interpretive frameworks that would introduce our audiences to the intricacies of interpreting the Atlantic world and the continuing impact of the African diaspora on the United States. Edna Medford and her colleagues at Howard pushed the museum to find ways to examine how the recent migration of Africans to America, since the 1970s, that now outnumbered the total of Africans transported to the states during the era of slavery challenged our assumptions about the African American experience.

At Columbia University, my friend Eric Foner and his colleagues emphasized the need for the exhibitions not to shy away from either complexity or controversy. While much came from that meetings what I remember most was the presence of the late Manning Marable. Marable's work has enriched the field of African American history and I knew the museum would benefit from his contribution. What I did not realize was just how sick he was at the time. Despite his illness, he wanted to participate because, as he said to me: "I will do anything I can to help this museum create exhibitions that illuminate a history that is often misunderstood and underappreciated." Manning's presence reminded us what was at stake and how important our work was to scholars and to America.

The commitment of Manning Marable was echoed throughout the university community: preeminent scholars and professors just beginning their careers all offered their time and expertise to ensure that "the museum got it right." As the ideas and topics for the museum's presentations began to

solidify, each exhibition curator (there were twelve by 2015) had to present to me a group of at least five scholars who would work to help develop the shows. In essence, each exhibition would have its own scholarly advisory body to guarantee the academic integrity that was essential to our success. Ultimately, more than sixty historians in addition to SAC worked directly with the museum.

The culmination of that support came at a conference that James Grossman, the executive director of the American Historical Association, and I organized, The Future of the African American Past, in May 2016. This gathering was planned to be the first major event in the completed building on the Mall, but the realities of construction forced us to house the conference in my former home, the National Museum of American History. This symposium was both an opportunity to revisit a groundbreaking three-day conference in 1986 that assessed the status of Afro-American history, and to position NMAAHC as the site, generator, and advocate for the current state of the field.

This conference was a signature moment because I wanted my university colleagues to view this new museum as an essential partner and an opportune collaborator whose presence helped illuminate their work. I was humbled when the field embraced these sessions and this museum. Thanks to the creativity and connections of James Grossman, we were able to organize panels that explored, for example, the long struggle for black freedom, the changing definition of who is Black America, the evolving interpretations of slavery and freedom, race and urbanization, capitalism and labor, and the role of museums and memory. When I arose to speak at the session exploring the state of museums, I was stunned to behold a standing ovation from my university colleagues. This meant so much, not just to me but to all historians who labor in museums and in fields outside of the university. Early in my career, those labeled "public historians" were considered second-class citizens, academics who could not make it in the academy. Though attitudes slowly changed, this positive embrace by the totality of the profession, I hoped, signaled a new and greater appreciation for educational reach and public impact of those who are not university professors.

The guidance provided by SAC, the university history departments that hosted the museum visits, the scholars associated with specific exhibition ideas, and the reams of data gleaned from audience surveys and focus groups all influenced our decisions about what displays to mount. The final determinations were made by the curators, educators, and myself as to what exhibitions would grace the galleries of NMAAHC and present our interpretations

of history and culture to the millions who would eventually come in contact with the museum. We decided that we needed a historical narrative, within a space designated as the History Galleries, which would guide the visitor's experience and provide a foundation for the rest of the museum presentations. This narrative would begin at some point prior to the creation of the American colonies and continue into the twenty-first century. There were many questions to be answered: should the exhibition start in Africa? how should slavery be remembered and interpreted? how should racial and sexual violence be presented? how hopeful should the exhibition be? and how does the museum ensure that the exhibitions are not seen simply as a progressive narrative, a linear march to progress?

We then determined that we needed a floor of exhibitions that explored community. Here it was necessary to examine the regional variations of African American life. But we also wanted to explore the history of African Americans in sport and within the military through the lens of community as well. Most importantly, we needed to create an exhibition that responded to a notion that appeared quite consistently in our audience research: the inevitability of racial change and progress. We had to find ways to help our visitors understand and problematize just how change happened in America and that nothing was inevitable, not freedom, not civil rights, not economic mobility.

The third gallery would be dedicated to an exploration of the diversity of African American culture. It was important to frame culture as an element of the creativity of a people but also as a bulwark that empowered African Americans and helped them to survive and even thrive despite the racial strictures that were a constant reminder that all was not fair and free in America. This floor would house exhibitions that explored African American music, featured African American fine art, examined the role occupied by African Americans in the performing arts of film, theatre, and television. All of these presentations would be contextualized by a major exhibit that looked at the various forms of cultural expression from foodways to speech to fashion and style.

As with all the galleries, the challenge would be how to determine what aspects of this history to omit due to spatial concerns or the lack of an artifactual presence. As the son of two teachers and the spouse of a museum educator, I believed the museum also needed to dedicate significant square footage to our educational agenda. We wanted a floor that would contain classroom space, technologically sophisticated and yet accessible interactives that would broaden our ability to service a variety of learning styles, and an area that would house a center that aided visitors with genealogical

research. Additionally, because of the uniqueness of both the building and the long saga of the museum, I needed a modest presence somewhere in the museum that deconstructed the structure and shared the process of creation.

There was to be one other interpretive space within the museum. I had always been impressed with the Mitsitam Café within the National Museum of the American Indian. That museum had made a brilliant use of the restaurant by serving Native American cuisine from a variety of regions: buffalo burgers from the Southwest, clams from the Northeast. NMAI used the café as part of the way it introduced visitors to the diversity within the native communities. I borrowed freely from their creation. I wanted a café within NMAAHC that would use food to emphasize the regional variations within black America. I sought to turn the entire café into a family friendly interpretive space that would explore the role and the preparation of food in African American communities. Yet this would be more than a living gallery, it would also serve exceptional cuisine. After all, if visitors to the Smithsonian were willing to pay fifteen dollars for a mediocre hamburger, why would they not spend the same amount for shrimp and grits or chicken smothered in gravy?

While the curatorial and scholarly discussions helped to determine the types of exhibitions the museum would display, answering many of the questions we raised and determining the exact flow, pacing, placement, and look of the exhibitions required a team of exhibition and graphic designers with the capacity to handle such a massive endeavor and the courage and creativity to help us be bolder than we could have imagined. Initially I wanted to hire three distinct design teams, each assigned to either the history, community, or culture gallery. I worried that the visitors exploring so many galleries would experience "museum fatigue." Having three different teams designing distinct spaces would, I hoped, energize and not tire out our audiences.

Lynn Chase, who oversaw the Smithsonian Office of Project Management, argued that having three independent design firms would be a logistical and contractual nightmare. Working through the contracting bureaucracy of the Smithsonian, she suggested, would add years to this endeavor as the federal process would be a drag on my need to move quickly. Lynn was right. I eventually trusted Ralph Appelbaum Associates (RAA) with this crucial task. To many outside of the museum, hiring the architectural team to design the building was the most important decision I would have to make. I disagreed. Bringing on the designer who would work closely with a large team of educators, curators, collection specialists, and project managers to produce the

exhibitions upon which the reputation of the museum rested was my most significant and thorniest decision.

RAA had a history of designing exhibitions on the scale and the importance of those we envisioned at NMAAHC, including the United States Holocaust Memorial Museum in Washington, DC, the Canadian Museum for Human Rights in Winnipeg, and the National Constitution Center in Philadelphia. Yet I was hesitant. I knew that RAA had mastered the creation of twentieth-century exhibitions, but I was unsure if the firm could help the museum identify and address the challenges of audience and technology that would be at the heart of the twenty-first-century exhibition development. As a result of some preliminary interaction with the firm's principal, Ralph Appelbaum, RAA developed an impressively diverse team that included millennials whose comfort levels with issues of race and interest in embracing a multigenerational audience convinced me that our partnership could produce memorable work.

Though the process benefitted from the insight and presence of Ralph Appelbaum, our group worked closely with Melanie Ide who led the design team. Each exhibition was assigned a museum team that included curators, historians, project managers, and educators. They worked with RAA to identify storylines, interpretive goals, key artifacts in the museum's collections, and the visual look of the exhibition. There were literally hundreds of meetings, dozens of staff, and thousands of pages of ideas and drawings that slowly sharpened the focus of the exhibitions. Unless I was on a fundraising journey, I tried to attend many of the meetings. I participated in the discussions helping to shape the character and the content of the specific exhibitions, but I also needed to provide oversight as to how the totality of our exhibition program fit together. This was a challenging process that was both exhausting and exhilarating. Part of the dilemma was that the curators had varying degrees of exhibition experience, which either slowed the development efforts or often allowed the designs to move in directions that were unsatisfactory. I know that it frequently frustrated the curators, but I intervened whenever I thought the exhibition designs did not reach the levels of excellence and creativity that we needed. To achieve the quality I wanted, the curators and designers had to become comfortable with revision after revision until I felt we had crafted an excellent exhibition that was visually engaging and educationally rich.

In working together for so many years with competing needs and the pressures of schedule, there were bound to be moments that were tense and testy. RAA needed closure so the process could move forward,

while the museum staff needed flexibility because they were still developing the curatorial posture and the acquisition of collections. The issue of the artifacts needed to finalize the design packages caused much consternation. NMAAHC had to find collections as the exhibition designs were being finalized in the meetings with RAA. Waiting to confirm the list of collections was, at times, infuriating to both sides. We agreed that we would include objects from "a wish list" in the initial exhibition design. As the material was collected, the "wish list" became the actual list. We agreed that we would set deadlines for each of the exhibitions and once the deadline passed the design would encompass only the artifacts actually in the museum's holdings. This put inordinate pressure on the curatorial team because they had to shape and reshape their work based on unearthing collections that we hoped could be found in time to have an impact on the design process. Usually we accepted the concept of the deadline. There were artifacts, found late in the process, that I demanded be included. The design package for the Slavery and Freedom exhibition was 90 percent completed when the curators found a stone auction block from Hagerstown, Maryland, where enslaved African Americans were torn from family and friends and examined like animals. This painful and powerful artifact was too important to omit, so RAA adjusted their plans, not without concern, but they recognized that they had to be flexible if we were to create the best products possible.

Despite the tensions, the brilliance and the creativity of RAA, thanks to the leadership of Ralph Appelbaum and Melanie Ide, led to an inspired design that created moments of wonder and inspiration. Shortly after the design meetings began in 2012, Ralph asked if we could meet to discuss a serious issue. I was surprised. It was too early in the process to be at a crisis point. Ralph understood that the museum needed to provide an in-depth overview of African American history. He posited that if we were to accomplish that goal, the History Gallery, located just below ground, needed to be expanded, from one level into a three-tiered exhibition experience. Ralph brought drawings that provided a better sense of what he was proposing. I was intrigued, but concerned that this idea would be a casualty due to the fact that both the architectural and construction planning was six months ahead of the exhibition development. This difference was caused by our inability to hire the exhibition design team until I raised the money to offset the costs. I was unsure of what to do. I had always said that you only get one shot to build a national museum—so the museum, in other words, me—should be bold and do what is right. This was one of the riskiest decisions I would make during the entire project. Do I make changes that will

slow the process of design and construction? Will it look as if I would change directions and earlier decisions on a whim? And was this a decision that I wanted to expend a great deal of my personal capital on this early in the building process?

I immediately met with the architects to gauge their reactions and assuage what I knew would be their fears about unplanned revisions because they would have to alter the design of the building foundation to account for the added depth that this change would require. During the discussions I could see that David Adjaye and Phil Freelon were apprehensive: did this action signal other changes that would need to be made to accommodate the design of the exhibitions? There were concerns about cost and schedule, but I believed we could find a way to make this work. So, I forced this fundamental change, which ultimately transformed the exhibition strategy within the building. To the architects' credit, they saw the possibilities of Appelbaum's ideas and soon shared my enthusiasm, just not to the same degree. I realized that if I was the museum's director then I had to lead, to do what I thought would strengthen the museum and give the public, especially the African American community, an institution worthy of their struggles and dreams. Today, the tiered History Gallery is one of the most distinctive features of the museum. I cannot imagine what the gallery experience would be if we had been forced to limit the content and collections to only one floor. As a result of this adaptation, the exhibitions convey a sense of rising from the depths of the past to a changed present and a future of undefined possibilities. This was the correct decision. There would be costs, both financial and political, but that was yet to come.

I was impressed with the ideas, large and small, that RAA brought to the design. RAA's use of entire walls emblazoned with the names of individuals affected by the domestic slave trade and the listing of the data about the ships that carried the enslaved during the brutal Middle Passage gave a sense of humanity and a better understanding of the scale of the international slave trade. The presentation was enriched by the display of the artifacts from the slaver, the *São José*, which would enable the visitor to understand this history through the story of the enslaved on a single vessel. RAA's creativity and sophisticated design aided the museum in its desire to make difficult stories of the past more meaningful and accessible to those who would one day explore the history we presented. And the idea to create vistas throughout the History Galleries so that the visitors would understand how the spaces, whether it was Slavery and Freedom, The Era of Segregation, or 1968 and Beyond, were all interrelated. The use of dates on the elevator shaft walls that

assisted the audience's transition back to the fifteenth century was another example of their imaginative design.

RAA's creativity is apparent throughout the museum. For example, in the Sports gallery on the third floor the use of statutes of athletic figures like Venus and Serena Williams or the manikins that capture the Black Power Olympics of 1968 not only reinforce the interpretations within the gallery but they also provide visitors with opportunities for selfies that document their visit to the museum and place them in history. Simple touches, such as exhibiting George Clinton's Mothership as if it were floating much like it appeared during the group's concerts, or the directional use of music throughout the galleries to aurally place the visitor in a specific time or place all contributed a great deal to the overwhelmingly positive reactions the exhibitions have received.

One area of the design that meant a great deal to me was the creation and implementation of the reflection booths. I had never forgotten how moving the stories were that we captured as part of our collaboration with Dave Isay and the StoryCorps Griot Program. I wanted to have a space where families could reflect not just on their museum visit but on their own history. RAA designed these booths with simple prompts that allowed the user to record stories about their families, the meaning of African American culture, or the reasons why they chose to spend time at NMAAHC. These recitations became an important part of the museum's archives and an opportunity to reinforce our commitment to sharing the stories of the past that are often little known.

Not every idea that RAA developed made a successful contribution to the exhibitions. The curators wanted to contextualize the stories that were in the History Galleries by using the words and images of the generation explored in the space. The placement of these reflections of a generation were not conducive to engaging the audience, nor did the design strengthen an idea that was, candidly, underdeveloped from a curatorial perspective. We spent weeks grappling with a design idea that was supposed to capture the feel of battle during the American Revolution and during the Civil War. These interventions, eight feet long and four feet in depth, were designed to create a movie set-like feel with props (not actual historic objects) that would provide the audience with a sense of what battles were like during these two wars. These pits were a compromise because the museum's interpretation of both the Revolutionary and Civil Wars downplayed the actual battles in order to explore the social and cultural impacts of these two key moments in American history: how the Revolutionary era began a process of that

emboldened the antislavery sentiment in many Northern states and how the Civil War was a watershed moment that changed the tenor and tone of America by enabling the conditions that led to the emancipation of 4 million enslaved African Americans. Other than a media overview that simulated the feel of war, we never settled on the effective use of those spaces. And the final design resembled an unexciting re-creation of a re-creation. It is one of the few aspects of the final exhibition installations that was unsuccessful. That said, the collaboration between NMAAHC staff and the team from RAA worked well, if the final product is any arbiter of success. While a great deal of the credit belongs to RAA, my colleagues at the museum were equal partners whose ideas and whose scholarship challenged RAA and in the end created a set of exhibitions driven by a strong curatorial vision that engaged, entertained, and educated.

Another unit in NMAAHC deserves much of the credit for this successful collaboration, the Office of Project Management. From the beginning of the creation of the museum, I knew that our ability to handle the myriad of tasks and issues that had to be addressed would determine the success or failure of our work. I believed an office that could coordinate and manage the tasks that emanated from the challenges of construction, exhibition design, curatorial and collections concerns, and object installation was an urgent necessity. To create this essential function, I turned to Lynn Chase, a no-nonsense colleague, who had worked with me for thirteen years at the National Museum of American History. She had managed significant projects while at NMAH, including the nineteenth-century exhibition and the traveling version of another exhibition in which I was involved, The American Presidency: A Glorious Burden. During my last years at NMAH, Lynn worked directly for me as my de facto chief of staff. Her ability to organize large-scale endeavors and her willingness to confront me over the years when she thought I was wrong convinced me that she was the person I needed. Under Lynn's leadership, talented project managers like Carlos Bustamante and Dorey Butter joined our growing staff and brought order and systems that helped in our organizational transition from a start-up to a full functioning museum.

I cannot overstate the value that Lynn and her colleagues brought to the museum's ability to identify and address the myriad of hurdles that we faced. Working with RAA, the Office of Project Management coordinated—and sometimes changed—individual calendars so that the hundreds of design meetings could be scheduled. OPM did more than schedule the assemblies: they shaped the agendas, prepped the participants, and illuminated areas of

debate that needed to be confronted. The OPM team was the fuel that allowed these gatherings to be productive. A large part of their work was the gentle prodding of all the participants from the curators to RAA's designers to confirm that progress was being made. No one was spared from the pressure to meet deadlines and make some headway no matter how incremental. And that included the director. Almost every day, Lynn would march into my office with a notebook full of issues and challenges that required my attention, my consent, or my curatorial experience. While there were times that I wanted a respite from Lynn's laser-like focus and intensity, I knew that her commitment to the museum and to me guaranteed that we would build the museum of my dreams. I am sure that without Lynn and her colleagues the process of design would have slipped and delayed the opening of the museum by several years. The efforts of the curators and the designers would receive most of the acclaim and attention, but the unsung heroes were the staff of OPM. They not only believed in the vision, they actually knew how to implement it.

The use of media was another factor in the successful interpretation of the African American past within the museum. RAA wanted the shaping and the production of the nearly 140 media pieces that enlivened the exhibitions to be under their direction. That would make a seamless relationship between the exhibition design and one of the most visible interpretive elements in the galleries. I decided to move in a different direction, though. I did this partly for reasons of budget but also for my own comfort level. As I have done so often in my career, I turned to someone from my past to help me overcome a particular problem. I contacted one of America's most talented producers, Selma Thomas, who I think is the queen of museum filmmaking. Selma has either made or produced some of the most important film work in American museums, including pieces that captured the Japanese American experience as part of the exhibition A More Perfect Union: Japanese Americans and the U.S. Constitution. Selma also produced films for the National Gallery of Art, the Franklin Institute, and the National Museum of American History, where she developed several projects for me, among them the American Festival in Japan.

Knowing that media was both a way to tell more complex stories within exhibitions and to attract younger audiences often drawn to film, I needed leadership that would help the museum craft media presentations that were integral to the interpretation of the exhibition subject. I had never been involved with a project that was so media rich. Selma's job was to help the curators and RAA decide what aspects of the history would be best explored through media, and how much would rights issues limit our use of

the medium. She was also in charge of overseeing the production so that the final product reflected the initial concept.

Complicating those tasks was the decision to work with the Smithsonian Channel. Initially my thoughts had been to work with the History Channel, a known entity that had produced films for me as early as 2000. In 2014, I was approached by the Smithsonian Channel. They were excited about the branding opportunities associated with the newest Smithsonian museum and offered to create all the media pieces we needed. Ultimately, that proposal swayed my decision. Its great appeal: it provided significant budget relief as the channel would bear all costs. Selma, then, had to be my liaison with the channel and evaluate every script and rough cut to maintain the quality and the interpretive clarity the museum demanded.

For the next two years, Selma attended design meetings, nurtured curators who had limited exposure to the medium of film, wrote concepts and rewrote treatments from the Smithsonian Channel that sometimes failed to meet our needs, oversaw research in film archives, and provided direction as each film was being developed. Selma raised issues that needed my attention. As a result, I also reviewed every media piece that would one day be shown in the museum. At least the days of half inch tape using unwieldy film and slide projectors were long gone. Selma would send me links to the films to my computer and I would then I would email her my comments to share with the directors hired by the Smithsonian Channel. Working with the Smithsonian Channel was not without hurdles, such as the need to have many more editing sessions than they normally do because of the museum's insistence that the films find a way to make complexity accessible and that the media pieces be shaped mainly by the curatorial vision. I do not want to downplay the contributions of the Smithsonian Channel. Their willingness to adjust their television-based procedures and goals in order to craft products that worked within the exhibition framework was both a challenge to them and a key to the successful media pieces that enriched the visitor experience. I am still enthralled every time I view the monitor that documents the enthusiasm and pride of the music created by Motown. And my mood always saddens when I view the media piece that captured the hatred and the casual bigotry of the 1920s by showing the footage of thousands of members of the white supremacist organization, the Ku Klux Klan, being embraced and celebrated as they marched through the streets of the nation's capital. Thanks to the Channel's skill and Selma's attention to detail and to quality, the films within the museum are part of that mosaic of image, word, and object that allowed NMAAHC to present a complicated yet accessible history.

Museums are at their best when the collaboration among designers, curators, and educators sharpens the interpretive and visual edges of the exhibitions, making the past accessible in a way that provides both emotional and intellectual sustenance. The partnership with RAA enabled the museum to tell, in John Hope Franklin's words, "the unvarnished truth." Or in the words of a visitor who stopped me as I walked through the museum one day and thanked me for exhibitions that "do not shy away from the pain but dull that pain by celebrating the wonders of a community."

All in the Family
Building a Community of Caring Colleagues

*Only a fool believes that he or she
has a monopoly on wisdom.*

—Lonnie G. Bunch Jr. (My Dad)

So much of what I initially learned about leadership and about developing and working with a gifted community of colleagues was shaped by conversations with my parents often over dinner in our house on Beech Street in Belleville, New Jersey. As it was with so many Americans who came of age in the 1960s, family dinners were sacred rituals, where nuggets of knowledge and family lore were passed around the table along with the pot roast and baked potatoes. Being raised by two teachers meant that the dinner table was more than a site of a shared repast; it was also a place where wisdom and the stress of Socratic learning were doled out like the Cool Whip that topped the Duncan Hines cakes my mother baked every other Sunday. My brother Gregory and I were expected to offer cogent analysis on subjects ranging from eighteenth-century philosophers to the poetry of the Harlem Renaissance to the current state of race relations in America. All while trying to avoid eating the canned peas. My father emphasized that success was based on a collaborative mindset and only a fool believed he or she had a

monopoly on wisdom. This notion that success was dependent upon a collective effort and that wisdom should be gleaned from every corner of an organization became the cornerstone of how I thought about the kind of staff that would be needed to create the National Museum of African American History and Culture. From these conversations I realized that a leader is only as good as the people he or she hires, mentors, and listens to.

One day during my first year in high school, my parents interrupted the conversation I was having with a group of kids on our front porch. My mother began questioning my friends as to their future dreams. She would ask each one what they wanted to do after graduating high school. A few said they wanted to join the military or attend the local state college. When it was my turn, she framed the question differently: "What do you want to do after graduate school?" While Billy and Ron needed to think just beyond high school, the expectations were greater for me. At first, I chaffed under the higher standard, but I realized that her challenge motivated me to fulfill her hopes for me. As I began to conceive a plan and a vision for developing the staff of the museum, I never forgot the burden and the gift of my mother's expectations. I wanted to build a museum staff that could bear and understand the importance of the weight of great expectations.

The hopes of many African American families like mine were colored by the realities of the racial environment of the 1960s. My parents struggled to find ways to prepare their children to face the discrimination and racist assumptions that were part of daily life, yet not let racism defeat us by destroying our optimism and limiting our aspirations. The phrase we heard often was that African Americans had to be twice as good to get half as far. In essence we were schooled that though life was not fair, you could overcome the barriers with hard work, strategic choices, and a nimbleness that used racism as a motivator that pushed one to achieve. I knew that assumptions based on race would challenge our ability to open this museum. I wanted staff that was cognizant of the racial realities we would experience but would use those challenges to inspire and propel us to a level of excellence this project, this culture, deserved.

Building the staff would be the key to creating a successful cultural institution. I needed to use the lessons from my parents in combination with the experiences I had gleaned from working in a variety of educational and cultural entities in order to develop an efficient and effective group of caring colleagues who could handle the pressures that would accompany this task and would have the confidence to develop ideas and directions far

beyond any I could imagine. All of which informed my vision for forging a staff where none existed. Beginning in 2005 with a staff of two (counting myself) meant that I had to determine the specific jobs that were necessary to operate a museum; assess the order the positions would be filled; and put in place a process that would satisfy the museum's goals while maneuvering through the policies and procedures embedded within the federal hiring system. Yet the benefits far outweighed the challenges. This would be the first time in my career that I could determine the entire staff. I would not have to find ways to convince those who had been employees of long standing to accept my vision. When I became the Associate Director for Curatorial Affairs at the National Museum of American History, I was anxious to share my ideas with my curatorial colleagues. At one gathering, after listening to my vision for the museum, a senior curator responded with a mixture of boredom and arrogance: "Lonnie, we already tried that twenty years ago." At NMAAHC, I would have the freedom not to be held captive by colleagues more attuned to the past than to future possibilities. And rather than hiring a few individuals who could slowly help transform an organization, I was now able to create an organizational culture that reflected my ideas without the impediment of employees who feared change.

I wanted to foster a culture of great expectations where the staff embraced the notion that what they were doing was for the greater good of a nation. And that to reach that level of excellence, I would ask them to work harder and longer in an atmosphere of uncertainty because it is always part of the challenge of a start-up. In addition, my future co-workers would even have to find a level of comfort with ambiguity as I did not intend to replicate the traditional museum. I wanted colleagues who could create a museum that individually we could not imagine but collectively we could achieve. In short, since we were making it up as we went along, the staff *had* to embrace innovation and risk-taking.

To accomplish this kind of culture, I wanted to foster a sense of family within the museum. I wanted colleagues to realize that if they accepted the inherent ambiguity of our shared goal, they would be part of a clan that is demanding, yet nurturing. I wished for my co-workers to understand that I cared about them, would celebrate their family milestones, and share their moments of pain and grief. Unlike some supervisors I had experienced over the years, I felt that it was my job to protect those who worked with me and to acknowledge almost daily their efforts on behalf of the museum. Being paid for doing a job was not enough of an acknowledgment. Saying thank

you was a simple gesture that mattered. And by "protect," I meant that I would create an environment that treated staff as equals, not as interchangeable parts. I wanted them to believe that their success, both as it related to their specific career goals and to their contributions to the completion of NMAAHC, was important to me. I did not want to be seen as a leader who was distant or who acted as if he were superior to the staff. Throughout my career I tried to find the right tension between hierarchy and camaraderie. I was determined to take advantage of what could be seen as a hurdle, the need to staff an entire museum from scratch. I had worked in the past with colleagues who were self-centered and prima donnas and I wanted to avoid their presence on this remarkable journey. So I tried to hire staff whose personalities and commitment to a greater cause meshed with hopes for the kind of collegial and effective workplace I sought. That is why I asked that all the formal job descriptions for the positions I sought to hire include the phrase, "No assholes need apply." Unfortunately, the Smithsonian Office of Human Resources felt that it would be unwise and difficult to limit the employment pool using that criterion.

I was committed to building an inclusive and diverse staff. I believed that the museum needed to find a balance between hiring individuals who had prior experience within the Smithsonian and those who brought a non-governmental perspective. The Smithsonian is a wonderful institution. It is also a challenging workplace, shaped by both centuries-old traditions and a sometimes-oppressive federal bureaucracy. During my tenures at the National Air and Space Museum and the National Museum of American History, I had seen gifted and passionate scholars, educators, and administrators struggle to reconcile the public image of the Smithsonian, a site of prestige and scholarly productivity, with the day-to-day realities of laboring within its institutional parameters and culture. Some had left, frustrated and disappointed by the glacial pace of decisionmaking exhibition curation, production, and hiring. Yet it was important to have colleagues who both understood the realities of the Smithsonian and also knew how to manage and "work" the bureaucracy. So much of the Smithsonian operates based on an understanding of its traditions and practices and on the personal relationships built over time. This is especially important at the Smithsonian because employees tend to remain at the Institution for decades. As associate director at NMAH, I was surprised to learn that nearly 70 percent of the curatorial staff had been at the museum for over twenty years. It was essential, then, that I find those with Smithsonian experience to ensure that our

dreams for the museum were not smothered by our inability to master the Smithsonian systems.

I was, however, also committed to finding strong leaders from outside the Smithsonian, people like Deputy Director Kinshasha Holman Conwill and Director of Development Adrienne Brooks, both of whom would question basic protocols and assumptions and push me and the museum to be as nimble and as innovative as cultural entities outside the orbit of the Smithsonian. Finding the appropriate tension between those who understood the Smithsonian and those who brought differing perspectives was essential if NMAAHC was to be a museum of today and tomorrow and not just yesterday. So as I planned the staff allocation on paper, I aspired to finding 60 percent of the staff with Smithsonian experience and 40 percent who were unencumbered by the traditions. I continue to aspire to this same ratio as the museum evolves.

The federal hiring process is glacial even in the best of circumstances. What made growing the staff more challenging was the need to increase the federal allotment to the museum annually in order to be able to enlarge the team. To grow the museum's budget from $1.3 million in 2005 to nearly $40 million by 2016, I had to not only convince the Smithsonian hierarchy to support my budget request, sometimes to the detriment of other institutional financial needs, but also to convince the president and the congressional appropriators to hear and support my pleas for growth among the myriad of worthy needs that sought their attention. What made this process more difficult was the fact that in order to maintain our schedule the museum needed support for both our capital (construction) costs and the growth of the staff. Each budget cycle I had to decide whether to ask for money for the building or for the staff. There were fiscal years where I maintained a smaller staff so we could find congressional appropriations to hire the architects or begin the actual construction. In 2007, I needed to grow the staff, but there was little appetite to help in Congress. Fortunately, Congressman James Clyburn took on my cause and shepherded enough support so that I could hire an additional twenty employees. These hires enabled me to fill the curatorial and educational voids that were necessary to provide guidance and direction for the architects and designers. At this juncture, I made a key decision. Rather than seek program planners and managers who can help plan the building, as many museums in the predesign phase had done, I decided to hire scholars, administrators, and educators—colleagues who could operate the museum even though we were years away from completion,

men and women who could help create the exhibitions, programs, and collections that would trumpet to the country that this endeavor was not a project but an actual active museum.

I was keenly aware that the racial composition of the staff would be watched closely and could be a flash point for criticism. As with all aspects of the creation of NMAAHC, race cast a large shadow over the development of the staff. I have spent my entire career pushing and prodding the museum community to do more than mouth platitudes about the necessity of diversity within museums. Even as the pool of museum-trained and culturally interested individuals of color has grown, museums still acted as if they could not find credible candidates for employment. It was paramount for NMAAHC to hire, train, and later export museum professionals of color in order to counter the notion that there is a paucity of talent. I wanted NMAAHC to showcase the array of African American, Latino, and Asian American curators, educators, collections specialists, designers, development professionals, and administrative staff who would one day work at the museum. It was crucial that the culture and history that the museum explored would be shaped, preserved, and made accessible by a staff immersed in the African American experience. NMAAHC would be a museum profoundly and proudly shaped by an African American aesthetic and interpretive framework.

Yet I also believed that the museum told an American story through an African American lens and that all Americans, regardless of race, have a role in sharing and preserving this history. When I first conceived the plan for the composition of the staff, I realized that I wanted to hire individuals who could create the museum and not just build a structure. Using my experience, I imagined the number and type of staff I needed for a museum that explored America through a different and distinct lens. And I needed to think about how the politics of race could—or should—inform my thinking about the composition. While I understood the challenge of racial-based decision-making, I actually listed all the positions that the museum would need when it opened to the public—from curators to security, from management support to collection managers, and from financial specialists to educators. I then wrestled with issues of race. I reviewed my list of potential positions, picked one, and analyzed what the impact would be should a non-African American hold that job. This was a political calculus that required an assessment of the impact that certain hires *could* have on support within a variety of segments of the black community. For example, must the Deputy Director of the museum be an African American? What about the Associate Director for

Administration? Should the positions of Curator of Collections or a Specialist in Musical History be held solely by African Americans? What about the Director of Development or the head of the Office of Project Management? What color should the floor staff be? And how racially diverse should the museum's Council be? It was not always easy or comfortable to frame the hiring through this racial lens, but I believed that a misstep in building the staff would hurt both the museum's credibility and its fundraising capabilities.

I knew that this was not an abstract intellectual exercise but a statement about not only what kind of museum I wanted, but also what kind of America I believed in. There has always been a tension within the field of African American history revolving around the question: who has the right to tell this story. Who owns the academic franchise of African American culture? How can an institution privilege blackness but also make room for the scholarship and perspectives of those who are not African American? There is no doubt that the field of history, and my own career, was transformed as more African American scholars—W.E.B. Du Bois, Carter G. Woodson, John Hope Franklin, Darlene Clark Hine, Sterling Stuckey, as examples—brought a cultural specificity and discipline to the study of the American past. Their work has shaped generations of white and black scholars and brought a vibrancy that has made African American history one of the most important areas of study within the academy. I believed that NMAAHC would be made stronger if a diverse staff, though led by African Americans, brought a variety of insights to the work of the museum. While more than 70 percent of the museum staff is African American, I feel that the racial and ethnic composition of NMAAHC is one of our strengths. It was not always easy to obtain that diversity.

Shortly after I returned from Chicago in 2005, I determined that the plethora of activities and endeavors undertaken by the museum would benefit from being coordinated by an Office of Project Management. And I knew the perfect person to head the unit, Lynn Chase. We had worked for twelve years together at National Museum of American History. Not only was Lynn able to handle complicated projects and problems, she was aware of racial politics in a way many non-African Americans were not. I was always impressed when she alerted me to the way race was being used at NMAH to influence my actions. As I contemplated the challenges before me, I asked Lynn to join the small but growing staff. I was surprised when she hesitated. While some of her trepidation involved leaving a museum where she had spent her entire career, she admitted that she wondered how she would feel being the only non-African American on the staff at that moment and how her colleagues

Lonnie G. Bunch III, not even two years into the job, on the site of the future museum, with his staff. **PHOTOGRAPH BY KEN RAHAIM/SMITHSONIAN INSTITUTION**

would react to her presence. I realized that integrating staffs and gatherings was an essential part of the job for me, but it would be unprecedented for Lynn. We discussed the organizational culture that I imagined, different from that of NMAH, but welcoming and demanding regardless of race. It took nearly a year before I could assuage her concerns and the timing worked for her. Lynn became one of the pillars of the museum and conveyed to me just prior to her retirement that her time at NMAAHC was the most rewarding achievement of her career. Her contributions reinforced my commitment to building a staff that would model the diversity that I expected from the museum field.

The diversity of the staff has been controversial for some, but not to me. There have been debates usually based on the array of false rumors often carried by the pony express of the twenty-first century: social media. I have been called the figure head or the face of a staff that was 90 percent white. Some social media have posted notices that all the curatorial staff at NMAAHC was white. Or that the African American-dominated Scholarly Advisory Committee was never consulted on issues of scholarship and interpretation. Or that instead of recognizing that three curators, two of whom are

African Americans, created the exhibition that explored slavery and freedom, the tweets chastised the museum for "using a white woman to tell our story."

The controversy over the composition of the staff reached a nasty apex during the summer of 2018 when there was a series of mean-spirited Twitter attacks on a museum specialist who is white, Timothy Anne Burnside, who was part of the team that curated the permanent exhibition that chronicled African America music and helped to create an anthology that explored the history of hip hop and rap. She was condemned and criticized as another example of the white appropriation of African American culture. And the museum was, once again, accused of having only whites working on black history. I cannot excuse the vitriolic attacks that went viral that addressed her in the foulest of language, questioned her competency, based on her color, and led to a series of national media outlets from National Public Radio to the *Washington Post* echoing some of the criticism. I had hoped that the public would realize that the museum would never hire anyone, regardless of race, who did not bring the highest ethical and scholarly standards to their work. I will stand behind Timothy and my other colleagues who are not African American because they are part of the museum family whose expertise and good will helped make the museum a success.

I do, however, understand the concerns about the influence of white scholars on the interpretation of black culture. As a nineteenth-century historian, I was always guided by words printed in the first African American newspaper published in the United States, *Freedom's Journal*. In 1827, the paper's editors, Samuel E. Cornish and John B. Russwurm, wrote: "We wish to plead our own cause. Too long have others spoken for us." This notion has always been important to me. I have always criticized how white art historians felt the power to determine what African American art was. And I have seen too many white folklorists and cultural anthropologists revel in their discoveries and misinterpretations of African American folk culture.

What is different about the white scholars at NMAAHC is that they were hired by African American historians and shaped by an African American aesthetic, which means the museum stands behind their work because it is really a product sanctioned and blessed by NMAAHC, not simply the creativity of an individual white researcher. Their work, their voice is part of a choir conducted by African Americans. In essence, the museum serves as a system of checks and balances to ensure that any scholarly analysis is informed by the most innovative research and reflects the museum's interpretive framework. It was prudence on my part to anticipate what the public and scholarly reactions would be to the racial composition of my staff. Yet even after careful

consideration, the centuries-old struggle to find a voice independent from white privilege guarantees that the interpretation of black culture by those outside of the community will always be a flashpoint. Another of the controversies this museum could not avoid.

Going from a staff of two to over two hundred colleagues when the museum was dedicated in 2016 necessitated using a variety of tactics and strategies that would help to integrate the different groups of staff hires. Due to the vagaries of congressional allocations, I never knew if or how many new positions the museum would receive annually. I worked to ensure that all the employees embraced a shared vision to create a sense of family that would limit the growth of silos that often lead to division and frictions within cultural organizations. Once again, I turned to my time in Chicago as a guide. As the new president of the Chicago Historical Society, I knew very few of the staff. In order to introduce myself and to build a sense of camaraderie, I began hosting weekly lunches with six to ten staff members. These lunches were usually the first time many of the employees had spent time with each other, with only a few ever having met with the senior leadership of the organization. These lunches allowed me to shrink the chasm between my office and my colleagues.

I implemented a similar practice at NMAAHC. As the staff expanded, I could no longer hire every new employee, so the lunches served as opportunities to share my vision for the museum in an informal setting where hierarchy mattered little. The conversations during lunch were free wheeling. They could focus on the museum or on any issue the group wanted to discuss. My only requirement was that the specifics of any conversation must remain within the room. These gatherings became part of the glue that held the organization together. While I learned about issues that needed to be addressed, I also believe that the lunches made me seem more approachable to the staff and helped to cement their respect and support for my leadership as I was able to share my fears and my expectations in a manner that was unusual within the hierarchically rigid Smithsonian Institution. This reflected my commitment that my staff would feel a sense of ownership, that they were partners in this great enterprise. In essence, I would encourage them to share their ideas, their hopes, and their creativity because I knew I did not have a monopoly on wisdom.

I also came to rely on the careful use of travel as a means to chip away at the chasm caused by hierarchy and to create a sense of camaraderie and shared experiences. While there were visits to Los Angeles, Cape Town, South Africa, Ghana, and New York City that helped to bond the expanding

staff of NMAAHC, the most important and most influential trip was to Israel from December 30, 2007 until January 10, 2008. Ironically, the road to Israel first ran through Chicago. For more than a year, I had commuted between Washington and Chicago so that my youngest daughter could graduate high school with her friends. Which meant that every Friday I rushed to National Airport to spend the weekend with my family. One Friday during March 2007, I was stranded at the airport as weather had caused significant flight delays. As I stood by the counter in the airline lounge, I noticed another traveler who mentioned to the person at the desk that he was awaiting information about the delayed flight as well. While we never spoke, the attendant said she would alert us whenever the flight was ready for departure. After nearly two hours, each of us approached the desk separately to learn that the plane was about to depart and that if we did not hurry to the gate we would be stranded in Washington. Running through the airport, we made it to the plane and were seated across the aisle from each other. Still we had not exchanged one word to each other. After being in the air nearly three hours for a flight that was usually ninety minutes long, the pilot announced that the weather in Chicago was so bad we would be landing in Indianapolis, adding that the airline would provide transportation for the five-hour drive to Chicago. When we finally did land, we were informed that the pilot had misspoken: we were on our own to find a way to Chicago. That turn of events prompted us to speak to each other in order to find a way home. We agreed that he would rent the car, and I would drive us to Chicago, only at that moment did I learn his name.

During our nearly six hours together, Allan Reich and I talked about our careers, traded family stories, and debated the challenges of being black and the burdens of being Jewish. Though our political views diverged, we found that we had much in common. We bonded, in part, over our shared commitment to creating a fairer America. It was unusual for two strangers to confide such details, but the snow- and ice-covered roads were so dangerous that talking took our minds off the treacherous conditions. At one point we stopped at the only diner we could find in a small town in rural Indiana. When we walked in, it seemed as if everybody stopped eating and stared at the two outsiders, one black and one Jewish. Even snowy roads seemed more appealing than the food and clientele at that place, so we quickly continued our slow drive to Chicago. As we neared the city, I mentioned that I had been invited by the American Jewish Committee's Project Interchange to visit Israel but work prevented me from accepting the offer. I added that it would have been an important trip to share with some of my staff. Allan had long been a supporter of Project Interchange, and he promised to mention our

conversation to those involved with the operation. The end of our road trip did not an end our relationship I am glad to say. As a result of our adventures, Allan and I became good friends.

The goal of Project Interchange was to build bridges among American educators, government officials, and political leaders so that they better understood the realities of the political life of Israel. While I was interested in Israeli-Palestinian issues, I could not justify a trip that focused on the politics of the region. I suggested to Ann Schaffer, a senior leader of the American Jewish Committee, that a visit could include grappling with the political concerns but would also devote a significant amount of time to exploring Israeli museums and experiencing the holy religious sites of Christianity, Judaism, and Islam. And the trip would be comprised of only ten of my colleagues and staff, rather than the diverse groups that usually traveled as part of Project Interchange. I was surprised when Project Interchange agreed to my proposal. Only later did I learn that my new friend Allan Reich had convinced the American Jewish Committee to accept this unique request.

The trip to Israel would help move the process of creating NMAAHC forward in several ways. The journey would include more than my staff. I invited several members of the Scholarly Advisory Committee and a representative from the museum's Council to join the excursion. I hoped that the emotional impact of traveling to the Middle East would bring these three essential entities—my staff, the intellectual leadership of SAC, and the high-profile fundraising Council—together in a manner that would facilitate future communication and contribute to a clearer understanding of the complementary yet separate role each played. I also believed that we had much to learn from immersing ourselves in Israeli museums. The cultural institutions that we would visit—the Palmach Museum, the Israel Museum, the Museum of the Jewish People, and Yad Vashem, the Holocaust Museum of Israel—were inspiring but offered little new in the way of nontraditional exhibits or state-of-the-art technology that was unfamiliar to us. Rather, the Israeli museums, regardless of the stated subject matter, explored, defined, and reinforced notions of national identity. I wanted to understand how they infused the sense of being Israeli into each cultural entity. I believed that while NMAAHC was a site of history and culture, it needed to do more. We should help the visitors understand how the stories and the memories within the museum reflect and define our national identity. Whether the subject is music, slavery, popular culture, or fine art, they are all lenses that point us towards understanding what it means to be an American and how the African American experience continues to shape our national identity.

Though visiting and absorbing the culture of the Israeli museums was my primary goal, it was our evenings together when we addressed thorny political issues that we found transformative. All of our differences paled one night at Kibbutz Levy as we discussed the politics of Israel with a senior rabbi, the leader of a Christian Lebanese sect, and an Imam. After a long day of visiting museums and traveling by bus, I was not excited, frankly, at the prospect of debating anything. My mood changed when the three religious leaders admitted that their faiths had failed to bring peace and understanding to the Palestinian-Israeli conflicts. They spoke with a painful candor about their fears for the land they all loved. We were especially moved when the son and grandson of the Islamic cleric mentioned that they travel in separate cars so that an attack on the Imam would not endanger the other members of his family. As the evening ended, the clerics stressed the importance of our work and offered hopeful prayers that we could create a museum that would lead to understanding and reconciliation, something that was still elusive in Israel. We sat transfixed and, in some way, transformed. Their words reminded us that building the museum was a calling.

Visiting the holy sites of Jerusalem, Bethlehem, and the Sea of Galilee not only awaked a spirituality in us all but also seemed to bond us together. At the location of the Sermon on the Mount, the soaring oratory of Rex Ellis, an ordained minister who later served as the associate director for curatorial affairs at NMAAHC, brought a contemporary feel to words spoken so long ago. We were moved by the beauty and the sense of peace as we left our Israeli guides behind to experience one of the holiest sites in Islam, the Dome of the Rock. And few of us could have imagined the power of the Wailing Wall, the fortress at Masada, or the Church of the Nativity. As we drove back towards Jerusalem, I realized we were about to cross the River Jordan and I startled the driver and our guide by insisting that they stop the bus and let us walk to the banks of the river. The River Jordan is such a powerful symbol of the promise of freedom for African Americans that I starting to sing the spiritual "Roll Jordan Roll." We got back on board and soon the entire bus was singing songs of hardship and hope created by enslaved African Americans. Crossing the River Jordan became the metaphor for the success of our work. It would take a great deal of time and effort, but after this trip I knew this group would get us to the Promised Land.

As we neared the end of our trip to Israel, we were more than a collection of like-minded professionals and colleagues tasked with building a museum, we had become family, shaped by the unique experiences of this wonderful yet troubled land. On the final evening, the staff of Project

Interchange held a reception in our honor. While there were acknowledg-
ments of the special nature of the journey, the highlight of the night was
Rex Ellis and Debora Scriber-Miller teaching our Israeli hosts how to do the
"electric slide," a dance that is a staple at all African American family events.
More than a decade later, the trip to Israel remains a touchstone, a reservoir
that we still dip into whenever we need to be reminded about the importance
of the work we do, and we continue to depend on the relationships that blos-
somed in the Israeli desert.

Not every effort to build a sense of community among my co-workers
required a trip of thousands of miles. As the staff grew throughout the
decade, I borrowed a tactic that I had learned from reading books about
start-up businesses in Silicon Valley. There was limited literature that dis-
cussed the challenges of creating an environment of innovation and support
in nascent museums. There were, however, a number of publications that
explored the evolution of business leaders like Jeff Bezos and his creation
of Amazon, or books that examined the early stages of internet businesses
like Facebook and Google. All emphasized the need for a leader to remain
connected to his or her colleagues despite pressures to the contrary. One
of the ways to retain that personal interaction that I had gleaned from
studying those works was what I called "management by walking around."
I would build into my schedule at least three or four hours a week where I
would spend a few minutes with my colleagues in their offices or work
spaces. Just asking what they were working on or what unshared ideas they
had allowed me to lessen the hierarchical boundaries that contribute to a
sense of isolation that limits the effectiveness of any leader. At first I think
my colleagues were surprised that I would just drop by. It also unnerved
some of the senior managers who feared that my presence would upend the
chain of command. But building on the sense of shared values and open
communication that flowed from those "walkabouts" made them a very use-
ful tool in my management portfolio. From informal gatherings to holiday
parties at my home to simply acknowledging their efforts with a word of
thanks to just being visible, I realized that it was the modest and obvious
actions that made the greatest difference with my staff. At one of the weekly
meetings with the museum's senior managers someone mentioned that one
or their staff remarked after one of my impromptu visits, "He seems to care
about me, not just what I do." That is exactly how I wanted the staff to feel.

My goal was always to create a caring and collaborative staff that felt
as if they were a close-knit community. Though there would always be ten-
sions, personality differences, and pressures that could cause stress and

divisions, I hoped that the environment of mutual support and respect that we created, and our shared commitment to building a museum that mattered, would help us overcome the fractious nature of so many bureaucracies. I also felt it was essential for the staff to understand that so many people, inside the Smithsonian and within the halls of Congress and academia, doubted the successful outcome of this endeavor. I believed that having an edge, feeling that it was NMAAHC against so many, would motivate and help the staff find the strength and creativity to prove the doubters wrong. I had always carried a small chip on my shoulder throughout my career that reminded me of every slight based on race or every time someone underestimated my abilities, which I then used as motivation that encouraged me to persevere even in the most difficult of moments. I understood that the museum's staff would have numerous challenges and disappointments that could threaten our work. I wanted to give them every tool—from scholarship to righteous indignation—I could find to help them weather the storms and controversies that could chip away at their momentum and confidence.

Though my colleagues were the key to any success we had, not everybody was capable or willing to handle the stress and the effort that was needed. Nor did every tactic I used to meld a group of individuals into a community prove successful or useful. When we were a small band of colleagues laboring in our modest offices with the broken door in L'Enfant Plaza, the hours were long, weekends were nonexistent, and the tasks before us—creating a fundraising strategy, developing plans to build the collections, crafting programs to give the yet-to-be-designed museum visibility, working to find congressional support—were daunting. To assist us with the administrative requirements, I hired a senior operations officer from another federal agency. After a few months with the museum, this individual asked for a meeting to discuss his job performance. He complained that he was working harder than at any time during his career and that my expectations were too great. After all, he said, "I am just a good government bureaucrat." Before I could respond, he proposed that the solution to his concerns might be for us to spend some time together outside of the office so that I could better comprehend his strengths. He then suggested that we go to night club along the waterfront in Southwest Washington, where "we could pick up chicks." Shortly thereafter, I helped him pick up his belongs and facilitated his departure from the museum with a speed unusual for the federal government. He was the outlier. Overwhelmingly, the museum staff made the sacrifices necessary to accomplish the goals and obtain the results needed to realize the dream of so many generations.

I was less successful when it came to working with the staff to undergo a formal process of strategic planning. Though I considered myself very strategic in developing the plans and approaches for the museum, it was done in an ad hoc manner, where unrelated thoughts were captured on large sheets of yellow paper rather than through a thorough and established process. I would never be a candidate for an MBA. I am much closer to a headline I once saw in a scholarly journal "history out of chaos." Several members of the staff pressed me to bring in consultants to aid the museum in determining future challenges and strategic directions. I contacted a consultant who had helped the National Museum of American History create an effective planning document during the mid-1990s. Though he was gifted and personable, I hated the process almost from the beginning of this exercise.

While it was essential that the museum assess candidly the threats and hurdles that had to be overcome, I struggled with the question of what we would do if we were unable to complete this endeavor successfully. Although the consultant and a small segment of the staff wanted to focus on failure, I could not. I did not want the staff to be preoccupied with defeat and disappointment. I was comfortable with planning for all eventualities, but there was no way that this endeavor would not be successful. We would not fail. I do not know exactly how I came to this unassailable belief, but I knew I would never let this endeavor fail to fulfill the dreams and expectations of all those who believed in this museum.

The consultant felt it was essential that staff be allowed to air their concerns about the viability of this enterprise. I thought that it was an exercise that catered to the worst fears and stimulated an atmosphere of negativity, which worried me more than any threat to the museum that the consultant could imagine. Maybe I was being held captive by a slogan I once saw in a tacky souvenir shop, "thou shall not tattle, whine or pout." More likely, my sense of the importance of creating an environment for staff that was ripe with optimism shaped my strong reactions to these discussions. After six months of battling his negativity, I decided to end the process and thank the consultant for his efforts. Rather than part amicably, he chastised me for being an autocrat that limited the staff's ability to offer opinions counter to my own. And he warned me that the project would never succeed under my current leadership style. I realized at that moment the extent to which I had been shaped by my father's admonition to be wary of those with all the answers. I had never intended to be an autocrat; a benign dictator, maybe.

If I have learned anything in my more than thirty years in the museum field, it was to trust my instincts and to rely on the leadership skills that

Lonnie G. Bunch III receiving an honorary doctorate from Georgetown University in January 2017. **PHOTOGRAPH BY PHIL HUMNICKY/GEORGETOWN UNIVERSITY**

were sharpened and tested by my diverse work experiences. A journalist once asked, prior to the opening of NMAAHC, what was the accomplishment that gave me the most pride. Without hesitation I knew the answer. I am proud that 90 percent of the people who ever worked with me or for me would join my staff today if I asked. This is reflective, I believe, of a leadership style that is consultative but also confident in my vision and my problem-solving skills. The best description of effective leadership was one I encountered during a speech given by Kenneth Chenault, the former CEO of American Express and a member of the museum's Council from its inception. Quoting Napoleon Bonaparte, Chenault said that the most effective leaders "define reality and give hope." While I have not quoted Napoleon since I wrote a mediocre essay on his life in eighth grade, his definition of leadership encapsulated all that I hoped my colleagues would glean from my tenure as the founding director. I also learned much about leadership from many quarters, from a former girlfriend who in tough times would always remind me to "never panic, adjust." And from my parents, Lonnie and Montrose, who taught me to trust in myself, to strive for excellence, and to fight the good fight. I believed that the difficult nature of this endeavor meant that I must demonstrate an optimism and confidence that created a façade that read

despite all the turmoil, we will be successful. I never wanted my colleagues to doubt their abilities, or to think that I questioned their will to accomplish what once seemed so improbable.

I was so fortunate to work with such a gifted and dedicated group of colleagues. I stood in front, I had the pictures in the newspapers, and I received the honorary degrees. Yet they are the real heroes who helped me to believe that this was more than a fool's errand. I never once forgot the efforts and the sacrifice of a staff that grew from 2 in 2005 to 12 in 2007, 30 in 2008 to 80 in 2011, to 120 in 2014, and then to 200 by September 2016. I am in awe of their achievements. I do not want to be melodramatic, but few will ever understand the sacrifice and the stress they endured. Fewer still will experience the shared joy that comes from accomplishments that were once deemed impossible. There is an unshakeable bond that was forged by years of struggle and by a shared belief that a museum could be a site of memory, meaning, and racial reconciliation. Much like the descriptions in Shakespeare's *Henry V*, I will always have a permanent connection with the staff that built the National Museum of African American History and Culture: "From this day to the ending of the world . . . we in it shall be remembered—we few, we happy few, we band of brothers [and sisters] . . ." Like Henry V, I found a family of colleagues who trusted me and believed in our common cause and suffered so much to make it happen. I think of Kinshasha Holman Conwill struggling to catch the 5 a.m. Acela train, almost weekly, for a series of meetings in New York City. I still see travel-averse Esther Washington crisscrossing the country to oversee the "Treasures" program. I marvel at Debora Scriber-Miller's good will as she mastered the impossible task of managing a director who had not learned to say no. Or John Franklin's willingness, with little warning, to speak to groups large and small in his role as the ambassador for the museum. I will be indebted to each forever.

Filling the Hole
The Challenge of Building on the National Mall

Water, water everywhere,
And all the boards did shrink;
Water, water everywhere,
Nor any drop to drink.

—Samuel Taylor Coleridge, "The Rime of the Ancient Mariner," 1798

On February 22, 2012, all of the staff's attention was focused on the ground-breaking ceremony, the official beginning of the construction of the National Museum of African American History and Culture. Great care had been paid to the order of speakers. My staff had grappled with a number of thorny issues: Who would actually be given a shovel to break the ground? Was the diversity that we championed visible on stage and in the audience? Had we the capability to shepherd effectively the multitude of reporters and television cameras clamoring for interviews? Were the plans to cultivate and coordinate the array of Council members, government officials, and donors appropriate? And would President and Mrs. Obama be pleased with the event? While my colleagues were preoccupied with the logistics and implementation of the day's activities, I was more concerned about February 23.

That was the day we had planned for the equipment to arrive that would dig a hole on that five-acre site located within the shadow of the Washington Monument. Creating that hole was a key element of my strategy to boost our private and public fundraising and to demonstrate that this museum would actually materialize after nearly a century. For nearly seven years, I had sold air. I had traveled throughout the country sharing stories about the importance of embracing a diverse and difficult narrative of American history. I had described our hopes for the building to anyone who would listen. And I had conveyed a sense of optimism and confidence that now was the moment for the birth of this institution.

Yet many still had doubts. After all, it was, as a reporter once wrote, "a museum in the mind of its director." There were concerns about the ability to reach the development goals: would Congress accelerate the support needed for the building? Often in gatherings, people would approach me to ask will the museum really happen? It was difficult to dispel the doubts that accompanied a wait of nearly a century. I had to find ways, large and small, that conveyed progress. I wanted to make the museum concrete. I needed that big hole.

By early 2012, the private support outweighed the budget allocated by the federal government. Because we did not have all the money needed to complete the building, some within the Smithsonian wanted to defer the construction efforts. I argued against any delay as I believed that our support would increase, once we began our excavation.

There was no way that Congress would allow a hole next to the Washington Monument to remain empty for long. As the first dirt was displaced, I was cautiously confident. It was a calculated risk, but I could not believe that our actions would not generate a reaction on Capitol Hill. Thanks to both the Obama administration and Congressman James Clyburn, Congress increased its support and my gambit worked. The beginning of actual construction also stimulated renewed public interest that led to increased membership and philanthropic giving. Digging first and paying later proved to be a viable strategy.

Initially, the needs of the building foundation required a modest amount of excavation to reach the preferred depths. But then the impact of my decision to dig deeper in order to implement Ralph Appelbaum Associates' concept of more impressively designed history galleries became painfully clear. Rather than excavating to thirty feet below the surface, the new plan required changes to the foundation drawings and a crater that extended another fifty feet—to eighty feet below the surface. Digging into an area that

Construction of the museum's foundation, 2013. **IMAGE COURTESY OF CLARK CONSTRUCTION**

was once a swamp, the excavation began finding water at eight feet. And by the time the dig reached eighty feet, there was more water than dirt. The traditional shoring—a process where wood and concrete were used to hold back mud and water until the concrete foundation was in place—proved ineffective and water continued to pour into the cavity. It seemed as if the decision to go deeper might just scuttle the entire project. As I learned more about slurry walls, dams, and reinforced rebar—medal bars used to strengthen the concrete—I began to question my earlier actions. There seemed to be no way to stop the water. Every day I visited the site, the deeper the water, and no one seemed to have any answer other than returning to the initial foundation depths. Clearly the preexcavation assessment of the underground creek that supposedly flowed through the site had underestimated the force and amount of water we would encounter.

We summoned a group of the best construction engineers to spend the weekend in Washington to assess the problem and offer a way to control the water. Their issue was exacerbated by the location of the site within a 100-year flood plain. If we could not handle the current levels of ground water, how could the building withstand the impact of future flooding that was bound to happen? After hearing more about water ratio and the size of rebar needed to stem the tide than any historian should ever have to experience, the

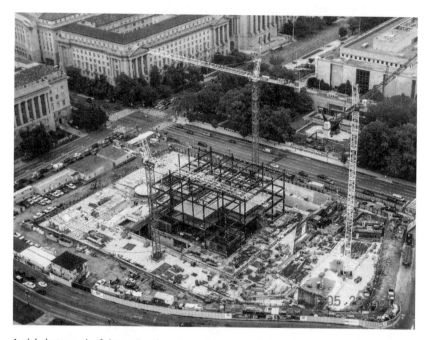

Aerial photograph of the National Museum of African American History and Culture site during construction, 2014. **PHOTOGRAPH BY MICHAEL BARNES/SMITHSONIAN INSTITUTION**

group decided that the foundation needed to be redesigned and reinforced as if it were a dam holding back a river. I asked what this meant and how much additional cost would this add to the project. The answer gave me great pause. Not only would the costs increase by $20 million, but also the time needed to complete this work would prevent the museum from meeting its 2015 deadline. I had fast tracked the project based on the opportunity to use the opening of the museum to celebrate three important commemorations in 2015: the sesquicentennial of both the end of the Civil War and the ratification of the Thirteenth Amendment to the Constitution that outlawed slavery. Additionally, 2015 would be the fiftieth anniversary of the passage of the Voting Rights Act that sought to guarantee that all Americans, regardless of race, have equal access to the vote. Thanks to the presence of excessive water, I had now lost the leverage of a hard deadline for the construction of the museum. I had fought hard to maintain a cap on costs and to secure a firm schedule for the completion of the construction, but I could not defeat the water. At first, I worried that this significant alteration to my plans would be

seen as an example of my overly aggressive leadership. I decided that I should not act defensive but just admit that this was one of the many unforeseen and inevitable setbacks in any large construction project. And while the extent of the water issue was unexpected, the key was responding to the situation in a thoughtful and effective manner. In other words, work towards solving the problem.

Every day I would visit the construction site, often to see if the revisions were actually stemming the flow of the water, but also to convince myself that progress was being made. For almost an entire year, most of the effort was focused below grade, with few visible markers of the work that was being accomplished. To get close to the excavation, one had to climb a series of rickety scaffoldings with few guard rails or protective barriers that led to a wooden viewing stand, though that is an overly generous description. As I peered into the eighty-foot deep chasm, I missed a step and almost stumbled into the pit. Just as I was about to fall, what was left of my youthful athleticism, enabled me to grab on to a railing before tumbling into a sea of mud and concrete. An eighty-foot drop. I could not believe my luck. After all this work I was one stumble away from being part of the concrete pour. How New Jersey.

This unprecedented water problem should have prepared me for the array of challenges we faced during the construction of this building. Concurrent with the water dilemma there was concern about the impact of the construction on the Washington Monument. Many of the regulatory agencies worried that our construction might alter the water table and undermine the stability of one of the city's most recognizable monuments. Or, that the vibrations from our equipment would damage the centuries-old infrastructure. To ease the trepidations of the guardians of the Mall, we agreed to absorb the cost for a monitoring system that could determine the slightest variations caused by our efforts. As we unearthed more soil and information, we learned that the monument did benefit from the underground water that flowed throughout the National Mall. And the pressure produced by the water was an important factor in keeping the monument from slowly sinking. It meant that we had to be very careful as to how we addressed the water issue on our site. Over the years there had been many descriptors that I did not mind that followed my name in the press, but I did not want to be known as the person who knocked down the monument to the nation's first president. Though I still think a little lean would enhance the monument's appeal to tourists. Who could resist the leaning tower of Washington?

Monitoring the Washington Monument, something we continued throughout the period of construction, added an element of complexity and uncertainty to a construction job that was already burdened with a variety of unknowns. It was surreal to think that part of my job was to ensure the stability of one of the oldest memorials in the United States. Me, a guy whose mechanical aptitude is nonexistent. I had rarely allowed my ignorance to stop me from leading, but I was clearly unprepared to master the intricacies of the vast number of processes needed to build on the Mall. I sat in many meetings hoping no one realized that my knowing nods and silent assents during discussions about BIM (Building Information Modeling), CAD (Computer-Aided Design), and D-B-B (Design-Bid-Build, a process where the interplay between the designers and those with expertise in certain construction trades would lead to budget and building efficiencies) were simply ways to cover my lack of understanding. The Smithsonian was fortunate in its choice of the construction company, a joint venture of Clark/Smoot/Russell. I was insistent that the lead contractors would reflect the America I hoped we would become. Clark Construction Group was the biggest builder in the Washington, DC, area with expertise in dealing with federal projects. We added two gifted minority-owned firms, H. J. Russell & Company from Atlanta and Smoot Construction from Columbus, Ohio. As this was a major and costly endeavor, I wanted to make sure that those who built the museum would be reflective of my commitment to racial diversity and that a diverse workforce would be drawn primarily from workers who resided in Washington, Maryland, and Virginia.

Even prior to the commencement of the actual construction, I spent a great deal of time with the construction principals, Clark/Smoot/Russell. I knew that this structure would test all the expertise they brought to bear and I needed them to care as much about the project as I did. I had a series of meetings with all levels of the construction team where I shared the vision for the museum. And I reminded them that they were not just constructing another office building but that they were creating a cultural institution that would help all of our children live in a better world where the tensions and the hatreds of the past can be lessened thanks to their work. I wanted all involved to accept the challenge to erect a museum that aimed to make a country better, and to do that on time and under budget. I guess my harangues had an effect because just prior to opening Brian Flegel, the Senior Vice President at Clark Construction, thanked me for my vision and commented: "There was real unity and cohesion on this project. Everyone was

working together because this project is for every American citizen. . . . This museum is meant to be a place for bridge-building and collaboration, and I feel our team embodied that from the start."

It was that spirit, that understanding of the meaning of the museum, that helped the team overcome all of the trials that accompanied building on the National Mall, such as puzzling out the construction needs of erecting the Corona. The innovative nature of the building design dominated by the three-tiered filigreed bronze envelope was a visual strength but also a construction challenge. This new building form, from its engineering requirements, to its materiality, to its sustainability needs, to the Smithsonian's reliance on a Design-Bid-Build process to meet the schedule demands, were all untested and strained the abilities of the joint venture. Adding to these difficulties was the relative inexperience of David Adjaye, as this was his first highly visible major endeavor. Fortunately, all the parties, including the Smithsonian construction team led by Derek Ross, put aside egos and relied on years of experience to grapple effectively with the complexity that this building required.

Because of the overall complexity, it was decided to build a scale model of one of the three Corona tiers that was two stories tall and about 200 feet in length in a research site in York, Pennsylvania, so that all aspects of the construction could undergo rigorous testing. In the spring of 2013, Lynn Chase and I drove two hours from Washington to view the test structure in York. On seeing the test model, I became quite emotional. Although the scale was reduced, this was the first time I could experience the look and feel of the building. I was able to view it from above, looking down on it from an upper floor to experience the porosity of the Corona. Prior to this trip, I had only reviewed the look and reflectivity of a single sample panel of the Corona. Now I could see how an entire wall of filigreed bronze panels glistened and shimmered based on the position of the sun. The model had a beauty and a presence that foreshadowed the impact the building would have on the Mall. Seeing the model convinced me that this structure when completed would become part of the iconic views of the nation's capital. Our visit to the site had more importance than introducing me to the beauty of the building. In York, we could explore how the Corona withstood the elements: whether prolonged sunlight would affect the color and the sheen of the panels; how extended periods of rain might affect the building; or the extent of the impact of a more dramatic event like an earthquake? For several months, the model was buffeted with an array of tests that ensured

the final product would be a long-lasting contributor to the beauty and aura of the National Mall.

As the Mall changed as a result of the building's construction, we wanted to provide a way for the public to see the progress and also to experience what the museum would entail. We used the construction progress as another way to increase the museum's visibility and to engage interested parties as they strolled past the building site. We put the actual construction fence that provided security on the site to work as a canvas upon which we placed images of African American figures or events and information on the 2015 opening of the museum. I thought it was powerful to see a curious public enjoy representations of Frederick Douglass or the Little Rock Nine as they drove along Constitution Avenue or rode on tour buses past the still-standing Washington Monument.

We also stationed a trailer next to the site to encourage in-depth conversations with visitors. While the trailer would allow views of the big hole and the early steel infrastructure, it also served as a visitor center, providing information and a much-needed respite from the summer humidity as visitors strolled down the Mall. Upon entering the visitor center, there was a large model of the National Mall that situated the museum among the other sites of the area. Additionally, there were beautifully designed panels with information about the museum's vision, its collections, the look, and symbolic meaning of the building, and our donors. The centerpiece of the trailer was a compelling video, narrated by the actor Dennis Haysbert that included other performers such as Courtney Vance, Mandy Patinkin, and Tatyana Ali, introducing visitors to the richness and complexity of African American history and culture, and the way the museum would convey that history. Using recognizable actors from television and Broadway conveyed the importance and gravity of the museum. If celebrities cared about the museum, then maybe the visitor should take notice, too. At one end of the center, there were several computers for visitors to view the museum's online offerings and to easily join as charter members as a way to demonstrate their support for the museum. Most important of all, opening the visitor center enabled the museum to provide to the hundreds of volunteers who wanted to serve as docents in NMAAHC when it opened the opportunity to share their knowledge and passion with those who visited the site. All these initiatives increased the buzz about our endeavor and heightened the anticipation of the opening of the museum.

As the construction began in earnest, we soon realized that the design of the building when completed made it unlikely that the museum could

install several of its largest acquisitions. Again, we had to adjust our schedule and mount the Southern Railway car and an early twentieth-century guard tower from the prison in Angola, Louisiana, within the exhibitions *before* the roof was in place, which would limit our access because the doors and the elevators were not capable of handling the size and weight of these two objects. This caused a great deal of angst and unrest from both the construction contractors and the installation staff of the museum. The notion to collect and exhibit the segregated railcar had been my idea, and I heartily approved of Curator Paul Gardullo's desire to install the large concrete guard tower from one of the most dangerous prisons in America with an overwhelmingly black inmate population. But positioning these pieces in the museum earlier than originally conceived caused serious logistical problems. There was transportation involved, the challenges of moving such significant and large objects from Louisiana and Kentucky respectively. And there had to be places to put the objects once they arrived, meaning that the construction staff had to prepare exhibition spaces out of sequence and then determine how best to protect said pieces as construction continued throughout the rest of the building. The museum was fortunate to have a senior member of the Office of Project Management, Carlos Bustamante, organize and implement this complicated undertaking. This was another example of how a director's wish (or whim) seemed so simple to accomplish. In actuality, it took several years and hundreds of phone calls and emails by a gifted team to fulfill my directive.

First, Carlos had to coordinate the movement of the objects from the prison in Louisiana and the train restoration facility in Kentucky so that both would be shipped together and at the same time to Washington. Who knew that transporting these artifacts would be so difficult? In addition, the museum had to obtain clearance from the Office of Homeland Security, which also determined the path that these collections could travel. I could not imagine that these materials would be a target of terrorists, but the government wanted to restrict both the movements and any information about the routes the artifacts would follow. But the story of this shipment soon leaked, and wherever the caravan passed, the local press wrote a story, which was an unplanned contribution to the museum's visibility. There were no secrets when it came to this specific odyssey. Part of the press fascination with the shipment was the fact that unlike the guard tower the railcar was shrink wrapped in protective material that was gleaming white. I never knew that there was that much shrink-wrapping material in America.

After a week's journey, the artifacts arrived, but had to be stored in a secured outdoor location at Dulles Airport in Virginia. Homeland Security

continued to be concerned that this material could be an even bigger target once it entered the nation's capital. Carlos had been working with the government of the District of Columbia, the National Park Service, local police jurisdictions in Maryland, Virginia, and the District, the Federal Emergency Management Agency (FEMA), and the Secret Service to facilitate a smooth entry onto the Mall. Due to heightened precautions, Homeland Security would not release the specific route from Virginia until the morning of November 16, 2013. This meant we had to plan for either a short trip that crossed the 14th Street Bridge or a longer trek around the Capital Beltway to Silver Spring, Maryland, and then an amble down Georgia Avenue.

At 4 a.m., we were cleared to bring the collections across the 14th Street Bridge to Constitution Avenue, where two 500-ton cranes were positioned to deposit the railcar and the guard tower in the unfinished structure. I arrived at the site by 6 a.m. and nervously scanned the cranes. Due to the fragility of the retaining walls of the museum's foundation, which could crack under the weight of the cranes and the artifacts, the hoists were placed on Constitution Avenue, further away from the site than we preferred. That meant that the derricks were now located on top of the main natural gas line in the District. And there were worries that the lines could rupture and cause fires or explosions. At that point, I no longer worried about upsetting the angle of the Washington Monument. I was concerned that bad luck or an unplanned movement might destroy much of monumental Washington. But then the excitement of seeing the caravan come into view soon replaced my worries, at least temporarily.

There was something beautiful about seeing that column of vehicles, lights flashing, followed by one flatbed truck that carried the guard tower and then another with the shrink-wrapped railcar. My fascination with this spectacle was broken by the sound of clapping and cheers. The museum's Development Office had alerted the membership base about the date of the installation. I had not expected that morning to see hundreds of people, some of whom had traveled from New Jersey, Chicago, and North Carolina to witness the moment when the first artifacts were installed in the National Museum of African American History and Culture. I shared their joy. This was as if I was viewing the best parade every assembled. And when the trucks parked on Constitution Avenue, we all watched as the cranes first approached the guard tower from Angola Prison. It took many minutes to secure the tower, but then, suddenly, it was floating in air, on its way to its home in the museum. And now I was switching my attention back and forth, first to see if there were any signs that the weight of the crane would affect the gas line, and then

back to the dangling tower. More cheers erupted as it was gently lowered to its permanent site in the history galleries.

The tower's weight was a fraction of the eighty-ton railcar. And my fears about explosions and gas ruptures returned as it inched its way skyward. Just before noon as the encased car hovered over the site, one of the ubiquitous tour buses in Washington approached the space and I overheard the driver proclaim that all those on board "were witnessing history." How true. There was a roar of satisfaction and a cheer of relief from me once the railcar was safely nestled into an area that would house the exhibition that explored the era of segregation. As the crowd began to disperse, I remained behind. Witnessing history was tiring. Although my job involved making everyone believe that incrementally the museum would happen, I was stunned by the events of that day, amazed at the array of colleagues and contractors needed to transport and install two artifacts and overwhelmed by the sheer audacity of the moment. I also wondered how a future director of NMAAHC would feel when he or she realized that now in place neither the railcar nor the tower could ever be moved. As my wife and I made our way to the car, a police officer stopped to congratulate me with the words, "great job, we are almost home." His handshake seemed to sap what was left of my energy as I realized we had, metaphorically, only swum half of the English Channel. There were still many waves to come.

One of those unexpected waves came from Eleanor Holmes Norton who was the nonvoting yet highly influential member of Congress who represented the District of Columbia. Over time the congresswoman became a greater supporter of our work, but that did not prevent her from acerbically questioning me then about who was reaping the economic benefits from the construction budget. Cheryl Johnson, my congressional liaison, and I were summoned to Congresswoman Norton's office, where she demanded that a percentage of the jobs on the site go to residents of the District of Columbia. While I did not want to set a precedent where a member of Congress could exact that a certain percentage of their constituents receive a specific share of the economic benefits of a contract, I, along with the Smithsonian Office of Equal Employment and Minority Affairs, had already developed plans to ensure that women and minority-owned firms had access to the array of contracts that were needed to complete the construction. Though this was not created to include District-specific hires, I was sure that by expanding the access of firms of color residents of Washington, DC, would be well represented. Even without the congresswoman's prodding, I knew that all aspects of this endeavor had to be inclusive, even if it forced a nimbleness,

such as increasing the pool of workers from the District that was unusual for the nineteenth-century institution that is the Smithsonian. Once again, this was an opportunity for this undertaking to model the behavior and the expectations I have for the entire museum profession, but especially for the Smithsonian Institution.

For the next year, the pace of construction accelerated, but because so much of the work involved the foundation and the efforts were below grade, people often stopped me to find out if there was a problem. "When will," I was often asked, "I see the museum rise out of the ground?" By the end of 2014 and the beginning of 2015, the museum arose and became a visible marker of the work and the progress that had been made.

In terms of the construction of the building, 2015 was a year of visibility, of sadness, of hard decisions, and ultimate satisfaction. On April 14, 2015, the first of 3,600 bronze-finished Corona panels was installed on the site. And the signature feature of the building was soon visible. This was a key moment for me because the fight to find the right color, tone, and sheen for the panels had been like a long-running soap opera. I cannot recall the hundreds of samples I reviewed, in the sunlight, with limited light, holding the panel close or viewing it from a distance. Others could see the minute differences; they often all looked beautiful and fine to me. Periodically I would return to the museum after everyone had gone, accompanied by my wife, Maria, an artist with a visual eye for color and composition that usually eluded this historian, to share her opinion about the look of the panels. Eventually the architects, the builders, Smithsonian colleagues, and I came to an agreement and used our collective wisdom and clout to receive final approval from the two key regulatory agencies with jurisdiction over the National Mall, the National Capital Planning Commission and the Commission of Fine Arts. While some critics were dissatisfied with our choice, I think the way the public became enamored with the look of the building suggests we made the correct decision.

The joy of that moment was short lived when I received a call on the evening of June 2, 2015. Brian Flegel, Senior Vice President of Clark Construction, alerted me that a construction accident took the life of one of their employees, Ivan Smyntyna. A metal worker, Smyntyna had relocated temporarily from his home in Georgia to work on the installation of the Corona panels. I was devastated, this was the worst news I could have received. I immediately wanted to know the details, which were sparse, and I needed to contact his family. Both the Smithsonian and Clark Construction advised that the communication be left in the hands of his employer. I was

frustrated because I wanted to do something personally, but I accepted their suggestion. However, two days later I wrote a note to the family expressing my sadness and sorrow at our shared loss. His death continued to haunt me so much that I included a reference to it as part of my remarks at the museum's dedication. His passing reinforced the notion that so many had died or made sacrifices that enabled this museum to develop. I vowed that we would create a museum worthy of their sacrifice. This is a vow I will keep as long as I am involved with NMAAHC.

I continued to visit the site often throughout 2015, and one of the days that stands out to me was November 3, 2015. Since the beginning of the construction I consciously made the time to thank everyone I encountered for their efforts. I also continued making formal presentations about the museum's goals and my hopes for this building to various groups of workers. I understood just how important constructing this building was for African American workers, but I wanted all who labored on the site to feel the special character of the project and how essential each individual was to the success of this endeavor. One of the lead foremen on the site was a man named Mac Naeemi. He told me he was from the Middle East and had just finished a major project when he was asked to participate in creating NMAAHC. He initially turned down the opportunity until his daughter reminded him of how important African American culture was to all who believed in freedom. His daughter convinced him to take on this challenge. While meeting with the construction staff that November morning, Mac asked if I would take a selfie with the workers. I was flattered. The selfie taken by Mac shows me and nearly two hundred workers whose diversity was dazzling. I was so moved by the image that I had one copy installed in an exhibition that discusses the history and the creation of the museum, and a second copy graces a wall in my office so that I am reminded daily of those whose hands and hearts that made the building possible.

Near the end of 2015 I was called into a meeting with Al Horvath who was the relatively new undersecretary for finance and administration at the Smithsonian Institution. Horvath's presence had a positive impact on the construction process. He became an advocate and was the financial engine behind creating a bond issue that would allow the Smithsonian to bear some of the construction costs as the philanthropic pledges to the museum were fulfilled over a period of several years. Horvath said to me there was a problem with the construction schedule that we needed to discuss. Apparently, without sharing any information with me, some members of the joint venture went to Horvath and said that they could not complete the building

A large group but not all of the more than 600 dedicated construction workers who built NMAAHC, with Lonnie G. Bunch III in 2015. Taken by a lead foreman and given to Lonnie, this photo hangs in his office. **PHOTOGRAPH COURTESY OF CLARK CONSTRUCTION/MAC NAEEMI**

by the September 2016 deadline. The contractors felt they could finish all the interior needs except the second floor, which housed the educational class-rooms, the interactive facilities, and the family history center that a donor had funded. If I insisted on opening the museum in September, they could "wall off" the second floor so that no one would notice. Horvath then sug-gested that the Smithsonian would support efforts to finish the building after the opening ceremonies. And they needed me to accept that reality.

As I listened to Horvath, I could not believe that the general contrac-tors would make that suggestion without at least having the courtesy to speak with me first. After all, as a result of issues of water and the unique challenges of the building design, we had agreed to delay the opening for ten months. More importantly, we finally had a commitment and a date certain from the White House as to when President Obama could keynote the dedication ceremony and I did not want to revisit a decision that had taken months of negotiation.

I left the Castle pretty dispirited that day. I could not imagine telling Oprah Winfrey how much I appreciated her support of over $20 million, but we still could not finish the second floor. I could feel the tension and the disappointment once I told the Council that after their herculean efforts, we would have to wall off portions of the building. And I was sure that my colleagues at the museum would feel a sense of failure. My mind flashed back to the 1984 Olympics, when the Los Angeles Olympic Committee threatened to hide the California African American Museum under a load of trees if we could not complete the building on their timetable. I hate it when someone hands me a no-win situation. Postponing was not an option. And opening an unfinished building would be an embarrassment and reinforce the notion of some that African Americans could not handle a project of this size and this importance.

Then I remembered something that the Smithsonian architects and construction experts always stressed to me: these projects have only three variables to manipulate: schedule, scope, and budget. If I could not alter the scope or the schedule, could the budget provide a solution? So I went back to Horvath and asked him to see if additional resources would address this problem. I could tell that the general contractors did not want to reopen their decision, but they had to answer my question. They decided that we could meet the deadline, but it would cost an exorbitant amount of money that was not in the budget nor could the Institution absorb the extra expenses. So I was presented a number that they believed was way above any resources that I could access immediately.

What no one knew, except a few of my senior staff, is that I always kept a reserve of several million dollars that usually came from the continued growth of the museum's membership campaign because I feared that eventually some kind of budget surprise or financial need would be presented to me and I wanted to be prepared. Each year I would scrape off some money that was not part of the museum's federal allocation that I simply labeled for the opening fund. It could be used for the exhibition costs or for the building, but it was earmarked to provide the museum a cushion to ensure that we had what was necessary for a successful opening. Now it was time to use that cushion.

The next day I instructed the contractors to finish the second floor because the museum had all the cash they requested that would allow access to the space on opening day. I ended the conversation by saying "So, to what account should I send the money?" As I left the gathering, I thought of my pinochle-playing parents who would have said, "Son, slam your cards on the table, you just trumped 'em."

Lonnie G. Bunch III adds his name to the many other signatures on the final girder in the construction of the National Museum of African American History and Culture, October 2014. **PHOTOGRAPH BY MICHAEL BARNES/SMITHSONIAN INSTITUTION**

My contributions to the construction of NMAAHC were minor when compared to the effort and creativity of so many who came to feel a sense of ownership, not in a structure, but in a museum. At its peak, a diverse lot of six hundred men and women worked directly on the site and hundreds of small businesses contributed materials and expertise. The daily interactions were wonderfully managed by the Deputy Director and the head of the Office of Project Management, Kinshasha Holman Conwill and Lynn Chase, respectively. In a series of regular gatherings called the Project Executive meetings, Lynn and Kinshasha met with representatives from the general contractors and the Smithsonian to grapple with issues of budget or any other hurdles that threatened the progress of the construction. Regardless of whether the challenge was the delivery schedules of materials, the increased price of steel and concrete, the regulatory approval process, or the ever-present concerns about damaging the Washington Monument. They

worked collaboratively to solve hundreds of issues and small crises that never made their way to my office, something for which I am truly grateful.

As I sit in my office, with views of the Mall monuments, the US Capitol, the Custis-Lee Mansion in Arlington Cemetery, and Smithsonian Castle, vistas that have some periodicals calling my workplace the best office in Washington, DC, I am in awe of what it took to complete the construction. When I think back to the daily waterfalls, not to mention my own near fall into the big ditch, the first concrete pour in November 2012, or my signing of the last steel girder to be placed within the building in October of 2014, or the installation of the Corona panels in 2015, I wonder when I will awaken from this dream. I often struggle to remember how Tasha Coleman and I believed in 2005 that one day a building would stand on the National Mall. In the beginning, when the staff was small, I used to walk into the unassigned offices and whistle, using the sound to counter the emptiness and to pretend that the spaces were occupied and that I was not so alone in this fool's errand. As the construction of NMAAHC neared its conclusion, I whistled as I strolled the empty corridors. This time it was a whistle of celebration, a sound of relief and notes of thanks to the colleagues that made this moment, this building, possible. Yet the whistling also foretold of the work that still remained. An empty building had to be filled with the artifacts and the dreams of a people that commemorated a nation's journey.

Welcoming America Home

The Opening of the National Museum of African American History and Culture

The ache for home lives in all of us,
the safe place where we can go as we are.

—MAYA ANGELOU, 1986

For ten years I had pushed and promised that the National Museum of African American History and Culture would be completed by November 2015. Dedicating the museum at that time would have allowed the country to celebrate not only the opening of a national museum but also to commemorate the 150th anniversaries of the passage of the Thirteenth Amendment to the Constitution that outlawed slavery and the end of America's bloodiest conflict, the Civil War. It would have also recognized the enactment of one of the most important pieces of legislation of the twentieth century, the Voting Rights Act of 1965. This perfect synergy provided a way to create hard deadlines that helped to move the museum from idea to reality. Unfortunately, issues of water and construction delays prevented the museum from being ready by the fall of 2015. Yet the exterior of the building was completed and as Council member Jim Johnson pointed out during a board meeting: "The building was just sitting there. Shouldn't we do something with it?"

Part of my strategy for creating the museum was to always convey a sense of optimism and a certainty that America would soon have another cultural jewel on the National Mall. I was worried that missing my much-promised opening date could give some of the naysayers the perception that the museum was in trouble. Jim Johnson's prodding about the nearly finished structure forced me to think how we could celebrate the completion of the building, fulfill our desire to recognize those important anniversaries, and demonstrate the real progress that had been made. Several months earlier I had just left the parking lot at the National Air and Space Museum heading for home when I approached the Hirshhorn Museum. I was fascinated by a series of projections on the façade of the building by a contemporary video artist. I wondered why NMAAHC could not do something similar. I remember that during the Bicentennial in 1976, I visited Mount Vernon to see what they called an illumination, a series of colorful images accompanied by music projected on the home of George Washington. I did not recall any special message or interpretation, but I never forgot that evening. If we mapped the museum, using illustrations projected onto the building, it would signal a new phase in the life of the project, and the images that would grace the building could reference the anniversaries that we had hoped to acknowledge. I asked Deputy Director Kinshasha Holman Conwill to lead this endeavor that would allow us to use the building façade as a canvas to celebrate African American history.

The first challenge was to determine the costs and the likelihood that the museum grounds could withstand the weight of the equipment needed to map the building. And the second consideration was what kind of program would be projected and who would create such a presentation that we now called a Commemoration and Celebration of Freedom? Once we determined that the costs were reasonable and the permits and permissions obtainable, we contacted one of the most gifted documentary filmmakers of his generation, Stanley Nelson Jr. His award-winning films explored an impressive sweep of American history and included such works as *The Black Panthers, Freedom Riders,* and *The Murder of Emmett Till.* Nelson and I had often discussed his interest in participating in the creation of the museum. I was excited that he would accept the challenge of creating a large-format media piece that would be projected upon the building for three nights beginning November 16, 2015, especially since he had only five weeks to produce and test the film. Nelson's willingness to scramble his normal production schedule to fit our needs was another example of the generosity we encountered throughout this endeavor.

Nelson captured the sentiments of so many others who participated in the creation of the museum when he said to me, "I just want to contribute in whatever ways I can to this monument to our ancestors."

Nelson married music and poetry from the Harlem Renaissance with images of the African American freedom struggle from slavery through the Black Lives Matter movement. For three days, cars stopped along Independence Avenue, Madison Drive and 15th Street, people were enthralled, and Washington took notice as these powerful images flashed against the recently installed bronze Corona panels and reminded all who experienced them of the importance of remembering the passage of the Voting Rights Act, the ratification of the amendment ending slavery, and the commemoration of the end of the American Civil War. I loved the fact that photographs of Frederick Douglass, enslaved African Americans, black soldiers from WWI, Fannie Lou Hamer, and protesters from recent demonstrations that called attention to police violence were so visible on the National Mall in a manner that introduced this history to thousands who might never enter a museum.

On the first night, there was a program that included performances by gospel legend BeBe Winans, Darin Atwater and the Soulful Symphony, and the Heritage Signature Choral that sang at the museum's groundbreaking ceremony, all voicing the African American commitment to making America a freer and fairer nation. Nearly a thousand people braved the chill of November to experience the warmth of this community celebration. I framed the evening to acknowledge that we were a museum in and of the District of Columbia. My remarks made clear that when the museum was dedicated the following September, it would belong to the world, but tonight was a moment to honor the District. I think these sentiments resonated with two champions of the District, both of whom we had asked to speak: the city's mayor, Muriel Bowser, and its congressional representative, Eleanor Holmes Norton. Each spoke about the importance of the black history embedded within the nation's capital and how NMAAHC would enrich both the city and the nation by illuminating stories often untold or forgotten. After Secretary of the Smithsonian David Skorton emphasized the Institution's commitment to the museum, I concluded the evening by saying that now that you have seen the exterior of the museum in a different light, I invite everyone to return in the fall of 2016 to experience the inside of the building. The applause that followed convinced me that through this program, the museum had repositioned a delay in our construction schedule

into an opportunity to forge heightened anticipation and excitement for the opening in 2016.

Shortly after the mapping of the museum, the *Washington Post* ran an article chronicling all the tasks yet to be completed with only eight months until opening. As usual, I conveyed a sense of calm using the catchphrase from my time in Japan *mondai nai*—no problem—to suggest that everything was under control. Though we had the plans in place, there was still a mountain of work that needed to be completed if we were to reach the Promised Land of opening by the fall of 2016. One of the most important issues that I needed to address was the creation of an orientation film that would air several times a day in the Corona Pavilion located within the main entry space of the museum, Heritage Hall. The words "orientation film" did not capture what I hoped to accomplish. I did not want a piece that would help the public understand how to use the building or even the collections. I wanted something that would be engaging and would help visitors find new ways to think about the role, impact, and meaning of African American history. I did not want the standard museum video. I needed something more powerful, more imaginative, and more cinematic.

Through the process of museum-making, I urged the staff never to think small and never to cut corners. This project, this community, deserved the very best we could produce. When it came to the orientation film, I turned my attention to the creativity within black Hollywood. And the person I wanted to produce this film was Ava DuVernay. I had first met her in December 2014 when I attended one of Oprah Winfrey's Legend Balls in Santa Barbara, California, where she created a weekend-long event that honored pioneers of the Civil Rights struggle—from Marian Wright Edelman to Harry Belafonte to John Lewis and Sydney Poitier. This event included a dinner, or rather an unforgettable and classy dining experience, that recognized and thanked so many of the freedom fighters for their love of America and their sacrifices for the cause of racial justice. Over the course of the weekend, there was a concert in the amphitheater located on the grounds of Ms. Winfrey's estate followed by the most amazing outdoor barbecue I ever attended with food brought in by some of Oprah's favorite restaurants from all over the country.

Yet one of the highlights for me was a preview of Ava DuVernay's film *Selma*. I was captured by her storytelling ability that made a history that I knew well seem fresh and untold. I knew then that Ava was someone whose talents needed to be included within NMAAHC. We then met again when I

interviewed her as part of the museum's important public program to address the pain and the significance of the death of Michael Brown in Ferguson, Missouri. We spent an hour on stage at the National Museum of the American Indian discussing the role that the arts and cultural institutions could fulfill in response to tragedies like the shooting of Michael Brown.

Whenever I thought about the importance of the orientation film, I returned to my conversation with Ava. Several months later I decided to ask her if she would create a special film for the museum. Candidly, I was unsure if she would be interested or that we could afford what I thought would be an exorbitant fee for a publicly funded museum that was part of the federal government. After a series of phone calls where I discussed the museum's vision and our desire to be an activist institution with a commitment to social justice, Ava expressed a great deal of interest. I tried to contain my excitement because I just knew that we could not afford one of the most in-demand directors in Hollywood. Much to my surprise and relief, she offered to create the film as long as we could offset some of the direct costs. When I asked about her fee, she said this is about honoring our culture, not about her.

As we began to discuss the specifics of the film, Ava felt that such a broad message required us to narrow the focus of the project and find the thread that would knit the piece together. During one of our calls, she shared that she had discovered that the calendar day August 28 was an important date in black history. She believed that she could craft a film that looked at the array of events that had either begun or ended on August 28 over the years. I was even surprised by all that had transpired on that specific day: from Nat Turner's insurrection against slavery to the murder of Emmett Till to the March on Washington to the first landfall of Hurricane Katrina to the acceptance by Barack Obama of the nomination of the Democratic Party to be its candidate for the presidency. I was fascinated by the idea, but I worried that it might be too narrowly focused. We then considered looking at the month of August as a timeframe, which would, of course, increase the number of possible events that the film could depict. But Ava was right in her desire to focus on one day in the history of a people.

Ava was able to make this concept work by drawing on a diverse cast of talented actors who recognized the importance of the museum and reveled in the opportunity to work with Ava. I could not believe that so many actors I admired participated in this production. As I reviewed the rough cuts, I was so moved to see Don Cheadle, Regina King, Angela Bassett, Gugu

Mbatha-Raw, Lupita Nyong'o, David Oyelowo, Michael Ealy, Andre Holland, and Glynn Turman using their skills to benefit NMAAHC. What made this film work was Ava's talents—her unique way of focusing on two men creating a coffin to carry the body of Emmett Till, her vision of experiencing the carnage and loss caused by Hurricane Katrina through the struggle of one woman to survive, her sensibility in exploring the tensions between a mother and daughter through the music of the Marvelettes' "Please Mr. Postman"— all brought a needed humanity and accessibility to these historical events. I will always be indebted to Ava for sharing her gifts so generously and to Oprah for inviting me to the party.

Another gift that appeared at just the right movement was from one of my Chicago connections, Hill Hammock. Hill was the chair of the Board of the Chicago Historical Society who recruited me, who convinced me to leave the National Museum of American History to become the president of one of Chicago's oldest museums. It was Hill who had organized a series of early donations to NMAAHC from former board members at CHS. As I prepared for the sprint to the opening, Hill called and said that he worried that I needed a break prior to the stress of the stretch run. He offered the use of his Paris apartment as a respite where I could bring my wife and members of my immediate family. I was overwhelmed by his kindness. So with my wife, my daughter, son-in-law, and my four-month-old granddaughter in tow, we spent two weeks enjoying Paris. We strolled the city, visiting only a few museums, stopping instead to take pictures at the Eiffel Tower, the Arc de Triomphe, the Louvre, and many of the sites of culture and history that one can only find in Paris so that my granddaughter will one day have a record of her first trip abroad.

Even a trip to Paris was not enough to keep me from worrying about the museum. During this sojourn I thought a great deal about an issue that I thought would be very problematic. How would we handle the process of preparing and installing 3,500 objects, thousands of graphics, hundreds of media pieces, all within a compressed schedule? The names of those who accomplished this task were not as well-known as Stanley Nelson or Ava DuVernay, but their contributions had even greater significance. The challenges of installing artifacts have some of the same similarities as those that come with raising money. Both activities need clear organization and planning as to strategies and priorities. There is a shared nimbleness that allows for adaptation when the reality of the situation trumps the intended process. And both require an appreciation of how much work on a daily basis is

needed to achieve the goals. NMAAHC was fortunate to have the leadership of the Office of Project Management that included Lynn Chase, Bryan Sieling, and Dorey Butter, along with the expertise of Renee Anderson who led the museum's collection management activities.

They devised a scheme where three distinct teams were assigned specific galleries to install. In addition, another team was focused on making sure the artifact mounts and the case graphics were ready so that there was no need to revisit a case once the objects were installed. This was a carefully choreographed ballet that required each aspect of the preparation be completed so that the installation could move with dispatch. This was crucial as the installation period was shortened as a result of delays in the construction. Lynn Chase believed that the museum needed one year from the time construction ended in order to complete an orderly and safe period of installation.

Unfortunately, the building was not turned over to the museum until six months before the opening date. The April release of the building signaled a clean atmosphere where both the artifacts and the highly sensitive media and audio technology could be installed without fear of dust contamination or excessive vibrations caused by construction machinery. While some collections, such as the airplane flown by the Tuskegee pilots, could be installed while other work was being done, most of the artifacts needed the postconstruction environment. Now the teams could install the costumes from Ntozake Shange's play *For Colored Girls Who Have Considered Suicide / When the Rainbow is Enuf* in the Taking the Stage exhibition in the Culture Galleries, or place the sensitive Bible owned by Nat Turner in the specially designed case in the Slavery and Freedom Gallery without fear of damage or dust. I am so proud of the installation teams because rather than bemoan the delays, they revised plans and schedules so that, when necessary, overlapping shifts could accelerate the process. Most importantly, the sense of good will and a common mission helped the staff adjust to the new realities. An example of just that spirit was the moment the staff seized upon to mark the occasion when 50 percent of the cases were completed. To commemorate that, the installation leaders designed a clear drinking glass, 50 percent of which was it covered in blue with the words, "Half Full" emblazoned on the glass. Despite the abbreviated installation time, the teams recognized how much they had achieved by that point and used that confidence to help them believe that they could accomplish something few could imagine. The commitment of the installation teams in concert with the excellent planning

and leadership of Lynn Chase facilitated the installation of 3,500 artifacts in over 80,000 square feet of exhibition space within six months. They did it. Another example of the abilities and dedication of a gifted staff.

All the whirlwind of activities that dominated the work of most of the staff from dealing with a much shorter schedule for artifact installation to finalizing the last construction details paled in comparison to the stress of preparing for the opening of NMAAHC. Planning for the dedication in the fall of 2016 was almost as difficult and as challenging as working for eleven years to create the museum. There were very few models as to how one opens a national museum. And how should the opening of NMAAHC reflect a commitment to African American culture and yet be a place of welcome for all? How does an institution privilege its major donors while recognizing the important contributions of smaller funders? What role, if any, should Congress have that day? After tapping so many donors to support the construction of the building, how do you find the resources to pay for days of activities? How does one balance the private galas with the need for this to be a public event celebrated not just within Washington? Does one risk inclement weather by having an outdoor ceremony? How does the museum handle the myriad of media requests to come? Who should perform? When can we confirm the security requirements for the president's participation? How do we give my staff enough time to make the museum ready but not have the opening too near the forthcoming presidential elections? And the two thorniest questions, who gets what seat and who is allowed to speak on stage?

I relied on a small group of senior staff to help me wrestle with these issues, including the deputy director, the head of development, the government liaison, the chief of the Office of Special Events, and Tasha Coleman whose skill and wit had sustained me since 2005. I was concerned about the weather. The museum had been fortunate to date that the elements had had no impact on the earlier outdoor activities, namely, the groundbreaking ceremony and the mapping of the museum. I thought that we could house the event within the museum, easily servicing three or four thousand attendees. I think the entire team, all of them, laughed at my naiveté. They reminded me that we would have at least 7,000 VIPs, plus thousands who would want to be a part of such a momentous occasion. An outside ceremony also had its challenges: we would need the White House and the Secret Service to agree and to determine what security protocols were needed; the number of attendees would dwarf our five-acre footprint so we would have to close streets and convince the National Park Service to allow the museum to use land south of the museum as seating areas; and we would need a very sophisticated

inclement weather plan. Having the dedication outside under the porch of the museum would help address an issue that became apparent during the groundbreaking event. We had received a great deal of criticism that that event had catered only to elite donors and not to the average citizen. Holding our opening outdoors meant that thousands, perhaps tens of thousands, could share in our special day. Now we just had to figure out where to place them on the Mall.

It was imperative that the program reflect the diversity of America but also allow us to honor and recognize those who were key supporters of the museum. And it had to be completed in less than two hours. Obviously, President Obama would be the keynote speaker, but who else? The Smithsonian needed to be represented by its leadership including the Secretary and the Chief Justice of the Supreme Court in his role of Chancellor of the Institution and Chair of the Smithsonian governing body, the Board of Regents. We could not have speaking roles for all the congressional leadership nor could we include all those who introduced and supported the bill that created the museum. And who should represent the museum's Council? The co-chairs since the beginning were Dick Parsons and Linda Johnson Rice, but how did I recognize the central role of Kenneth Chenault as the chair of the Development Committee that was responsible for so many of the donations that helped to pay for the museum?

I was comfortable that my colleagues could resolve those questions, but I was insistent on two other issues. According to the political protocol, I was so low in the pecking order that I should speak near the beginning of the program, as I had for the groundbreaking ceremony. I felt that I should speak just prior to President Obama as a way to recognize the stature, not of me, but of the museum. More problematic was my desire to have former President George W. Bush play a central role in the ceremony. I felt strongly that his support of the museum and especially his public pronouncement that the museum should be on the Mall must be appropriately recognized. Yet many on the president's staff felt that the focus should be on the current occupant of the White House. I learned from having dealt with the experience of the groundbreaking ceremony to listen but not be held captive by the White House staff whose job it is to protect and place the president in the best situation possible. After discussing this with Valerie Jarrett, a senior advisor to Obama, it was agreed that the dedication ceremony would benefit from having two presidents on stage. Lastly, I wanted the program to have a few touching moments, like the appearance of the children at the groundbreaking ceremony who had raised $600 in coins to

support the museum. That said, I had no idea what would be appropriate and memorable.

I believed that whatever we did during the dedication ceremony needed to be leavened by music, performance, and poetic readings. As I contemplated the day, it became clear that this event be produced by experts in stagecraft, with access to talent, who were in the business of staging extravaganzas. And, as luck would have it, we had such a person, and he was on our Council: the amazingly talented producer, Quincy Jones. For the past eleven years, I had spent time with Quincy. We bonded the first time I visited his home, should I say his palace, in Los Angeles. While waiting for him to finish an earlier meeting, I walked around the first floor and I marveled at the Oscars and Emmys scattered around his house, reminders that this was a world light years removed from my New Jersey upbringing. As his meeting concluded, Quincy introduced me to another guest who had just arrived from Stockholm. My nervousness led me to fill the silence, talking on about how much I enjoyed Sweden and how I was especially moved when I visited a museum that housed a seventeenth-century naval warship that sank on its maiden voyage, the *Vasa*. Quincy looked at me quizzically and then said that the Vasa Museum was one of his favorite sites. He then proceeded to open a door revealing a closet filled with a whole array of souvenirs from that museum. We became close from that shared museum experience.

Throughout the years of our friendship, Quincy has shared stories with me about his production work for Frank Sinatra, Michael Jackson, and so many others. He casually mentioned that he could produce something for the museum. As we thought about the dedication, I returned to Quincy's quiet offer and I called and asked would he commit to producing the dedication ceremony. Not only did he and his producing partner, Don Mischer, agree to create the opening activities, they also committed to producing a separate musical concert that celebrated the museum and black culture that would be televised live the night before the dedication. Quincy Jones, the genius who produced the "We Are the World" video that aided hunger in Africa and who oversaw the celebration of the new Millennium in 2000, agreed to do the same for NMAAHC. I was overjoyed but still concerned about how soon we would be at September 24, 2016. Fortunately, the plans were solidifying and the sprint to the opening was on.

The six months prior to the opening was a blur of meetings, quick decisions, midcourse corrections, media interviews where I tried to find something new to say, "walkabouts" to help keep up staff morale, and internal debates to determine what needed my attention versus what I could delegate.

During this period I kept returning to the notion of how the general public could be a part of this opening celebration. Still stinging a bit from the criticism about the elite nature of the groundbreaking program, I wanted to do something on a grand scale for the public. I turned, as was my wont, to the familiar: the idea of a folklife festival. Why not create a three-day fair that would celebrate the museum opening by exploring musical traditions and by examining African American culture through storytelling, dance, and food? This would be a free event on the Mall that would exponentially increase the sense of public ownership of NMAAHC. I asked my Curator of Music and Performing Arts Dwan Reece to work with someone who had brilliantly shaped our prior involvement with the Folklife Festival, Mark Puryear, to create what came to be called "Freedom Sounds: A Community Celebration." This event would occur on the same weekend as the dedication ceremony, from Friday, September 23, through Sunday, September 25.

I wanted an event that would be memorable and a worthy accompaniment to the dedication that would include well-known performers and artists who deserved greater recognition. It had to be a special program that would leave the audiences overwhelmed by the breath of the activities and moved by the richness and diversity of the African American musical heritage. Once again, gifted colleagues had to struggle to accomplish the dreams of the director. Reece and Puryear had to convince the National Park Service that everyone benefitted if this celebration occurred near the museum on the grounds of the Washington Monument. It helped immeasurably that we could point to the public commitment of the President of the United States. With a whole host of fears and misgivings, the Park Service, nonetheless, relented, and presto, we had the site for the festival. The co-curators brought an intellectual rigor to the festival by exploring the role that music and performance has played in the lives of African Americans as both a vehicle of creative expression and as a bulwark to confront and lighten the burdens of racism. It was important that this festival encourage the audiences to tap their toes and to expand their understanding of black musical history.

Reece and Puryear gathered an amazing array of performers who presented a musical exploration of every genre, from blues to rhythm and blues to jazz to Afro-Latino fusion to hip hop. All in the three days. The program was enriched by the addition of spoken word and visual artists, poets, and food concessions that showcased the cuisine of the American South, the Caribbean, and Africa. The co-curators did a masterful job of bringing to the festival over twenty-five performers such as Stanley Clarke, Jean Carne, the Dixie Hummingbirds, and the Stax Music Academy. In addition,

there were two evening concerts headlined by well-known and in-demand artists that included hip hop royalty from Living Colour to Public Enemy to the Roots. The second concert highlighted both Washington, DC–based musicians Meshell Ndegeocello and Experience Unlimited, and international artists like Angélique Kidjo. I was personally excited that we could showcase the group Sweet Honey in the Rock, which was founded by Bernice Johnson Reagon, who was a colleague, a vocal member of the Scholarly Advisory Committee, and a much-admired friend. From the time I was a new curator at the National Museum of American History through my tenure as the director of NMAAHC, Bernice had schooled me on the politics of race at the Smithsonian and within Washington, DC. This was my send-off to her, for all she had done over the years.

The collaborative talents of Reece and Puryear crafted exactly what the museum needed, a way for everyone to share in the opening of NMAAHC. My only disappointment was that the demands of the days prior to September 24, 2016, prevented me from joining the crowds and enjoying the performers. I so wanted to tap my toes to Jean Carne or Public Enemy. Instead, I shook hands. Every evening I had an event or an obligation, and each morning I awoke worried about the myriad of details that could derail the opening. Not least, as plans for the opening activities coalesced, I was still struggling to find the money to pay for these dreams. Fortunately, the Development Staff had developed a strategy that would fund the celebrations. As a result of the timing of the successful capital campaign, many of our Founding Donors had already fulfilled their initial pledges. The staff decided to return to our earliest supporters to solicit their interest in being one of five sponsors of the opening weekend. Recognizing the attention that would accompany the president's presence, my colleagues in Development focused on the visibility that would accrue to any of the potential sponsors. Thanks to their efforts, Bank of America, Prudential, Target, Toyota, and Kaiser Permanente provided the support that made the dedication ceremonies possible.

When Debora Scriber-Miller came into my office on the morning of Friday, September 9, 2016, I could see her almost grimace as she handed me the schedule for the next two weeks. And I laughed. I could not even imagine as I looked over that agenda that I had the stamina to be witty and charming through the number of receptions that had seemed so manageable four months earlier but now looked so overwhelming. That line-up:

September 12, Interview with Gayle King, CBS *This Morning*
September 14, Media preview and press conference

September 15, Reception recognizing Aflac as $1-million donor to NMAAHC

September 16, Reception for NMAAHC staff and family; Speak at Congressional Black Caucus

September 17, Reception for families who donated artifacts

September 18, Reception for the staff of Smithsonian Institution in the morning

September 18, Reception for charter members in the evening

September 19, Special preview for sponsors of dedication weekend

September 20, Second special preview for sponsors of dedication weekend

September 21, Preview for donors who contributed $5,000 to $99,000

September 22, Preview for donors who contributed $100,000 to $1 million

September 23, Opening of Freedom Sounds Festival on the National Mall; Reception at White House; Performance at Kennedy Center

September 24, Dedication Ceremony, Smithsonian Board of Regents; Celebration for major donors

While I tried to remember and treasure every moment of the opening events, some left an indelible mark that reminded me why this endeavor was so important to so many. At each reception, I was touched by the expressions of appreciation for the work of my colleagues and by the constant refrain of "how essential" and "how much the museum is needed." The curatorial staff, especially the Curator of Collections Michèle Gates Moresi, felt the museum must acknowledge those who contributed something other than money, those who had entrusted us with their memories and their family artifacts. I decided that we would host a reception at the museum in their honor.

I must admit, I was surprised when nearly one thousand people traveled from around the nation to attend the event on September 17. I wandered through the galleries watching families point with pride to the object they had donated. I overheard grandparents explaining the stories about the artifacts to younger generations who, at least for the moment, seemed enthralled by the intergenerational sharing of family histories. And I was so proud that NMAAHC was a home for the stories of those famous only to their families. I had spent much of my museum career extolling the importance of being a community-centered profession. To see the rewards of that commitment unfold in front of me was an emotional moment that made being a voice in the wilderness of the museum community worth all the years of struggle. I

wondered how much material was still in the homes of the African American community. One thing I knew for sure: the collection gathered by NMAAHC should end any notions about the paucity of African American material culture.

Other nights proved almost as memorable. Often at the opening of major exhibitions or the launching of new museums, only a small portion of the staff is invited to participate in the festivities. I wanted to fete the entire staff and their families. Since every member of the staff carried some aspect of the burden of crafting this enterprise, I believed their efforts should be recognized and rewarded. A week prior to the White House gathering, we hosted a party for my colleagues and their families that was as fancy as, and maybe more fun than, any of the events for donors. We were a tad extravagant, but I wanted my colleagues to have the same overpriced hors d'oeuvres and chilled champagne that would be served to the million-dollar donors. I recall how many of the financial staff or those who worked as management-support assistants expressed how pleased and honored they were that the museum organized an event for them. As the staff danced in celebration of their achievements, I was too exhausted to party. I was really concerned. It was only the first week of galas, and already my energy was on the wane.

There was no time to be tired. I was reenergized when I attended an open house for the charter members during the evening of September 18, people who loved the museum but whose ability to give could not match the level of their enthusiasm. These supporters, whose contributions ranged from twenty-five to one thousand dollars, were *extremely* pleased that the museum rewarded their backing with access to the museum earlier than donors with greater philanthropic capacity. As I greeted the charter members, I reminded them how essential their support was and that many of them were some of the earliest believers in the museum, and in me.

Another preopening event proved unforgettable in a different way, in how we were spared a near catastrophe. Gayle King, one of the anchors on the television program CBS *This Morning*, had requested that the show be allowed to broadcast from the lawn on the Constitution Avenue side of the museum on Monday, September 12. This caused significant problems for Fleur Paysour and the Public Affairs staff. If we granted this request, CBS would have access to the museum, while broadcasting from a location that was offered to no other network, prior to the press conference scheduled two days later in the week. While I wanted to be fair to all, CBS had covered the museum extensively, including two episodes on *60 Minutes*. After being assured by the Smithsonian Office of Horticulture that the newly planted lawn with 350,000

crocus bulbs would not be damaged by the stage set and the necessary equipment, I risked the wrath of the rest of the media by agreeing to the request by CBS. As the stage was being built, a security fence, a requirement of the White House, cordoned off the entire museum preventing public access from the streets surrounding NMAAHC.

On the morning of the broadcast, I was pleased to spend time with Colin Powell, a member of the Advisory Council who was to be interviewed as well. Also there was Scott Pelley, at the time the *CBS Evening News* anchor who had accompanied me to Mozambique as I met with descendants of the enslaved who were lost with the sinking of the *São José*. Scott was going to speak to the importance of that journey. My conversation with Gayle King, Norah O'Donnell, and Charlie Rose was pleasant and broke no new ground. Next came General Powell. I had noticed even before my interview that there was a man screaming obscenities from behind the security barriers. As the general took his seat, the screaming ceased. Suddenly the man had scaled the fence and was running onto the set, passed me before I could respond, trying to get to Colin Powell. Fortunately, a vigilant CBS sound man tackled the intruder and held him until the museum's security removed him in handcuffs. Everyone was shaken. Everyone, that is, but the general who continued the interview as if nothing had happened. The segment ended, and as I walked back to my office I acknowledged just how fortunate we had been: the program could have ended differently, with grave overtones for the opening of the museum. We were fortunate that the sound man could do more than listen.

The events leading to the opening weekend foreshadowed the stress, the feelings, and the excitement that I had experienced on the weekend of the dedication. There was a sense of relief that after eleven years of what I defined as the longest period of gestation imaginable, the world would experience the birth of the National Museum of African American History and Culture. I still questioned whether we were ready for the next forty-eight hours. And was the country prepared for our attempt to change both the monumental landscape of the Mall and America's notions about its identity.

The reception at the White House that recognized the opening of the museum was very important to me. While I had been in the White House quite often, there was still something so impressive about strolling through this iconic edifice that was the representation for many of American democracy. This day was made even more special because of the current occupants of the White House. There was something so appropriate and so magical about opening the museum during the administration of America's first black

president, Barack Obama, and commencing the weekend of celebration at the White House. What excited me the most, though, was that my mother and many of my family would experience the honor of meeting the president and the first lady. As the director of NMAAHC, I rarely exercised any special privileges, but this time I insisted that twenty members of my family including my mother, brother, cousins, aunts, and my wife and daughters be formally invited to all the dedication activities. I especially wanted my mother, Montrose Bunch, and her elder sister, Margaret Lindsey, both of whom would never see eighty again, to meet President Obama.

As we waited to complete the security screening, I felt the weight of the moment, but also reveled in the joy of seeing my mother holding her great granddaughter as four generations of my family entered the White House for the first time. Throughout the reception, I enjoyed watching my relatives be tourists. My cousins took pictures with everyone they met, from John Lewis to Kobe Bryant to Reverend Jesse Jackson to Debbie Allen to Harry Belafonte, everybody except with me. One of the special moments occurred when my immediate family was ushered into the Blue Room for photographs with the president and first lady. Both my mother and my aunt jettisoned their canes so they could proudly walk unassisted into the room. The president warmly greeted my family who beamed as this moment was documented. As we left to return to the reception, my aunt grabbed my hand and thanked me for fulfilling one of her dreams. That was a moment I will always treasure.

It was now time for the president's remarks. I was surprised when I was instructed to appear with the president and first lady, especially when I was asked to greet the gathering first and then introduce my friends from Chicago. As I stepped to the podium, I could not stop smiling because of the hundreds of people who came to celebrate the efforts of my colleagues. In their faces I saw that they shared the pride and the sense of accomplishment of my staff. I loved initiating the speaking portion of the event by saying "welcome to the White House." How many chances will I ever get to say that at the White House? I felt blessed. Ripe with emotion and nerves, I then stumbled through my introduction of the President and Mrs. Obama as I tried to convey my appreciation for their support and for a friendship of sixteen years.

The crowd grew silent as the president began his comments by expressing how important this new symbol of America on the National Mall was to him and Michele. He expressed a bit of surprise that the museum even existed. He then spoke words that brought me to tears. Touching my shoulder, Obama continued: "It could not have been done without the persistence,

the wisdom, the dedication, the savvy, the ability to make people feel guilty, the begging, the deal-making, and just the general street smarts of Lonnie and his entire team." I was moved, pleased by his comments. I just wish my Dad could have heard the president praise the son he raised.

Immediately after the reception, I went to the Kennedy Center to attend the concert "Taking the Stage" that Quincy Jones and Don Mischer had produced for us. The demand to attend this performance had been overwhelming. The staff had struggled to find ways to seat all the donors, the celebrities, the politicians, and charter members who felt their support entitled them to attend the concert. This juggling act was made more difficult by my actions. As my colleagues negotiated with the Kennedy Center, they recognized the importance of the concert and wanted to stage it in the largest concert hall available. I decided that we should use a smaller venue, one that held eight hundred guests. I feared that if the hall were too large that the empty seats would be an embarrassment to the president and to the museum. I still do not know what I must have been thinking at the time. I do know that my colleagues were right, and I was wrong. Nearly two thousand people probably should have attended the performance. Due to my cautiousness, there were many bruised egos and anger from those whom we could not accommodate.

The concept developed by Quincy and Don Mischer incorporated some of the objects and the stories that appear in the museum's major exhibition on the African American musical heritage as a means to frame the musical performances. Using Louis Armstrong's trumpet allowed Quincy to present the music of the Harlem Renaissance. Highlighting the dress worn by Marian Anderson as she performed at the Lincoln Memorial in 1939 enabled Quincy and Mischer to introduce Mary J. Blige's rendition of the song Ms. Anderson sang that Easter morning, "My Country, 'Tis of Thee." As Quincy often said, "Trust me, I know how to do this." And he did. My only request of the producers was to acknowledge in my opening comments the incredible work of the Council by having them join me on stage prior to the first act. I wanted that celebrity audience to know that the museum would not exist without the leadership of the Council. As I was introduced, I did not expect the ovation I received, because after all the years being the face of the museum, I was still uncomfortable with my visibility. It would not be long before more recognizable faces would grace the stage.

I so enjoyed the concert, in part, because I sat with the president and first lady and I saw, based on the amount of dancing, singing, and swaying that came from the presidential box, how much they appreciated the

performances. And what an array of talent performing in honor of the efforts of my colleagues there was. From the moment Oprah Winfrey opened the program standing in front of images of the museum, I realized this was more than a concert. It was a recognition of the centrality of African American music in the shaping of American culture, a joyous appreciation of the creation of NMAAHC, and a call to remember the debt owed to those musical pioneers by this current generation of especially gifted and privileged performers.

Echoing the African American tradition of "call and response," each performer built on the prior performance in ways that were powerful and poignant. Each act was introduced by celebrities such as Rashida Jones, Jesse Williams, Jada Pinkett Smith, Angela Bassett, Tom Hanks, Janelle Monáe, and Dave Chappelle. A segment focusing on the music from Harlem in the 1920s began with Patti Austin performing the Ellington song, "Take the A Train," and was then enriched by Savion Glover bringing his unique dancing ability to the Ellington composition, "It Don't Mean a Thing (If It Ain't Got that Swing)." Or DC native Dave Grohl's singing of "Crosstown Traffic" segued nicely into Usher's electrifying embodiment of James Brown as he sang a medley that included "Papa's Got a Brand New Bag" and "Say It Loud—I'm Black and I'm Proud." Watching Christina Aguilera perform "Stormy Weather," later followed by Gladys Knight's beautifully resilient rendition of "I Heard It Through the Grapevine" spoke volumes about the impact of women on popular song.

There were so many wonderful moments. Quincy and Mischer believed that honoring the African American military experience would be one of the highlights of the entire evening. I must admit, I was not sure how that acknowledgment would flow with the rest of the concert. But unlike my inability to listen to my staff about the size of the venue, I accepted their idea. The producers brought several members of the famed WWII pilots known as the Tuskegee Airmen to the stage where they were introduced by Tom Hanks and then serenaded by the West Point Glee Club singing "America the Beautiful." What made this segment special was the appearance of General Colin Powell who formally saluted those who paved the way for him. This was the occasion when the evening went from a televised show to a transformative experience that could only happen because of the museum.

And as the tagline from an AM Radio program of my youth proclaimed "the hits just keep on comin'." No one who attended the concert would forget Ne-Yo's performance of the hits of Michael Jackson or the plaintive phrasing of John Legend as he sang "What's Going On" by Marvin Gaye, or Herbie

Hancock's spirited instrumental of his "Watermelon Man." And the famed gospel duo Mary Mary, the Howard University Gospel Choir, and Shirley Caesar roused the audience when they brought the church into the Kennedy Center. I believed that the show had to capture the beats of the generations shaped by rap and hip hop. As a result of the work that Quincy did with younger artists, the performance by rappers Common, Doug E. Fresh, and Chuck D, backed by percussionist Kevin Ricard, demonstrated the poetry, musicality, and contemporary urgency of a musical form that has shaped the globe.

Personally, the appearance of Stevie Wonder was a fitting end to an unforgettable evening. I remember so many parties where I tried to look cool as I danced to Stevie's music. To have him perform at the Kennedy Center concert seemed like a gift to me. His voice soared as he sang "Higher Ground," which reminded me of the aspirations for the museum: to be a place where America could reach a higher ground of understanding when it comes to issues of race. By the time the concert ended, I had accepted numerous congratulatory handshakes. Finally, I made it home. I was too excited to sleep. I just sat in the dark, waiting, waiting for the day that I had dreamed about for more than a decade.

I waited, and I worried. I had shaped all aspects of this museum, from the initial visioning to the architecture to the collections to the interpretive frameworks—this was my baby. What if I was wrong? As I mumbled my concerns, my wife simply said: "It is too late to do anything about that now." She was right, but I did not find her clarity comforting. I would have to live with the decisions of the past decade and hope that the thousands who would interact with the museum this day would agree with most of the choices I had made. Another issue that kept me from sleeping was my decision to open the museum as soon as the dedication ceremony ended. To service so many donors, the staff planned a late-night after party where the museum would be open for twenty-four hours throughout the weekend. Their initial idea was to restrict entry into the building the afternoon and early evening of the dedication in order to give the caterers and the performers the time they would need to prepare for the event. I felt we could not have a ceremony that launched the museum, and then close until the next day. Once again, my colleagues would have to struggle to accommodate my sense of what was appropriate.

Much like the morning of the groundbreaking in 2012, I had to arrive at the museum quite early to handle several media interviews. Unlike that

day, though, where my dressing in the dark led to mismatched socks and a tie that was so stained that I had to commandeer neckwear from a colleague, I had earlier laid out the suit and tie that my daughters insisted I wear so that I, at least, looked composed despite my growing apprehension. Once I arrived at the museum, there were already VIPs to greet. President Bill Clinton, who some in the African American community labeled the first black president, was an early arrival who once again demonstrated his mastery at working the room as others soon gathered. One person who could not attend was the Council Co-chair Dick Parsons who was recuperating from surgery. I was disappointed by his absence. More than any other Council member, his generosity, strategic acumen, friendship, and humor were essential factors in my growth as a leader. Whenever I worried about an issue, Dick Parsons was available, not to criticize, but to help. I would miss his presence at the dedication, but I knew he understood that this ceremony was also a celebration of his faith in the project, his commitment, and his leadership.

Just prior to the scheduled time for the program to begin, I noticed the activity as President and Mrs. Obama arrived just as Angélique Kidjo concluded her performance on the stage facing the early arriving audience. The president asked if I was ready for my big day. I mentioned that this was not mine, but America's moment. As the ceremony began and we took our places on the stage, the gravity of the day was visibly apparent to me. Sitting across from me was Chief Justice John Roberts, Shirley Ann Jackson, the President of Rensselaer Polytechnic Institute and the Vice Chair of the Smithsonian governing body, the Secretary of the Smithsonian Institution David Skorton, and two key members of the NMAAHC Council, Linda Johnson Rice and Kenneth Chenault. I was positioned just behind President and Mrs. Obama, and President and Mrs. Bush, and next to Congressman John Lewis. I must admit, I felt like an interloper.

As I gazed out at the rapidly expanding crowd, I was pleased to see such a large gathering that filled the area behind the VIP seating on the south lawn of the museum for nearly a quarter mile to Independence Avenue. And when I looked to my right, the grounds of the Washington Monument were also packed with spectators who wanted to be a part of this long overdue occasion. I was proud as I thought of the millions who would watch the televised coverage of the event. And I was so grateful to the museum's Office of Special Projects that had organized watch parties at museums, community centers, and schools throughout the United States, Africa, and the Caribbean. This would truly be a global celebration. What also enriched the day was the wonderful array of what Kinshasha Holman Conwill called "boldface

names." From my seat I could see Vice President Joseph Biden, Oprah Winfrey, Eric Holder, Justice Sonia Sotomayor, Samuel Jackson, Shonda Rhimes, the Speaker of the House of Representatives Paul Ryan, and the Minority Leader Nancy Pelosi, and so many more enter. Then I saw the person who meant the most to me, my mother.

I was thrilled by the diversity of Americans present at the ceremony. In some ways, the dedication of the museum was America at its best. As I took in the faces in that crowd, I thought this is the America that was the dream of Frederick Douglass, Martin Luther King Jr., and Shirley Chisholm. This is the America that was not only as Maya Angelou so poetically wrote "the hope of the slave," but a nation that made real the words of the Declaration of Independence, fulfilled the promise of gender equality that was articulated at the women's rights convention in Seneca Falls in 1848, and embraced the dignity and fairness championed by Cesar Chavez. The dedication ceremony brought together people of various races and backgrounds, with competing political ideologies, and vastly dissimilar economic status who put aside differences in order to unite to create a museum that all could support. One of the most important moments occurred when photographers captured a wonderfully warm embrace between President Bush and Mrs. Obama. This hug seen around the world spoke volumes about how a hopeful America could cross racial and political boundaries that had divided the country for centuries. I wanted to believe that the optimism, the spirit of working for the greater good, and the sense of finding common cause that was so apparent on that day would signal a changing America despite the divisive and ugly presidential campaign that was just weeks away from concluding.

After a moving invocation delivered by Reverend Calvin Butts, John Lewis rose to speak. As the member of Congress who had championed the idea of a museum for nearly two decades, we thought that he should initiate the formal program. He began by saying that the crowd reminded him of the thousands who participated in the March on Washington in August 1963. His remarks set a high moral tone for the day when he said: "As long as there is a United States of America, now there will be a National Museum of African American History and Culture. We are gathered here today to dedicate a building, but this place is more than a building. It is a dream come true." As the audience cheered, Lewis continued: "This museum is a testament to the dignity of the dispossessed in every corner of the globe who yearn for freedom. . . . All the—voices—roaming for centuries—have finally found their home here, in this great monument to our pain, our suffering, and our victory." He concluded with his hope for the museum that all who visit will be

"filled with a greater respect for the dignity and worth of every human being and a stronger commitment to the ideals of justice, equality and true democracy." As he has done throughout his life, John Lewis challenged America to renew its commitment to social justice.

To many in the audience, one of the most powerful, and most surprising, of the day's speeches was delivered by former President George W. Bush. He began by expressing how important it was to his administration that he signed the legislation to create the National Museum of African American History and Culture. With words he later confirmed to me that he had personally drafted, President Bush, in his own way, challenged America to be better. Possibly reacting to the venom and the obfuscation that was coming from his own party's presidential nominee, Bush believed the museum was important because "It shows our commitment to truth. A great nation does not hide its history. It faces its flaws and corrects them. This museum tells the truth that a country founded on the promise of liberty held millions in chains. That the price of our union was America's original sin." The audience showed its approval when he ended his remarks by emphasizing: "Our country is better and more vibrant because of . . . the contributions of millions of African Americans. No telling of American history is neither complete nor accurate without acknowledging them."

Like President Bush, so many of the speakers spoke from the heart about their hopes for the museum, and for America. The Chief Justice detailed how often the Supreme Court was on the wrong side of history with many of its decisions about racial equality, citing cases like Dred Scott or *Plessy v. Ferguson*. He believed that within the museum these stories will be told as well as other Supreme Court actions like the *Brown v. Board of Education* ruling that ended de jure segregation. Council members Kenneth Chenault and Linda Johnson Rice shared their reasons for their decade-long commitment to the museum. Chenault expressed the sentiment of all involved with NMAAHC that this was "a museum for all Americans." I was particularly heartened by the remarks of Regent Shirley Ann Jackson who drew from her early life in segregated Washington to reflect on the importance and impact of NMAAHC.

Interspersed between the formal speeches were presentations, first by Oprah Winfrey and Will Smith and, later, Robert De Niro and Angela Bassett that reflected one of the tenants of the museum. Within the walls of NMAAHC, it was important to hear and experience the voices and the words of African Americans who lived the history. This served to humanize the stories of the past by sharing the sentiments, not of curators but of those whose lives were shaped by this history and who, in turn, molded America.

I wanted those words, those lives, to take center stage at the dedication. Oprah and Will Smith engaged in a funny and engaging poetry slam, reading the words of Maya Angelou, Langston Hughes, and Dr. King. Oprah captured the beauty and the self-confidence of Zora Neale Hurston as she read: "Sometimes, I feel discriminated against, but it does not make me angry. It merely astonishes me. How can any deny themselves the pleasure of my company? It's beyond me." Robert De Niro and Angela Bassett brought life and passion to quotations from Frederick Douglass, Ida B. Wells, Rosa Parks, and John Lewis. De Niro poignantly channeled Muhammad Ali's admonition that affecting change requires an understanding that "will is stronger than skill."

I just hoped that I could will my legs to work when I was introduced as the next speaker. To follow the wonderful presentations of President Bush and John Lewis was a bit unnerving. Even after navigating the challenge of climbing over Congressman Lewis without tripping, I still feared I would not rise to this occasion, that my speech would be uninspiring, and my nervousness would negatively affect my ability to project with confidence and clarity. As I slowly moved towards the podium, my mind was flooded with memories of the changes that had occurred in my life in the eleven years it took to arrive at this moment: I thought of the death of my father and the birth of my granddaughter; I could see the door that I broke so we could enter our first office; I could recall all those fundraising trips that took me away from family. For the first time in many years, I thought about an incident that forced me to confront my fear of speaking in front of any audience. In a ninth grade Civics class, we were assigned to speak for ten minutes about any topic that we found in a newspaper or magazine. I was quite shy and hated this assignment that would force me to stand in front of the class. To minimize the challenge, I decided to choose an article about my favorite baseball player, Mickey Mantle. When my father learned of my choice, he suggested an alternative: an article written by Dr. King entitled "What the Negro Has and Has Not Gained." I could not believe that he expected me to stand in front of a class of all white students and discuss race when all any adolescent wants is to fit in. I was terrified, but I gave my talk. I have no memory of how the presentation was received by my classmates, but I earned a superior grade. More importantly, that episode taught me that if I could survive discussing race in that junior high school classroom, I could face any audience, even with three presidents in attendance.

As I approached the podium, I became aware that the crowd was standing and applauding me. I looked out and I noticed former Senator Sam

Brownback, one of the original supporters of the bill to create the museum, smiling at me. I heard people calling my name. I saw luminaries and dignitaries that I admired celebrating me. I took a moment to do something I had never done, bask in my own notoriety. I began by saying that "Today a dream too long deferred is a dream no longer." I experienced a sense of accomplishment the likes of which I had never felt before. I was so pleased that we had fulfilled the promise and realized the expectations of so many generations who dreamed of this day. It was important to me to discuss what the museum meant to me. As I looked at the museum I said I did not focus on the materiality of the structure as much (though I did remember how much all those components ultimately cost), as I believed that the memories of the African American community were embedded in every piece of steel or every foot of concrete in the building. I was honored that the spirit and the stories of black America would now be forever enshrined and available on the National Mall, that sacred space for so many. I wanted all Americans to see the museum as a place of belonging, a site that they must visit often to be challenged and nourished. So I concluded with the phrase "welcome home." I glanced to my left and saw my mother nodding her approval. I just hoped that all my ancestors, the Bunchs, the Boones, the Andersons, the Brodies, the Dunns, the Easons, the Perrys, the Daughtrys, and all the others whose names I will never know were nodding proud of what my colleagues and I had created, and pleased that their toil, their ambitions, and their sacrifices, their enduring strengths had contributed mightily to who I am. And because of them I could become the Founding Director of the National Museum of African American History and Culture.

After having our spirits soar on the voice of Patti LaBelle performing a rendition of Sam Cooke's "A Change Is Gonna Come," and being surprised and uplifted by the gift of an unplanned appearance by Stevie Wonder, the stage belonged to the President of the United States, Barack Obama. It was appropriate that President Obama provide the closing address at the dedication. After all the times he goodheartedly pressed me to make sure that "the brother would get to open the African American museum," I was grateful that I could keep that promise. President Obama first discussed why the museum was important to him. "The building," he said, "is surely a site to behold . . . but what makes this occasion so it special is the larger story it contains." Because the history that the museum explores "is an essential part of our American story." The president than provided an example of how this museum can change our understanding of history. He was struck by a stone auction block in the museum and how it was saved and celebrated as a rock

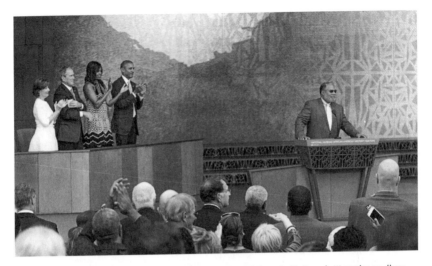

The dedication ceremony, on September 24, 2016, with Lonnie G. Bunch III at the podium, facing a standing ovation, and two presidents and two first ladies applauding. The museum opened to the public that same day. **PHOTOGRAPH BY LEAH L. JONES/NATIONAL MUSEUM OF AFRICAN AMERICAN HISTORY AND CULTURE**

upon which the presidential candidates of 1832, Andrew Jackson and Henry Clay, once stood, rather than as a site where hundreds of enslaved African Americans were torn from families and sold as chattel. To Obama that "block explains why this museum is so necessary . . . in context that object tells us so much more." Thanks to the museum, we learn a "richer and fuller story of who we are . . . and binds us together."

He then reminded the audience that "African American history is not somehow separate . . . not the underside of the American story, it is central to the American story." He continued by saying that African Americans are not a burden on America or a stain on America. . . . We are America. The president clearly centralized the black experience when he quoted Langston Hughes, "I, too am America." Echoing the remarks of George Bush, the President made clear the need to confront a difficult past. "History can make us uncomfortable. Yet out of that discomfort comes growth." Obama then suggested that it is "in the embrace of the truth . . . where real patriotism lies" and it was "an act of patriotism to understand where we have been." The President seemed to have enjoyed the juxtapositions that the exhibits in the museum present. How one depicts "the . . . uniform of the Chairman of the Joint Chiefs of Staff alongside the cape of the Godfather of Soul"; how another presents the way

Muhammad Ali "could float like a butterfly and sting like a bee"; and how this building reminds us that during difficult times we could "still Rock Steady like Aretha Franklin." President Obama became emotional as he neared the end of his speech. While suggesting that the African American "story needs to be told now more than ever to help provide the context for the debates of our time," he struggled to maintain his emotions when he discussed how important it would be to one day take his grandchildren to the museum.

President Obama concluded his prepared remarks, and the crowds gave him a wonderful and prolonged ovation, as if this was their opportunity to thank him for eight amazing years. But before he could bask in that acclaim, there was still a special activity that would require his involvement. I had promised him that he would cut the ribbon to open the museum. I decided that rather than a ceremony with an actual ribbon, though, we would christen the museum by ringing a bell. The sound of a bell has meanings both painful and uplifting to the African American community. Often a bell was used on a plantation to summon the enslaved to work. The sound of a bell, however, was also a symbol of African American spirituality and community. From the late nineteenth century into the twentieth century, the ringing of the bell on watch night (New Year's Eve) signaled the dawn of a new year and commemorated the coming of freedom promised by the Emancipation Proclamation on January 1, 1863.

We borrowed the "Freedom Bell" from the First Baptist Church of Williamsburg, Virginia. One of the oldest African American house of worship, it dates back to 1776. What better way to celebrate the opening of the museum than by ringing the Freedom Bell? To enrich the ceremony, we had contacted numerous African American churches in the District of Columbia and throughout the nation. At the conclusion of the dedication, the sound of the bells would let the entire country acknowledge and participate in the opening of NMAAHC.

Rather than simply have the president ring the bell, Cheryl Johnson, who by now had been promoted to my chief of staff, suggested that a multigenerational family participate in the ceremony. She was able to contact the Bonner family, whose matriarch, ninety-nine-year-old Ruth Odom Bonner was the daughter of an enslaved man, Elijah Odom, who had escaped from Mississippi to freedom. The family consisted of four generations, including Mrs. Bonner's six-year-old great granddaughter Christine. Watching the First Lady and the President Obama pull the rope with Mrs. Bonner, I knew that this family represented the arc of history that was the cornerstone of the African American community, from slavery to freedom to the possibilities

and challenges of the twenty-first century. As I heard bells ringing across the city and beyond, I could finally exhale as I realized hundreds of visitors were slowly making their way into the National Museum of African American History and Culture. Now no longer a dream.

I raced up to my office balcony to watch the crowds. Instead of dispersing, they stood, talked to each other, and sang. It was as if they did not want the ceremony to end. That sea of people helped me to forget the eleven years of doubt and struggle that was finally over. The throngs inside the museum demonstrated a thirst for what John Hope Franklin had demanded, "the unvarnished truth." I then strolled through the museum and outside to walk along the Mall. I was touched by everyone who wanted to greet me, take a selfie, share their pride in our achievement, and thank me and make certain I understood what a gift to America the museum was. Though my day was not done, with receptions and an after party still to attend, nothing matched the dedication ceremony and my own "walkabout" greeting the very people for whom we created NMAAHC.

At the end of the night, after all the festivities had ended and the museum was finally quiet but filled with the spirit of the day and the memories of all those whose stories were now told, I cried. I had nothing left to give. All I could think about was the biblical phrase that on the seventh day, he rested. After 4,085 days where there was not a waking hour that the museum was not on my mind, I was to finally get my day of rest.

A First Year of Surprise and Wonder
Helping America to Remember

You satisfy my soul
You make me feel like a sweepstakes winner.
—Bob Marley, "Satisfy My Soul," 1978

Several months after the dedication ceremony, I received an email from someone I did not know. That, in itself, was not unusual. What she said, though, was. She explained that her godmother was nearly ninety years old, with a fading memory, but that she had seen my name on a television program and expressed an interest in meeting me since "she knew my family." I am not sure exactly why I was intrigued by this, but I responded to the email writer and received back the phone number of her godmother. During our conversation, the older woman had some recollection about my family, but it seemed that her loneliness trumped her knowledge of my family. As she lived within fifty miles of the museum, I decided to visit her on the following weekend. I had no expectations other than helping someone my mother's age feel less alone.

When my wife and I arrived, she was excited and rambled on a bit about her mother and my family, but I was unclear as to the connection. Then, in a moment of clarity, she explained that her mother and my

paternal grandmother, Leanna Brodie Bunch, were best friends in North Carolina. She continued that when my grandmother moved to the north in 1909 she gave her mother a keepsake. Then she went to a drawer and retrieved a photograph of Leanna taken in the early twentieth century. I was stunned to tears. My only recollection of my grandmother was as a woman in her late seventies who died when I was four. And the few images I had ever seen of her were taken of a mature Leanna. In my hand, I had a photograph of a young woman about to transform her life by leaving the rural South for the promised land of Newark, New Jersey. I pressed her for more information about my grandmother, but she had told me all that she could remember. But that was enough, I had seen my grandmother in a new light. As I was about to take a photograph of the image, she stopped me and gave me the picture of Leanna, saying: "Your work has given so much to so many, my gift to you is this photograph of your grandmother." It was an extraordinary day. My only regret was that my father could not share that moment.

I could not believe that I had a picture of Leanna. Who could have imagined that the photograph would survive for more than 100 years, only to be given to me because of the visibility that came from the opening of NMAAHC? I expected the museum to affect my career, but I did not conceive that it would lead to a sense of personal discovery that would increase my knowledge about my own family. Without the visibility that accompanied the opening, this wonderful image of my grandmother would have been lost to the family forever. I now realize that since its opening in 2016, the museum has also contributed to that sense of discovery and greater understanding of self to the millions who have visited it.

We were overwhelmed by the demand for the museum, and that the desire to visit did not decrease even after two years. We planned for 4,000 daily visitors. Instead we averaged 8,000 per day, with some peak periods where the galleries were filled with 11,000 people, 20 percent of whom were under the age of thirty. I was even more pleased with the composition of those who entered the museum: 57 percent of our audience is African American, with 25 percent defining themselves as white, and 19 percent either Latino/a or Asian American. This affirms that we were successfully attracting a broad audience, in part because we are on the National Mall, which makes NMAAHC one of the most diversely visited museums in the world. I am so thrilled with the demographics of our visitation because it confirms my notion that the African American experience is more broadly significant and too essential to understanding America's identity to simply be presented

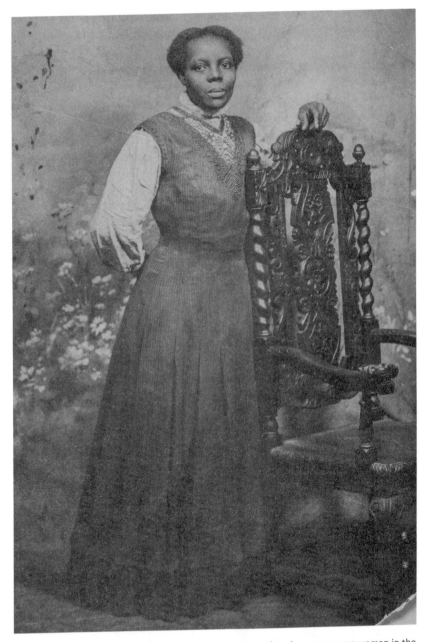

An ancestor, Leanna Brodie Bunch, Lonnie's paternal grandmother, as a young woman in the early 1900s, prior to her move from the South to New Jersey. **PHOTOGRAPH COURTESY OF LONNIE G. BUNCH III**

to its own community. Even more important is the fact that the exit surveys performed by the museum show 30 percent of our visitors are first-time museum goers. As many museums are struggling to find new audiences, the experience of NMAAHC posits that complex, diverse, and community-driven exhibitions will contribute to increased interest in museums. At the very least, our numbers suggest that it is possible for museums to reposition themselves within their community and become institutions that are venerated, valued, and visited.

One aspect of our visitation came as a complete surprise. Traditionally, people spend ninety minutes touring a Smithsonian museum before they return to the Mall. The audiences of NMAAHC have a dwell time of five to six hours spent exploring the exhibitions. This demonstrates a high level of curiosity as visitors read labels, engage in intergenerational and intergroup conversations, and take the time to reflect on the history and culture presented. It is difficult not to conclude that there was a hunger, a pent-up thirst, for an institution that would make the African American experience visible and accessible.

But statistics alone cannot fully capture the interest in and excitement about the newest Smithsonian museum. In September 2018, I visited Eastern Europe and traveled to the shrine of the Black Madonna in Czestochowa, Poland. There I was moved by both the number of pilgrims who had made their way to the famous icon in a rural monastery and also by the sense of urgency and belief that visiting the shrine will alter and improve one's life. That may be an appropriate way to describe the visitation at NMAAHC. It has become a site of pilgrimage, a place that people feel they must experience. And that they will be changed by the visit. That is a daunting responsibility, to craft a museum that is more than a temple to the past but a site that gives meaning and hope to a contemporary community. As people visit the museum, one feels not only the sense of reverence but also the spirit of community. I often overhear visitors' comments, then listen more closely to the wonder of their discoveries. I also observe the bonds that are created among strangers who interact while sharing a common space or come to realize a shared interest in an object or an event. One example of this was an exchange between parents of different races who had just met at NMAAHC and were helping their children find a common understanding about the meaning of the death of Emmett Till. And like any pilgrimage site, it is important to share the intergenerational experience within the family. Visitors at a pilgrimage site often leave behind words that describe their experience. So too at NMAAHC.

To mark the first anniversary of the museum's opening, I received an unsolicited letter from Elizabeth Hemingway, a well-wisher who expressed her sentiments in the form of a prayer:

NMAAHC Museum Prayer

Thank you for those who have come; upon whose shoulders we
 stand.
We have come over a way that with tears have been watered.
We have come to this sacred place. Upon this holy ground we
 stand.
Thank you Lord for our ancestors
And the historians of this National Museum.
Amen.

I have been sent many missives, notes of appreciation, and emails of thanks during my career, but this was the first prayer that I have ever received. With its mention of sacred space and holy ground it clearly frames the museum as a site of pilgrimage and reverence. As a destination that allows the visitor to honor their ancestors by engaging a complex history. We take the notion of pilgrimage seriously: the visitor services staff and the security force are trained to maintain an environment that allows our visitors to find the mental and physical space for contemplation and also provides assistance when the impact of the museum site and its presentations becomes emotional and overpowering. Just like a place of religious pilgrimage.

I have been pleasantly surprised by the favorable public and critical response to the museum. As I thought about the reception that the museum would receive, based on my experience, I hoped that 75 percent of the general public and 70 percent of the media and scholarly outlets would approve of the museum's exhibitions. Based on our surveys, almost 95 percent of the visitors rate their experiences at NMAAHC from very good to excellent. Our audience has shared their thoughts on Twitter: "this place is amazing," "one of the most awe-inspiring, achingly powerful museums I have ever been to," "my entire life has been changed"; left notes behind: "Thank you so much for this experience. I am from Selma and I learned so much," "God bless you for this wonderful museum," "I am grateful to God for having the opportunity to partake in an extraordinary experience at the National Museum of African American History and Culture" and stopped me on streets, delayed my departure at airports, and interrupted date nights with my wife in order to express a sense of gratitude and appreciation for my efforts.

Even the critical evaluation by scholars and the press has been very positive. Professional colleagues who have written to me have shared their evaluations. One wrote that "the state-of-the-art museum experience was truly unforgettable, and I was deeply impressed by the care, thought, and love imbued in every inch" of the museum. An essay written by a journalist in *Vice* magazine captured the power of the museum in ways I could not imagine. He wrote:

> I did not cry when Trayvon Martin was killed. . . . I did not cry for Eric Garner or Philando Castile. . . . But I was profoundly touched by the casket of 14-year-old lynching victim Emmett Till which sits solemnly in the museum. . . . As I followed in a slow procession . . . toward the coffin. . . . felt this wave of feeling rise inside of me. . . . For the first time in I don't know how long, I cried. . . . I cried for all the men who died in the struggle. . . . At the foot of that coffin in that hallowed space, I found the strength to cry. It is a power that I will never give away again.

I am touched that so many people find meaning and maybe find themselves in the museum.

The overwhelming popularity of the museum has also posed significant challenges to our everyday operations. To accommodate the demand, I reluctantly agreed that passes would be needed to enter NMAAHC, making the museum the only part of the Smithsonian in Washington to require a ticket to enter. I hate the idea of passes. Even though they are without a cost to the visitor, it meant that we had to create online opportunities to acquire the passes, structures to process visitors holding the entry tickets, and a system that would release passes in plenty of time for families to plan their visits to the nation's capital. I disliked the idea that we would turn away patrons who did not know about the required passes. Despite my distaste for the passes, I realized that we had no other options when I arrived at the museum on the Monday after the opening and saw hundreds of people, including some in wheelchairs, wilting in the summer humidity of Washington to the point of collapse. I would rather have a system that is odious to me than put the health of our visitors at risk.

Creating and managing a ticketing system that must be responsive to such overwhelming interest has not been without problems. The public has been frustrated by slow response times, the glitches that can occur in connecting to the system, and the unevenness of the museum's communication about the process. As a result of the difficulty in obtaining passes, people have

resorted to interesting methods to gain entry to NMAAHC. One day I received a call from a woman who demanded that she receive passes. I explained that as the director I am not involved in dispensing tickets. She then responded by asking if I remembered her. She said she was my girlfriend in seventh grade. Now I know that every thirteen-year-old boy recalls each crush, but I did not know this person. Her approach was so innovative, however, that I gave her the passes she requested. Once, as I passed the security desk near the entrance to the museum, a guard remarked to me that he was amazed at the number of relatives I had, at the numerous people who had gained entry by claiming to be a cousin, an aunt, or a sibling. I told him my family is small in number, so check with my office prior to accepting a filial claim.

The crush of visitors include a high number of potential donors and VIPs who require special handling. As crowded as the museum is, it is difficult to navigate the space with a celebrity in tow, so usually these visits take place prior to the opening of the museum on any given day. Since I need to greet or tour so many, but not all, of the VIPs, I realize that I have made the transition from founding director to daily tour guide. There are literally hundreds of VIP tours each quarter that have taken not only my time, but also altered the schedules of curators and educators. I have toured diplomats, heads of states, film and television personalities, sports franchises, corporate CEOs, and members of the US Congress. Despite the time and the toll, I love showing off the museum. As a result, I have met an array of interesting personalities from political figures such as Melania Trump, Sara Netanyahu, Elizabeth Warren, Nancy Pelosi, and Paul Ryan to musicians who included Chuck D, Kanye West, Jon Bon Jovi, and Gladys Knight to highly visible stars like Kevin Costner, Octavia Spencer, David Oyelowo, Chris Tucker, and Angela Bassett to entire sports teams like the Golden State Warriors, the Boston Celtics, and the Washington Football Club. I cannot deny it is exciting for a guy from Belleville, New Jersey, to meet such celebrities. I think my excitement stems from their interest in the museum, in their recognition of the importance of the past. While I may moan about the number of tours I must give, I never tire of reveling in and revealing the amazing collections within the museum and sharing the story of America through an African American lens.

There was one group visit that reminded me of just how much America has changed since my youth. A friend from high school who is also a historian, Larry Spinelli, organized a gathering of a number of my classmates from Belleville High School, most of whom I had not seen in forty years. Growing up in Belleville as one of the few African Americans meant that racial lines hardened as I aged and racial bigotry or at least racial insensitivity

was something that I faced daily. I remember being frequently called a nigger and being excluded from social gatherings. I can never forget how hurt and embarrassed I was when after a neighborhood backyard basketball game I was told to drink out of the garden hose rather than use a glass like the other thirsty players. I can still hear the derogatory comments about the hopes of the Civil Rights Crusade or the scorn expressed by some denigrating the demands and pride that accompanied the burgeoning Black Power Movement.

I was, candidly, quite uncertain about this reunion and curious how they would respond to being in the museum. As we walked together through the galleries, I was taken by both their attentiveness and their interest in a history that we never broached in high school. During lunch, they expressed great admiration for the existence of the museum and spoke about how proud they were that a guy from Belleville was the founding director of a national museum. I never expected to feel so good about the visit. I am not naïve about the changing racial landscape in America, but I would have never expected people from my hometown to have an appreciation for seeing America from a different perspective and to applaud a museum that challenged much of what was once the prevailing sentiment in that small North Jersey town. It was no longer 1970.

The post-opening years brought an astounding number of events and moments that confirmed the need for the museum and celebrated the successful culmination of our eleven-year journey. In September 2017, I was surprised to learn from the United States Postal Service that it planned to issue a stamp that recognized the importance and the visibility of the museum. That conversation generated memories of my own interest, though short lived, in stamp collecting. As a kid, I learned about the world by examining stamps from exotic places like Ghana, Romania, the Congo, Bolivia, and Greece. Now other children will be introduced to the museum through our Forever stamp.

There was, however, a debate as to what image would grace the stamp. The Postal Service tries not to use the image of a building on its stamps. Yet our building is the most visible representation of the museum. After determining that the size of a stamp would limit the ability to view adequately a single artifact from the collection, we all agreed that the stamp should capture the likeness of the building.

On October 13, 2017, the stamp was unveiled at a ceremony in the museum. What enriched the day was the presence of David Rubenstein, the chair of the Smithsonian Board of Regents, whose father had worked for the US Postal Service and facilitated Rubenstein's first job at a

mail-handling facility. David, a key supporter of NMAAHC, spoke about the importance of the stamp and how it will make the museum visible to all who still use stamps. As I stood on stage next to an enlarged image of the stamp, I marveled that an idea that few embraced and took more than a century to be realized would now be celebrated with a stamp of its own. Though you might think that the director of the museum on that stamp on that occasion would be allotted a few books of stamps as remembrances, there were no free stamps given out that morning. So I rushed to the nearest post office and bought two hundred stamps that I gave to family and colleagues at the Smithsonian. I was so proud, and surprised that something so small could be so big and meaningful to me.

An equally impressive moment was the recognition of the excellence of the museum's Sweet Home Café. Sweet Home was always an integral part of the museum's commitment to enriching the visitor experience. Enjoying the cuisine of the Carolina Low Country or sampling the staples of the cooking of New Orleans or discovering the impact of black culture on seafood dishes from New England helped visitors understand the regional and ethnic diversity that has shaped the African American community. And the quality of the food at the Café made it a destination in and of itself. That excellence was recognized when Sweet Home was named as a semi-finalist in 2017 for the James Beard Award as one of the Best New Restaurants in America. Few restaurants ever receive such an honor, but it is highly unusual for an eatery in a museum to be so recognized. I think this award also confirms the innovative cooking and restaurant-quality service that Chef Jerome Grant and his colleagues provide daily. What makes this more impressive is the fact that the Café serves thousands of meals a day, much more than a stand-alone restaurant. Once a week, I steal away to sit in the Café and marvel at the camaraderie and the conversation among strangers that the good food produced by the Sweet Home Café makes possible as I delight in a bowl of their singular version of shrimp and grits.

Another sign that the museum was gaining recognition and visibility came from the film and television industry in their increasing number of requests to use our building as a location site. Council member Bob Johnson had always prodded us to make sure that the museum became part of the American lexicon, that it was known to many, and that due to its visibility, people would assume that the museum had been a component of the American landscape for decades. And that came to pass. The iconic appearance of the building and the emotional atmosphere within the exhibitions soon attracted the attention of Hollywood. One Sunday evening my cellphone

rang repeatedly as friends alerted me that the museum had been used as a backdrop for scenes in the television drama, *Madame Secretary*. More exciting still was the decision by Shonda Rhimes to film the concluding episodes of her timely and popular political thriller, *Scandal*, in the museum. Some of the climatic scenes where the character played by Kerry Washington, Olivia Pope, grapples with her future were filmed in the museum's contemplative court. My only disappointment is that I was away the day of the taping and never had the chance to meet Ms. Washington.

I had always believed that the museum should be a safe haven that helps Americans wrestle with and better understand the difficult current issues of race, justice, and equality. In essence, the museum is a bully pulpit that provides NMAAHC with the opportunity and responsibility to clarify and contextualize concerns that often divide or perplex the American public. When President Trump led the public criticism of athletes, who were overwhelmingly African American, who took a knee during the playing of the National Anthem to protest police violence, I felt that there needed some light shed on the issue instead of the hatred and vitriol that dominated the news cycles. To bring reasonableness to the discourse, the Secretary of the Smithsonian Institution David Skorton and I wrote an op-ed for the *Washington Post*. In it, we suggested that sports had always been political, just look at the Olympics. More importantly, we argued that the players do not hate America, they are just trying to use the tools at their disposal to illuminate the problem of police violence in America. We concluded the essay by suggesting that protest is the highest form of patriotism. And that it is often only through protest that America begins to live up to its highest ideals. I think it is important for NMAAHC, for the Smithsonian, to engage in the public square in a manner that brings reason, knowledge, and contextualization to the contemporary challenges faced by America. Actions like this are not without risk to an institution that operates within a federal umbrella. Yet I believe that museums like NMAAHC have an obligation to use their expertise, their platform, to contribute to the greater good of a nation.

In addition to op-eds, the museum has hosted symposia, such as when we collaborated with the National Museum of the American Indian to convene a conference entitled Mascots, Myths, Monuments, and Memory that explored the history and contested memory of racialized mascots and Civil War monuments. This program is an example of how the museum seeks to bring clarity to complicated contemporary issues. In response to the debates about the removal of Confederate monuments and the violence that cost a human life in Charlottesville, Virginia, we created a conference that did help

the public understand that many of the memorials to the Civil War were created as a way to reinforce nineteenth-century notions of segregation or later as a symbol of the massive resistance to the Civil Rights Movement, not to simply honor Southerners who participated in the war. Also, it was essential to help the public better understand what was at stake in the debates surrounding the use and misrepresentation of Indian mascots in American athletics. While the specific programs are important, what is critical is that the museum must remember that its work should not just illuminate yesterday but be useful to help understand today and point us towards a different future.

Few could comprehend how dramatically the mood of the country would be altered by the election of Donald Trump just months after the dedication of NMAAHC. His selection changed the atmosphere in Washington and throughout the nation. And whether intentionally or not, Trump's presidency gave voice to a conservative agenda that encouraged, or at least made visible, the hatred and the far-right groups that had been underground or lay dormant in recent years. Many individuals regardless of race have approached me since the election to express their gratitude that the museum opened during the Obama administration. And to note how different the dedication would have been with President Trump as the keynote speaker. Some immediately saw the museum as a symbol of resistance, a beacon of hope on the National Mall, a site that championed a more progressive America. Others found the museum to be a refuge, a place of support and inspiration in a challenging time. If the African American community could survive and fight for justice during the history depicted within the museum, surely the community of today could find sustenance and guidance as to how to combat the hatred that was suddenly omnipresent.

That vitriol soon touched NMAAHC. On May 31, 2017, a noose was found in front of an exhibition case that contained artifacts of the Ku Klux Klan of the 1920s and material from African American soldiers who fought for freedom in the First World War but found little freedom upon their return. The noose is one of the most painful symbols of the violence that African Americans have always experienced, and continue to confront, in this country. I was disappointed but not surprised that a talisman of racism made its way into the museum. As if I needed reminding that there continues to be a battle for the soul of America between those who expect America to be the land of the free and fair, and those who want to return to an idealized past that would turn back much of the progressive racial reform of the past fifty years. Many of the staff, especially the younger members, were hurt, confused, and

angered by this act. I spoke to my colleagues and explained that criminal acts like the leaving of the noose are part of the reason the work they do, the programming of the museum, is so important. They should be fully aware that discrimination and hate are not yet confined to the past.

Later that day I was summoned to the front of the museum. There, hundreds of Smithsonian colleagues, throughout the Institution, had marched, organized by Kevin Gover, the director of the National Museum of the American Indian, across the National Mall in a show of solidarity with the museum and to demonstrate that the Smithsonian stood united against hatred and bigotry. I was overwhelmed with gratitude and emotion. In my nearly thirty years working at the Smithsonian, I had never experienced such support, nor had I seen such a demonstration that included the senior leadership of the Smithsonian, museum directors, and the rank and file SI staffer. At that moment, I was never more proud to be a member of the Smithsonian family.

As I sat on a bench near the entrance to the museum, I noticed more than a dozen red roses had been placed along the flowing water feature that symbolizes the oceans that enslaved Africans crossed to arrive in the Americas. I was told by a fellow worker that a woman was so angered when she learned about the noose that she brought the flowers to show her commitment and support for our efforts. It was a difficult and troubling day, but the balm was the unsolicited support the museum received. That day reminded us that we were not immune from the political and cultural debates of our time and that we needed to be prepared, like our ancestors before us, to fight the good fight for a country we loved.

The museum was attacked by some with a more conservative bent in other ways as well. In addition to the almost yearlong push to provide greater visibility for Justice Clarence Thomas, the museum's decisions about who was featured in the exhibitions and who was not were filtered through an ultraconservative prism. The conservative media decided that an organization led by "a leftist historian" must have an agenda, one that included a conscious effort to "keep black conservatives" out of the museum's exhibitions and programs. Nothing could be further from the truth. I think it is a legitimate critique to disagree with some of our progressive narratives. That challenge should be based on intellectual arguments and evidence and not simply boil down to political posturing and ideological attacks. We may well be questioned on many of our decisions, but they were informed by scholarship and debate within the curatorial staff, not based on the director's political agenda. No matter what we say, however, we will still face ideological condemnation. That is the price of being a national museum.

From the moment the museum opened, my visibility quotient increased dramatically in ways reassuring and disquieting. I had to learn how to accept what a colleague at the American Historical Association described as my celebrity status. He suggested that I "was one of the most visible historians in America." I was quite uncomfortable with that assessment. I think my uneasiness stemmed both from a childhood shyness that I never truly outgrew and from being black in Belleville, where it was better not to call too much attention to yourself. More likely, my reticence is tied to my belief that as part of a wonderful team, I do not deserve all the acclaim and visibility.

The recognition, though problematic, is occasionally useful. Being visible does allow me to share my love for history and to help encourage a national conversation about the importance and contemporary meaning of the past. During the summer of 2017, I received the President's Award at the NAACP Image Awards Ceremony in Los Angeles. This recognition is usually reserved for political figures or entertainment stars like Bill Clinton, Colin Powell, Kerry Washington, and John Legend, so it was humbling and quite unusual for someone like me to be so honored. I decided to use my acceptance speech as an opportunity to remind the audience of the power of the past and how important it is to recall the ways in which African Americans have shaped the identity of our nation. I asked the audience to remember the enslaved, the Pullman porter, the teacher, and the farmer because the current black community was built and shaped by their work, their faith, and their sacrifices. I continue to use my visibility to increase and enhance the public's interest in the American past.

What has been made clear to me is that in the years since the opening of NMAAHC, the museum has become a site that matters. It is an oft-used symbol that for some signals the ascendency and acceptance of African American culture. At the very least, its gleaming bronze presence on the National Mall ensures that public perceptions about America's identity have been challenged and enlarged by the history explored within NMAAHC. And that the black existence in America's history can no longer be ignored or undervalued. Museums throughout the country conveyed to me just how the interest in NMAAHC has translated into excitement in and awareness of the role of African American history in local communities. And how that attention and visibility has helped regional cultural institutions find additional resources and new audiences.

I love that the museum has become a site of family reunions. Every day I see people who enter wearing the same colorful T-shirts that proudly proclaim they are related, who feel their reunion is not complete without

the chance to immerse the family into the history that is available here. That same desire to experience a past that is little known has led to hundreds of requests from corporations, educational institutions, and cultural entities to hold events at NMAAHC. Rather than see the museum as simply another venue, they view NMAAHC as a place that will engage, educate, and add meaning to their event. To me, the museum has been embraced and become part of the American lexicon and mindset much sooner than anyone expected. It has become one of the "must see" attractions for anyone visiting Washington, DC.

In a conversation with a senior scholar at the Smithsonian, he mentioned that his daughter had an experience that he needed to share with me. His daughter was then attending law school and had a volunteer internship at the Arlington County Jail, just outside of Washington in Virginia. She was working with a soon-to-be-released inmate, trying to prepare him for the challenge of readjustment to life outside the criminal justice system. He told her that upon his release he had two priorities: to see his daughter and to "go to the new African American museum." It is so meaningful to me to hear that story, to learn that this man felt that visiting the museum was second in importance only to spending time with his daughter. And that anecdote helps to explain something more about the attraction of the museum. It is a space where one can find sustenance from the knowledge and the spirit of the past. And in using that history, people find a sense of validation, legitimization, and resiliency. They can also discover feelings of racial pride in the achievements and hard-fought racial struggles faced by earlier generations. Ultimately, confronting the past increases one's hope for a future yet to be defined. By helping our visitors to recall, as Princy Jenkins said, what they need to remember, NMAAHC can assist this country in finding not only reconciliation but redemption.

I have been moved by the excitement for and appreciation of the museum that I experience wherever I travel. The museum has become singularly important to more people globally than I could have ever dared to assume. Since the opening, numerous countries, from the United Kingdom to France to Barbados to Argentina, have asked the museum to assist in finding ways to use culture and museums to uncover and reposition the African presence in their national narrative. The challenge of redefining conflicting national identities is not just an America dilemma.

Museums alone cannot ease the tensions that come from the debates surrounding the fluidity of national identity in the twenty-first century. Nor can any cultural institution solve the problems of poverty, racial injustice,

and police violence. But museums can contribute to understanding by creating spaces where debates are spirited but reasoned. Where contemporary challenges are addressed through contextualization and education. Since its opening, NMAAHC has become a site where racial healing and reconciliation are possible. It has changed the discourse, bringing history, especially African American history, into the current debates around memory and the ownership of a contested and complicated past. Ultimately, what the National Museum of African American History and Culture has done is to use history and culture, to paraphrase Napoleon, to "define reality and give hope."

EPILOGUE

The Moving Finger writes; and, having writ,
Moves on: nor all thy piety nor Wit
Shall lure it back to cancel half a Line
Nor all thy Tears wash out a Word of it.

—*Rubáiyát of Omar Khayyám, 1859*

Working to create NMAAHC for thirteen years has given me a wonderful gift. A gift that provided me with a calling and a purpose. The notion of a calling was never something I considered but often people who were religious and some who were not emphasized the spiritual nature of my work. I have come to believe, whether it was through God or my ancestors, this was the job I was put on this earth to do. It was a gift of faith that enabled my colleagues and me to persevere. A gift that challenged my abilities, made me uncomfortable, and forced me to be better. NMAAHC was a present that allowed me to use my tools as a historian and curator to the fullest, to marshal those skills to help a nation better understand its past. Ultimately this gift taught me that fulfilling the hopes of others was the best way to realize my own dreams.

I did not expect that even the exhibitions that graced the museum would also provide me with gifts. It was unusual for me to spend a significant amount of time in an exhibition after my farewell rituals. Yet I was constantly drawn to the museum's presentations. I came to understand that the exhibitions gave me the gift of knowledge about my own family. These were insights that became even more precious after my father's death in 2012. Whenever

I looked at the artifacts that illuminated the lives of those held in bondage, I learned something that helped me to fathom how my own enslaved paternal ancestors like Candis Bunch and Jane Dunn lived and survived. Each time I was drawn to exhibits about sharecropping and segregation it illuminated the life of Lee Brodie, my maternal great grandfather. When I look at the flip books of images that depict the great migration of southern African Americans to the northern urban centers in the exhibition chronicling the era of segregation, I would find a moment to view the actual photographs of my grandparents, Lonnie and Leanna, and reflect upon the courage it took to start anew in an unfamiliar city. Or when I stand in front of the façade of the Baxter Terrace projects, I imagine how my mother and father struggled to find decent housing in the segregated Newark of the early 1950s. The museum gave me the gift of knowledge and a sense of discovery about my own family that I did not expect. So like the millions who toured the museum, I found more about myself through the exhibitions within NMAAHC.

Long after I have vacated the best office with the most impressive views in Washington, I hope that the museum will continue to be a source for understanding American history through the lens of African American history and culture and that while it will reveal the richness and complexity of the black experience that it never forgets to seize and own its American-ness. I hope that the museum never retreats from embracing controversy and, no matter how multifaceted or incendiary the issue, NMAAHC will strive to help the public find contextualization and common ground in a safe and civil environment. I trust that the museum will always be a bully pulpit where boldness and innovation are more than just words. And to use that platform to combat the creeping sense of selective historical amnesia that limits America's ability to understand its past, and itself. I hope that NMAAHC will always celebrate its diverse staff in ways that nurture, protect, and challenge. And it is my hope that the museum will prod and remind other cultural entities, both within and outside of the Smithsonian, that the ultimate goal is to make a people, make a country better.

When the nation was in the throes of the Great Depression, out-of-work historians were hired by the Works Progress Administration, a program of the New Deal, to interview the formerly enslaved to create a compendium of what was then called slave narratives. One of the individuals interviewed was Cornelius Holmes who was enslaved on a low country South Carolina rice plantation. He was asked after nearly seventy years whether slavery still matters. Holmes responded, "Though the slavery question is settled, its impact is not. It is in our homes, on our streets, on our highways, in our

schools, in our courts and in our politics, all the day, every day." I always want the museum to realize that it should give America a gift of historical knowledge, of resiliency, of community, of clarity, and of hope "all the day, every day."

I wanted to extend this gift to the profession that shaped my life, the museum community. I knew that many cultural institutions throughout the world often look to the Smithsonian for guidance and inspiration. I hoped our work would have an impact on the broader field of museums and public history. I believed that our commitment to sustainability that was embodied by our LEED Gold building might encourage other museums to embrace sustainable practices. I wanted sister institutions to adopt, when appropriate, a community-driven model of interpretation, collecting, and relationships that might assist them in navigating the tensions between history and memory and, by doing so, become museums that matter. I wanted museums to discover a boldness and a commitment to fighting the good fight; to pursue a policy that contributes to the greater good by using collections, exhibitions, and programs to help audiences find the contemporary resonance of a museum's efforts. Finally, I wanted our efforts to aid museums in the struggle to reposition cultural institutions as sites of value that are at the centers and not the peripheries of their communities.

Yet when I look back at the more than a decade that was needed to complete the museum, I still do not know how I believed that the efforts of a staff of two could one day lead to a national museum. Perhaps it was the discipline to begin the day by assessing the broad strategic challenges, but then quickly focus on the tasks that could be accomplished that day. Possibly we believed because we strategically sought little victories that marked our efforts and helped us believe that we were making progress. And maybe the passion and creativity of Tasha Coleman who began this journey with me in 2005 and the enthusiastic support from so many unexpected quarters cemented our belief that a building was not too far distant. And possibly it was our desire to prove so many wrong, those who doubted, who disrespected, and who did not believe. When confronted with moments of difficulty and despair, I remembered the eighth grade shop teacher who criticized my interest in college because the "best a Negro could do was to be a good assistant," or the Smithsonian museum director who wanted to end this endeavor "because it is hurting the Smithsonian," or the potential donor whose rudeness was only outweighed by his condescending manner. I vowed that we would build this museum and prove them all wrong. I admit, I had a chip on my shoulder, not huge but very present. The desire to confound the doubters is what enabled

me, what motivated me, as I worked to create the museum. I wanted this endeavor to be successful to honor families like mine that chopped cotton and worked in service but believed that a better day was coming for their children. So this effort was about a museum—and so much more.

What I do know is that after the opening I felt a keen sense of achievement and vindication. The ability to finally fulfill the hopes and dreams of earlier generations meant so much to me. I promised myself that I would do whatever was needed to build a museum that honored those often forgotten or considered historically unimportant. And by honoring them, I soon realized how much I had changed. Still shy and at times uncertain but I was now comfortable in settings and with individuals that I once found unnerving. Lyndon Johnson was correct when he wrote that facing great challenges frequently made you better, if it did not break you. At least that was what happened to me. And although I have grudgingly learned to appreciate my new, highly visible status, I still think of myself as someone who has a lot to prove. I remember when I gave my first paper at an academic conference in Louisville, Kentucky, as an obscure assistant professor. After preparing for months, I was ready to join the scholarly community. When it was my turn to speak, I realized the room was empty. No one was interested in what I had to say. Part of me is still that guy who gave a paper no one heard.

On July 26, 2018, the museum was visited by His Imperial Majesty, Ooni Adeyeye Enitan Babatunde Ogunwusi Akanda, the traditional ruler of the Yoruba kingdom in Nigeria. For some reason, I was nervous awaiting his arrival, perhaps because of my lack of knowledge about the history and the culture of the Yorubas. I knew much more about America than I did about Africa. As he approached the museum, my nervousness dissipated as I was enthralled by the ritualistic performance that unfolded before me. Singers, musicians, holy men, royal retainers, and lesser chieftains heralded the Ooni's entry into NMAAHC. As I moved to greet him, I was struck by the ceremonial nature of his visit. In a way, his presence seemed to link the African and the American together. I was fascinated by the array of textiles, jewelry, and the accoutrements of power that he carried on his person, or rather, others carried for him. I was instructed to sit to the left of the Ooni so that we could share greetings. I committed a major error when I moved to take my assigned place next to the Ooni before he had settled into his chair. Traditionally one does not see royalty doing something as banal as taking a seat, so I was pushed aside as his retainers held shields and textiles that prevented anyone from observing the challenge of sitting wrapped in the royal regalia.

As we toured the building the ruler of the Yoruba was pleased to see an array of artifacts that reflected his culture. He spent nearly one hour in the Cultural Expression gallery explaining the intricacies, symbols, and meanings carved into the Yoruba Veranda post that influenced the shape of the museum's building. As we viewed the rest of the museum, he seemed quite pleased, even inquiring if we could help them create something similar in Nigeria. As we ended the visit, the leader of the Yoruba people expressed his gratitude and appreciation for what he experienced during our time together. Then he said, "This museum makes your ancestors proud. And I know they are smiling." I could not believe that he referred to the barometer that I used to measure the success of the museum. Could I make my ancestors happy? As he departed, I realized that no review, no critique, no attack from the left or the right could mar what my colleagues and I accomplished. As long as there is an America, this museum will be on the National Mall as a beacon that challenges, celebrates, and remembers. I had kept the faith. The ancestors are smiling.

Acknowledgments

Only the final aspect of writing a book—the hours spent staring at the computer screen praying for words to appear—is a solitary experience. The rest of the process relies on the efforts and goodwill of others. Without the support of so many, this book would be an unrealized dream. I must begin with my family: my wife Maria Marable Bunch who shared this unrelenting expedition for more than a decade and who understood my need to escape to London for months to finish this book. And I so appreciate the support and patience of my daughters Katie and Sarah who had no choice but to be dragged along on this journey. My family at the National Museum of African American History and Culture was also essential to this project: Debora Scriber-Miller remains the glue who managed my life from 3,662 miles away; Tanya Barbour provided a calming influence when the twenty-first-century technology overwhelmed a nineteenth-century guy; Tiffany Gass and Nicole Fuller handled my anxious calls with their usual grace; and I cannot overstate the importance of the leadership provided by Kinshasha Holman Conwill and Debra McDowell during my absence. I am especially grateful to my colleague Erin Golightly who was the wonderfully organized research assistant, cheerleader, and smart critic whose efforts were invaluable to me. And LaFleur Paysour who shepherded me through more than a decade of media interviews handled the image acquisition with creativity and goodwill. Colleagues throughout the Smithsonian supported my desire to complete this book, especially Secretary David Skorton, Provost John Davis, Chief Operating Officer Albert Horvath, and the Smithsonian Distinguished Scholar Richard Kurin. I am so grateful that Kenneth Chenault and the rest of the NMAAHC Council understood and supported my need to disappear into the academic isolation of London.

I am indebted to many of my university colleagues who encouraged me to write this book and who prodded me at just the right moments, especially James Grossman, Elliott Gorn, James Campbell, Ira Berlin, Ibram X. Kendi, Darlene Clark Hine, Genna Rae McNeil, Alan Kraut, and David Blight.

I cannot express the depths of my appreciation to my colleagues at University College London who supported and welcomed my sabbatical by making me an Honorary Visiting Research Fellow, provided a home—both materially and spiritually—and allowed me to participate and flourish in the rich intellectual life that is at the heart of UCL. UCL President and Provost Michael Arthur, Vice Provost Anthony Smith, and the faculty and staff have extended extraordinary kindness. I owe so much to Tamar Garb from the Institute of Advanced Studies and Simon Cane from UCL Culture for facilitating my fellowship. And the administrative support and goodwill of Albert Brenchat and especially Catherine Stokes ensured that my time at UCL would be productive and enjoyable. And I cannot thank Keith Magee enough for all that he has done for me. He took on a wayward sojourner and ensured that my time in London was useful and well spent. Dr. Magee worried about my health, protected my diary, or to, the non-British, my schedule, introduced a London that was unfamiliar to me, and became a close friend who always impressed me with his intellectual acumen and his generosity.

My time in the United Kingdom was enriched by conversations and meals with many friends, both newly acquainted and longstanding, including Baroness Lola Young, Paul Reid, Elaine Gurian, Garrett Hornsby, Alan Morrison, Makeda Coaston, Caroline Bressey, Kim Dubois, Catherine Hall, Carl Shakespeare, and Anna Sanden.

And finally, I am so fortunate to have an editor as gifted as Carolyn Gleason, whose gentle but firm touch has enhanced all the publications by NMAAHC, and I am pleased to benefit from the talents of Matt Litts and Christina Wiginton, and especially the editing wizardry of Evie Righter.

Members of the Founding Council of NMAAHC (appointed 2005)

Richard D. Parsons, Co-chair
Linda Johnson Rice, Co-chair
Kenneth Chenault, Campaign
 Committee Chair
James I. Cash
Ann M. Fudge
James A. Johnson
Robert L. Johnson
Quincy Jones
Ann Dibble Jordan

Michael Lomax
Homer Neal
Stanley O'Neal
Samuel Palmisano
Franklin Raines
Lawrence Small
H. Patrick Swygert
Anthony Welters
Wesley Williams
Oprah Winfrey

Scholarly Advisory Committee

John Hope Franklin, Chair
Michael Blakey
Taylor Branch
Johnnetta Cole
Drew Days
Rex Ellis
Leslie Fenwick

Deborah Mack
Alfred Moss
Richard Powell
Clement Price
Bernice Johnson Reagon
Alvia Wardlaw
Deborah Willis

Original NMAAHC Staff Members

Tasha Coleman
Kinshasha Holman Conwill
John Franklin
Debora Scriber-Miller
Cynthia Smith
Susan Samaroo
Jacquelyn Serwer

Michèle Gates Moresi
Esther Washington
Cheryl Johnson
Fleur Paysour
Lynn Chase
Adrienne Brooks
April Holder

INDEX

Page numbers in *italics* refer to figures

AAAM. *See* Association of African American Museums

Abela, Rodrigo, 84–85

Adams, Robert McCormick, 6

Adjaye, David, 76, 78, *79*, 80–83, 120, 171, 201. *See also* Freelon Adjaye Bond team

Adjaye Associates, 74, 76, 77

Aflac, 117

African American culture: American identity and, x, 30–31, 188; celebrated at Folklife Festival, 51–54; as downplayed in mainstream, 25; freedom and, 207; global context of, 29; as NMAAHC focus, 167; preservation of, 6, 87; visual arts and, 100–101; water and, 82

African American history: global context of, 28–29; key moments in, 32, 198, 213; meaning of being American and, x, 28, 188; as NMAAHC foundation, 167; recentering of, 160; scholarship on, 162, 164–66, 183, 185–86

Aguilera, Christina, 230

Ain't Nothing Like the Real Thing: How the Apollo Theater Shaped American Entertainment (exhibition), 60

Alexander, Lois K., 98–99

Alfred Street Baptist Church (Alexandria, Virginia), 125

Ali, Muhammad, 149

Ali, Tatyana, 202

Allen, Debbie, 228

American Festival (Tokyo, Japan), 61

American Historical Association, 166

American Jewish Committee, 187–88

American Presidency: A Glorious Burden, The (exhibition), 13, 173

American University (Washington, DC), ix

Amos, Dan, 117

Amos, Wallace, Jr. "Famous Amos," 58

Anacostia Museum (Washington, DC), 30

ancestors, 9, 105–6, 107, 236, 261

Anderson, Marian, 34, 97–98, 229

Anderson, Renee, 219

Angola Prison (Angola, Louisiana), 203

Appelbaum, Ralph, 169, 170

architects: landscape, 78, 84–85; race and, 69; selection of, 69, 71–79

Ariel Investments, 127

artifacts: acquisition of, 87–90, 94–96, 97–101, 105, 108–10, 112–15; Marian Anderson, 98, 229; Angola Prison guard tower, 203–5; Louis Armstrong, 229; artwork, 100–101; of the enslaved, 101–2, 108, 170; exhibitions and, 161, 170; of Gullah culture, 109; installation of, 203–5, 218–20; of the Makhuwa people, 105–6, *106*; military, 98, 114, 219; music, 108, 114, 229; Barack Obama, 114; Pullman porters, 94; radio broadcasts about, 56–57; reception for

artifacts (*continued*)
donors of, 225–26; *São José*, 108; segregated railcar, 109, 203–5; slave cabin, 108; Emmett Till, 112–13; Harriet Tubman, 88–90, *90*; Nat Turner, 110, *111*, 112; Tuskegee Airmen, 114, 219; of the Yoruba people, 261. *See also* Save Our African American Treasures program
Arts and Industries Building (Washington, DC), 7, 34, 36–37
Association for the Study of African American Life and History (ASALH), 44
Association of African American Museums (AAAM), 32–33
Atlantic Philanthropies, 133–34
Austin, Patti, 230

Bailey, Joyce, 98–99
Baldwin, James, 6
Bank of America, 109, 224
Banneker, Benjamin, 36
Banneker Overlook (Washington, DC), 34, 35
Bassett, Angela, 217, 230, 234–35
Bates, Ernest, 129
Bearden, Romare, 101
Belafonte, Harry, 228
Bellamy, Michael, 74
Belleville High School (Belleville, New Jersey), 247–48
Bentzon, Peter, 56
Bercaw, Nancy, 108
Berry, Chuck, 114
Bethune, Mary McLeod, 5
Biden, Joseph, 233
Bill & Melinda Gates Foundation, 124
Black Angelenos: The Afro-American in Los Angeles 1850–1950 (exhibition), 91
Black Fashion Museum (Washington, DC), 99
Black Olympians, The (exhibition), 158
Blakey, Michael, 163, 164
Blige, Mary J., 229
Blight, David, 58, 165
Blockson, Charles, 87–90, *90*
Bloomberg Philanthropies, 122
Board of Regents (Smithsonian), 33, 38–39, 40, 74
Board of Trustees (Smithsonian). *See* Council, the
Boehner, John, 151

Bond, J. Max, Jr., 45–46, 47, 48, 49, 78
Bonner, Ruth Odom, 238
Booker, Cory, 152
Boshoff, Jaco, 103
Boston Globe, 108
Bowser, Muriel, 215
Brady, Robert, 89, *90*
Branch, Taylor, 163, 164
Bridges and Boundaries: African Americans and American Jews (exhibition), 159
Brodie, Lee, 258
Brooks, Adrienne, 65, 123, 124, 181
Brown, Claudine, 6–7, 12, 36–37
Brown, Willie, 129
Brownback, Sam, 7, 77, 144, 235–36
Bryant, Kobe, 122, 228
Bunch, Candis, 258
Bunch, Leanna Brodie, 26, 242, *243*, 258
Bunch, Lonnie G., Jr., 2, 4, 137, 163, 177–78
Bunch, Lonnie G., Sr., 2, *3*, 4, 258
Bunch, Lonnie G., III, *62*, *79*, *90*, *111*, *126*, *184*, *193*, *208*, *210*, *237*; approached for NMAAHC position, 7–11; at California African American Museum, 67–68; at Chicago Historical Society, 7–9, 14, 23, 130–31, 138–39, 158, 186; criticism of, 24, 147, 154; dedication ceremony speech, 236; as face of museum, 132–33; heritage, 2, 4, 9, 26, 257–58; interviewed for NMAAHC position, 11–13; in Japan, 61, 80–81, 127–28; media and, 14–15, 39, 55–57, 104, 109, 130–33, 226–27; at National Museum of American History, 4–5, 48, 65, 127–28, 173, 179; NMAAHC promotion and, 57–59; offered NMAAHC position, 13; visibility of, 132–33, 253; vision for NMAAHC, 158, 161
Bunch, Maria, 14, 140, 206
Bunch, Montrose, 178, 228
Burke, Sheila, 11, 20, 32
Burnside, Timothy Anne, 114, 185
Burr Oak Cemetery (Alsip, Illinois), 112
Burroughs, Margaret, 30
Bush, George W., 7, 38–39, 138, 140–41, 221, 232; at NMAAHC dedication, 1–2, 233, 234, *237*
Bush, Laura, *62*, 63, 95, 139–41, 232; at NMAAHC dedication, 1, *237*; at NMAAHC groundbreaking, 144, *145*
Bustamante, Carlos, 104, 173, 203–4

Butter, Dorey, 173, 219
Butts, Calvin O., III, 144, 233

Caesar, Shirley, 231
California African American Museum (Los
 Angeles, California), 67–68, 209
Campbell, James, 58, 165
Campbell, Robert, 74
Cantor, Eric, 152
Cape Coast, Ghana, 58–59
Cape Town, South Africa, 107
Carne, Jean, 223
Carroll, Diahann, 99
Carson, Ben, 148, 149
Carson, Emmett, 129
Carter, Earl "Buddy," 154–55
Catlett, Elizabeth, 101
CBC. *See* Congressional Black Caucus
CBS This Morning, 224, 226–27
Center for African American History and
 Culture (Washington, DC), 12
*Changing America: The Emancipation
 Proclamation and the March on Wash-
 ington* (exhibition), 60, 66
Chappelle, Dave, 230
Charles H. Wright Museum (Detroit,
 Michigan), 30
Charleston, South Carolina, 95
Charlottesville, Virginia, xi, 148, 250
Chase, Lynn, 80, 168, 173–74, 183–84, 201,
 210–11, 219, 220
Cheadle, Don, 217
Chenault, Kenneth, 19, 118, 120, 122, 193,
 221, 232, 234
Chicago, Illinois, 70, 93–94, 152–53
Chicago Historical Society (CHS), 7–9, 14,
 21, 23, 67, 130–31, 138–39, 158, 218
Chicago Tribune, 131
Chinese People's Anti-Japanese War Resis-
 tance Museum (Beijing, China), 159
Chisholm, Shirley, 233
CHS. *See* Chicago Historical Society
Chuck D, 231
Civil Rights Movement, 5–6, 14, 112, 251;
 international impact of, 29
Civil Rights Museum (Jackson, Mississippi),
 152
Civil War, 32, 172–73, 198, 213; African
 American soldiers, 5, 97; monuments,
 250–51
Clark, Virginia, 118

Clark Construction Group, 200
Clarke, Stanley, 223
Clark/Smoot/Russell team, 200
Claussen, Pete, 109
Cleland, Max, 7
Clinton, Bill, 2, 232
Clinton, George, 53–54, 114
Clinton, Hillary, 2
Clough, G. Wayne, 71, *79*
Clyburn, James, 95, 153, 181, 196
CNN, 144
Cole, Johnnetta Betsch, 163, 164
Coleman, Tasha, 17, 143, 161, 211, 220, 259
Collins, Michael, 153
Columbia University (New York City), 165
Commission for the Preservation of the
 White House, 139
Commission of Fine Arts, 37, 39, 206
Committee on Appropriations (House of
 Representatives), 22–23
Common (rapper), 231
Congress, 22–23; funding and, 118, 126,
 181, 196; NMAAHC location and, 33–34;
 racial issues and, 138; working with, 138,
 150–55
Congressional Black Caucus (CBC), 153
Conwill, Kinshasha Holman, 32, 39, 53, 57,
 61–62, *79*, 80, 100, 143, 153, 155, 161,
 181, 194, 214, 232; Congress and, 153;
 fundraising and, 118, 123, 124; museum
 construction and, 210–11
Cook, Peter, *79*
Coolidge, Calvin, 5
Cornish, Samuel E., 185
Cornyn, John, 155
Corona, 78, 81, 83–84, 201–2; installation
 of, 206
Cosby, Bill, 134–35
Council, the (Smithsonian), 18–19, 38–39,
 73
Cox, Maurice, 73
Crew, Spencer, 13, 91, 96, 158–59
Cuba, 80, 102–3
curators, 49, 158, 164, 166, 169

Daley, Richard M., 23–24
Dana, John Cotton, 50
Darden, Joshua, 158
Darin Atwater and the Soulful Symphony,
 215
Daufuskie Island, South Carolina, 109

Davis, Danny, 22
Davis, Hal, *79*
Davis Brody Bond (architecture firm), 74, 76, 77. *See also* Freelon Adjaye Bond team
Days, Drew, 163, 164
Dee, Ruby, 46
Delaney, Michelle, 65
Dempsey, Mary, 93
De Niro, Robert, 234–35
Department of Homeland Security, 203–4
Devrouax & Purnell, 74, 75, 77
Diana, Princess of Wales Memorial Fountain (London, England), 84
DiBacco, Thomas, ix
Diller Scofidio + Renfro, 74, 75
Dixie Hummingbirds, 223
Doug E. Fresh, 231
Douglass, Frederick, 29, 30, 233
Drayton Hall plantation (Charleston, South Carolina), 109
Driehaus Foundation (Chicago, Illinois), 72
Du Bois, W.E.B., 5
Dunn, Jane, 258
Durbin, Richard, 22, 152
DuSable Museum (Chicago, Illinois), 30
DuVernay, Ava, 216–18

Ealy, Michael, 218
Earth Day, 70–71
Elliott, Mary, 108
Ellis, Rex, 110, 189, 190
Enrique (slave ship), 102
Era of Segregation, The (exhibition), 171
Executive Leadership Council, 122
exhibitions: Bunch's philosophy of, 65, 159; creation of, 13, 65; design of, 168–73; NMAAHC gallery at NMAH, 64–65; plans for, at NMAAHC, 49; as promoting NMAAHC, 59–61; scholarly advisors for, 166; temporary, for NMAAHC, 59–63, 66
Experience Unlimited, 224
Exposition Park (Los Angeles, California), 67–68

Feldman, Judy, 35–36
Fenwick, Leslie, 163
Ferrus, Diana, 107–8
Field to Factory: Afro-American Migration, 1915–1940 (exhibition), 91, 158–59
First Baptist Church (Williamsburg, Virginia), 238

Flegel, Brian, 200–201, 206
Fleming, Tuliza, 100
Flemister, Frederick C., 101
Folklife Festival (Washington, DC), 51–54, 108
Foner, Eric, 165
Fool's Errand: A Novel of the South During Reconstruction, A (Tourgée), ix–x
For All the World to See: Visual Culture and the Struggle for Civil Rights (exhibition), 60, 66
Ford Foundation, 72, 124
Foster, Norman, 75
Foster + Partners, 74, 75
Francis family, 110, 112
Franklin, John Hope, 26, 161, 162, 163, 194
Fredericksburg, Virginia, 132
Freedom's Journal, 185
"Freedom Sounds: A Community Celebration," 223–24
Free Lance-Star, 132
Freelon, Philip, 45–46, 47, 48, 49, *79*, 80, 171
Freelon Adjaye Bond team, 78–79
Freelon Group, 74, 76, 77
Friendfield estate (Georgetown, South Carolina), 4–5
Fudge, Ann, 19
fundraising, 117–28, 133–34; governmental, 118; schedules and, 129–30; travel and, 128–29. *See also* Congress: funding and; National Museum of African American History and Culture: donations to
Future of the African American Past, The (conference), 166

Gamble, Kenny, 53, 108–9
Gamble, Princess, 123, 127, 133
Gardner, James, 64
Gardullo, Paul, 65, 102, 104, 203
Garnet, Henry Highland, 62
Garza, Juan, 99–100
Gaye, Marvin, 96–97
George Clinton and Parliament Funkadelic, 53–54
George Washington University (Washington, DC), 102
Georgetown University (Washington, DC), *193*
Getty, Ann, 130
Ghana, 58–59
Glass, Brent, 63–64

Glover, Savion, 230
Gordy, Berry, 96–97
Grant, Jerome, 249
Graves, Denyce, 97–98, 144
Greensboro Lunch Counter, 23
Gregory, Dick, 52
Griffin, Patrick, 39
Griffiths, Douglas, 104
Grohl, Dave, 230
Grossman, James, 166
Gullah culture, 95, 109
Gustafson, Kathryn, 84–85
Gustafson Guthrie Nichol, 78

Haley, Shiba, 123
Hammock, Hill, 8, 21, 218
Hampson, Thomas, 144
Hancock, Herbie, 230–31
Hanks, Tom, 230
Harold Melvin & the Blue Notes, 53
Harper, Gregg, 152
Hartshorn, Willis "Buzz," 63
Havana, Cuba, 80
Haysbert, Dennis, 202
Headley, Eva, 123
Helms, Jesse, 6
Hemingway, Elizabeth, 245
Heritage Hall (NMAAHC), 83, 216
Heritage Signature Chorale, 215
Heyer, Heather, 148
Heyman, I. Michael, 6
Hill, Anita, 155
Hirshhorn Museum (Washington, DC), 214
History Gallery (NMAAHC), 149, 167, 170–72
H. J. Russell & Company, 200
Hobson, Mellody, 127
Holder, Eric, 54, 233
Holder, Geoffrey, 99
Holland, Andre, 218
Holmes, Cornelius, 258–59
Holocaust Memorial Museum (Washington, DC), 31, 44, 159
Horton, James Oliver, 58
Horvath, Al, 207–8
Houston, Texas, 152
Howard University (Washington, DC), 165
Howard University Gospel Choir, 231
Hoyer, Steny, 152
Huff, Leon, 53, 108–9
Hurricane Katrina, 51, 141, 217, 218

IBM, 21, 57
ICP. *See* International Center of Photography
Ide, Melanie, 169, 170
Institute of Contemporary Art (Boston, Massachusetts), 75
International Center of Photography (ICP; New York City), 62
Isay, David, 54, 172
Israel, 187–90
Israel Museum (Jerusalem), 188
Iziko South African Museum (Cape Town), 103, 107

Jackson, Jesse, 228
Jackson, Michael, 56
Jackson, Samuel, 233
Jackson, Shirley Ann, 232, 234
James, Virginia "Ginny," 154
Jarrett, Valerie, 142, 144, 221
Jazz Museum (Kansas City, Kansas), 30
J Dilla, 114
Jenkins, Princy, 4–5, 26, 59, 161, 254
Jewish Museum Berlin, 80
Joe Willie (Red Cap), 129
Johnson, Cheryl, 126, 150–51, 152, 153, 155, 205, 238
Johnson, Jim, 73, 213–14
Johnson, John, 113
Johnson, Robert, 19, 38, 100–101, 249
Jones, Quincy, 222, 229, 230
Jones, Rashida, 230
Joyner, Tom, 54

Kaine, Tim, 152
Kaiser Permanente, 224
Kellogg Foundation, 124
Kennedy, John F., 137
Kennedy, Roger, 10–11
Kidjo, Angélique, 224, 232
Kinard, John, 30
King, Alveda, 148, 149
King, Gayle, 224, 226–27
King, Martin Luther, Jr., 6, 29, 139, 149, 151–52, 233; monument to, 34
King, Martin Luther, III, 151–52
King, Regina, 217
Kinsey Collection: Shared Treasures of Bernard and Shirley Kinsey, The (exhibition), 60
KlingStubbins, 74, 75

Knight, Gladys, 230
Kogod, Robert, 74
Kolasinski, Sheryl, 72, 74, 79
Krakora, Nicole, 143
Kraut, Alan, 162
Kurin, Richard, 20, 51, 79, 118

LaBelle, Patti, 2, 236
Leadership in Energy and Environmental
 Design (LEED), 70, 259
Lee, Sheila Jackson, 152
LEED. See Leadership in Energy and Envi-
 ronmental Design
Legend, John, 230
Leland, Mickey, 6
Let Your Motto Be Resistance: African
 American Portraits (exhibition), 60,
 61–63, 62
Lewis, John, 6, 7, 148, 151, 152, 228; at
 NMAAHC dedication, 1–2, 232, 233–34;
 at NMAAHC groundbreaking, 144
Liberty Loan location (Washington, DC),
 34, 35
Libeskind, Daniel, 80
Lieberman, Evelyn, 39, 131, 134
Liljenquist, Tom, 97
Lilly Endowment Inc., 124
Lindsey, Margaret, 228
Litow, Stan, 57
Living Colour, 224
Logan, Minda, 120–22, 123
Lubkemann, Steve, 102
Lucas, George, 127, 129

Mack, Tom, 6
Makhuwa people, 103, 105–7
Malveaux, Suzanne, 144
Mandela, Nelson, 29
Marable, Manning, 165
March on Washington (1963), 34, 217
Marian Anderson: Artist and Symbol (exhi-
 bition), 60
Martin, Trayvon, 147
Mary Mary, 231
Mascots, Myths, Monuments, and Memory
 (exhibition), 250
Matsui, Doris, 62, 63
Mbatha-Raw, Gugu, 217–18
McDaniel, George, 109
McVey, Gina, 98
McVey, Lawrence, 98

Medford, Edna, 165
Memory Book (website section), 57
Mendive, Manuel, 102
Menendez, Robert, 152
Miller, Kelly, 5
Mina, Tracey, 145
Mischer, Don, 222, 229, 230
Mitsitam Café (National Museum of the
 American Indian), 168
Mobley, Mamie Till, 14, 27–28, 112, 113
Monáe, Janelle, 230
Montgomery Bus Boycott, 139
Moody Nolan Inc., 74, 75–76
Moran, James, 154
Moran, Jason, 144
More Perfect Union: Japanese Americans and
 the U.S. Constitution, A (exhibition), 174
Moresi, Michèle Gates, 56, 161, 225
Moshe Safdie and Associates Inc., 74, 76,
 77–78
Moss, Alfred, 163, 164
Mothership (George Clinton stage prop),
 53, 114, 172
Motley, Archibald, 101
Motown Museum (Detroit, Michigan), 96
Moutoussamy-Ashe, Jeanne, 109
Moynihan, Brian, 109
Mozambique, 103, 104–7, 227
Muhammad, Thameenah, 123
Museum of Mississippi History (Jackson,
 Mississippi), 152
Museum of the African Diaspora (San Fran-
 cisco, California), 129
Museum of the Jewish People (Tel Aviv,
 Israel), 188
museums, 50, 56–57; African American,
 29–30, 32–33; film work in, 174;
 international, 25, 80, 103, 159, 188–89;
 leadership of, and race, 9; sustainability
 and, 70; twentieth century, 169; twenty-
 first century, 9–10, 22, 25, 161, 169, 259
Museums In the Park (Chicago), 138–39
music, 29, 52–54, 96–97, 172, 189, 223–24,
 229–31
Mustakeem, Sowande' M., 101
"My Name Is February" (Ferrus), 108

NAACP Image Awards Ceremony, 253
Naeemi, Mac, 207
National Air and Space Museum (NASM;
 Washington, DC), 150

National Association of Counties, 46
National Capital Planning Commission, 39, 81, 206
National Coalition to Save the Mall, 35–36, 37
National Mall, 48, 70; African American memorials and, 5–7, 34; NMAAHC construction and, 202; as NMAAHC location, 7, 23, 33, 34–37; symbolic value of, 34, 138
National Museum of African American History and Culture (NMAAHC; Washington, DC): budget for, 49, 118, 181; café, as interpretive space, 168, 249; collections, building of, 56–57, 90, 91–101, 108, 114–15; collections, wish list for, 170; concerns about, 20–21, 154–55; construction of, 195–203, *197*, *198*, 206–11, *208*, *210*; critical response to, 245, 246; criticism of, 162–63, 184–85, 252; dedication ceremony, 1–2, 232–39; dedication ceremony, planning, 220–23, 224–26; design of, 48–49, 67, 81–85; design of, models, 75–77, *79*, 201–2; design of, public opinion on, 76–77; design of, significance, 70; design of, suggestions for, 68–69; donations to, 21, 117, 123–27, 134–35, 145, 196, 218, 224; as existing, before construction, 24–25, 44, 51, 65; groundbreaking ceremony, 142–45, *145*, 147, 195; identification badges, 20; importance of, xi, 8, 9–10, 148, 200–201, 253–55; legislation enacting, 7, 38–39, 138, 234; location of, *36*, 47–48; location of, concerns about, 37–38, 39; location of, and legitimacy, 34–35; location of, selecting, 33–38; media pieces, 174–75, 218, 219; membership program, 125–27, 135, 196; mission of, x, 1, 11, 50, 160, 250, 258–59; as museum for all, 28, 30, 142, 154, 182; noose found at, 251–52; online presence of, 21–22, 57, 202; opening of, 220–27, 230–39; opening of, White House reception for, 227; opinions on, academic, 44; opinions on, political, 44–45; opinions on, public, 44, 45, 245; orientation film, 216–18; pillars of, 26, 28–30; popularity of, 246–47; seen as project, 24–25; seen as threat to Smithsonian, 20–21; staff, 178–88, *184*, 190–94; staff, and race, 182–86; strategic planning

and, 192; technology and, 161; timeline for, 31–32, 198, 213; as twenty-first-century museum, 25, 28, 91–92, 161, 181; visibility of, 130–34, 142–43, 151, 206, 248–50; vision for, 25–26, 28–31, 119; visitor center, 202; visitors to, 242, 244–45
National Museum of African Art (Washington, DC), 18
National Museum of American History (NMAH; Washington, DC), 4, 6, 7, 23, 63–65, 173
National Museum of the American Indian (NMAI; Washington, DC), 10–11, 31, 71, 159, 168, 250
National Organization of Minority Architects, 69
National Park Service, 223
National Portrait Gallery (Washington, DC), 61, 63
National Public Radio (NPR), 55–57
Ndegeocello, Meshell, 224
Nelson, Stanley, Jr., 214–15
Netanyahu, Sara, 149
Newark, New Jersey, 152
New Orleans, Louisiana, 51
New York City, 62–63
New York Historical Society, 159
New York Times, 134
Ne-Yo, 230
Nichols, Elaine, *90*
1968 and Beyond (exhibition), 171
NMAAHC. *See* National Museum of African American History and Culture
NMAAHC Council, 109, 119–20, 122, 143, 229
NMAAHC Oversight Committee, 20
NMAH. *See* National Museum of American History
NMAI. *See* National Museum of the American Indian
Norton, Eleanor Holmes, 65, 205, 215
NPR. *See* National Public Radio
Nyong'o, Lupita, 218

Oak Park, Illinois, 70
Obama, Barack, 22, 28, 141–42, 143–45, 147, 217, 221, 228–30; at NMAAHC dedication, 1–2, 232, 236–38, *237*; at NMAAHC groundbreaking, 144–45, *145*, *146*; presidential campaign office, 114
Obama, Malia, 147–48

Obama, Michelle, 1, 145, 147, 229–30, 232, 233, 237
Obama, Sasha, 147–48
O'Brien, Soledad, 144
Odom, Elijah, 238
O'Donnell, Norah, 227
Office of Advancement (Smithsonian), 21, 125
Office of Communications and Public Affairs (Smithsonian), 131
Office of Contracting (Smithsonian), 73
Office of Equal Employment and Minority Affairs (Smithsonian), 205
Office of Government Affairs (Smithsonian), 22
Office of Management and Budget (Smithsonian), 140
Office of Project Management for NMAAHC (OPM), 162, 168, 173–74, 183, 203, 210, 219
Office of Public Affairs (Smithsonian), 39
Office of Special Events and Protocol (Smithsonian), 143, 220
Office of Special Projects (NMAAHC), 232
Olowe of Ise, 81
Olympic Games (1984), 68, 159
Ooni Adeyeye Enitan Babatunde Ogunwusi Akanda, 260–61
OPM. See Office of Project Management for NMAAHC
Oyelowo, David, 218

Pachter, Marc, 61, 62, 63
Palmach Museum (Tel Aviv, Israel), 188
Palmisano, Sam, 19, 21, 57, 120
Parks, Rosa, 99
Parsons, Dick, 19, 73, 118, 120, 221, 232
Patinkin, Mandy, 202
Paul, Billy, 53
Paysour, Fleur, 104, 131, 226
Pei Cobb Freed & Partners, 74, 75
Pelley, Scott, 104, 227
Pelosi, Nancy, 2, 151, 233
Person, Maurice, 112
Peterson (Red Cap), 129
Philadelphia, Pennsylvania, 87–90
Pinkett Smith, Jada, 230
Point of Pines Plantation, Edisto Island, South Carolina, 108
Poor People's Campaign (1968), 34
porch, in NMAAHC design, 82–83

Porter, John, 22
Porter, Wendy, 112
postal stamp, 248–49
Powell, Colin, 140, 227, 230
Powell, Richard, 163
Predock, Antoine, 74, 75–76
Price, Clement, 96, 163, 164
Project Interchange, 187–90
Prudential, 224
PT-13 Stearman aircraft, 114, 219
Public Enemy, 224
public engagement, 46–47
Pullman porters, 94, 109
Puryear, Mark, 223, 224

RAA. See Ralph Appelbaum Associates
racism, xi, 14, 38, 147, 148, 178, 248, 251–52, 259; environmental, 71
Raines, Franklin, 73
Ralph Appelbaum Associates (RAA), 168–73, 174, 176, 196
Rashad, Phylicia, 144
Raz, Guy, 56–57
Reagon, Bernice Johnson, 163, 164, 224
Red Caps, 128
Reece, Dwan, 223, 224
Reeves, Martha, 53
reflection booths, 172
Reich, Allan, 187–88
Rhimes, Shonda, 233, 250
Ricard, Kevin, 231
Rice, Condoleezza, 141
Rice, Linda Johnson, 19, 73, 113, 118, 120, 221, 232, 234
Rising Up: Hale Woodruff's Murals at Talladega College (exhibition), 60
River Road Plantations (Louisiana), 30
Roberts, John, 1, 232, 234
Roberts Temple Church of God in Christ (Chicago, Illinois), 113
Robinson, Harry, 30
Robinson, Jackie, 6
Robinson, Marian, 147
Rockefeller Foundation, 124
Rogers, John, Jr., 127
Roosevelt, Eleanor, 98
Roots, the, 224
Rose, Charlie, 227
Ross, Derek, 31–32, 201
Rubenstein, David, 248–49
Rubenstein, Harry, 13

Rush, Bobby, 22
Russwurm, John B., 185
Ryan, George, 139
Ryan, Paul, 2, 151, 155, 233

SAC. *See* Scholarly Advisory Committee for
 NMAAHC
Sachs, Albie, 107
Saint (Red Cap), 129
Saint Helena Island, South Carolina, 95
Sant, Roger, 40
Santos, Adèle Naudé, 73
São José Paquete Africa (slave ship), 103–4,
 107–8, 133, 171, 227
Saturday Night Live, 40–41
Save Our African American Treasures
 program, 92–96, 152–53
Schaffer, Ann, 188
Schakowsky, Jan, 22
Schermer Hall, Smithsonian Institution
 Castle (Washington, DC), 76–77
Scheuer, James, 5–6
Scholarly Advisory Committee for
 NMAAHC (SAC), 26, 162–65, 184
Scott, Tim, 148, 155
Scriber-Miller, Debora, 69, 190, 194, 224
Scurlock family, 65
Scurlock Studio and Black Washington, The
 (exhibition), 60
Senate Appropriations Committee, 154
September, Vanessa, 108
Serwer, Jackie, 80, 88, 100, 161
Shabazz, Betty, 6
Shange, Ntozake, 219
Shaw College (Raleigh, North Carolina), 163
Sieling, Bryan, 219
Sims, James, 91
60 Minutes, 104, 107, 133–34
Skorton, David, 148, 155, 215, 232, 250
slavery: humanization of, 4, 108; as
 NMAAHC focus, 59, 101, 160; reactions
 to discussion of, 44, 66; resonance of,
 132, 162, 258–59
Slavery and Freedom (exhibition), 170, 171,
 185
Slavery at Jefferson's Monticello: The Para-
 dox of Liberty (exhibition), 60, 66
Slavery Memorial Garden (Mozambique
 Island), 104–5
slave ships, 101–2, 158. See also *Enrique*;
 São José Paquete Africa

Slave Wrecks Project, 102–3
Small, Lawrence, 12–14, 19, 32, 117
Smallwood, Stephanie E., 101
Smith, Will, 234–35
Smithsonian Center for Folklife and
 Cultural Heritage (Washington, DC),
 51
Smithsonian Channel, 175
Smithsonian Institution (Washington, DC):
 ambivalence about African American
 museums, 6–7; collaboration and, 30,
 63–64, 93, 162; donations to, 21, 135;
 internal systems of, 180–81; leadership
 of, 10–11, 13; museum design and,
 71–72, 74, 76; museum location selection
 and, 33–34; NMAAHC director search,
 7–13; NMAAHC seen as threat to, 20–21;
 support within, 252; as unprepared for
 NMAAHC creation, 19–22. See also
 individual museums
Smoot Construction, 200
Smyntyna, Ivan, 206–7
Sorin, Gretchen Sullivan, 159
Sotomayor, Sonia, 233
Soul Train, 53
South Africa, 103, 107–8
Southampton County, Virginia, 110
Spinelli, Larry, 247
Stafford, Earl, 120
Stanford University (Stanford, California),
 165
Star-Spangled Banner, 23
Stastny, Don, 72, 73, 74
Stax Music Academy (Memphis, Tennes-
 see), 52–53, 223
Stewart, Rowena, 30
Stonesifer, Patty, 120, 124
StoryCorps, 54
StoryCorps Griot Program, 54–56, 172
Strait, Kevin, 114
Stuyvesant Heights Montessori School
 (Brooklyn, New York), 145
Sulton Campbell Britt & Associates, 74, 76
sustainability, 70–71
Sweet Home Café (NMAAHC), 249
Sweet Honey in the Rock, 224

Taking the Stage (exhibition), 219
"Taking the Stage" concert, 229–31
Tanner, Henry O., 101
Target, 224

Temple University (Philadelphia, Pennsylvania), 88
Te Papa, Museum of New Zealand (Wellington, New Zealand), 159
Terkel, Studs, 27
Terrell, Mary Church, 5
Thirteenth Amendment, 32, 198, 213
Thomas, Clarence, 154–55, 252
Thomas, Kevin, 123
Thomas, Selma, 174–75
Through the African American Lens: Selections from the Permanent Collection (exhibition), 60
Till, Emmett, 14, 27–28, 217, 218, 246; casket, 112–13
Tolva, John, 57
Tourgée, Albion W., ix
Toyota, 224
Trammell, Joseph, 97
Trump, Donald, 148–50, 250, 251
Trump, Melania, 149
Tubman, Harriet, 87–90
Tupelo, Mississippi, 152
Turman, Glynn, 218
Turner, Margaret, 123, 124
Turner, Nat, 110, 112, 217; Bible, 111, 112, 219
Tuskegee Airmen, 56, 114, 219, 230
Tyson, Bernard, 129

United States Commission of Fine Arts, 81
United States Navy Band, 144
URS Corporation, 74, 75
Usher, 230

Vance, Courtney, 202
Vasa Museum (Stockholm, Sweden), 222
Voting Rights Act of 1965, 32, 198, 213

Walker, Madam C. J., 94
Walker, Darren, 124

Wardlaw, Alvia, 163, 164
Washington, Esther, 194
Washington, Kerry, 250
Washington Monument, 36, 48, 223; NMAAHC construction and, 199–200; site near, as NMAAHC location, 34, 37, 40–41
Washington Post, 250
water: in African Americans culture, 82; museum construction and, 197–99; in museum design, 82
Watkins, Yelberton, 153–54
Watt, Mel, 153
Watts, J. C., Jr., 7
Welters, Tony, 120
Wesley, Howard-John, 125, 126
West Point Glee Club, 230
Wicker, Roger, 152
Williams, Anthony, 35
Williams, Eric R., 5
Williams, Jesse, 230
Williams, Maggie, 39–40
Willis, Deborah, 61–62, 63, 163
Winans, BeBe, 215
Winfrey, Oprah, 19, 122–23, 216, 230, 233, 234–35
Wonder, Stevie, 231, 236
Wood, March, 123
World War I, African American soldiers in, 98
Wright, Frank Lloyd, 70
Wright, Giles, 96
Wright, Robert, 7, 117
Wright, Simeon, 112–13

Yad Vashem (Jerusalem, Israel), 188
Yale University (New Haven, Connecticut), 165
York, Pennsylvania, 201
Yoruba people, 260–61
Young, Nicole, 104, 133